The Art of John Martin

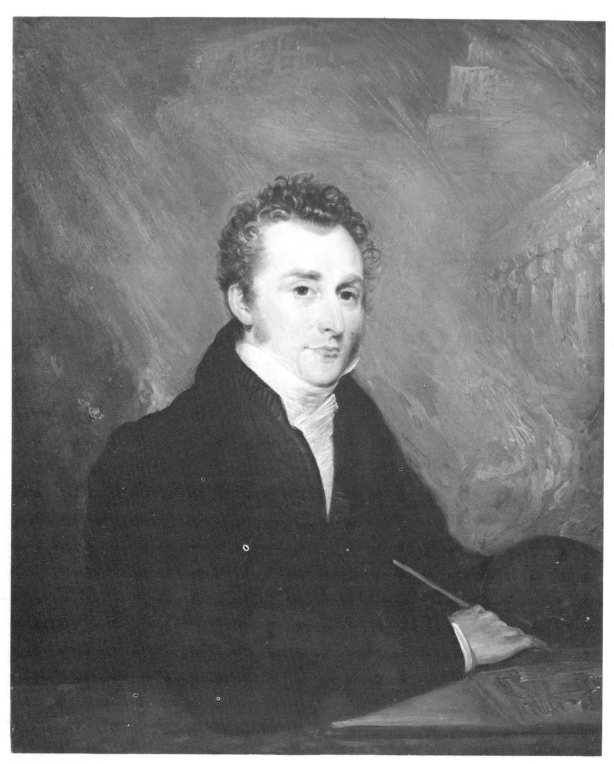

John Martin by Henry Warren, 1839. Oil on canvas, $8\frac{1}{4}''\times 10\frac{1}{2}''$.

The Art of
John Martin

William Feaver

Clarendon Press · Oxford · 1975

Oxford University Press, Ely House, London W.1

GLASGOW NEW YORK TORONTO MELBOURNE WELLINGTON
CAPE TOWN IBADAN NAIROBI DAR ES SALAAM LUSAKA ADDIS ABABA
DELHI BOMBAY CALCUTTA MADRAS KARACHI LAHORE DACCA
KUALA LUMPUR SINGAPORE HONG KONG TOKYO

ISBN 0 19 817334 2

© OXFORD UNIVERSITY PRESS 1975

PRINTED IN GREAT BRITAIN
BY FLETCHER AND SON LTD, NORWICH

For Vicki

Acknowledgements

This book was completed during my tenure of a Sir James Knott Research Fellowship at the University of Newcastle upon Tyne, 1971–3.

I am most grateful to a great number of institutions for their help, notably the following:

The Ashmolean Museum, Oxford; Birmingham City Art Gallery; Boston Museum of Fine Arts; British Museum Library and Department of Prints and Drawings; Dewsbury Town Hall; the Department of the Environment; Fitzwilliam Museum, Cambridge; the G.L.C. Library; Laing Art Gallery, Newcastle upon Tyne; The Manx Museum, Isle of Man; The Paul Mellon Centre for Studies in British Art (London and Washington); The National Gallery of Scotland; Newcastle upon Tyne City Libraries; Newcastle University Library; R.I.B.A. Library; Royal Academy Library; Sir John Soane's Museum; The Tate Gallery; Victoria and Albert Museum Library and Department of Prints and Drawings; The Walker Art Gallery, Liverpool; Westfield College Library, London University; The Whitworth Art Gallery, Manchester University; The Witt Library of the Courtauld Institute of Art.

Among the individuals who have given me help and advice I particularly wish to thank Miss Cecily King, Mrs. Francis Powell, and Mrs. Ruth Wright (descendants of Martin); also Patricia Allderidge, Bruce Bernard, David Bindman, Martin Butlin, David Elliot, Sibylla Jane Flower, Richard Green, William Hood, H. B. Huntington-Whiteley, Charles Jerdein, Nerys Johnson, Christopher Johnstone, Michael Kitson, Lt.-Col. J. L. B. Leicester-Warren, Lynn R. Matteson, Charles Morley-Fletcher, John Nicoll, Ian Phillips, Stephen Rees-Jones, Tristram Powell, Susan Stenderup, Charles Stuckey, Ruthven Todd, and Christopher Wood.

Above all I am grateful to the late Charlotte Frank for her support and encouragement in so many ways and to my wife for her invaluable collaboration.

The Eve of the Deluge is reproduced by gracious permission of H.M. the Queen. I would also like to thank all the other owners for allowing me to reproduce works.

The following have kindly given me permission to quote from letters and manuscript notes in their possession:

The Ashmolean Museum; The Bodleian Library; the Hon. David Lytton-Cobbold; H. B. Huntington-Whiteley, Esq.; the Trustees of Bethlem Royal Hospital; The National Library of Scotland; Newcastle upon Tyne City Libraries; Sir John Soane's Museum; Westfield College, London University.

W.A.F.

Allendale
August 1974

Contents

List of Plates

(*Those plates which have no credits have been supplied by the author.*)

CHAPTER I

'My native vale'

> The deluge pours upon the plain,
> And all it bears falls sacrifice;
> Before it fertile fields remain,
> Behind a barren desert lies.[1]

WHEN A flood swept down the Tyne valley on the morning of 17 November 1771, destroying all but one of the bridges in its path, John Mulcaster, a home-brew poet from the Langley lead mills, immediately compared this local disaster to the drowning of Herculaneum and Pompeii in ash and lava and to the great archetypal flood 4,119 years before, if Bishop Ussher's reckoning was anything to go by, in which the whole world had been overwhelmed save Noah, his family, and livestock in their grace-and-favour ark. The following year the half-repaired Haydon Bridge was again washed away and a few miles downstream at Bywell churchyard, where John Martin's ancestors, Ridleys and Fenwicks, were buried, coffins and skeletons were washed out of the ground.

> Nor bounding hedge nor wall remains,
> The hamlets too are swept away;
> Driven from their homes th' astounded swains
> Are sunk in terror and dismay.[2]

Two further floods occurred before John Martin's birth on 19 July 1789 in a one-roomed cottage beside the Tyne at East Landends (Pl. 1), just outside the village of Haydon Bridge; a place whose history was largely a recital of natural disaster: blizzards, births of monstrous two-headed calves, and occasional violence and sudden death in the remote mining hamlets of the hills to the south. All this could be interpreted in terms of portents, judgements, and visitations. It was easy to envisage lead-mines as the mouths of infernal regions, nearby Hadrian's Wall and border peel towers as the relics of vainglorious powers. Martin, the artist of flood, apocalypse, and disordered time-scales, could not have been born at a more appropriate time or in a more formative place.

Isabella Martin reared the five out of her thirteen children who survived infancy in the fear of the Lord, with prayers twice daily. She gave strict instruc-

1

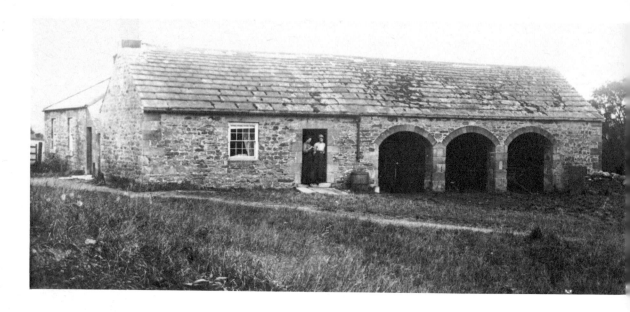

1. John Martin's birthplace: East Landends, Haydon Bridge.

tions that 'there was a God to serve and a hell to shun and that all liars and swearers were burnt in Hell with the devil and his angels.' With the result, as Jonathan, one of the brothers, wrote years later: 'The more I read the more I feared, the terrors of Hell stared me hourly in the face.'[3] Martin was taught to relate all he saw and experienced to Biblical precedent and to regard the broad, lush Tyne valley as an earthly paradise bordered by wilderness and outer darkness.

Isabella was obviously a forceful parent, exceptionally ambitious for her four sons, whose fame, she claimed on her death-bed, would one day sound from pole to pole. She credited herself with special visionary powers, which she passed on to William and Jonathan whose everyday decisions came to be inspired by their waking dreams. And her prophecy was remarkably accurate. William, the eldest, became locally famous; Jonathan achieved national notoriety as one of the most impressive arsonists since Herostratus and, subsequently, Bedlam's prize criminal lunatic; and John became internationally known, if not from pole to pole, at least from the Alps to the Rockies and beyond.

Isabella had come down in the world by marriage—her family were petty landowners from further down the valley. Her mother claimed descent from Nicholas Ridley the Protestant martyr and had objected to her marriage with Fenwick Martin. But he, 'a powerful man of dauntless resolution',[4] had eloped with her to Gretna Green. Their married life became a hand-to-mouth muddle, and the elder children spent long periods with their grandparents while Fenwick went from job to job. At one stage he was a foreman tanner in Ayr, where Richard was born in 1779. Then he enlisted in the army, during the American

2

war, but after only three months was wounded and discharged with a pension. After that he kept a pub on the Northumberland coast, acted as a woodman near Hexham, and gave fencing lessons in Newcastle. He used Isabella's money to set himself up as a pedlar and once drove cattle to London simply in order to see the sights. By the time John was born he was, apparently, resigned to being more or less permanently out of work, the family flitting from one tiny cottage in Haydon Bridge to another. 'By birth,' John recalled, 'my station could scarcely have been humbler than it was.'[5]

Fenwick passed on to his sons a sense of relentless discontent, the urge to widen horizons and fight single-handed if need be to promote themselves and their beliefs. John always regretted that both parents died, in 1813, before he had reached the point in his career where their good intentions and efforts on his behalf could receive their reward. However, the rest of the family remained closely linked, though the youngest, John, like any successful self-made men of the time, found himself encumbered with a string of improvident relatives. His brothers were to become an exceptional embarrassment; each in his own way parodying his achievements, painting, inventing, and drawing devastating conclusions from their dreams and fantasies. Eventually, like the doltish elder brothers in the Grimms' fairy tales, they all had to be bailed out in one way or another. Anne, the only sister, lived under his roof for many years. William, born in 1772, spent some years as a ropemaker and soldier (he joined the army in 1795, for the sake of the enlistment bounty money, to pay off the bailiffs), then married well and launched himself as Wallsend-on-Tyne's 'Anti-Newtonian Philosopher and Conqueror of all Nations' and spent over thirty years exhausting his wife's money and John's patience, publicising himself and his notions and composing jog-trot poetry in a Baron Munchausen vein, before taking up residence with John in old age.

One of the brothers, probably Richard, who later became a Quartermaster-Sergeant in the Guards and published a book of poems, *The Last Days of the Antediluvian World* with a frontispiece by Martin, in 1830, took lessons in drawing as a child and was given a paint-box; and this, according to a biographical outline of John's life (published in *Public Characters* in 1828), 'excited the attention of little John and he was induced to make an effort to surpass him. His brother, finding he had skill and genius very superior to his own, undertook in the most generous manner every kind of effort by which he was likely to enable John to rise to eminence and wealth.'[6]

There is no doubt that, although Martin was to suffer greatly from his brothers' demands and notoriety, he also derived from them some of the preoccupations that helped set him over and above the majority of painters. The visionary extravagances of the field preacher, the poet-soldier, and the self-informed scientist and philosopher stimulated him and enlarged his interests. Perhaps his strongest quality as an artist was to embrace sweeping ideas and events, rather than to delay unduly over specialized and blinkered detail. 'It

3

would not be hard to fancy', S. C. Hall, the founder of the *Art Journal*, once remarked, comparing Martin to his brothers, 'that John possessed the genius that to madness nearly is allied'.[7]

Martin left little autobiographical material, least of all about his own up-bringing, but he did emphasize the significance of childhood incidents:

If a man has accomplished anything worth talking about, I like to know him thoroughly. And how can you know him thoroughly without an acquaintance with his early history, cogitations, hopes and fears, crosses and joys, aids and obstructions? All this you learn best from himself. If he worked miracles, it is advantageous to know how he set about them, and to trace the steps of his progress; to contemplate the boy Franklin secretly trying his strength at an article, or the boy Burns at the plough stringing rhymes together. To the self revelations of autobiography—call them vanity if you choose—we are much indebted. No reading invites more to noble emulation.[8]

Stories in a conventional *Lives of the Artists* idiom of drawings that he made in the sand below the bridge and caricatures of his schoolmasters were told by Haydon Bridge villagers.[9] Martin mentions the 'wretched' scribbles he did in his copybook. He ground his own mud-pie pigment to paint the portrait of his grandmother's cat on an old canvas he found in the tower of the ruined Langley Castle, and decorated coarse canvas screens which were stuck on cottage roofs in the fête season. He claimed that he learnt little from school.[10] However, he left Haydon Bridge Grammar School at 14 on nodding acquaintance with the classics, notably Herodotus and Virgil, and with a hard-core foundation of history and legend which coloured his views for life, giving him a considerable advantage over his brothers who had received no sustained education.

The countryside, meanwhile, shaped his ideals of 'historical landscape'. At the beginning of the nineteenth century the hills around the Tyne were heavily wooded, the valley floor a wide cleft in the Pennine backbone of England. To the north of Haydon Bridge runs Hadrian's Wall, for centuries the formal northern frontier of the Roman Empire, the border of civilization, dividing order from chaos. By Martin's time it had decayed into a grassy dike with dressed stones poking through in places, straggling across empty fells. 'The ruins . . . give evidence of such massiveness and grandeur that the stranger, when wandering alone amongst the scattered broken columns, will feel he is in a city of the dead and will be reminded of Pompeii or Babylon or of Scipio amongst the ruins of Carthage'.[11] So Martin grew up in the shadow of one of the wonders of the ancient world: the Roman version of the great walls of Babylon and China which were later to fascinate him.

South of the Tyne, beyond Langley Castle, Allendale Gorge makes a dramatic crack in the landscape, with huge shelving rocks in the river-bed humped together like the platforms on which Martin was later to plant his focal figures: Moses, Joshua, and Satan. Oaks and beeches claw up the cliff-faces and stand ranged along distant skylines; Staward Peel, a toothy ruined tower, perches on

its own naturally fortified peninsula, an obvious eyrie for a gang of Salvator Rosa banditti—the sort of imaginative landscape Alexander Cozens conjured up from inkblots. Long before Martin came across the formal conventions of the sublime and the picturesque in landscape, he had clambered around the real thing, looking for bird-nests and making sketches.

At that time upper Allendale was one of the most important lead-mining areas in Europe. Jonathan used to get up at 2 o'clock in the morning and stand in the dark waiting to see the miners' lamps bobbing along the horizontal drift tunnels. He mentions the terror of the open pits, how once, as they played blindfold, his sister saved him from falling. John was 'always fearing to be in the dark and dreading ghosts and hobgoblins in every corner';[12] while Jonathan used to have wild premonitory dreams, set with flashes of lightning and broken by heavy groans. Dreams quite possibly fuelled by doses of 'Mother Bailey's Quieting Syrup' or 'Batley's Sedative Solution' which were responsible for much of the more staggering imagery of the romantic age.[13] Whatever the stimulus, this extraordinarily diverse, extremist landscape became a ruling theme in Martin's work. The Plains of Heaven and Eden lay on one hand; the nether world, Paradise Lost and the Pit, on the other. Summer lightning flickered round the valley, heralding floods, highlighting the remains of Empire along the Roman wall, underlining the myths and moralities learnt from schoolbooks, the Bible, Milton, and Foxe's *Book of Martyrs*.

Martin left school in 1803. His obvious future lay in apprenticeship or enlistment, but he was determined to become an artist. 'The question was how to turn my desire to profitable account'.[14] His parents did their best to help and so moved to Newcastle. Being rootless and to some extent shiftless, this put them to no great inconvenience.

Newcastle, piled in layers along the precipitous banks above the Tyne and the bridgehead, was the focus of traffic between England and Scotland. Steep lanes, 'sides' or 'chares', lined with tenements, wound up from the bridge, Guildhall, and Quayside to the Norman keep and cathedral on the more level ground above. The town was still defensively inclined. It had barely ceased to expect Scottish invasions when the Napoleonic wars began. In 1803 wagons were mustered on the Town Moor, and the militia was enlarged to meet a threatened French invasion.

That year the Revd. Thomas Malthus published his enlarged essay on the *Principles of Population*. Newcastle was an apt illustration of his fatalistic warnings of the general tumult and impoverishment resulting from an uncontrollable excess of people. The town was bursting out into suburbia, the walls discarded and pulled down to make way for traffic. David Stephenson, the leading local architect of the time, drove a new street across the town in 1803 and built a Palladian round church to offset castle and cathedral above the river. Over the next two generations Newcastle was to become a highly planned town with long

classical-revival streets (most of them the work of John Dobson, for a time Martin's fellow pupil), a northern counterpart to Nash's London.

The Newcastle skyline facing the hills of Gateshead across the Tyne appears in many of Martin's Biblical and classical townscapes with added Claudian trimmings and cross-references to Edinburgh, then in process of becoming the 'Athens of the North'. The theme of two towns in confrontation across a central ravine was to appear as Gibeon facing Beth-horon (in *Joshua Commanding the Sun to Stand Still upon Gibeon*, 1816) and in Martin's reconstructions of Nineveh, Rome, and Jerusalem. The Newcastle Keep juts up in central Jerusalem. The whole town shivers and subsides as Sodom and Gomorrah, just as in *The Great Day of His Wrath*, 1852, Edinburgh collapses, with Calton Hill, Arthur's Seat, and the Castle Rock falling together upon the valley between them. In *The Last Judgment*, 1853, the New Jerusalem, pure and gleaming white as Nash or Dobson would have ideally envisaged their rebuilt cities, soars above the ranks of the saintly immigrants to Kingdom Come, who stare across the flooded Tyne (disguised for the occasion as the Valley of Jehoshaphat) towards the scrabbling mob of the damned.

Being an important regional centre, Newcastle supported a certain amount of art of one kind or another, mostly designed to be applied decoratively. Book illustration was flourishing. Thomas Bewick's workshop in St. Nicholas's churchyard was an offshoot of a glass business established by William Beilby in the 1760s. Bewick had become an apprentice to William's son, Ralph Beilby, in 1767, and over the years the firm had come to offer a complete service of decorative jobs: anything from engraved inscriptions to heraldic paintings. Ralph Beilby had specialized in enamelled glass and developed an elaborate repertoire of masonic emblems, urns and obelisks, sporting scenes, and even classical landscapes complete with appropriate figures. When Bewick took over he continued to carry out silver-engraving jobs but concentrated on chap-book illustrations and show cards, meanwhile developing his unique skill as a wood-engraver most notably in the exquisite vignettes of Tyneside life in the tailpieces for his books, *The History of Quadrupeds* (1790) and *The History of British Birds* (1797–1807).

Bewick took in apprentices, like Luke Clennell who left in 1804 to try his fortune in London, only to break down in 1817 under the strain of commemorating Waterloo in an epic painting; but Martin, with little to recommend him and with an ambition to take up a steady trade as a painter rather than engraver, was apprenticed for a term of seven years to Leonard Wilson, a coachbuilder in Low Friar Street, on the understanding he would be taught how to execute the neat flourishes, the slick lines, and, on occasion, the bargee rococo of formalized heads, flowers, and coats of arms on carriage doors.

In his spare time he wandered round the town admiring the only freely available picture-matter: the shop boards and inn signs which offered in their portraits of the Chancellor's Head and the Royal George and their still lives of fruit

and ironmongery, street-level versions of gallery art. There was an art market of a sort; for, besides the Bewick workshop, print-sellers stocked portfolios of current attractions, Boydell's *Shakespeare Gallery* and Pyne's *Microcosm* (which laid down standardized figures and fittings for landscape composition) and mezzotints by J. R. Smith 'with difficulty distinguished from oil paintings'. Occasionally old masters or, more often, replicas that were supposed to be as near and as like as made no difference were exhibited, advertised in the *Newcastle Courant* as: 'Original paintings from the finest collections in Rome, Venice Turin, Flanders and England by Leonardo Da Vincey, Titian, Paul Veronese, Guido, Wright of Derby, Gainsborough, Hogarth and Wilson'. Besides offering a complete service as 'Coach House and Sign Painter, Glaziers, Japaners and Varnishers', Collinson's of Dean Street supplied 'the most faithful portraits of Horses and Dogs' to order, while Mr. Rosenberg, 'Profile Painter to their Majesties and the Royal Family, and their Graces the Duke and Duchess of Northumberland', anticipated photography with 'the most striking LIKE-NESSES in Profile, painted on Glass, superior to any before done. Time of Sitting one minute. Price one GUINEA, elegantly framed'. With reasonable luck and steady application Martin could have emerged from his apprenticeship as a coach painter to become, in William Bewick's words, one of 'the "Dick Tintos" of the provinces who, uniting the fine arts to a department of trade . . . adapt the the supply of their genius to the demand . . . are at once house, sign, coach and heraldry painter', prepared to venture on order 'upon the higher departments of art, landscape or portraits, as well as those luminous displays yclept "transparancies" painted upon a system of glazing of the Venetian school'.[15]

However, Martin found himself confined to menial jobs and quit after twelve months, on the excuse that Wilson had withheld promised opportunities and a rise in his wages. After lurking at home for a few days, passing the time by sketching cloud and lightning effects through his bedroom window, he was taken to the Guildhall to explain why he had broken his indentures. He managed to convince the authorities that Wilson had treated him badly and so he was set free and 'roamed the hills at daybreak, exulting in the sublime grandeur of the surrounding beauties of Nature, watching effects of light and shade, and trying to imprint those beautiful images indelibly upon my memory which, upon my return home, I endeavoured to retrace on paper'.[16] With his father's help he made a second and more promising start as the pupil of a Piedmontese immigrant, Boniface Musso, who had established himself in Newcastle as a teacher of fencing, perspective, and enamel-painting. Martin was to have lessons twice a week. In addition he skipped church on Sundays to learn oil-painting, with an eagerness which William Bewick, again, put into words:

Need I tell of the sleepless nights, the raptures of anticipation of an artist's first beginning in oil? When I did sleep, my dreams were of pictures of ineffable harmony and brilliance, my visions of beautiful paradises and glowing sunsets, of Jacob's Dream and the ladder with the Angels ascending and descending—of the tender aerial

landscapes of Claude and the depth and richness of Titian;—all the wonders of pencil and of nature arose before my ardent imagination.[17]

When, after three months, Fenwick ran out of money for lessons, Musso offered to continue to teach Martin free, with little hope of any return since the sitter's mother refused to take delivery of his first commission, a portrait in charcoal, complete with glass and frame for 25s., as she objected to a squint in the likeness. So Martin's second bid for a professional art career, this time in portraiture, faltered, establishing what was to become a lifelong pattern whereby each setback simply served to provoke him to enlarge his ambitions.

From Musso he learned the essentials of portraiture, topography, and enamel-painting and absorbed the manners of the Claude, Salvator Rosa, and Della Bella engravings that Musso owned. These gave him some ideals to emulate. Drawing books supplied useful assortments of ears, noses, throats, and examples of how to add the correct tints to huddles of cottages or Vesuvius in full discharge. In addition he was given a grounding in the rules and devices of perspectives, and in technical drawing, which he began in a rudimentary sort of way at this time by sketching out a mine ventilation system to William Martin's design. His architectural interests were probably developed through his fellow pupil John Dobson who was to make an impact at the Royal Academy in 1818 with a novel architectural drawing: a coloured perspective view (where the norm was genteel sepia) of Vanbrugh's Seaton Delaval Hall near Newcastle, itself a possible source of some of Martin's more grandiose architectural fancies.

Musso's living was precarious, dependent on the whims of young ladies who might favour water-colour one season but abandon it the next for poker-work, philanthropy, or even to take up clock- and lock-smithing. So, when in 1805 his son Charles took a job at a china-painting works in London, eventually intending to set up on his own, Musso went to join him, and Martin was invited to follow.

A view of Haydon Bridge[18] with two inert shepherds looking down on the toy-box village survives from this period, a piece of journeyman art, no doubt similar to the sample landscape and portrait of Musso that Martin took with him to London in September 1806.

A few years later and Martin might have felt less need to move because after the war there was to be a great flowering of provincial art with the development of art academies to flourish alongside self-help organizations like the Literary and Philosophical Societies and Mechanics Institutes. The Northumberland Institution for the Promotion of the Fine Arts, founded in 1822, came to boast a complete native school of artists, including T. M. Richardson, J. M. Carmichael, and H. P. Parker, specialists in squalls off Tynemouth harbour and Geordie genre paintings. But for the Mussos' invitation, Martin would probably have ended up among them.

CHAPTER II

Sadak

MARTIN went like any other product of Newcastle—coals, glass, and Bewick's books—by the sea route to London. He was robbed of his five shillings pocket money by a fellow passenger on the boat and became lost when he arrived, between the docks and Musso's lodgings. 'With the dense smoke and wet it seemed as if we were entering into an inhabited cloud', William Bewick recalled in similar circumstances, 'London appeared to me the heaven of youthful hopes and expectations, that Armida's garden of enchantment where all bright visions must be realised or disappointed.'[1] Indeed, as it turned out, there was no job for Martin. Charles Musso's hopes had fallen flat. However, he offered to put him up for a few weeks while he looked for work, wandering around half-starved, no doubt, like de Quincey, 'to gaze from Oxford Street up every avenue in succession which pierces northwards through the heart of Marylebone to the fields and the woods; for *that*, said I, travelling with my eye up the long vistas . . . *that* is the road to the north . . . If I had the wings of a dove, *that* way I would fly for rest.'[2]

It was the reaction of any workless provincial come to try his luck. The American artist Washington Allston, who for some years pursued a career that rivalled Martin's, had arrived in London from New York in 1801 and wrote: 'The country is beautiful and picturesque. But when I arrived in London, what a contrast! Figure to yourself the extremes of misery and splendor, and you will have a better idea of it than I can give you.'[3] London was already the biggest city in the world. Its population of nearly a million inhabitants was to double over the following thirty years. Largely as a side effect of the war, trade, with the Americas in particular, was growing rapidly. The West India Docks, built at a cost of £4 million, had been opened the previous year and the East India Docks were just receiving their first ships.

The Thames itself was combined trunk route, water supply, and sewer, vital to London's survival. 'If this river were rendered unnavigable, London would soon become a heap of ruins, like Nineveh or Babylon.'[4] The three bridges over the river were already inadequate, and plans for a new London Bridge were being considered. In 1800 George Dance the Younger suggested two bridges in place of the old one, linked on each bank by precincts to form an immense circus,

straddling the river; and Thomas Telford submitted a design for a 600-foot single cast-iron span with huge approach roads and supporting embankments, which also was rejected as a practical scheme. Telford's concept sold well as a print, but the riverside remained a clutter of wharves, stores, and workshops; for although London was assuming the role of the world's greatest capital, it had not yet achieved an imperial appearance. It was an overgrown trading town, the business centre of a nation of shopkeepers, where Wren's monument to the Great Fire of 1666 and his city churches still dominated the skyline. For half a crown one could climb into the gilt ball on top of the dome of St. Paul's and spy on the whole metropolis laid out in miniature. In 1806, with the war just resumed, there was little building taking place, though there were signs of a new, triumphant architecture in Henry Holland's new Carlton House for the Prince of Wales, And already for years Dance and Nash had been concerned with improving the layout of London, planning streets, squares, and colonnades. John Fordyce, the surveyor, was urging a new building development in Marylebone Park, later to be known as the Regent's Park. Their ideas of London as it could be were to influence much of Martin's later work, while the city as it existed was to colour his views on the downfall of civilizations.

In 1806, though, his main concern was his livelihood and his art. That year the British Institution opened in Pall Mall, in the former premises of Boydell's Shakespeare Gallery, which had gone bankrupt in the attempt to glorify both the British School of Painting and Alderman Boydell himself. The Institution was intended to promote modern works of art, as a challenge and alternative to the Royal Academy, and also to give young artists the chance to absorb and copy from selected old masters. Otherwise access to works of art was strictly limited, though some collectors, like Angerstein or Thomas Hope, allowed, even encouraged, visitors and most artists' studios were open to inspection. At the Royal Academy in Somerset House, Opie and Lawrence flattered Society, City, and Royalty with french-polished portraits. West and Flaxman dominated history-painting in the grand manner, while Fuseli and, increasingly, Turner provided the cosmic dramas and toppling spectacles which were to shake Martin out of the confined niceties of the applied arts.

Martin, scrabbling at the tail end of the profession, had the consolation that in this period, before the establishment of formal art schools, most young painters, including Turner a few years before, faced much the same hurdles as he. Some of the established artists, West and Lawrence in particular, were generous in their encouragement, although as far as Martin was concerned their patronage proved more valuable to his successive rivals, Allston and Danby.

Although most artists were obliged to make a start in their profession as scene painters, decorators, and illustrators, once they had reached academic status such vulgar occupations were generally dropped with relief. The Academy was concerned to erect barriers of good taste and professional ethics, to promote the artist until he could mingle on an equal footing with the god-like heroes of his

own ideal subject-matter. The finest artistry, the highest ideal, was to be found spread over the Sistine Chapel ceiling. Such art, in Reynolds's terms, involved first of all 'Industry'; in other words an Industrious Apprentice's scheme of things whereby the artist advanced by dint of steady application, high-mindedness, and obedience to the guiding rules to win the artistic equivalent to the hand of the master's daughter: full membership of the Royal Academy and the support of someone like Sir George Beaumont who ran a string of artists to whom he liked to give decisive advice.[5]

The most significant result of the rigid class distinction between assumed works of genius and those of mere manual dexterity was that popular and polite art became more definitively separated than ever before. Caricaturists and topographers in particular remained suspended in a commercial limbo; Hogarth might not have existed. Phillip de Loutherbourg was one of the few willing and able to step between the Academy and the general run of both painters and public; he did so by designing stage sets, collaborating with Gillray on a painting of the Battle of Valenciennes in 1793, and at the same time achieving R.A. status largely on the strength of his stock-sublime Alsatian landscapes. He had drawn on the traditions of masque and pageant, the narrative arts of Hogarth, the cults of ruin-building, and the recovery by excavation of lost civilizations for his Eidophusikon of 1781, a small-scale, concentrated spectacle involving artificial light, colour, and schematized movement on a 4 × 8 ft. stage.[6] The Eidophusikon was just a faded memory in 1806, but there was a great variety of instructive entertainment available, in which generalized sublimity and documentary particulars were blended in comparable ways. In Grosvenor Street de Bourg showed cork models of ancient temples 'in their present state'. More important were such panoramas as Mr. Serres's *Panoramic Picture of Boulogne* and Mr. Porter's *Agincourt*. Only a few years before, Turner had helped re-stage the Battle of the Nile at the Naumachia and Girtin had painted his *Eidometropolis* or panoramic view of London from the South Bank, both enlarged, popularized variations on the acres of history and classical landscape on the walls of the Academy and Institution, with four-foot figures and model ships to set the scale. Reinagle and Barker of the Strand were showing 'the Bay of Naples and the recent eruption of Vesuvius', an obligatory subject for showmen at the time, whether in the theatre where it could be merged with aquatic spectacles, ballets, and set pieces of Satan in Pandemonium, or at Astley's Amphitheatre where disasters and victories of every sort were staged daily. Then, reaching still further beyond the curious and exotic into the marvellous, there was the Phantasmagoria at the Lyceum: a magic lantern, back-projecting light on a transparent screen, with double slides to add movement.

The British Museum, still a store-house for picturesque curiosities rather than a Temple of the Arts, contained an extraordinary assortment of remains. A model of a Chinese junk was placed next to a cast of the Laocoön and Egyptian mummy cases. The mineral gallery included an Egyptian pebble, broken by

accident and inside, 'discovered on both pieces, a lively picture of the poet Chaucer', and 'a sectional representation of a coal mine' in variegated marble.[7] While Merlin's Mechanical Museum, off Hanover Square, included 'The Temple of Flora, Merlin's Cave, the Antique Whispering Busts, the Vocal Harp, the Bird Cage for Ladies, the Aerial Cavalcade, the Artificial Flying Bat',[8] to amaze the audience and send them away marvelling at man's growing power to guide the elements and create artificial life.

The Mechanical Museum and demonstrations of curiosities of 'natural philosophy', such as air pumps (as illustrated by Wright of Derby) and frogs galvanized by electricity, marked the beginnings of nineteenth-century scientific achievement. Audiences were set laughing by doses of gas. In 1805 Frederick Windsor put gas lighting along the wall of Prince George's garden in Pall Mall and night flared briefly into artificial day. The same year John's brother William came to London with a perpetual-motion machine which he exhibited in a room at 28 The Haymarket. He sold out two years later, but the machine was shown running for another twenty-seven years, and the Prince Regent was among the visitors.[9]

At the Society of Arts, at the Adelphi, pictorial, engineering, and scientific invention were considered all as one. There William and John Martin believed they could find an audience and make their bids for immortality. In 1814 William received a silver medal from the Society for his spring weighing-machine; while, on the walls, James Barry (who died six months before John's arrival in London) had painted the series of mythological history paintings, *The Culture and Progress of Human Knowledge*, which was to have a sustained influence on Martin's work, right through to his *Last Judgment* of 1851.

If Martin was to progress as an artist, however, it had to be in one of two ways: either slowly, though reasonably assuredly, up the ladder from china-painting and water-colour, passing through topography, life study, and portraiture, towards the sort of grand finale represented by Barry's Adelphi murals; or he could perhaps make a place for himself in the public eye as an entertaining polymath like de Loutherbourg, an artist prepared to appeal to wider and, by definition, more vulgar interests than those bounded by the high-flying Academy definitions. Barry, though, had been expelled from the Academy for his unsatisfactory attitudes. Perhaps in the final analysis both means of progress could lead to the same, equally significant, ends.

Topography being the first resort of the starving artist, for a while Martin tried to support himself by selling drawings of Northumbrian scenes; but without much success: 'Many a day after fruitless effort to dispose of my designs, have I returned to gaze on them, and feed myself with hopes.'[10] Ackermann bought three, for 12*s*., and asked if he had more to sell, but Martin refused: 'Want compelled me to request you to purchase these drawings: hunger compelled me to dispose of them for this inadequate sum: but you have not used me well, sir, and I will never deal with you again.'[11]

However, around this time, probably in 1807, Charles Musso started up in business with a partner and took Martin on at £2 a week for five years on the understanding that he would return half the wage to pay for his tuition in glass- and china-painting. However, Musso then put on an exhibition in Bond Street which failed. He went bankrupt and was obliged to join the workshop of William Collins, in the Strand. John was also given a job there. Following 'some little indifference', as he put it, with one of the family, he moved out to lodgings in Cumberland Place and in 1809 married Susan Garret (a friend of the Mussos) from Hampshire who was about 28, nine years his senior. Clearly Martin married because he believed that, with a steady job at Collins's and some prospect of making extra by painting, he could support a family. In any case Musso refused to take any more tuition fees. Martin moved to 8 Thanet Place, behind the workshop, and worked harder than ever, 'sitting up at night till 2 or 3 o'clock even in winter, acquiring that knowledge of perspective and architecture which has since been so valuable to me'.[12] However, days spent on cups and plates, nights in study and painting still left him in poverty.

A son, Fenwick, was born in 1811; his eldest daughter, Isabella, in 1812; and seven more children followed up to 1825, the births keeping pace with Martin's expanding means. Fenwick, John, and William died, but the six survivors were obviously a mounting burden. Little is known about Susan Martin. Dutifully, one suspects, her son Leopold described her as 'a true and loving helpmate, esteemed of all'. Early on in marriage her main occupation, apart from childbirth and housekeeping, was to read aloud to Martin as he worked. Isabella eventually took over this function, and the only accounts of Mrs. Martin in late life refer to her anxieties during the period of financial crisis in the 1830s and her insistence on being addressed as Lady Martin on the strength of her husband's knighthood of the Order of Leopold.

Martin taught in the evenings in order to support the family, and in 1810 once again sent a painting, *Clytie* to the Academy. This was rejected, but a 'Landscape Composition'[13] was hung the next year and went unnoticed. Then, in 1812, he left Collins's because his workmates, resenting the fact that he had served no apprenticeship, went on strike against him. Martin wrote: 'I saw that I was crushed and there was no help for me. I was too proud to contest against such antagonists. I resigned, and was thrown upon my own resources once more, with a wife and child to support.' He explained it all away to himself: the workmen were jealous, 'finding my productions the greatest favourites and fetching the highest prices'; he 'had never mixed with the men. Their tastes, habits, and views were discordant. They drank and smoked and wasted their lives in public houses; in short, they were content to stagnate, whilst I wished to progress.'[14]

So at the age of 22 (and, indeed, for the rest of his life), he was self-employed and still forced into teaching and hack topographic work, which tended to look much the same whether painted on china, paper, or canvas, or carried out in the orderly reversed procedures of the glass-painting trade, where every stroke

2. Landscape, *c*. 1807. Oil on panel, 10″ × 12″, inscribed on back 'to the best of my belief painted by me about the year 1807. John Martin', one of a pair.

had to be decided in advance, starting behind the glass with the highlights and details and working back towards the generalities of the setting. The products had to be uniform and anonymous, each feature filled in with a flick of the brush and details established with staccato brush jottings. None of Martin's painting on cups and plates is known to survive. However two small landscapes painted shortly after his arrival in London (Pl. 2) could almost have been designed to be wrapped around a pair of vases. They are competent, though slightly cramped, compilations of familiar classical motifs. Token figures loiter in the foregrounds, looking into the picture towards ruined cities in the mid-distance. Fallen Corinthian columns, a broken amphitheatre, and the pyramid of Caius Cestius make their first appearance. At this stage the architecture that Martin was to dislodge, smother, and overturn on so many occasions lies open to the evening sunshine.

By 1812 Martin had become an established craftsman and drawing instructor, a professional in art-forms that demanded small-scale and extreme stylization, in which a smooth finish and general brightness were all-important (Pl. 3). In his evidence to the Select Committee on Arts and their Connexion with Manufacture in 1835 he paid his respects to the arts for which he had been trained:

14

Glass painting must have surpassed all other branches of art in splendour, as it is capable of producing the most splendid and beautiful effects, far superior to oil-painting or water-colours, for by the transparency we have the means of bringing in real light, and have the full scale of nature as to light and as to shadow, as well as to the richness of colour which we have not in oilpainting nor in watercolour.[15]

Elements of the techniques of china- and glass-decoration, especially the treatments derived from glass-paintings of Bible scenes—harsh green Edens produced as fairings or hell-fire stained-glass windows—appear in practically all his subsequent painting. 'It seems to me that Martin never looked at Nature except through bits of stained glass,'[16] Coleridge once observed, slightingly, no doubt, while referring to the extraordinarily uniform high-key pitch of the *Paradise Lost* mezzotints. In a more literal sense it is arguable that Martin's oil-paintings were convenient portable versions of what could eventually have been realized on glass: 'I should have painted some of my own subjects, as the effect produced on glass would be particularly adapted to them, if the experiments etc, had been less expensive.' And he added:

I did not leave this branch of art without establishing a mode which has been and will remain in use, as long as glass painting is an art: but I could not get a sufficient price for a highly finished work to pay for the hazard. I painted some very highly finished paintings which were purchased by Lord Ennismore, who was very fond of glass-painting, and I finished Mr. Charles Musso's work when he died.[17]

In March 1812 de Loutherbourg died and Martin, if perhaps unconsciously, took up the succession. 'Having now lost my employment at Collins, it became indeed necessary to work hard, and, as I was then ambitious for fame, I determined on painting a large picture, "Sadak" which was executed in a month.'[18] It combined the Pandemonium of de Loutherbourg's Eidophusikon tradition with the sunset fury of the brightest stained glass.

3. The Cave, 1812. Sepia, 2¾″ × 3¼″, signed.

Up to this point this water-colours and oils had been agreeable, unremarkable essays in a purely decorative idiom. *Sadak in Search of the Waters of Oblivion* (Colour I, p. 17)[19] demonstrates all he had learnt about dramatic effect by means of lurid transparency. For the first time Martin contrived a fresh departure in romantic imagery; and although unsold at the Academy it was bought immediately afterwards, for 50 guineas, by William Manning, a governor of the Bank of England, whose son had been very taken with the image of the lone figure struggling on a lip of rock to maintain a foothold on life, and had subsequently died. So, as far as Manning was concerned, the painting served as a memento.

The story of Sadak came from James Ridley's *Tales of the Genii* (1762). Sadak was a Persian nobleman whose wife, Kalasrade, was abducted by the Sultan, who then tricked Sadak into volunteering to go in search of the Waters of Oblivion, which, unknown to Sadak, he planned to make Kalasrade drink so as to brainwash her into compliance with his evil wishes. The tale is concerned above all with themes of honour, justice, and retribution. It had already been adapted by Dibdin as an 'Asiatic Spectacle' in 1797, and was re-staged, at Covent Garden, in 1814. In Martin's painting, however, the story is edited down to the decisive episode where Sadak hangs in the balance between here and eternity.

After the fatigue and scrambling upwards he reached a broad flat prominent rock, whereon he laid his weakened body and looked downward on the waves below. ... Fear seized his body, though fortitude possessed his soul, and nature, tired of the struggle kindly stole him from himself and consigned him to oblivion. ... For a few minutes he lay entranced, and as he wakened, forgetful of his situation he rolled over to the brink of the rock, and was falling downward, when he clasped the rock, and secured himself with his hands.[20]

Martin shows him at journey's end, stuck mid-way between the glory of achievement and despair in the face of probable oblivion.

When Stothard illustrated the tale in 1781 he had been content to present it like some Georgian stage production, the characters expressing themselves politely but emphatically in a neutral setting. Martin intensified his effect by reducing his hero to a midget, marooned in a fiery furnace landscape. In his mind's eye the onlooker instinctively readjusts Sadak to life-size, just as Gulliver stands as a man of average height in Brobdingnag, 'relative to the scale of proportion'. Thereupon, as Martin said in his *Descriptive Catalogue of the Picture of the Fall of Nineveh*, 'the *great* becomes *gigantic*, the *wonderful* swells into the *sublime*.'[21] The painting expresses all that de Loutherbourg had been at pains to represent in the Eidophusikon: the super-colossal rocks, the parting strands of the waterfall, and behind, backlit, the mountains, 'whose smoke and eruption darkened the air and filled it with sulphorous stench. Here the hot cinders blown from the mountain fell in black showers upon him and scorched his raiment and his flesh.'[22]

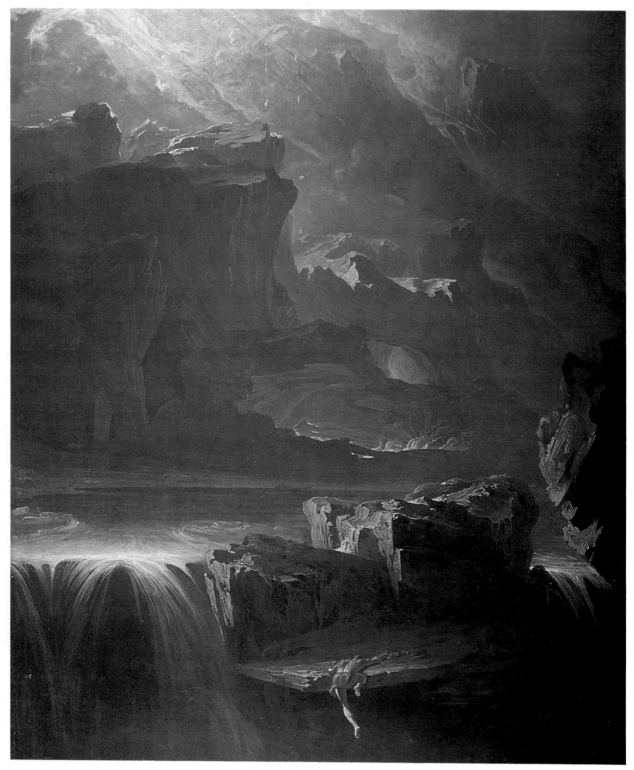

I. Sadak in search of the Waters of Oblivion, 1812. Oil on canvas, 30″ × 25″, signed.

Keats, it has been suggested,[23] had Sadak in mind when he wrote of

> The solid roar
> Of thunderous waterfalls and torrents hoarse,
> Pouring a constant bulk, uncertain where.
> Crag jutting forth to crag, and rocks that seem'd
> Ever as if just rising from a sleep,
> Forehead to forehead held their monstrous horns.[24]

Nothing in these romantic terms succeeds like excess. Sadak is the artist trying to grasp at Idea through execution. In Martin's hands the situation transcends the story. The Waters of Oblivion serve as a Holy Grail, Sadak's predicament becomes a desperate struggle for survival and personal advancement in circumstances beyond his control. 'Improve your power of action,' Martin used to say, 'and you improve your condition.'[25]

The painting was engraved for the 1828 *Keepsake* and appeared with a poem, now known to be by Shelley,[26] called 'Sadak the Wanderer'.

> Onward, Sadak, to thy prize!
> But what night has hid the skies?
> Like a dying star the sun
> Struggles on through cloud-wreaths dun;
> From yon mountains shelter'd brow
> Bursts the lava's burning flow:
> Warrior! Wilt thou dare the tomb
> In the red volcano's womb![27]

Whereas in the original story Sadak's scramble up the rock-face marked the half-way point in the tale, in the revised version—'The Story of the Deev Alfakir' (also printed in the *Keepsake*)—the complications of the original were eliminated. Sadak was reborn in Martin's image, a world-weary philosopher:

He stood on the brink of the wished-for flood, yet hesitated to drink. While he deliberated, the noxious vapours mingled with his breathing: at once overcome by their influence, he staggered, reeled and fell. From the state of senselessness he passed into one of uneasy sleep, disturbed by a thousand painful visions. The calamities of the past— the faithless friend—the selfish mistress, rose before him. He awoke from his slumbers, calling aloud on death to free him from the pangs of memory. As he opened his eyes, he found, to his horror, he was hanging over the edge of a rocky shelf, that overlooked a fearful chasm.

Eventually Sadak is put out of his misery by the satanic Deev Alfakir who hurls him into the air: 'He rose to a fearful height, then turned and fell. The waters of oblivion received him—they parted and closed again over Sadak for ever.'[28]

The most dramatic of Martin's early paintings, *Sadak* is remarkable for its direct translation of word to picture form. Though clearly influenced by the popular topographic motifs of firework displays, volcanic discharge, and industrial furnaces, heated and expanded uniformly to a red and raging pitch, the

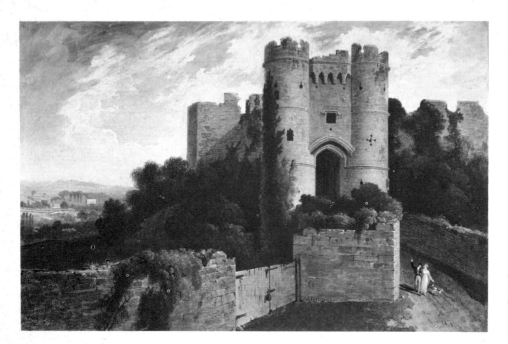

4. A View of the
Entrance to
Carisbrooke Castle,
1815. Oil on canvas,
$11\frac{3}{4}'' \times 17\frac{3}{4}''$, signed.

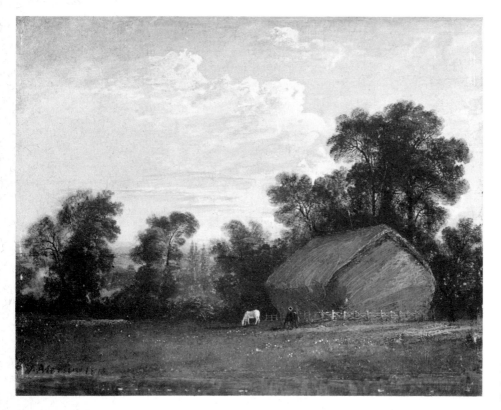

5. Landscape with
haystack, 1815. Oil
on panel, $10'' \times 12''$,
signed.

6. View in Kensington Gardens, 1816. Oil on panel, $8\frac{5}{16}''$ × $7\frac{3}{8}''$.

painting remains, essentially, very similar in style to Martin's sepia drawings, with the same over-all detail, the same air of tight, highly defined resolution. With Turner as a living example to guide and inspire him, Martin then moved cautiously for a while, confining himself, happily enough, to conventional subject-matter and unexceptional treatments, hoping to gain, eventually, independent, freehold artistic status.

Martin's tiptoeing *Clytie*, 1814 (Pl. 10), and the sightseers at *Carisbrooke Castle*, 1815 (Pl. 4), would not have been out of place among the products of the Musso studio or of the Beilby or Collins workshops, though studies such as the daisy-strewn *Landscape with haystack* (Pl. 5), the *Distant View of London* and the *View in Kensington Gardens*[29] of 1815 (Pl. 6), are outstandingly freshly ob-

19

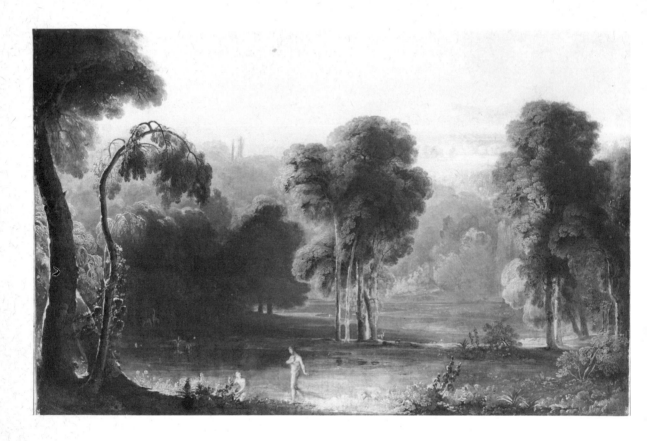

served. Composition became as much a set routine as typographic layout, obedient to the precepts of the picturesque established by the aesthetic theorists Gilpin, Price, and Payne Knight and propagated in copy books, in Mrs. Noel's art establishment in Albemarle Street[30] and *Northanger Abbey*. Turner's *Liber Studiorum*, Humphry Repton's 'Red Books' of suggested improvements to country estates and other, lesser, outlines provided landscape schemes and 'Gardens of Idea' which could make a Paradise or a Campagna of the Home Counties. Setting out in 1809 on his Tour in Search of the Picturesque, Combe and Rowlandson's Dr. Syntax said to himself:

> 'I'll *prose* it here, I'll *verse* it there,
> And *picturesque* it ev'ry where.'[31]

On such terms prose, verse, and picture-making made a perfect match.

Adam's First Sight of Eve, 1812 (Pl. 7), barely ventures beyond the discipline of china-painting; Eden is afforested with dank broccoli-trees and set about with an abundance of flowers displayed like wreaths strung on wire, with a dab or two of red to catch the eye. Two giraffes graze beside a thickly painted pool, while Adam and Eve, blurred at the tricky parts of their anatomies, are drawn, all too clearly, from third-hand sources, from engravings of antique models.

7. Adam's First Sight of Eve, 1812. Oil on canvas, $27\frac{5}{8}''$ × $41\frac{5}{8}''$, signed.

20

In 1813 Martin exhibited *The Expulsion of Adam and Eve* at the British Institution. The surviving half-sized version (Colour II, p. 32)[32] conveys brilliantly the sense of bleak, spreading despair when mankind (in the form of the two first persons) fell from its initial rapturous, timeless state of oblivion into the seasonal, temporal thereafter. The light of Paradise streams through great stagey rock portals as Adam and Eve, errant figures handed down from Masaccio, Raphael, and Michelangelo, stumble away from God's citadel or stately pleasure dome into a depressive Monument Valley beneath a smouldering overcast sunset. From this point onwards they are to be the victims of circumstances, frail, weatherbound, and, indeed, completely at a loss until Kingdom Come. In this painting Martin illustrated the sombre dying fall of the end of *Paradise Lost* more effectively than any artist before or since. As with *Sadak*, he succeeded in revitalizing the given imagery so that it became by adoption his own.

He set *Cadmus*, 1813 (Pl. 8),[33] in a dark valley, far beneath crags bathed in perpetual sunshine, very much like those of Allendale, repeating, in general terms and in reverse, the compositional scheme of *The Expulsion* and echoing Turner's *Jason and the Dragon* in the first instalment of the *Liber Studiorum*,

8. Cadmus, 1813.
Oil on canvas, 24″
× 35″, signed.

1807. Cadmus, a figure closely related to Sadak in both appearance and role, descended, in search of his sister, to do battle with a dragon that guarded the well of Ares. Pinned by Cadmus's spear to an oak, the pagan symbol of eternity, of prehistory, and half-sheltered by a cave of false refuge (both to become recurrent images in Martin's work), the dragon had already disposed of many assailants whose bodies lay strewn around; and though Cadmus succeeded in slaying the monster, its teeth immediately sprouted into armed men. If it has little of the outlandish quality of *Sadak* or *The Expulsion*, the painting has the same distanced precision.

Martin gave the painting to his brother William, who, reduced to selling it some years later, advertised it in a pamphlet dated 12 June 1827:

> *The Downfall of the Newtonian System!, or the Martinian System Triumphant*
> Now the picture of Cadmus by John Martin 14 year old
> May be seen at Mr Cales St Nicleses Church yeard to be sold
> For 100 ginnees in Gold,
> That is not one half of its value its very clear to be seen
> To those that understands the subject of that part of history keen.

9. Salmacis an
Hermaphroditu
(?), c. 1822. Oil o
canvas, 24″ × 26″

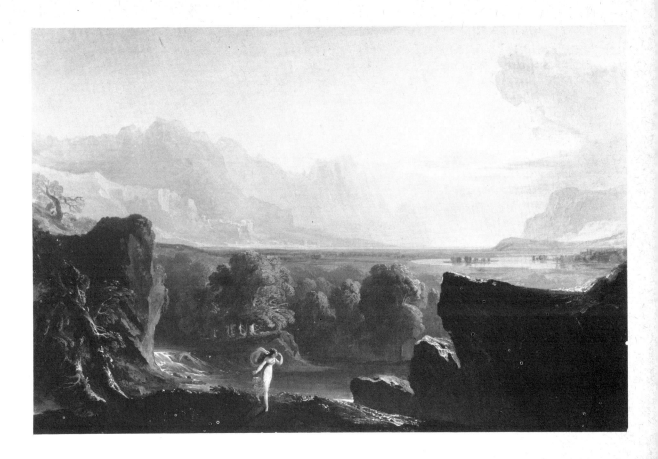

To those who understood, Martin was already deeply concerned with metamorphosis, with changing sorts and conditions ranged between time and eternity. He showed *Salmacis and Hermaphroditus* (Pl. 9)[34] at the British Institution in 1814 and sent another *Clytie* to the Academy. Both subjects were from Ovid's *Metamorphoses*. A surviving version of *Clytie* (Pl. 10) represents the forlorn nymph who, having fallen in love with Apollo the sun god, was condemned to wander, distracted, like Eve after her expulsion. Apollo, the onlooker was assumed to know, then turned Clytie into a sunflower, condemned to gaze at the sun for ever.[35] With its pale starched blue sky, its mountainsides tempered with faint gold and dusky pinks, *Clytie* has all the clarity and delicacy of a work on fine bone china, a sense of genteel pathos, of decorous passion.

The larger version of the painting, repainted years later as *Alpheus and Arethusa*,[36] was damaged before the opening of the 1814 Royal Academy exhibition, at some time during the five Varnishing Days set aside for Academicians to retouch their works, in Turner's words, 'the only occasion we all come together in an easy unrestrained manner'.[37] A thick stream of varnish was somehow spilt down the middle of *Clytie*. Martin, who only found out about this on the opening day, was furious and regarded the accident as a deliberate attempt to slight

23

him and blight his reputation. The President, Benjamin West, sent his regrets, and although Martin remained on friendly terms with him,[38] he became convinced, with growing reason, that the Academy as an institution was opposed to him and the sort of art he came to practise. He received no votes when he was put up for membership in 1820. He and B. R. Haydon were to become the most noted artists outside the Academy, and in 1835 they both gave heated and effective evidence to the Select Committee on the Arts on the caste-bound 'abomination' of the whole organization. By that time Martin had no need for academic status; he had exhibited at the Academy when it had suited him to do so and had succeeded on his own terms. As Constable remarked, he eventually 'looked at the Royal Academy from the Plains of Nineveh, from the Destruction of Babylon',[39] indeed from a unique vantage point. But in 1814, when so much depended on a good showing at the exhibition, the incident seemed a devastating setback.

At this time, however, he was developing some useful friendships, notably with Prince Leopold of Saxe-Coburg who came to England for the victory celebrations of 1814.[40] Leopold, a poor and insignificant member of the King of Prussia's retinue, could only find accommodation above the grocer's shop in Marylebone High Street where the Martins also lodged. They became friends and confided their ambitions to each other. Leopold guessed he might 'end by getting married in England'[41] and staying there. Sure enough, within two years Leopold returned to marry Princess Charlotte, the Regent's daughter and idolized 'Daughter of the Nation'. She died soon after in childbirth, but not before Martin had served as her drawing master and had been given the titular appointment of 'Historical Landscape Painter' to the Prince and Princess. Leopold later became king of the Belgians and remained Martin's most constant patron. He was godfather to his younger son, Leopold, and in 1833 appointed Martin a Knight of the Order of Leopold, which to some extent made up for the lack of official recognition of his achievements in England.

In 1814 the American artist C. R. Leslie introduced Martin to Washington Allston, who later claimed that they had met as early as 1813 when Martin, he said, had been in poverty, making baskets for a living. Martin denied this.[42] However, Allston's influence was most important for he was exceeded only by Haydon in his ambition to establish himself as a top-flight historical artist, and he helped stimulate Martin to venture beyond the status of drawing master and beyond the Claudian idiom. As it turned out, their tastes were incompatible. Allston's aims were strictly Raphaelite with neo-classical leanings and he produced studiously calculated, compositions, larger than life and twice as heroic; while Martin did the opposite, in effect, by dwarfing his figures in overwhelming schemes of things.

CHAPTER III

Babylon

As Martin said in his autobiographical notes,

Down to this period I had supported myself and family by pursuing almost every branch of my profession, teaching, painting small oil pictures,[1] glass enamel paintings, water colour drawings: in fact, the usual tale of a struggling artist's life. I had been so successful with my sepia drawings that the Bishop of Salisbury, the tutor of the Princess Charlotte, advised me not to risk my reputation by attempting the large picture of Joshua.[2]

However, he took the risk and sent *Joshua Commanding the Sun to Stand Still upon Gibeon* (Pl. 11) to the Royal Academy of 1816, where, although hung obscurely in the ante-room, it attracted great attention. Shown again the following year at the British Institution, it made even more impact and was awarded a second prize of £100. For all its public success *Joshua* was very much a probationary picture, Martin's first attempt at an epic, densely populated composition. It was, perhaps inevitably, slightly incoherent. As Lamb later wrote: 'The marshalling and the landscape of the war is everything, the miracle sinks into an anecdote of the day; and the eye may "dart through rank and file traverse" for some minutes, before it shall discover, among his armed followers, *which is Joshua*.'[3] In Lamb's view, whatever way the 'imaginative faculty' was developed, the proper study of mankind in terms of history painting was morally superior men, enlarged far and away above their everyday size and stature.

To some extent Martin met these requirements in *Joshua*, or had intended to do so at any rate. The principal players stand to the fore, the action taking place at a safe distance, and the whole event is caught at the peak moment when God intervened on Joshua's behalf and made time stand still. It was a day-long gap in history. Martin showed the mighty armies as a swarming flea circus; even Joshua and his ungainly attendant priests are totally subordinated to the prevailing conditions, strutting and fretting against the backdrop of apocalyptic special effects. Martin had, it seemed, made manikins of mankind; he had overlooked human dignity and underrated human passions by concentrating on the sublimities of thunderstorm and earthquake. He had made a mockery of the conventions of all the usual historical characters who emerged, ready armed,

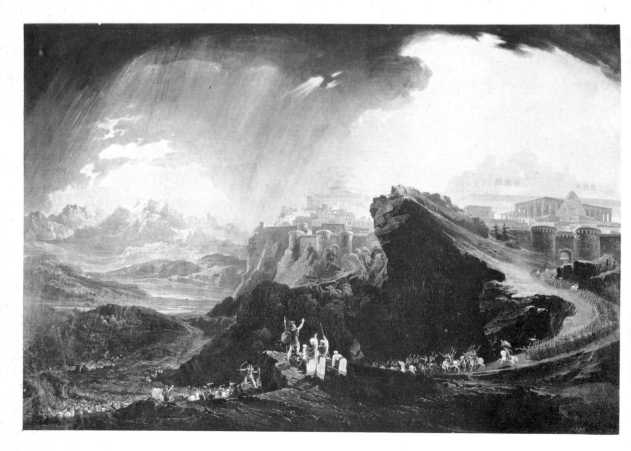

from the heroic mould—not, his critics implied, from choice but from sheer ineptitude. They considered Martin incapable of producing a decent full-size figure. He had never been to a life class and was merely a poor man's Salvator Rosa, a novice, very much like Northcote's 'young student in Painting' who, viewing 'with astonishment and delight the expression of the panorama on the stage . . . [thinks] this copy even preferable to the original in Nature itself, because it is more obtrusive and glaring'.[4]

Certainly *Joshua* was stupendous theatre. Where previous illustrations of the event (in Macklin's Bible, for instance) had shown Joshua the prophet dominant and taking full responsibility for the miraculous events, Martin gave the elements full play, reducing Joshua to the rank of aide-de-camp acting on orders from above, as he marshalled the tribes of Israel and their allies the men of Gibeon until the Canaanites and Amorites and their cohorts of elephants in the valley were thrown into total confusion by God's interference with the natural order.

The milling troops move in counterpoint to the clouds overhead, in a snaking double-vortex effect that Martin was to repeat in many of his later paintings. He used Hogarth's curving line of beauty galvanized like lightning, reinforced by the

11. Joshua Commanding the Sun to stand still upon Gibeon, 1816. Oil on canvas, 59″ × 91″, signed.

pelting diagonals of hail, spears, and arrows, and clearly drew on the storms of Turner's *Hannibal Crossing the Alps* (Pl. 12)[5] and *Eruption of the Souffrier Mountains*[6] and, perhaps by way of Turner, on Tintoretto's *St. George and the Dragon*[7] and Altdorfer's *Battle of Alexander* (Pl. 13) in which the armies are set firmly in context, wheeling and charging in co-ordination with the cloud cover.

Joshua was also Martin's first major exercise in architectural painting; the cities of Gibeon and Beth-horon (in the distance) were contrived from Claude's seaports, from Piranesi, the real estate of the Adelphi and Somerset House, and the citadels of Rome and Athens seen in terms of Newcastle and Edinburgh. They are planted, slightly uneasily, in the lustrous top-lit glow of a panorama scene, the two sets of gated and turreted man-made mountain tops demanding comparison with the eternal fastnesses of Mount Lebanon.

Disparate and disjointed the painting may be (it after all represents a jarring interruption of the normal course of time), but Martin's calculated outrage, in a composition that divides neatly along the skyline between battlescape and apocalypse, was, by most standards, a major achievement. Martin himself was well pleased: 'The confidence I had in my powers was justified, for the success of my *Joshua* opened a new era to me.'[8] His *tour de force* was a challenge to the authorities, a bid for attention which made him worthy of the title of 'Historical Landscape Painter'. In gratitude to his patrons he decided to make a mezzotint of *Joshua* to be dedicated to Prince Leopold.

If, as he soon discovered, the original was more or less unsaleable,[9] reproductions in print could bring him an income over a considerable length of time and greatly enlarge his reputation. After many delays and postponements Martin's mezzotint eventually appeared in 1827.[10] He made other studies in oil[11] and painted a full-scale copy for Charles Scarisbrick in 1848.[12] This painting, like the

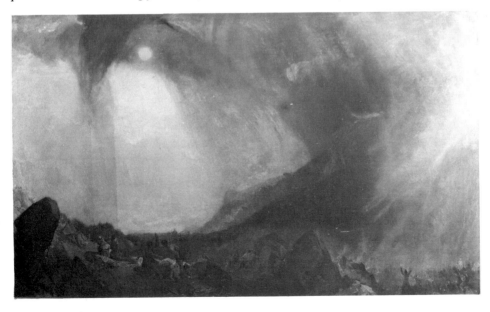

12. J. M. W. Turner: Snowstorm: Hannibal crossing the Alps, 1812. Oil on canvas, 57″ × 93″.

27

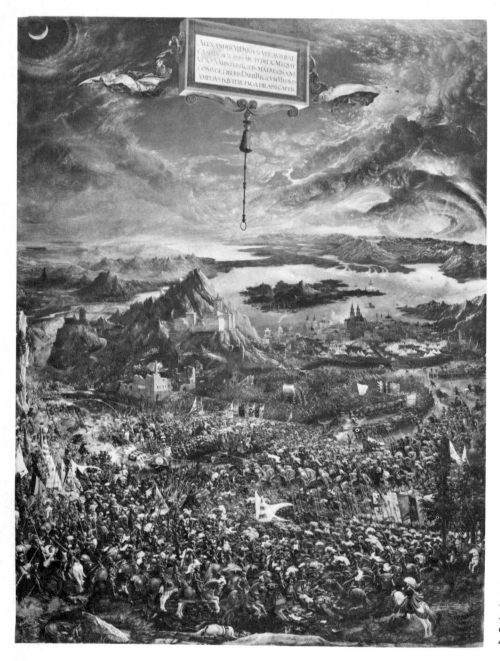

13. Albrecht Altdorfer: Battle of Alexander, 1529. Oil on canvas, $55\frac{1}{2}'' \times 47\frac{1}{8}''$.

mezzotint, has square towers on Moorish lines in place of the uncertain New-castle-style city walls of the original. With each repeat the circling elements—of storm, rock, armies, and colonnades—were more convincingly integrated, until Martin's design became the definitive representation of the scene, repro-duced in several later generations of Family Bibles.

From 1815 the London exhibition rooms were awash with sea victories, aglow with burning Moscows, and cluttered with commemorative allegories of Waterloo.[13] History painting became at once a documentary art, as much concerned with current affairs as with the decisive battles of the ancient world. While Napoleon had identified himself with Alexander and now stood brooding satanically on St. Helena, Wellington seemed a match for Caesar or Joshua, Great Britain, the new seat of Empire, developed heroes and mythologies to match. Scott's myth-raking brought about the sudden upsurge of enthusiasm for the Scottish heritage which helped attract the Regent to Edinburgh and carriage parties to the Trossachs. The works of Shakespeare, Spenser, Milton, and the fictional Ossian were plundered to provide imagery of Heaven, Hell, fairyland, and Ultima Thule, all located somewhere in the British Isles. Nationalist religious theory prospered. Richard Brothers spotted the devil walking down Tottenham Court Road and subscribed to the belief that the Ancient Britons had been the lost tribe of Israel, the Druids had been British Levites, and their monuments— Stonehenge and Avebury—equivalent to classical sites and the holy places. Blake envisaged his England as Albion, a country to be redeveloped, ideally, into a new Jerusalem.

In something of the same spirit Martin turned from the foothills of Mount Lebanon to Snowdonia, basing his painting *The Bard*, 1817 (Pl. 14) on a poem by Thomas Gray in which the one Welsh bard to survive a massacre ordered by Edward I had found refuge on a crag, where he stood pouring curses on the departing troops:

> 'Ruin seize thee, Ruthless King!
> Confusion on thy banners wait.'[14]

A bard's accustomed role was, like Orpheus',[15] to reclaim his fellow men from a savage state with the charm of his music.[16] As the sole survivor of his race, Gray's bard could only chant woe and damnation. Gray provided precise stage directions:

> On a rock, whose haughty brow
> Frowns o'er old Conway's foaming flood,
> Robed in the sable garb of woe,
> With haggard eyes the Poet stood;
> Loose his beard and hoary hair
> Stream'd like a meteor, to the troubled air. (I.2)

Most of the earlier illustrations of the poem[17] had been decidedly cramped, entirely taken up with the infuriated bard. Blake's versions, for instance, showed the poet rampant, breathing wrath down the necks of his enemies. De Loutherbourg and Fuseli had been slightly more concerned with the setting. Even so, their Bards ranted from a mere hustings level. Martin made an immense enlargement on the situation, his figures ranking in scale, if not in impact, as little more than afterthoughts. His Bard, like Sadak before him, stands

14. The Bard, 1817, Oil on canvas, 84″ × 61″.

dwarfed but, paradoxically, all the more insistent. Martin produced two versions[18] of *The Bard*, but he omitted it from his lists of major works after his Egyptian Hall exhibition and did not see fit to engrave it. The reason for this modesty, .or dissatisfaction, was that the composition was derived direct from a painting by Richard Corbauld that had been exhibited at the Royal Academy in 1807.[19] Charges of plagiarism concerning *Belshazzar's Feast* and *The Deluge* were repeatedly levelled at Martin during the 1820s, so the painting was a likely embarrassment, even though Martin's composition outstripped Corbauld's in practically every respect. He elevated the Bard far above the common herd of soldiery, to rank as prophet and seer among the eagles, free to climb among the eternal snows of the mountain tops in radiant daylight. His raving gestures are taken up by the massed oaks on the steep banks between castle and river. They writhe, root and branch, reminders of the murdered bards, promising revenge.[20] The castle—based on Harlech, the picturesque climax of any topographical tour of Wales—is installed well away from its actual site, as though an enlargement on Staward Peel in Allendale. Its walls serve as an artificial rejoinder to the natural fortifications on which the Bard stands. Its white banners play in the wind as though signalling back to his black robes fluttering above the gorge.

15. The Oak, plate 5 of *Characters of Trees*, 1817. Etching, $11\frac{3}{4} \times 16\frac{7}{8}''$, published by R. Ackermann.

The Bard perches solitary, facing Edward's Gideonite soldiery, who pour down, in apparently inexhaustible supply, parallel to the River Conway, the white horses' tails echoing the waterfalls. The painting is a showdown between might and right, between expediency and ideal, kept apart by the stream of time but interlinking with pattern and image until, in the last line of the poem, the Bard takes his own life. 'Deep in the roaring tide he plung'd to endless night', to find his own Waters of Oblivion.

Since neither the large *Clytie*, nor *Joshua*, or *The Bard* sold for years, Martin's living still came from his sepia drawings; these, uniformly finished, bright and deft, are instantly recognizable as his work, though the stories, from Ovid for instance, which many of them illustrate, are not so easily identified. They consist by and large, of wide valleys and bays lined with flossy trees (Pl. 16) and cliff-hanging cities (Pl. 17) and enlivened on occasion with dashes of incident such as a shipwreck,[21] wolves attacking a family (Pl. 18), archers hunting stags (Pl. 19), or wagons rolling along winding tracks towards Claudian destinations (Pl. 20).

In 1818 Martin moved from lodgings to 30 Allsop Terrace, in the New Road, bordering the development site of what was later to be named Regent's Park. He took the house because Charles Musso impressed on him that the only way to gain full acceptance as an artist[22] and, consequently, sales and commissions,

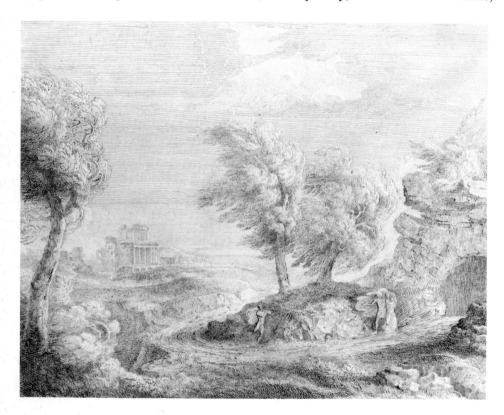

16. Classical Landscape, *c.* 1817. Water-colour, $7\frac{1}{2}'' \times 10\frac{3}{4}''$.

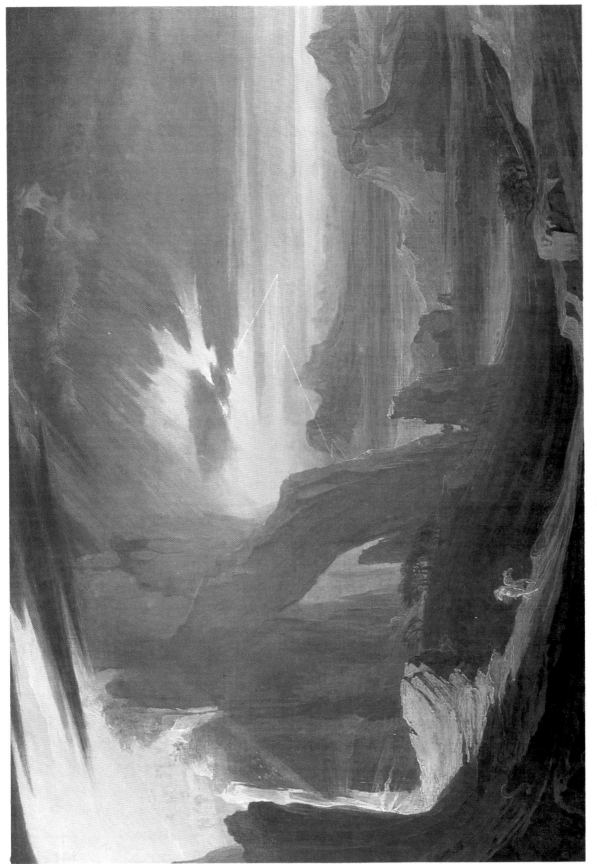

II. The Expulsion of Adam and Eve. Oil on canvas, 31″ × 43½″.

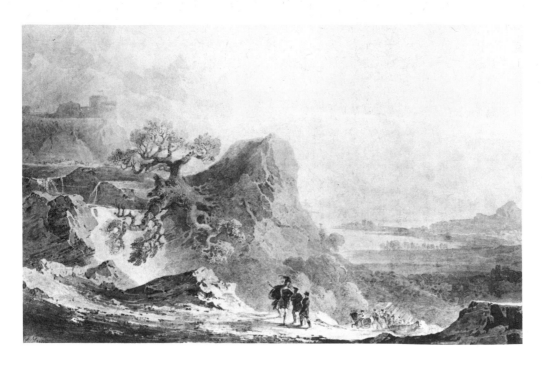

17. The Highland Fortress of Lessing Cray, 1818. Sepia, $7\frac{3}{4}'' \times 10\frac{3}{4}''$, signed.

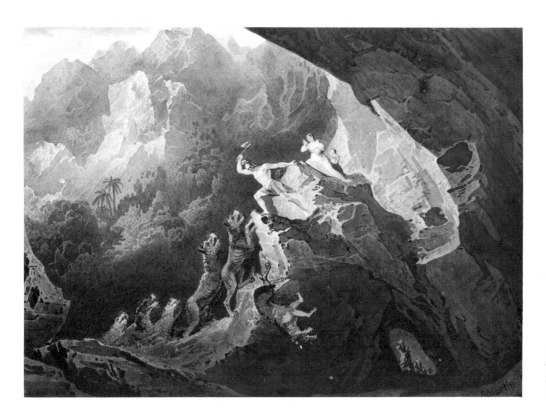

18. Landscape with figures. Sepia, $7\frac{3}{4}'' \times 10\frac{3}{8}''$, signed.

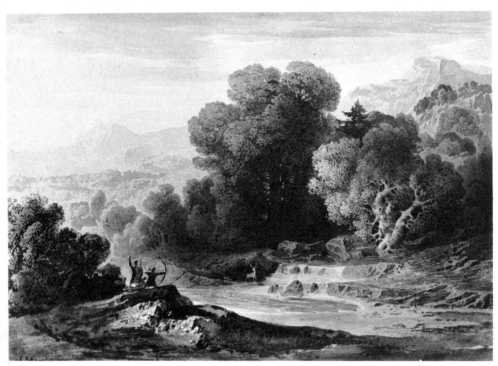

19. Archers and
Stag, 1821. Sepia,
$7\frac{1}{2}'' \times 10\frac{3}{4}''$, signed

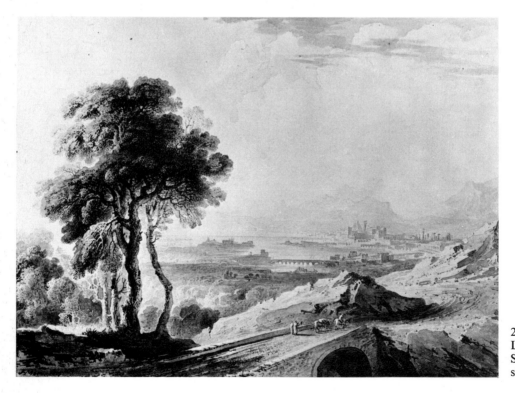

20. An Egyptian
Landscape, 1817.
Sepia, $7\frac{3}{4}'' \times 10\frac{1}{2}''$,
signed.

34

was to appear well established by living above his immediate means.[23] He borrowed £200 from William Manning, to whom he had sold *Sadak* for half the asking price on the understanding that Manning might, at some point, do him a favour in return. However, he was anxious to discharge his debt as quickly as possible, and so, besides doing a rapid succession of water-colours, towards the end of 1817 he took on a topographic commission to draw and engrave views of Sezincot, an Anglo-Indian country house, perched on the edge of the Cotswolds, overlooking a wide expanse of Gloucestershire.

At Sezincot Martin was brought into contact with a whole new vocabulary of design, in both architecture and landscape. The house was designed by S. P. Cockerell around 1804 for his brother Sir Charles, to be a reminder of the Indian civilization that had furnished him with his fortune; its chattris, domes, and colonnades in bright yellow stone—based on the mausoleum of Hyder Ali Khan at Laubaug—masked the prosaic lines of chimneys, the stable block, kitchens, and other offices of a conventional English country house. Cockerell drew on sketches made in India by Thomas Daniell.[24] From these he derived porticoes, a tall onion dome, and a long sweeping conservatory that linked the main part of the house with Sir Charles's bedroom.

Humphry Repton, the standard authority on Gardens of Idea, who was later employed on the Brighton Pavilion, was brought in to advise on the layout of the grounds. Repton believed in a dictated order of shrubberies, paths, and

21. Sezincot House, South Front of Mansion house and Conservatory, *c.* 1819. Etching/ aquatint (aquatint by F. C. Lewis) after John Martin, 10″ × 15″.

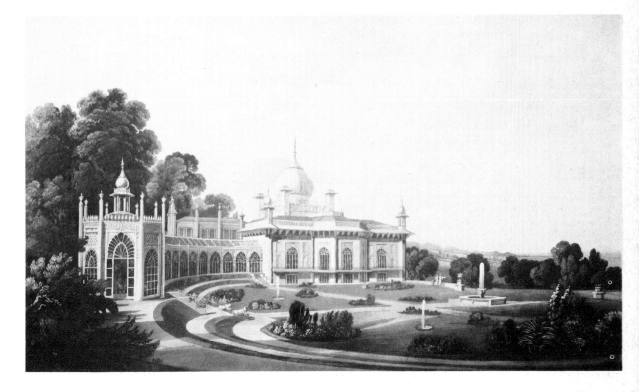

defined vistas. Approaching landscape from the conventions of painting, he believed with Burke that 'no work of art can be great but as it deceives' and went beyond practical lengths to contrive a conscious art-form landscape.[25] So at Sezincot Martin was confronted with grounds established almost in the terms of Indian miniature painting; a bridge, guarded by sacred cows in cement, crossed a stream which led the eye towards rock pools, a cave, a fountain, and a temple. An Eden where roses, palms, rhododendrons, hollyhocks, and oaks could all flourish together was established in his mind, a vision far more convincing than the conservatory horticulture, the teacup landscape conventions he had used in *Adam's First Sight of Eve*.

His ten neat self-effacing etchings (Pls. 21–3)[26] show the house barely completed and the grounds fledgeling in appearance, the ornaments and exotic shrubs as yet unsettled among the native beeches.

The Sezincot commission came at the time Martin was contemplating not merely his departure from Marylebone High Street to assume householder status in Allsop Terrace, but a further move from historical landscape into the architectural reconstruction of *The Fall of Babylon*: an advance from depicting exotic landscape gardening to constructing an entire imaginative capital city.

Though restricted to representation as opposed to actual building, Martin was pursuing a course similar to that of John Buonarotti Papworth, who, employed by the Earl of Shrewsbury to design a phantasmagoric garden at Alton Towers, included an ice-house in Egyptian taste, a Chinese temple and fountain, and a Stonehenge. Like Repton, Papworth moved on from the 'Garden of Idea' to develop, in Cheltenham, the beginnings of a City of Idea. The rotunda and verandas of Montpellier Spa were comparable to the Nash plans for London and to the Palaces of Idea: Sezincot, Fonthill, the Brighton Pavilion, Thomas Hope's Deepdene and Carlton House (demolished shortly after completion to make way for the triumphal spread of Carlton House Terrace). It was an art and an architecture specially suited to empire builders.

London, dominating a commercial and colonial empire (much of it the spoils of victory over Napoleon), and the stately-home counties were thus townscaped, landscaped, and reorganized; they were made exotic and altogether tremendous in artificial stone, stucco and theatrical perspectives. Keats's description of epic poems as 'splendid impositions' applies, right across the spectrum, to all contrived landscape and town planning. The theatre was moving out of doors and into reality, from backcloth to permanent set. Well before the Nash rebuilding schemes had got under way in London, Martin discovered at Sezincot, around the house itself and in the Daniells' drawings in the library there, that an alien architectural tradition could be revived and that past civilizations—whether Hindu, Egyptian, Babylonic, or Roman—could provide models for the present. History painting could become a blue print or forewarning of the future.

A sketch-book made by Martin in 1817 demonstrates the overlapping complexities of these concerns and his own ideas.[27] Most of the forty pages contain

22. Sezincot House, Entrance Door of East Front of main house, *c.* 1819. Etching/aquatint (aquatint by F. C. Lewis) after John Martin, 10″ × 15″.

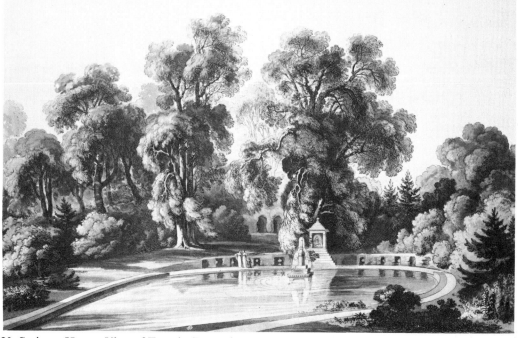

23. Sezincot House, View of Temple, Fountain, and Cave, *c.* 1819. Etching/aquatint (aquatint by F. C. Lewis) after John Martin, 10″ × 15″.

studies of the architecture of Sezincot and Babylon (Pl. 24). The Sezincot fountains and trees become enlarged to fit the hanging gardens. Clumps of plants are worked up into full flower to be used as motifs on the architectural friezes. Reality gives way to invention with pages of Babylonic pediment and stairway. Elephant roof-supports, spouting lions (Pl. 25), and overwrought figures appear, interspersed with sketches of carriage suspension, ships' rudders, and gun barrels (with a note of the address of 'the Honourable and Principle Officer and Commissioner of His Majesty's Navy'), and a detailed drawing of a safety lamp (Pl. 86).[28]

These doodles are the only surviving illustrations of Martin's trains of thought at this time. They show clearly that his interest in invention existed long before he published his first pamphlet in 1827 and how one project overlapped another. Similarly, a sepia drawing, 'Diogenes Visited By Alexander',[29] shows the general pausing to consult the philosopher, who is musing in the sun at the mouth of his barrel; a meeting mirrored in the backdrop of aqueduct, arcades, birches, and willows which represent a frontier between ordered civilization and, perhaps, a simplistic, escapist nature. Beside a fountain, Martin's chosen symbol of perpetual regeneration, the two worlds move momentarily into conjunction and harmony.

24. Sketchbook,
page 13, sketch of
the South Front of
Sezincot House,
c. 1818.

25. Sketchbook,
page 10, c. 1818.

The Fall of Babylon[30] took nearly a year to paint and was shown at the British Institution in 1819 to great acclaim (Pl. 26). The *Examiner* described how 'The spectators crowd around it, some with silence, some with exclamatory admiration; sometimes very near to look at the numerous small objects that cannot be distinguished at a distance, sometimes further off to feast upon the grandeur of the whole.'[31] C. R. Leslie, who was later to mock Martin's 'pantomimes', wrote to Allston: 'Though I mention it last, certainly very far from least, a magnificent picture of the Fall of Babylon by Martin, which, I think, even surpasses his Joshua, I need say no more.'[32] It sold immediately for 400 guineas to Henry Hope (an arbiter of taste whom Sydney Smith once described as 'the gentleman of sofas'), and hung eventually in Thomas Hope's neo-classical country palace at Deepdene. Martin 'felt as much joy, and glut of delight, at painting a picture on which I had put four hundred guineas, and getting it, as Wellington must have felt in conquering Bonaparte. I had thirsted to succeed as a Painter. Was not this success? If not with the world, it was for me and my family, my friends, my creditors, and my encouragement.'[33] He at once paid off his debt to William Manning.

Martin's Babylon was laid out in line with the docks, warehouses, and terraces of his own day and age. It was contrived to cater for a taste for distant eras,

knowledge of which had previously depended on the somewhat austere written sources of Herodotus, Josephus, and the Bible, but which were now in process of being exhumed by archaeologists and reconstructed from the evidence of measurements and surveys and from such trophies as the sculpted head of Ramases II brought to the British Museum in 1818, the Elgin Marbles, and the Sarcophagus of Seti I shipped to England by Belzoni in 1820 to delight both artists and public. To translate these findings from their fragmentary state and collate them with travellers' tales and legend into vivid, coherent expression involved great imaginative leaps backwards into the dark, together with considerable chronological readjustment as Bishop Ussher's deadline of 2004 B.C. for the beginning of the world was proved on investigation to be far too recent and precise.

Martin's special contribution was to popularize and make immediate vanished civilizations. While offering little or nothing in terms of original research, he turned literary references into visual reality. Steering clear of the god-like personalities painted so mightily by Haydon, Northcote, and Hilton and hung in clusters like swarming bats around the walls of the Academy, he concentrated on architectural heroics—the immense promenades, viaducts, canals, and sewers which had been commonplace, it appeared, in the ancient Egyptian and Babylonian empires. *The Fall of Babylon* was conceived as an instructive entertainment and designed with a scrupulous regard for all ascertainable detail. There were few precedents in fine art for this brand of panoramic epic painting. Brueghel's two towers of Babel, planted like multi-storey sandcastles beside the North Sea, provided the super-colossal scale but no comparable sense of sudden decline and fall. On the other hand, Bosch, for example, showed apocalyptic horrors but without documentary support. Such preoccupations, however, were common among Martin's contemporaries.[34] In April 1818 Canto IV of *Childe Harold's Pilgrimage* appeared; in it Byron is concerned above all with the vainglory of the kingdoms of this world:

> Behold the Imperial Mount! 'tis thus the mighty falls.
> There is the moral of all human tales;
> 'Tis but the same rehearsal of the past,
> First Freedom, and then Glory—when that fails,
> Wealth—Vice—Corruption,—Barbarism at last. (sts. 107–8)

The Napoleonic Empire had proved a mere ten-year wonder. At the time that Martin was rebuilding Babylon, Britain was showing all the symptoms of advancing breakdown.

Turner, whose reputation had been built on his *Destruction of Sodom*, *The Tenth Plague*, and similar paintings, exhibited *The Decline of the Carthaginian Empire* at the Royal Academy of 1817. However, like Claude and Poussin before him, he made no serious attempt to represent these cities as they had actually appeared, but showed them instead as sublimely inauthentic permanent stage

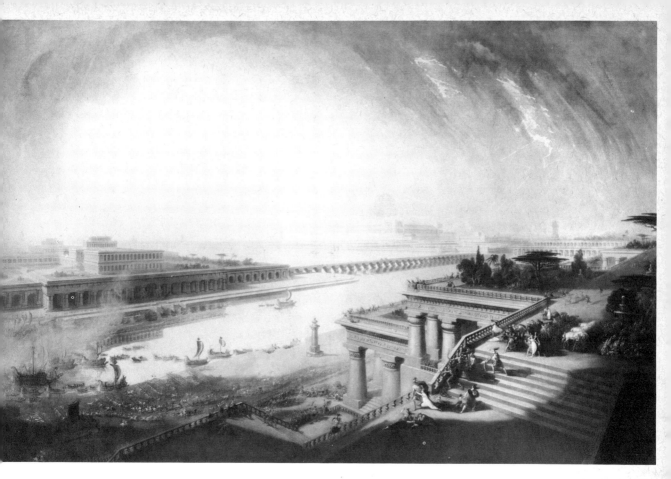

26. The Fall of
Babylon, 1819. Oil
on canvas, 61″ ×
96″, signed.

sets, adaptable to almost any age or circumstances. At this time Rome and
Venice were the only seats of bygone powers that were still readily accessible to
artists and offering evidence of how they had looked in their heyday.

> States fall—Arts fade—but Nature doth not die
> Nor yet forget how Venice once was dear . . .[35]

As excavations proceeded and as fresh sites were mapped out, recorded, the
findings published,[36] the neo-classical taste for accurate reconstruction of an
exemplary, awe-inspiring past (epitomized in English circles by the collecting
instincts of the Society of Dilettanti) was propagated by way of theatre design,
panoramas, and architecture. These are the frames of reference within which
Martin's epic 'machines' truly belong—not among the conventional history
paintings in the Academy, but some distance away, in the section where archi-
tects, among them John Dobson, his fellow pupil under Musso, showed
perspective views and models.

Where Piranesi and a succession of draughtsman-topographers expressed a
delight in the contemporary ruined state of ancient monuments, Martin, with a
showman's instinct, chose to depict the actual ruinous events. Where Sir John
Soane had toyed with the idea of the great buildings of his day (his own, osten-
sibly imperishable, Bank of England, for instance) fallen into ruin to become fit

41

subject-matter for some future Piranesi, Martin attempted to follow up the archaeologists and historians in salvaging long-lost capitals, setting them out as though he were planning to reconstruct these places, not beside the Tigris or Euphrates, but along the banks of the Thames. His cityscapes were thus, in his eyes and those of his admirers, triumphs of art over the ravages of time. In speculative terms they resembled the designs made by Soane's assistant, Joseph Gandy, who, unable to raise architectural commissions during the war, resorted to wishful and fanciful thinking, producing, in 1814, a *Tomb of Merlin*, a pale yellow and grey, complicated, melodramatically lit crypt in a slightly crazed order of rococo-romanesque, a virtually uninhabitable *Residence for the Duke of Wellington* in 1816, and a *Hall of Pandemonium* (1805) like a barley-sugar stock exchange. For sheer bubbling bravado these *capricios* surpassed anything Martin envisaged.

Martin is usually credited with a similar sense of fantasy: his architecture was born perhaps, like the stately pleasure domes of Xanadu, from opium dreams in which 'the sense of space, and in the end the sense of time, were both powerfully affected. Buildings, landscape, etc. were exhibited in proportions so vast as the bodily eye is not fitted to receive. Space swelled, and was amplified to an extent of unutterable and self-repeating infinity.'[37] Some of Martin's architectural projections—the Celestial City and City of Pandemonium—were indeed the stuff of dreams. In these instances he was following Milton and Bunyan in representing ineffable heavenly heights and unutterable fiery depths. But each of his successive wonders of the true ancient world was founded on the available facts. To his mind he was a Canaletto rather than a Piranesi in his role as a topographer of ancient history. He made this clear in the descriptive catalogues of his major paintings: 'By a reference to the Scale of Proportion, it will be found that Historical Accounts, as to the size and extent of the objects, are strictly attended to.'[38] His use of 'The Historical Accounts from Herodotus, B.I. Diod. Sic. B.2. Strabo &c.,' and from the Books of Isaiah and Jeremiah with chapter and verse all quoted[39] furnished his mannerisms with something of a scholarly aura, and gave his audience the status of sightseers in a conducted tour led, for instance, to note

9 The Palace built by Nebuchadnezzar, eight miles in circumference, on which were the Hanging Gardens.
10 The Bridge built by Nitocris:—observe the joining of the stones, which have the strength of an Arch without being one.

Other documentary sources of the painting included travel books about the Orient published during the previous twenty years, such as Louis François Cassas's *Voyage pittoresque de la Syrie, de la Phoenice, de la Palestine, et de la Basse Égypte* (1799), *Views in Egypt, Palestine and Other Parts of the Ottoman Empire* by Luigi Maya, and *Description de l'Égypte* (ed. F. Jorn, 1809–29). In

the introduction to his *Narrative of a Journey in Egypt and the Country beyond the Cataracts* of 1817 Thomas Legh wrote:

At a period when political circumstances had closed the ordinary route of continental travelling, and when the restless characteristic propensity of the English could only be gratified by exploring the distant countries of the East, an entirely new direction was given to the pursuits of the idle and the curious. A visit to Athens or Constantinople supplied the place of a gay and dissipated winter passed in Paris, Vienna or Petersburgh and the traveller was left to imagine and perhaps to regret, the pleasures of the modern cities of civilised Europe amidst the monuments of the ruined capitals of antiquity.

As once along Hadrian's Wall Jonathan Martin had herded sheep and 'meditated on the goodness of God',[40] now the actual remains of the great wall of Babylon, the pyramids, tombs, and temples along the Nile, Mount Ararat, perhaps Eden itself, were becoming accessible to be mused over and recorded, with amazed travellers shown sitting in the shadow of these wonders to convey the obligatory sense of overwhelming scale and of all things come to pass, been and gone.

For centuries the sites of Babylon were unheeded and untraced. Indeed there was no extensive archaeological knowledge of Chaldean and Persian civilizations until the first results of Layard's excavations were published in 1848. Martin found himself a pioneer with little to guide him. Claude Rich's *Memoirs of the Ruins of Babylon*, published in 1815, and the Revd. Thomas Maurice's *Observations on the Ruins of Babylon*, (1816) proved useful. Rich's book, illustrated with sketchy profile views and with a map, showed the change in the course of the river, the lumpy remains of masonry[41] sticking out of the desert. On these foundations Martin laid out the vistas of a city eight miles in circumference. Herodotus' account of the temple of Bel was the source for the over-all dimensions of the Tower of Babel:

In the midst a TOWER rises of the solid depth and height of one furlong upon which, resting as a base, *seven* other towers are built in regular succession. The ascent is on the outside which, winding from the ground, is continued to the highest tower, and in the middle of the whole structure there is a convenient resting place.[42]

Rich described Babel as 'pyramidal, composed of eight receding stages and the tower was solid (with the exception of small chambers or holy cells), and was cased with furnace-baked bricks'. But, whereas the classical orders of architecture were utterly familiar, serving as the Basic Design of Martin's age, while Indian, Egyptian, and Chinese motifs were becoming commonplace, the actual appearance of a Babylonic building remained very much a mystery.

Working from the given layout and measurements, Martin had to make logical deductions in order to evolve some sort of plausible hybrid architecture. He set down his reasoning in a pamphlet issued at the exhibition of *Belshazzar's Feast* in 1821:

It was the custom of Nebuchadnezzar, the conqueror of Egypt and India to bring from these parts to Babylon all the architects, the men of science and handicrafts, by whom the Palace and the external parts of the Temple of Bel etc. were built; therefore I suppose the united talents of the Indian, the Egyptian and Babylonian architects were employed to produce these buildings.[43]

Thus justified, he could forage around for his details; these included once again a Sezincot Hindu fountain, 'an emblem of perpetual generation',[44] and a Babel built according to Herodotus' general directions but with reference to a variety of preceding models,[45] among which was possibly the Trajan column lighthouse that appears in Barry's wall painting, *Navigation of the Thames*, at the Royal Society of Arts.

In 1818 the Prince Regent, the First Gentleman of Europe and, to the radically minded like Martin, the Belshazzar of his day, was busily commandeering modes from all the conquests and accessions and commercial outposts of his territories. Hence the Regency medley style in which neo-Gothic, Greek, Roman, Egyptian, Indian, and now, in Martin's hands, neo-Babylonic features were all intermixed.[46] Pastiche was piled on plagiarism until a kind of authority and identity was eventually achieved.

London was becoming commonly known as 'the New Babylon'. If Mr. Soho (Maria Edgeworth's fancy interior decorator in *The Absentee*) was 'the first architectural upholsterer of the age' and Nash, under the Regent's direction, its stage designer, Martin must rank as its leading art director. His Babylon anticipated the great Nash terraces, and preceded Turner's ventures into the same overwhelming architectural vein.

In *The Fall of Babylon*, and the series of like-minded paintings that followed, Martin contrived his own, though highly imitable, Empire style. To judge from a photograph, his *Babylon* offered the same widespread prospects as such panoramas as Girtin's *Eidometropolis*. In conventional painting terms it attempted the sort of precision normally achieved with the aid of a camera obscura, with an accompanying spread-eagled horizontal emphasis, and thus there emerged a horrorstruck version of a Canaletto view of the Rialto, or of the Thames from Westminster, with the customary strolling townsfolk swept aside and Belshazzar and his minions making little more than token appearances.

The real subject was of course the city, so dazzling in effect that, it has been argued,[47] the painting inspired Keats's description of the palace of Hyperion which

> Glar'd a blood-red through all its thousand courts,
> Arches, and domes, and fiery galleries;
> And all its curtains of Aurorian clouds
> Flush'd angerly.[48]

In much the same vein Milman's *Belshazzar* represents the burning of the palace and the temple of Bel in Martin's unmistakable manner:

> . . . o'er both the fire
> Mounts like a conqueror: here, o'er spacious courts,
> And avenues of pillars, and long roofs,
> From which red streams of molten gold pour down,
> It spreads, till all, like those vast fabrics, seem
> Built of the rich clouds round the setting sun—
> All the wide heavens, one bright and shadowy palace![49]

'Dramatic poems' such as this, couched in theatrical terms, with long volleys of dialogue and rhetoric and an underpinning of listed sources, succeed only in general terms and in passing flashes of detail. Like *Childe Harold*, Martin's Babylon is an extraordinary marathon performance sustained by occasional brilliant outbursts among the dogged narrative stretches. The stupendous production values added a sense of wide-angled immediacy to the antiquarian historical reconstructions of, for instance, the Waverley novels or the Revd. T. Clark's[50] *The Wandering Jew*. They helped inspire the historical spectaculars of Lytton's *Last Days of Pompeii* (1834) and, on a more parochial level, Harrison Ainsworth's journalistic treatment of the plague and fire of London in *Old St. Paul's* (1846). Both subject and treatment, in particular the parallels drawn tacitly between ancient and modern times, re-emerged in the climactic scenes of

27. The Fall of Babylon, 1831. Mezzotint, 18⅛″ × 28½″.

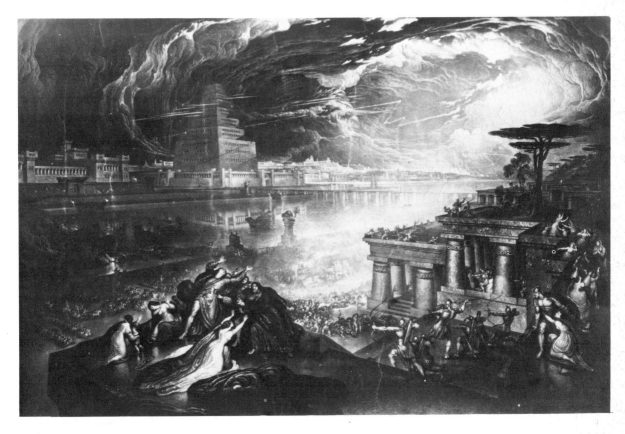

45

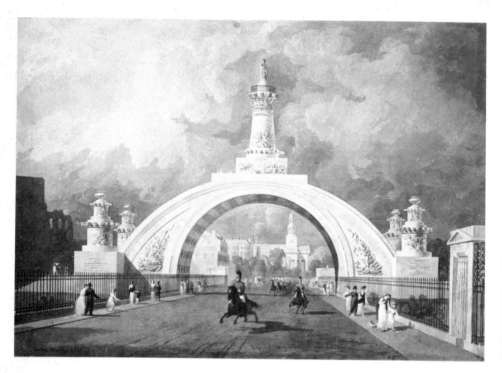

28. Proposed triumphal arch across the New Road from Portland Place to Regent's Park, 1820. Sepia, 13⅝″ × 19½″, signed.

D. W. Griffith's *Intolerance* where the fall of Babylon is cross-cut to the St. Bartholomew Day massacre and a twentieth-century strike.[51]

The mezzotint version (Pl. 27), less than a third of the size of the painting and published in 1831, differs considerably from the original. In the thirteen-year interval between them Martin became far more efficient at his effects, the architecture became altogether more fitting and imposing, the tempest more furious than ever. The foreground groups of figures, considerably enlarged and expressing affright and dismay with every inch of their being, still appear almost as afterthoughts, superimposed on the tumultuous backdrop where, following the lead of Cyrus the Great (who diverted the river, thus enabling his armies to splash across and take the citadel by surprise), Martin altered the course of the Euphrates, swung the great stone bridge of Nitocris round so that instead of turning at right angles, as in the painting, the river runs straight as a canal cut, formidably embanked, towards a distant vanishing-point. By 1831 Martin was already devoting the greater part of his time to his plans for embankments and riverside walks along the Thames. *The Fall of Babylon* had become an architectural perspective drawing of the London he envisaged, similar both in idea and execution to the painting and engraving of the (in general unrealized) projects of Telford and George Dance the Younger.

He declared his interest in producing something more solid than mere pictured edifices when in 1820 he exhibited at the Royal Academy two views of a

46

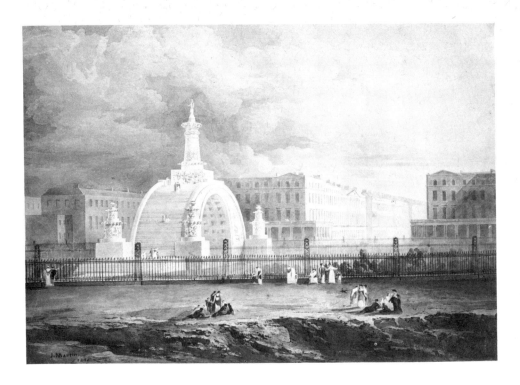

29. Side view of the Proposed triumphal arch across the New Road from Portland Place to Regent's Park, 1820. Sepia, 12⅛″ × 17⅛″, signed.

'Design for a National Monument to commemorate the Battle of Waterloo; adapted to the north end of Portland Place' (Pls. 28 and 29), near Allsop Terrace. This was to have been an archway, providing 'a noble and ample access to London', spanning the New Road, bridging the divide between the existing metropolis and the still-open space of Marylebone Park. In Martin's drawings Park Crescent stands raw and new across the road from the waste of claypits and grazing land that Nash was starting to develop into the professional man's Elysium of Regent's Park. The arch, flanked by bristling marble gun-barrels and urns, topped off with a choice pepper-pot turret and a victorious Wellington, was, like Martin's Babylonic architecture, a compendium of prevalent available models. The flight of steps leading up and over it was descended from a similar design submitted by Flaxman, to commemorate an earlier bout of military successes, in 1799.[52] Features from it were to reappear in *The Seventh Plague*, *The Fall of Nineveh*, and, more prosaically, in the embankment plans. Outstanding among the mass of Waterloo commemorative projects,[53] Martin's scheme stands in line with his paintings and plans as an attempt to bring to the attention key moments of past history and, equally, to plan for the future. Then, always assuming that Great Britain and its capital would, like Babylon, pass away, this huge marble amenity was designed to stand, for all time, as evidence both of a battle won and of an empire, eventually buried.

47

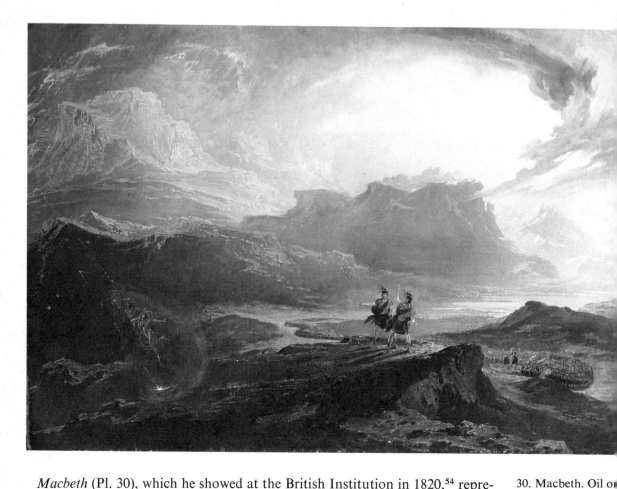

Macbeth (Pl. 30), which he showed at the British Institution in 1820,[54] represents an extraordinary conjunction of the forces of past, present, and future: Banquo and Macbeth at the head of their victorious troops, which trail away as though into the distant past, are approached by the three witches, who, taking them unawares, totally upset their futures and, as it turns out, the entire Scottish nation. Martin made the painting as authentic as he could by seeking advice on the tartans from the Sobieski brothers.[55] According to Leopold Martin, when Sir Walter Scott visited Martin's studio in 1831 he greatly admired the painting and regretted he could not afford to buy it.[56] *Macbeth* was indeed conceived in the idiom of *Rob Roy* rather than Shakespeare; the portentous event takes place in front of a scalding range of mountains, shivering with lightning and spelling out in no uncertain terms the impact the free-fall formation team of Fuseli-styled witches is having on Macbeth, who starts back with ostentatious alarm. As Martin's audience knew, Macbeth, like Belshazzar or Edward I, is going on, despite warning from prophet, bard, or seers, to 'o'erleap himself and fall on the other'. Banquo is destined to make his devastating posthumous appearance as the death's-head at Macbeth's feast. 'It

30. Macbeth. Oil on canvas, 20″ × 28″

is as usual tremendously grand',[57] Leslie wrote to Allston who, in 1821, painted his own version of Macbeth. Martin, meanwhile, moved on to the architectural pyrotechnics of *Belshazzar's Feast*.

'Mere enthusiasm will carry you but a little way,' Reynolds had pronounced in his *Discourses*; 'Mere Enthusiasm is the All in All,' Blake scribbled in the margin of his copy. Certainly it accounted for a good deal of Martin's success with *Belshazzar's Feast*, his resounding triumph over the Academy line. 'I mean to paint it, and the picture shall make more noise than any picture ever did before,'[58] he announced to C. R. Leslie who, a lifelong believer in professional conformity, became uneasy about his friend's enthusiasms. Martin clearly held, with Fuseli, the belief that 'every artist ought to have a character or system of his own'. And though Fuseli, Academy keeper and mentor of most of the great established names among the rising generation—Wilkie, Mulready, Etty, and Haydon—had little or no direct connection with Martin,[59] he no doubt influenced Martin's idea of painting as a sort of expansive illustration (notably of Shakespeare and Milton), as an exercise in which the first essential was an original, instantly recognizable, style of inspiration. Fuseli's bards, druids, and magicians, his *Satan and Virgin Mary dancing on the edge of the World*, his cult of shadow and unearthly flight flicker through Martin's stock imagery: 'If Fuseli's fanciful figures could have been combined with the imaginative and ideal scenery of Martin, I doubt not we should have had more perfect pictures in this kind than any at present in existence.'[60]

Fuseli maintained that 'a subject should always astonish or surprise, if it did neither it was faulty', and Martin's concept of Belshazzar was certainly considered remarkable, even before the painting itself was begun.

My picture of Belshazzar's Feast originated in an argument with Allston. He was himself going to paint the subject, and was explaining his ideas, which appeared to me altogether wrong, and I gave him my conception. He told me that there was a prize poem at Cambridge, written by Mr T S Hughes, which exactly tallied with my notions, and advised me to read it. I did so, and determined on painting the picture. I was strongly dissuaded from this by many, among others Leslie, who so entirely differed from my notions of the treatment that he called on purpose and spent part of a morning in the vain endeavour of preventing my committing myself and so injuring the reputation I was obtaining. This opposition only confirmed my intentions, and in 1821 I exhibited the picture.[61]

The stunning combination of high drama, moral precept, and banquet still life in the story had attracted many artists, notably Rembrandt, and it had cropped up fairly regularly at the Academy. Washington Allston had made the first studies for his *Belshazzar's Feast* in the spring of 1817, before Martin had set to work on *The Fall of Babylon*. He knew of no other subject 'that so happily unites the magnificent and the awful', and decided to include 'a multitude of figures . . . without confusion'.

Allston's painting was designed to be hung high on a wall and approached with veneration. His historical style was derived from rapt study of Sebastian del Piombo and Poussin (indeed, the layout of his *Belshazzar* is very similar to Poussin's *Aaron throwing down his Rod*). On the strength of it he achieved the formal recognition that Martin lacked. He was elected an A.R.A. at the time he left England, for the last time, in 1818; his *Belshazzar* was by then fully sketched out as a showdown between God's realm and that of Belshazzar, with Daniel posed as a righteous middle-man pointing out the error of the King's ways (Pl. 31). It was to be finished, he assumed, in a few months. However, he had second thoughts and these proliferated into a state of dithering impasse which, as far as this painting was concerned, lasted twenty-five years. He shifted the perspective, aiming to get light into the picture (perhaps the error that Sir George Beaumont complained 'is so common in the English School of mistaking whiteness for brightness'), and returned time and again to the canvas,[62] scraping it down, enlarging it, revising it, until his death in 1834, which left it a still-born neo-classical ruin.

Martin, on the other hand, treated the feast as a panoramic spectacle (Colour III, p. 65), viewed from on high like a battlescape, rather than from the lowly stance Allston assumed for the onlooker. While he worked on the painting the rumour went round that he was engaged on an extraordinary exercise in perspective, as it indeed proved to be. 'A perspective of light, and (if the expression may be

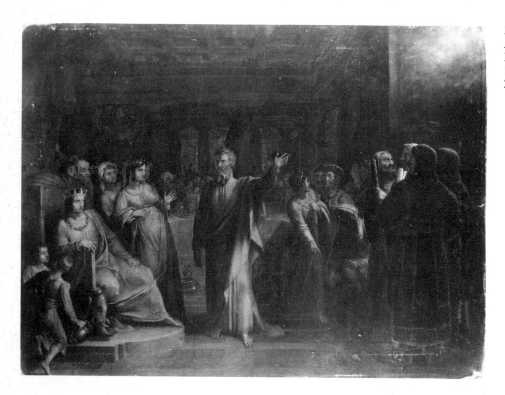

31. Washington Allston: Study for Belshazzar's Feast, 1817. Oil on card, 25½″ × 34″.

allowed) a perspective of feeling,'[63] Martin described it; a roller-coaster ride slap into the middle of a prime Old Testament crisis, with the planets in fateful conjunction, the heavens storming, the supernatural light flashing like the gas lamps in the streets of central London; a banquet vaster than even the Regent's extravagance could command, stretching away, Martin calculated, a mile into the distance, dwindling into obscurity beneath the hanging gardens; the whole event set out like a hysterical variation on the thrusting verve of David's *Oath of the Jeu de Paume*.

At first the praise was almost universal. Leslie had to admit to Allston, 'Martin's picture of your subject Belshazzar made more noise among the people than any painting since I have been here', and Wilkie wrote to Sir George Beaumont,[64] on 16 February 1821, after the exhibition opened at the British Institution:

Martin is certainly the first, both in effort and in success. His picture is a phenomenon. All that he has been attempting in his former pictures is here brought to its maturity; and although weak in all those points in which he can be compared with other artists, he is eminently strong in what no other artist has attempted. . . . His great elements seem to be the geometrical properties of space, magnitude and number, in these of which he may be said to be boundless. . . . Common observers seem very much struck with this picture; indeed more than they are in general with any picture. But artists, so far as I can learn from the most considerable and important of them, do not admit its claims to the same extent.

Later Lamb, though conceding that 'its architectural effect is stupendous', was to pour scorn on the whole conception of the feast, comparing it to a frolic down at Brighton Pavilion, a 'huddle of vulgar consternation'[65] aroused by some elaborate practical joke thought up by Prinny himself. Lamb described the flaming words as a transparency, and indeed that was how Martin saw the occasion—as a 'Grand Asiatic Spectacle' like those mounted at Covent Garden, which re-opened, gas-lit, with transparencies and fireworks the same month that *Belshazzar* went on show. Both Lamb and Ruskin (who was to make invidious comparisons between the painting and a bas-relief on the porch of Amiens cathedral)[66] overlooked the fact that the real Belshazzar's feast had been a thoroughly melodramatic incident in itself, that Martin had contrived an accurate impression of mass panic and individuals overcome by herd instinct, registering alarm and despondency in demented unison. Both Mrs. Siddons and Charles Young, a noted Hamlet, had visited Martin's studio and advised him on an appropriate pose for Daniel. The painting was therefore something of an epic stage production.

George IV's extravagant coronation feast, in Westminster Hall in July 1821, was quickly recognized as a realization of Martin's own prophesying. 'The Queen', Haydon noted, was 'the death's head at this stately feast.'[67] 'The procession in *The Curse of Kehama*, and in *Rimini*, with the painting of Belshazzar's Feast, were continually recalled to my memory,' one guest wrote. 'The conflict

32. Belshazzar's Feast, *c.* 1821. Oil on glass (cracked), $18\frac{1}{2}'' \times 28\frac{1}{2}''$. Probably the version Martin made for Collins's shop window as an advertisement for the original oil painting on exhibition inside.

of the *two lights* from the blaze of artificial day mixing with a splendid sunshine, the position of the King's table, the pomp of the banquet . . . rendered the resemblance so perfect it seemed as if the feast had been in some degree copied from the picture.'[68] Appropriately Martin, in the role of a suppliant Daniel, dedicated his 1826 mezzotint of *Belshazzar's Feast* 'by command to the King's most excellent Majesty' and, when it was re-engraved in 1832, changed the dedication to William IV.

The painting was intended to be hung low, as all panoramas demanded. Blazing away on the scarlet walls of the British Institution, it was such a conspicuous success that it had to be railed off as the 'picture of the year', it won a prize of 200 guineas and, by public demand, the exhibition run was extended three weeks. The Duke of Buckingham offered 800 guineas for the painting, but William Collins, Martin's former employer (whom Leslie described as a speculator), bought it to show in a special room in his shop in the Strand. Martin briefly resumed his old trade by painting a version on glass (Pl. 32)[69] which was placed in the shop window as an illuminated advertisement for the spectacle within. Five thousand people paid a shilling a head to see it, and Martin's pamphlet was reissued for this exhibition in May 1821.

In it Martin explains (and one can appreciate why his fellow workers at Collins' had so objected to him) that 'men of genius are not frequently thrown into our system by Providence; but, whenever they appear, they infallibly bestow an honour on the country to which they belong; create new epochs in the age they live in . . .'[70] and, by implication, in the places in which they had once

52

33. Diagram for Belshazzar's Feast, 1821. Engraving, 5″ × 7½″, from *A Description of the Picture Belshazzars's Feast painted by Mr Martin, lately exhibited at the British Institution, and now at no. 343 Strand.*

worked. Martin now returned to the shop trailing glory and taking part of the profits.

The pamphlet indicates some of the sources of the 'astonishing drama'. Its 'Atrium' was contrived from Martin's proven blend of Indian, Egyptian, and Babylonic styles, with 'Harps of an elegant construction' along the 'entablement of the first range of columns' and 'the whole building constructed of the same costly stone throughout: red and exceeding well polished porphyry'. Even the heavens were accurately disposed: the moon 'in immediate conjunction with the planet of Astarte, and just 3 days old, marks the very point of time at which the Chaldeans used to hold their national feasts'.

A diagrammatic line-engraving (Pl. 33) in the pamphlet shows, with the help of arrows and numbers, the correct order in which the painting is to be admired. The eye is to start with the sizzling words and 'the brazen serpent which seems to writhe in the portentous glare', and to pass over Daniel, who stands interpreting 'with that sullen appearance which never leaves entirely the countenance of an exile', his gestures repeating, live, those of the statue of Jupiter that Belus planted, which stands, wreathed in the coils of a serpent, several hundred yards behind him. Belshazzar is the next object of attention: 'the astonishment of the king is powerfully wrought upon the interesting but supercilious features of his face.' Then, after noting the groups of lurking assassins, soothsayers, and concubines, the eye is made to dart away into the remotest distance over a mile-long dance floor and up past gardens and temples to the Tower of Babel, where, according to the Book of Genesis, words and language had first failed mankind.[71]

53

In its present condition *Belshazzar's Feast* is rather the worse for wear.[72] Even so, the composition is highly compelling, its one-point perspective a disarming device, blatantly obvious in construction and effect. It is painted, like most of Martin's early works, on a red ground and thus has what Richard and Samuel Redgrave once described as 'a hot, foxy hue'.[73] Dean Milman described it, rather more politely, as

> a bewildering, red, and gloom-like light
> That swallows up the fiery canopy
> Of lamps[74]

This is broken by ragged areas of deep-blue sky punctuated by the detailing of the various orders of architecture—Babylonian, Egyptian, and Hindu—which, with their fretworked appearance, anticipate Gustave Moreau's highly wrought palaces. As a whole, the setting remains extraordinarily impressive, like some grand redundant dockyard. The figures are less successful: they fail (as, indeed, did their Babylonic originals) to live up to their surroundings; although in a study,[75] which Martin probably finished after the main painting, his handling is altogether more elegant and coherent.

More than *Joshua* or *The Fall of Babylon*, *Belshazzar's Feast* appeared to be a breakthrough in history painting, satisfying not only what Martin chose to call 'the discerning eye of taste and the mental ken of classical knowledge' but also a highly impressionable wider public. Indeed, its most avid audience must have been the readers of such products of the new steam presses as John Limbird's *Mirror of Literature, Amusement and Instruction*, a weekly digest of other, weightier magazines, which contained snippets of fact enlivened with anecdotes and engravings and followed much the same recipe as Martin's Babylonic paintings.[76]

After the exhibition *Belshazzar's Feast* became even better known in its various print forms[77] and was widely copied.[78] Its perspectives helped suggest appropriate styling for the railway cuttings, bridges, and stations on the Liverpool–Manchester railway[79] and further stimulated the taste for historical-reconstruction dramas and panoramas.

The composition is remarkably similar to *The Temple of the Sun*, a set designed in 1815 by Karl Schinkel for Act II Scene iii of a production of *The Magic Flute* which was staged in Berlin in January 1816 as part of the peace celebrations following the Congress of Vienna. The Tower of Babel stands in place of Schinkel's pyramid, but the same roof gardens, ranked columns of statues, and an identical scale of proportion of actors to setting are apparent. The artists were of course working from virtually the same source material and for similar dramatic purposes. Schinkel, who in 1815 abandoned panorama-painting for stage design and architecture proper, was little known at this time outside Prussia, while Martin never, as far as can be ascertained, travelled outside the British Isles. However, Leopold of Saxe-Coburg was in residence at the Court of

Berlin during the latter months of 1815 and until February 1816, when he came to England to marry Princess Charlotte. It seems possible that he gave Martin an account and possibly even some illustrations of Schinkel's much-applauded work.

Unable to buy *Belshazzar's Feast*, the Duke of Buckingham offered Martin 800 guineas for his next painting, which was to be *The Destruction of Pompeii and Herculaneum*. This became the centrepiece of his exhibition, in March 1822, at the Egyptian Hall, Piccadilly, where in 1820 Haydon had scored a triumphant success with *Christ's Entry into Jerusalem*. Like Haydon, Martin developed the occasion into a retrospective show, and assembled twenty-five paintings—including *Sadak*, *The Expulsion*, *Joshua*, *The Bard*, *The Fall of Babylon*, and 'the original design' of *Belshazzar's Feast*—all listed in a 32-page catalogue.

Papworth's Great Room at the Egyptian Hall, with its serpentine balustrades and pidgin hieroglyphs, was an appropriate setting for Martin's exhibition, a place in which the loftiest of fine art (Gericault showed the *Raft of the Medusa* there in 1820) shared common ground with freaks, curiosities, and theatrical spectaculars. In 1821, for instance, Belzoni, a former strong-arm prodigy, known professionally as the 'Infant Hercules', had altered part of the building—with darkened entrance and gaudy inscriptions—to resemble the interior of a pyramid and house the Sarcophagus of Seti I which he had discovered during his excavations of the Necropolis of Thebes in 1815. Martin's exhibition could almost have been designed to link the show-business sense of Belzoni with the spellbound and ideal qualities of the paintings and casts from Rome—these included reproductions of Michelangelo's *Moses*, Raphael's *Jonah*, and Canova's *Three Graces*—shown at the same time in another part of the Hall.

The destruction of Pompeii was such a well-documented event, such a ready-made subject for Martin, that his originality almost deserted him. Admitting that 'the most successful effort of the poet or of the artist, must fall far, very far short of the awful sublimity of the simple reality of that dreadful visitation', he added that he had 'sedulously consulted every source of information within his reach':[80] Pliny, Strabo, Diodorus Siculus, and, in particular, Gell's *Pompeiana*. The Duke of Buckingham also suggested various ways of representing the subject. Perhaps the most obvious approach was that adopted by J. G. S. Lucas, one of Martin's imitators, in a mezzotint, *The Last Day of Pompeii*, published in 1835 in which he took up position among the toppling columns of the forum, unmoved, like Sir Edward Poynter's *Faithful unto Death* Pompeii centurion of 1865, while liquid fire, molten rock, and flaming glaciers rained down. Martin, however, decided to stand back, to see the destruction in terms of panorama and battlescape.

Vesuvius, its summit 'encompassed by an abrupt and rugged natural wall', contained an enclosed space where, as Martin notes in the catalogue, the gladiator, Spartacus, had taken refuge with 10,000 followers during his revolt. It

represented a temporary paradise, 'an altar on which he might place his hopes of freedom'. He also cites Martial in describing Vesuvius in some mythical age as 'a retreat for which the gods of pleasure and gaiety forsook their most favored abodes'. The eruption, preceded by a series of earthquakes, was thus a quasi-divine act of retribution, and Martin's painting was based on the only tenable viewpoint: from across the bay in the town of Stabia, itself tottering, at which refugees from the doomed towns arrived, to look back and down, as though from the seat of the gods, on the greatest scene of destruction since the day that Sodom and Gomorrah had been overwhelmed. 'The elevation of the foreground, on which the principal figures are seen, is three hundred and forty-eight feet above the level of the sea; an elevation, according to the statement of the most intelligent travellers, more than sufficient to enable the spectator to take into view every city, within the angle of vision represented in this picture.'[81] From this height the eruption could be shown as a whole, as both source and effect: 'We find an awful horror thrown over the whole coast. It is represented as the ultimate limit of the unfruitful ocean and the habitable world.'[82]

Martin mentions Zonaras's description of the eruption sounding like 'the collision of mountains falling together'; but, Martin adds, 'modern science has invented new objects for simile.'[83] Indeed, although the mountainous collisions repeatedly appear in later set pieces—such as *The Deluge* and *The Great Day of His Wrath*—Martin's imagery was often likened to falling coals, or furnaces spilling over in the iron- and glassworks of the Black Country and Tyneside. More precisely, however, it derived from the innumerable representations of eruptions; those by Wright of Derby are obvious examples, though a *Mount Vesuvius in Eruption*[84] by Jacob Moore[85] is closest to Martin's painting in general treatment.

Eruptions were the only truly apocalyptic spectacles, apart from rare events like the burning of Moscow, to survive from the pages of the Old Testament into the age of enlightenment. Indeed, a stop-press announcement in Martin's catalogue refers the reader to 'an interesting account of a recent eruption of Vesuvius' in the *Literary Gazette*.[86] When in full discharge, Etna and Vesuvius stood as a horrific and sensational climax to any Grand Tour of Italy and were, in consequence, the timeless stock-in-trade of topographers and panorama painters.

Despite his strict attention to detail and his copious supporting theories and documentation, Martin's painting aroused relatively little comment. In a tradition that demanded, above all, considerable advances in size and ambition from one work to the next, *The Destruction of Pompeii*[87] must have appeared fairly commonplace after the blazing effrontery of *Belshazzar's Feast*: it was only marginally larger. A photograph of the original and the half-size surviving version, bought by Sir John Leicester for his comprehensive collection of British art (Pl. 34),[88] show it to have followed *Joshua* and *Macbeth* in the general disposition of mountains, cities, and fleeting figures. In place of the convulsive armies Martin arranged an aquatic spectacle of the Roman fleet heaving off shore, 'the sea

agitated by the earthquake, and retiring' leaving no fit place of refuge. The sky—
vast, back-lit, and cavernous—pours gobbets of hail and brimstone; the clouds
are 'more or less impregnated with earth and cinders'. In this monstrous up-
heaval of the natural order, where each element—earth, air, fire, and water—
was displaced from its appointed sphere, '. . . an impervious gloom, unenlivened
by rising or setting sun, spread a thick eternal shade over the beach, where the
dark and barren groves of the remorseless Proserpine, marked the entrance to
the regions of the dead.'[89] Time, once again, was standing still, for three days and
nights on this occasion.

<div style="text-align:center">

O'er each, in turn, the dreadful flame-bolts fall
And death and conflagration throughout all
The desolate city hold high festival.[90]

</div>

As in *Belshazzar's Feast*, Martin represents all stages of the event compressed
into one, into the 'sudden and more ghastly Night rushing upon the realm of
noon'.[91] But the surfeit of detail available to him and crammed into the painting
—amphitheatres, temples, 'the Granary wherein were found measures with false

34. The Destruction
of Pompeii and
Herculaneum, *c.*
1822. Oil on canvas,
33″ × 48″.

57

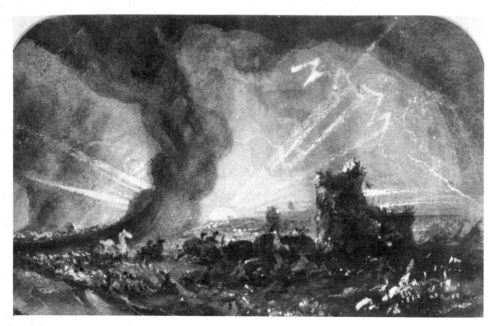

35. Cambyses on his way to desecrate the Temple of Jupiter. Sepia, 6″ × 9¾″.

bottoms', and the figure of Pliny himself—together with the map of the region which he included as part of the exhibition, cramped his style and tended to undermine that free association of ideas, from one epoch to another, which had vitalized his reconstruction of Babylon. In *The Destruction of Pompeii* the heavens alone afforded him the poetic licence, the chain reactions between sky and mountain tops, that had first appeared in *Sadak* and had continued through the amazing conjunction of sun and moon in *Joshua* to the blasted heights in *Macbeth*. Over Pompeii and Herculaneum he let loose a symphonic tirade of specks and dashes and sweeping swathes of cloud. 'The blue lightning', *Ackermann's Repository* commented mildly, 'saves the picture from the absolute tyranny of a scarlet tone.'[92] Martin was in his element. 'A thunderstorm entranced him! He would remain uncovered during one of the most frightful description, exclaiming with an expression of the greatest awe "There sounds the artillery of Heaven! God is in his wrath!"'[93], Leopold Martin remembered, John Galt's Hareach the Prolonged, the true time-traveller, had also 'often shouted, with impious satisfaction, as the wide sheets of lightning burst through the turbulence of vapour that rolled above'.[94] Taste, fiction, and legend were fused into a single romantic attitude. While lightning served Martin as a convenient device both to represent divine intervention and to tack a composition together, the same imagery, pillars of cloud by day, of fire by night, haunted his unstable brother Jonathan to such an extent that for him imagination became reality. While lodging in York early in 1829 he had an appalling dream:

... A wonderful thick cloud came from the heavens, and rested upon the cathedral; and then it rolled over, and rested upon the lodgings where I slept at. When I found it come, I awoke ... I prayed to the Lord, and asked the Lord what it meant; and I was told by the Lord, that I was to destroy the cathedral, on account of the clergy going to plays, and balls, playing at cards, and drinking wine, so fulfilling the will of God, that old men should see visions and the young men dream dreams, and that there should be signs in the heavens, blood and fire, and vapour and smoke and so on.[95]

Thus inspired he burnt down half York Minster.

Celestial portents were the keynotes of the majority of Martin's paintings and never more so than in *The Destruction of Pompeii*. As Constable remarked of skies in general, they served as 'the standard of scale and the chief organ of sentiment', with retribution meted out in thunderclaps, huge, flashing ellipses of cloud, and lightning strokes impaling towers and ramparts (Pl. 35). Later Martin's clouds were to become platforms for the Celestial City, hovering like the Isle of Laputa—Swift's home for over-fanciful inventors and natural philosophers—above the Plains of Heaven.

CHAPTER IV

'The light to lesson ages'

FOR HIS twenty-first birthday, in 1781, William Beckford hired de Loutherbourg to transform the then Palladian mansion of Fonthill into a setting for what must have been a drifting, lost week-end of soft and tempered radiance. Beckford recalled:

The solid Egyptian Hall looked as if hewn out of a living rock and an interminable staircase which when you looked down it—appeared as deep as the well in the pyramid —and when you looked up—was lost in vapour. . . . I still feel warm and irradiated by the recollection of that strange necromantic light which Loutherbourgh had thrown over what absolutely appeared a realm of Fairy, or rather, perhaps, a Demon Temple, deep beneath the earth, set apart for tremendous mysteries.[1]

Turner was commissioned to paint Fonthill during its later and more formal conversion and reconstruction into an airy-fairy abbey—a romantic annexe to Beau Brummel's Bath—with a great tower, erected successfully, on a second attempt, by James Wyatt and modelled on Ely Cathedral octagon. Then, in 1822, Beckford summoned Martin[2] to record his impression of Fonthill, shortly before it was sold to a gunpowder manufacturer.

Martin drew the transepts, the organ-case pinnacles, and the 230-foot tower, and sent his usual dash of lightning sneaking down one side (Pls. 36 and 37).[3] Three years later the tower collapsed. This latter-day Tower of Babel, this lath and stucco fantasy had rested on inadequate foundations. Despite this, the place was by no means a complete folly, any more than Martin's epics were works of fanciful caprice. Beckford shared with Martin a sense of paradise lost, of a polluted England:

Nowhere is there any country—the forests are being cut down, the mountains violated —one only sees canals for the rivers are disregarded—Gas and steam is everywhere— the same smell, the same puffs of dreadful smoke thick and foetid—the same common and commercial view on every side: a deadening monotony and an impious artifice spits at every second in the face of Mother Nature, who will soon find her children changed into Automatons and Machines.[4]

Fonthill, surrounded by 12-foot walls, was a paradise regained, where all creatures were free to live and, supposedly, let live.

36. View of the South Front of Fonthill Abbey. Engraving by T. Higham after John Martin, from *Delineations of Fonthill and Its Abbey* by John Rutter, 1823.

37. Distant View from south-west of Fonthill Abbey. Engraving by J. C. Varrall after John Martin, from *Graphical and Literary Illustrations of Fonthill Abbey* by J. Britton, 1823.

High roof'd, and walks beneath, and alleys brown
That open'd in the midst a woody scene:
Nature's own work it seem'd (Nature taught Art)
And, to a superstitious eye, the haunt
Of wood-gods and wood-nymphs.[5]

There, a morning stroll across the 'Fairie's Lawn' led down primrose paths towards a valley of shadows—'deep caverns of the most romantic form'—and an artificial bridge over chaos. From every viewpoint, framed in trees and surmounting the landscaped quarries, the abbey itself remained the focus of concern, an architectural sampler, a repository for Claudes and Turners and Miltonic enormities, a temple of applied art, a place where mundane amenities were missing (thirteen of the eighteen bedrooms were installed high up in the great tower and virtually inaccessible).

With Fonthill in mind, Martin completed *Adam and Eve Entertaining the Angel Raphael*, 1823 (Pl. 38), and a companion painting, *The Paphian Bower*, 1823 (Pl. 39).[6] Both were mocked. 'There is a trick and mannerism about Mr Martin's works that is purely mechanical,' the *Descriptive and Critical Catalogue* to the Royal Academy of 1823 maintained; 'The Graces are certainly the most graceless giantesses we ever saw, with long legs and little bodies. . . . There is a

38. Adam and Eve Entertaining the Angel Raphael, 1823. Oil on canvas, 51″ × 78″, signed.

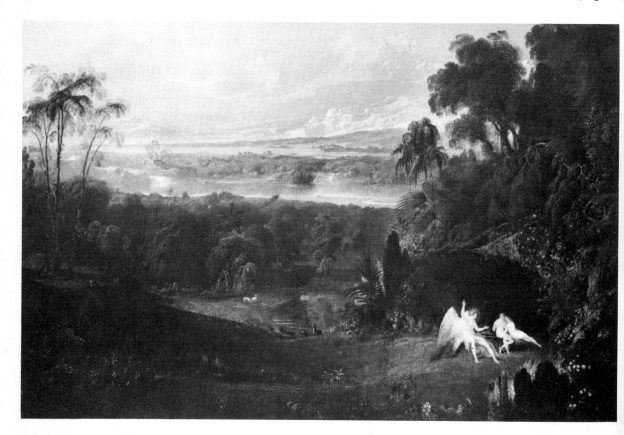

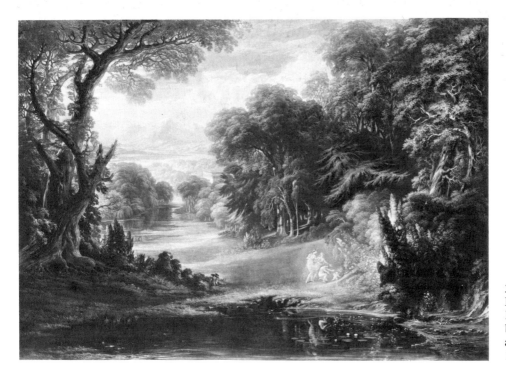

39. The Paphian Bower, 1826. Mezzotint engraved by G. H. Phillips after John Martin, 17″ × 23″.

forest of towering hollyhocks of the brightest crimson, as round and true as if struck out by compass and rule. It is altogether a most preposterous extravagance.' *The Times* indulged in banter: 'Mr Martin! Where does your colourman live? Where do such trees grow? Where such *lapis-lazuli* mountains and skies? Where such figures to be met with? We forgot that the whole picture is antediluvian.' And that, of course, is the whole point. Martin's Eden is the

> . . . smooth enamell'd green
> Where no print of step hath been,[7]

Milton's *Arcades*, Spenser's fairy paradise, an idealized English country garden where roses have no thorns, nothing decays or rots, where nature is balanced and harmonized in a state of perpetual noon and protected from outer wilderness by mountain bulwarks, Alps and Himalayas enclosing the never-never land of Shangri-la.

Hazlitt[8] talked about 'a preposterous architectural landscape, like a range of buildings' and in 1827[9] resumed his attack on Martin, but was cautioned by Northcote, who recognized 'some merit in finding out a new trick'. Hazlitt suggested that Martin's recipe was 'clouds upon mountains and mountains upon clouds, that there was number and quantity, but neither form nor colour. He appeared to me as an instance of total want of imagination.' *Adam and Eve* was, he considered, 'a panoramic view of the map of Asia, instead of a representation

of our first parents in Paradise'. But it was Hazlitt, in this instance, who was short-sighted. Martin's picture of a sleek, white Adam and Eve, entertaining the angel in an improvised shelter set in a superlative 'Garden of Idea', illustrates the ultimate ambition of Beckford and the great landscape gardeners: to contrive in a sort of visual poetry, horticultural compositions with clearly recognizable literary references. Martin's Garden of Eden was a Xanadu, where

> . . . twice five miles of fertile ground
> With walls and towers were girdled round:
> And there were gardens bright with sinuous rills,
> Where blossomed many an incense-bearing tree;
> And here were forests ancient as the hills,
> Enfolding sunny spots of greenery.[10]

In reality such carefree, ageless appearances were, of course, deceptive. Squads of gardeners and navvies had to tend the lawns, clear out the quarries, plant groves on hilltops, divert streams, and create agreeable reflective lakes. A painter—whether Claude or Wilson, Turner or Martin—laboured at an advantage. Translation from poetry to paint was a comparatively simple matter. And if Martin's landscape of innocence looked, to Hazlitt's eyes, simply naïve, Ovid, Spenser, Milton, and the other poets of idyll were initially to blame. Like all his garden landscapes, from *Clytie* and *Adam's First Sight of Eve* onwards, Martin's

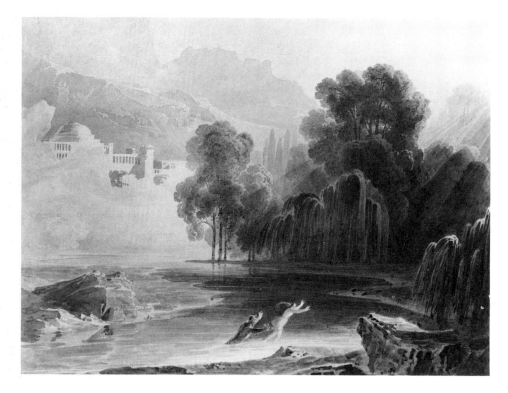

40. Glaucus and Scylla, 1820. Sepia, $7\frac{3}{4}'' \times 10\frac{1}{2}''$, signed.

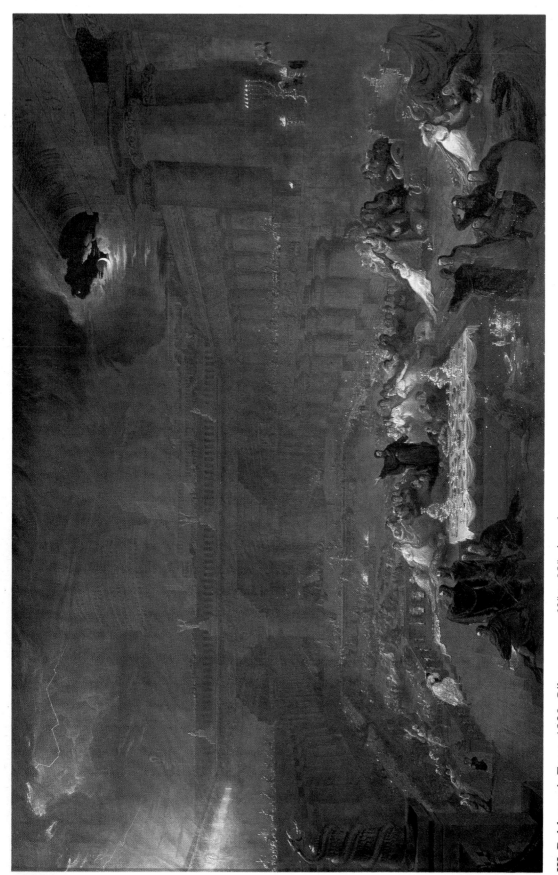

III. Belshazzar's Feast, 1820. Oil on canvas, 63" × 98", signed.

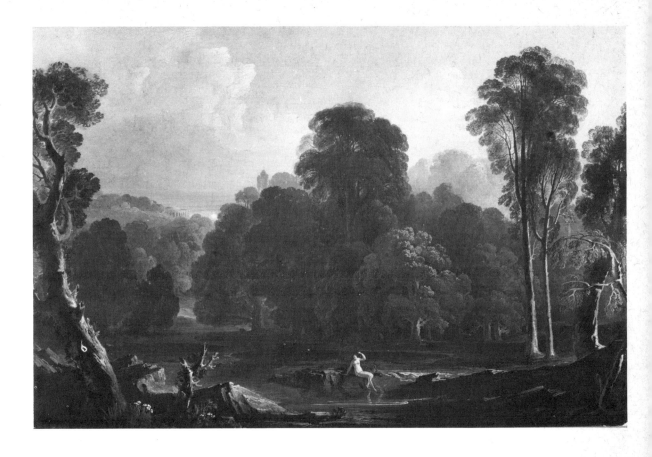

41. Landscape composition, 1823. Oil on canvas, 23½″ × 35½″, signed.

paradise paintings of this period, such as the water-colour *Glaucus and Scylla* (Pl. 40), are composed around neat lawns and lakes, bounded by rocks and copses. Similarly, in a *Landscape composition* (1823) (Pl. 41)[11] a diminutive nymph, reduced considerably from her initial size (to judge from the penti-mento visible behind her), poses on a rock, totally subordinate to the dapper porcelain Arcadia around her. As Martin and the poets assumed, and as Hazlitt failed or refused to recognize, in this ideal state of nature human beings had no power and no need to command.

In 1824 Martin showed *The Seventh Plague of Egypt* (Pl. 42) at the opening exhibition of the Society of British Artists in Suffolk Street, a body organized to provide a further alternative to the Royal Academy. The painting showed an ancient Thebes which Martin modelled on his Babylon but referred back to the Egyptian essentials that had served as his starting-point in 1817: the papyrus-leaf capitals, hieroglyphic friezes, and the distant image of a holy crocodile planted on a column as if in anticipation of the golden calf of the Israelites. Martin clearly derived ideas from Turner's resurrections of Carthage and from his *Fifth Plague of Egypt*,[12] which he probably knew from the engraving in *Liber*

65

42. The Seventh
Plague of Egypt.
1823. Oil on canvas,
57″ × 84″, signed

Studiorum (Pl. 43). This emphasized the darkness over the land, the distant pyramids punctuating the horizon like circumflexes, and focused on a central tangle of root and branch and fallen rider.

Once again, however, Martin relied largely on written evidence, starting with the meteorological Seventh Plague as described in the book of Exodus (9:23): 'And Moses stretched forth his rod toward heaven: and the Lord sent thunder and hail, and the fire ran along upon the ground; and the Lord rained hail upon the land of Egypt.' The words of the archangel Michael in *Paradise Lost*, fore-telling the Seventh Plague, established the storm effect even more precisely:

> . . . Thunder mixed with hail,
> Hail mixed with fire, must rend the Egyptian sky,
> And wheel on the earth, devouring where it rolls. (xii.181–3)

A gap, more pronounced in the painting than in the preparatory water-colour,[13] separates Moses and Aaron, the elect, from the mass of anguished Egyptians who register excitement and dismay like tic-tac men at a race meeting. Flaring lighthouses, closely matching the turrets in Martin's Waterloo Monument design, take up the alarm, and in a mighty harbour, which in these circumstances proves to be as useless a refuge as the Bay of Naples in time of eruption,

66

the Egyptian fleet flounders. Besides Moses and Aaron, the only unmoved figures in the whole spectacle of urban breakdown, a sarcophagus, probably modelled on that of Seti I, lies empty, presumably awaiting its presumptuous and vainglorious Pharaoh.

More precise in its architectural detail than anything Martin had previously attempted in this idiom, *The Seventh Plague* represents a late flowering of the neo-Egyptian cult. The style was enshrined in the Temple of Taste, No. 13 Lincoln's Inn Fields, when, in 1835, Sir John Soane laid Seti's alabaster and blue-inlay sarcophagus to rest in the basement Sepulchral Chamber next to the Gothic Monk's Parlour. The taste also survived, in a sense, in literature: Thomas Moore's *The Epicurean*, with its Egyptianate setting appeared in 1827. It lingered in the provinces. In *Our Village* (1823) Miss Mitford described a library 'all covered with hieroglyphics and swarming with furniture crocodiles and sphinxes'. Martin never made an independent engraving of *The Seventh Plague*;[14] after 1823 the taste had become somewhat stale. Nevertheless he succeeded in selling the painting to J. G. Lampton, later Earl of Durham, for 500 guineas.

The *Somerset House Gazette* objected to the 'violent oppositions of colour which prevail in the picture', and repeated a suggestion that 'Mr Martin must have been born with prisms for eyes'; such criticism was attuned to a bland drawing-room taste and bore little relation to the actual painting which, perhaps more than any of Martin's previous set pieces, was designed to stand comparison with the panorama shows. On grounds of authenticity and immediacy, with its staggering perspectives and scale of proportions, it also amounted to a challenge

43. J. M. W. Turner: The Fifth Plague of Egypt, plate 16 of the *Liber Studiorum*, 1808.

67

to the newly developed art of diorama. Here, as Martin had written of *Belshazzar's Feast*, was to be found 'a perspective of light, and (if the expression may be allowed) a perspective of feeling'.

Robert Barker (1739–1806) had hit upon the principle of panoramic painting when, in a debtors' prison in Edinburgh, he noticed the brilliant effect of light falling vertically on the wall of an otherwise darkened cell. He patented the idea in 1787 and took to painting views of capital cities, starting with Edinburgh and London, then laying out full-circle representations of naval reviews, battles, and places of interest, such as Pompeii. He showed them in a specially designed double-decker panorama theatre in Leicester Square (Pl. 44) where the larger scenes—16 feet high and 45 feet in diameter—had considerably more impact than did the small-scale Eidophusikon and phantasmagoric lantern shows. Barker and his successors, Schinkel included, showed the face of nature and, the wonders of the man-made world, often elaborately researched and assembled, intensified by lighting effects. At their best they so suspended disbelief, so sustained their illusions, as utterly to overwhelm and entrance their captive audiences. Inevitably the system gradually lost its novelty value, and by the 1820s the Barker panorama firm was reduced to showing a view of Geneva, which suggests it was running short of inspiration.

In 1822 Bullock, the owner of the Egyptian Hall, produced a panorama of the North Pole in which he attempted to double the illusion of reality by posing live figures against the backcloth. At the same time Louis Daguerre (who had been assistant to Pierre Prévost, the designer of panoramas celebrating Napoleon's proudest moments) patented the Diorama—a blend of stage scenery and panorama. His English version opened in September 1823 in a building in Regent's Park, where the auditorium revolved from the first scene to the second, from *Canterbury Cathedral* to *The Valley of Sarnen*. Effects of changing light and passing time, which had been missing from these shows since the days of the Eidophusikon, were here reintroduced. The moon rose over *Holyrood Chapel*, with light trickling over ruined walls and flagstones.[15] The verisimilitude which designers like de Loutherbourg, J. R. Planché, Schinkel, and, indeed, Daguerre himself had brought to stage design became the exclusive subject-matter; live actors were replaced by humble token figures engaged in prayer or meditation. Lights were projected from the front of the translucent paintings for sunlit scenes, from backstage for moonshine, and in various combinations for storm and apocalypse. Sound effects helped captivate the spectator still further, transporting him to distant exotic climes and eras. Dependent as it was on exact tones and perspectives, the diorama succeeded best with mountainous and architectural material such as *The Beginning of the Deluge* (Paris, 1829) and *The Inauguration of the Temple of Solomon* (1836). With these Daguerre was, in effect, offering a direct challenge to Martin. A version of *Belshazzar's Feast* (1833) by his pupil Sebron was a blatant copy.

Generally speaking, too, the diorama builders shared with Martin the need to

enlarge and improve upon each successive spectacle: aesthetic considerations were more or less incidental. The central concern was impact. In this spirit, in 1829, Colonel Langlois built the cross-section of a warship, so that the spectator could enter and explore from captain's cabin to quarter-deck and take in dioramic snatches of the action of the Battle of Navarino from conveniently placed portholes. The same year Thomas Horner built his Colosseum in Regent's Park, installing a bird's-eye view of London which visitors could inspect on three levels finishing up in the original golden ball from the dome of St. Paul's (which Horner had bought during repairs in 1822), whence they gazed down over the full-circle painted metropolis; the illusion was marred only by bars of shadow cast from the skylights above during sunny spells, which tended to destroy the open-air effect, and, since the perspective remained unaltered from one level to the next, there was only one point from which the streets and roof tops appeared convincingly aligned.

Martin's epics, scene painting, panorama, diorama, and, eventually, comparable aspects of photography and the motion picture were interlinked, above all in their attempts to establish sublime documentary values in narrative entertainment. All had to be exhibited under strictly controlled viewing conditions if they were to be appreciated fully. They could not be sold like ordinary works of art: as in the theatre, profits came from admission fees, programme sales, and

44. Panorama exhibited in the Rotunda at Leicester Square, plate 14 of Robert Mitchell's *Plans etc. of buildings erected in England and Scotland*, 1801.

69

souvenir prints. Increasingly during the 1820s, as Martin moved on from *The Seventh Plague* to *The Creation* and *The Deluge*—events, he must have imagined, beyond even the contrivance of Daguerre—his art appeared to be attuned not to the ways and means of the Academy at Somerset House, but to the dioramic spectacles to be seen all over London, from Regent's Park to the Egyptian Hall. The intention behind his 'perspectives of feeling' could no longer be confused with the sort of academic history painting epitomized by the works of Hilton or, later, Maclise. Constable's wry and perhaps sarcastic remark that 'John Martin looked at the Royal Academy from the Plains of Nineveh, from the Destruction of Babylon'[16] was another way of saying that, so long as Martin's works were good box-office and he remained 'the most popular painter of the day',[17] he had no reason to concern himself with Academy tastes.

Each of Martin's epic paintings was a 'mirror of literature, amusement and instruction' held up to history, reflecting the faults of previous civilizations in the face of contemporary London. Without doubt, Martin was consciously exploiting a real chord of fear in people as he illustrated, pressed home, and underlined the cyclical, virtually millennial, recurrence of catastrophe in world history. He was by no means exceptional in his awareness of threats to the well-being of his society; representations of storms, eruptions, and earthquake swept like tidal waves through early nineteenth-century periodicals, broadsheets, panoramas, and paintings. In this way the imagery of Martin's *Seventh Plague* re-emerged a couple of years later as a coloured 'eyewitness' print of the great St. Petersburg flood in the *Literary Magnet* for 2 April 1825 (Pl. 45).

Morals were drawn easily from standard comparisons of black and white ancient history with the more confused present. And, indeed, during the years that Martin produced his Babylonic epics, from 1817 to 1828, a deluge may well have seemed imminent in an England in which the government over-reacted to all conceivable threats, from riot in St. Peter's Fields to conspiracy in Cato

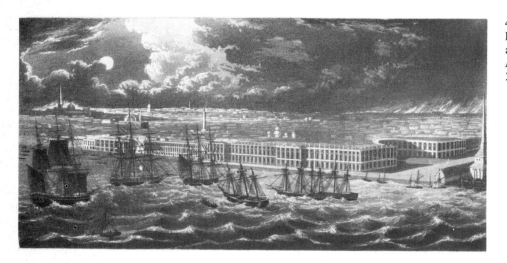

45. The Great St. Petersburg Flood, aquatint from the *Literary Magnet*, 2 April, 1825.

Street, and in which much of the population was suffering under a system that artificially sustained corn prices and depressed wages. Predictably enough, Martin had supported the cause of 'St. Caroline', George IV's notoriously estranged wife, for a time the incongruous figurehead of the movement of dissatisfaction against both the court and its satellite institutions—which, as far as Martin was concerned, included the Royal Academy. His radical hisses at a concert in 1821, when 'God Save the King' was played, had greatly alarmed his companion, C. R. Leslie.[18] Like his brothers Jonathan and William, though less exaggeratedly, Martin was sceptical of what he considered complacent established authorities. His fears were as unbounded and as ineffable as his romantic-Utopian ideals, and he found ready causes of concern and alarm. All of them demanded expression in one painting or another.

London was still expanding inexorably with new housing sprouting over pastures and open country. Villages were being sucked into the Great Wen, which in consequence grew ever more crowded and filthy. In 1815 the ban on discharging household refuse into the sewers, thence direct into the river, had been lifted; thereafter the pollution equalled the waste. London, the new imperial capital with its paved and gaslit main streets, was simply Babylon-on-Thames. 'Is it not probable', Martin was to write,[19] 'that a too ignorant waste of manure has caused the richest and most fertile countries such as Egypt, Assyria, the Holy Land, the South of Italy &c to become barren as they now are?'

The forebodings Malthus had voiced some years before—that society could spare no room, no mercy for useless mouths, that 'at nature's mighty feast there is no vacant cover'—appeared increasingly well-founded in the London of the 1820s. Although William Godwin, a friend of Martin at this time, suggested 'Burn Malthus, read Milton and Shakespeare and believe me that population and prosperity go together', his daughter, Mary Shelley, in her visions of Frankenstein's monster, of invention run disastrously amuck, and of *The Last Man* (1826), the sole survivor of a final, universal Black Death, matched Martin's views.[20] Wrath, he showed repeatedly, could erupt at any time, as at Pompeii. It could fall in showers of locusts or tainted rain, bringing famine and plague; it could descend in the form of the Angel of Death, sent down to cull the nation. 'Bentham, Malthus, Martin, sont l'expression de l'Angleterre. L'intérêt, la foule, l'étouffement de la population . . .' Michelet wrote in his diary in 1834.[21] Certainly Martin publicized and popularized theories of over-population and pollution and the themes of empires rotten at the core, both because he believed in them and because his paying public came to expect it of him.

CHAPTER V

Paradise Lost

AT THE age of 34 Martin must have seemed the epitome of a successful, self-made, business-like man. When William Bewick accompanied him and Haydon to the exhibition of Rubens's *Chapeau de Paille* in Bond Street in 1823, he saw 'nothing remarkable or eccentric in his appearance; he was smart and trim, well-dressed and gentlemanly, and when seen out of doors he seemed to delight in a light primrose-coloured vest with bright metal buttons, a blue coat set off with the same, his hair carefully curled and shining with macassar oil. He was pre-possessing, with a great flow of conversation and argument. He was also imaginative, and kept to his points with a tenacity not hastily subdued.'[1]

His Egyptian Hall exhibition had been only moderately successful. He had sold *Joshua*[2] and received the commission for the second version of *The Destruction of Pompeii* from Sir John Leicester. But, as it turned out, the exhibition marked the end of his full-time painting career; his tenacity was damped, though not subdued, and thereafter he diversified his interests. In 1824 he returned briefly to glass-painting when, following Charles Musso's death, he supervised the completion of his remaining enamel and stained-glass works, out of a sense of obligation for the favours and help he had received from the Mussos in the past. This was a charitable action, but later in the year, having lost all his savings in the failure of his bank, Marsh, Sibbald and Co., he was obliged to find and exploit fresh and immediate sources of income. Only his workshop and a few unsold (and possibly unsaleable) paintings apparently remained to his credit. The previous year Haydon had gone to a debtors' prison as a result of the failure of his exhibition of *The Raising of Lazarus*. More resourceful, Martin quickly re-established himself and within a year could afford to buy Etty's *The Combat* for 300 guineas on a good-natured impulse after it had failed to sell at the Royal Academy. His recovery, and the change of direction this involved, were the result of a commission he had received some time after his Egyptian Hall exhibition from a publisher, Septimus Prowett, to produce twenty-four mezzotints of *Paradise Lost* for £2,000 with an extra £1,500 for a second, smaller, set of plates. This venture was only feasible because of the development by Thomas Lupton, in 1822, of a soft steel plate which could stand up to far more

impressions than could copper: at one and the same time Martin had the opportunity and the means and, from 1823, the incentive to become a print-maker.

In the mezzotint process—known in France as 'la manière anglaise', in Germany as 'Schwartzkunst'—the plate was given a uniform, minutely burred surface which held the ink and printed as an intense black, thus providing the sombre keynote suitable for the portrait prints made, 'after the Masters', by such noted engravers as J. R. Smith. This ground was then progressively scraped away and burnished to provide a complete range of tone: from total obscurity to incandescent highlights.

Turner's *Liber Studiorum*, issued between 1807 and 1819, represented the effectual beginning of landscape mezzotint, and in some of the plates Turner had himself experimented, trying varied combinations of etching, aquatint, and mezzotint. His detailed instructions to his engravers, and the great pains he took to modify his designs from outline to full tonality, are the nearest approach any of Martin's painter contemporaries made towards his degree of involvement in the 'black art'.

Before the Prowett commission Martin's experience of engraving had been confined to a few etchings of trees, classical ruins, Sezincot, and the outline diagrams in his catalogues. He had commissioned Charles Turner, the engraver, to make a 22 × 30 in. mezzotint of *Joshua* for about £500, but he proved so uncooperative that Martin decided eventually to do it himself.[3] His first completed mezzotints, a prim and stilted *Christ Tempted*[4] and *The Ascent of Elijah*,[5] appeared in 1824, by which time he had begun engraving *Belshazzar's Feast* on copper which he abandoned for a larger version, on steel, published in 1826.

Martin's *Paradise Lost* mezzotints owed little to previous Miltonic illustration.[6] Indeed the only obvious precedent in scope and ambition had been Fuseli's *Milton Gallery*, exhibited in 1799 and 1800. Engravings taken from these paintings were published in Du Rouveray's edition of *Paradise Lost* in 1802, with William Hamilton's sweetly pretty studies of Adam and Eve added as a makeweight contrast to Fuseli's sour fretting Satan. Martin was no doubt affected by Richard Westall's dainty illustrations to Boydell's Milton (1794–7); but this influence had been most pronounced many years before when he had borrowed Westall's thistledown nymph from *L'Allegro* for his *Clytie*.

Like Fuseli, and for that matter any literate illustrator, Martin relied on the poetry itself rather than previous interpretations. He faithfully translated the solemn pace, the set expressions of ecstasy and horror, the perfect order of paradise compared to the echoing, hollow fabrications of Satan's underworld. '*Paradise Lost* is a poem which a painter can scarcely touch,' the *Quarterly Review*[7] maintained, adding that Martin's illustrations were 'deplorable: we doubt if they would have been much better had Martin been a Michaelangelo'. While Fuseli or Barry had at least employed something of a Michelangelo manner in representing Satan as a testy demagogue, rearing up, foreshortened over empty skylines and barren rock formations, Martin, true to form, concen-

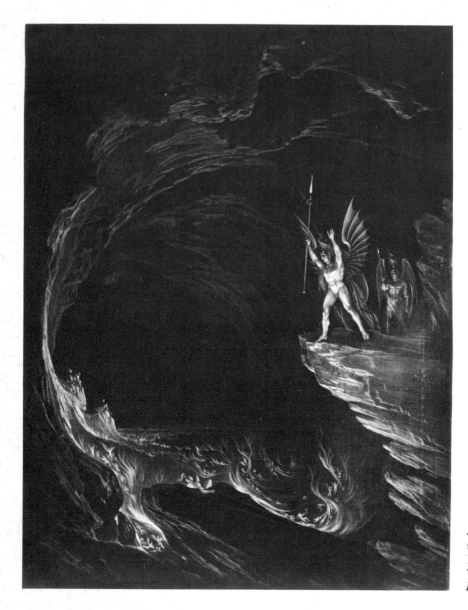

46. Satan Arousing the Fallen Angels. Mezzotint, $10\frac{5}{8}''$ × $7\frac{1}{4}''$, from *Paradise Lost* (first series).

trated almost exclusively on the epic-pastoral landscapes of Eden and on the vast industrial complexes of the nether regions.

Occasionally his designs came close to matching Fuseli's: *Satan Arousing the Fallen Angels* (Pl. 46), with Satan posing high on a rock above the legion of fallen angels, who twinkle like fire-flies on the stiff, curling waters, resembles Fuseli's *Satan Risen from the Flood* (Pl. 47). However, the connecting links are to be found not in Milton but in the two artists' illustrations to Gray's 'Bard'. Martin approached Milton from his own peculiar vantage point. As the *Literary Gazette* remarked in 1825: 'There is a wildness, a grandeur, a mystery about his

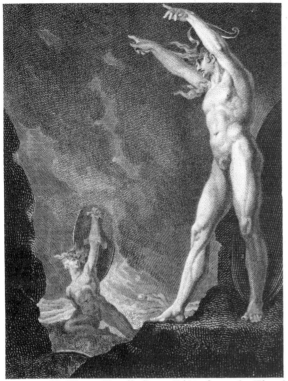

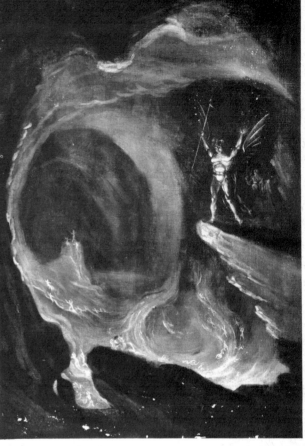

47. Henry Fuseli: Satan Risen from the Flood, 1802. Engraving $3\frac{1}{2}'' \times 4\frac{1}{2}''$, from Du Rouveray's edition of *Paradise Lost*.

48. Satan Arousing the Fallen Angels, *c.* 1825. Oil sketch on canvas, $26'' \times 18''$.

designs which are indescribably fine.' Like no other artist before him, he exploited the infinite black of the virgin mezzotint plate, which served him as the elemental void: in Milton's terms, the primeval state of Chaos, from which God conjured up the earth, the waters, and daylight, and within which Satan later contrived the menacing perspectives of hell. From initial adumbration to the final gleaming details, Martin found his medium perfectly suited to the ideas he was expressing.

The seven layers of hell were adapted from his Babylon; Eden came, unaltered from his earlier *Paradise Lost* paintings and from the Arcadia of his classical landscapes; but the series as a whole was designed especially for the mezzotint process. He made twenty-four preliminary oil sketches (Pl. 48)[8] in which the broad outlines of each composition were established. The rest was worked up, by degrees, on the plate itself. The series starts with *The Fall of the Rebel Angels* (Pl. 49), an avalanche of celestial boulders and bodies discharged into a total void, an oblivion that in the second plate takes the form of a burning lake, comparable to the volcanic limbo setting of *Sadak*.

75

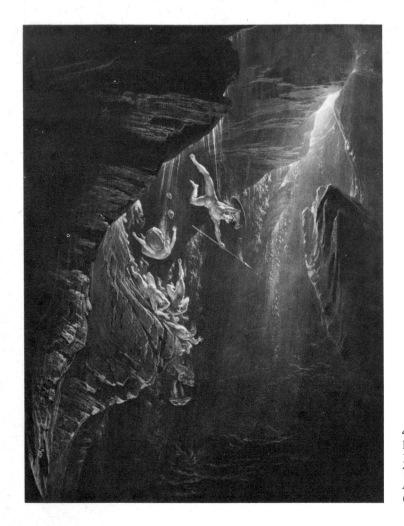

49. The Fall of the
Rebel Angels.
Mezzotint, 10″ ×
7⅚″, from *Paradise
Lost*, Bk. 1, p. 44
(first series).

Satan then orders the erection of the great Hall of Pandemonium (Pl. 50) where, in a huge set piece, he holds council as a truculent antichrist (Pl. 51), enthroned on a shining regal orb, his followers assembled round him like an opera audience, the naphtha house-lights burning as marker flares in the vast darkness. There were precedents for this composition in Hogarth's illustration of the scene, published in 1724, and in Isaac Taylor's frontispiece to the 1815 edition of Beckford's *Vathek*. Boullée's monument to Napoleon and Schinkel's set design for *The Queen of the Night* in *The Magic Flute* achieved much the same effect of overpowering enclosed space. In Martin's satanic halls, where Satan struggles with Death beneath a spotlight (or, more precisely, the beam from a phantasmagoric magic lantern) (Pl. 52), all ordinary sense of scale is reduced to a few cryptic indications of perspective in receding streaks of highlight. Represented exactly as Milton described them, these edifices belong in part, as

50. Pandemonium
Mezzotint, 7¾″ ×
10⅔″, from *Paradise
Lost*, Bk. 1, p. 71
(first series)

51. Satan presiding
at the Infernal
Council. Mezzotint
7⅝″. × 10⅓″, from
Paradise Lost, Bk
2, l. 1 (first series)

76

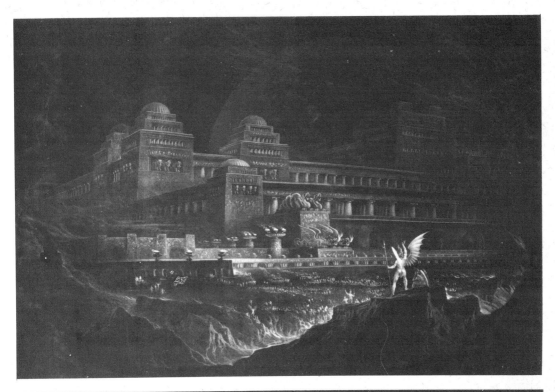

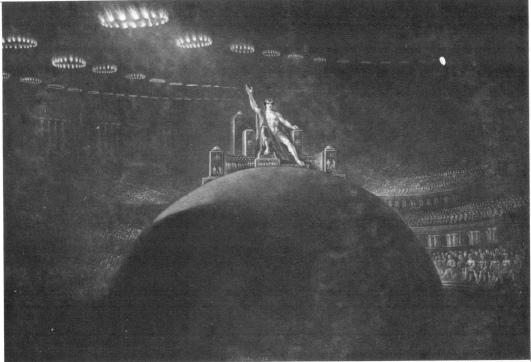

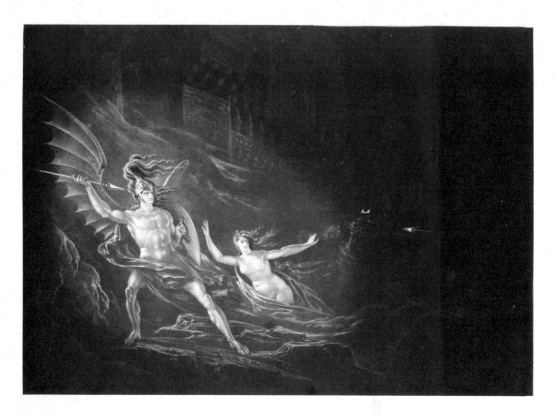

F. D. Klingender has argued,[9] to the new order of the Industrial Revolution. Pandemonium

> Rose like an exhalation, with the sound
> Of dulcet symphonies and voices sweet,
> Built like a temple . . .[10]

Martin set it in a huge stepped landscape, like a Welsh slate quarry or the seething inner space over the lip of Vesuvius. His City of Hell evokes the view from the dome of St. Paul's as described by a contemporary:

A panorama of industry and of life, more astonishing than could be gazed upon from any other point. In the streets immediately below one, the congregated multitude of men, of animals, and of machines, diminished as they are by the distance, appear like streams of living atoms reeling to and fro; and . . . they are lost in the vapoury distances, rendered murky by the smoke of a million fires.[11]

Its fortifications and crowning dome are a satanic parody of the architecture of the Celestial City. It refers as well to the complete subterranean world already in existence in the eighteen acres of vaults in the London Dock systems, in mine-workings, and in such burrows as the Harecastle tunnel, one of the greatest achievements of the canal builders:

52. The Conflic
between Satan an
Death. Mezzotin
7½″ × 10¾″, fror
Paradise Lost, Bk
2, l. 727 (first series

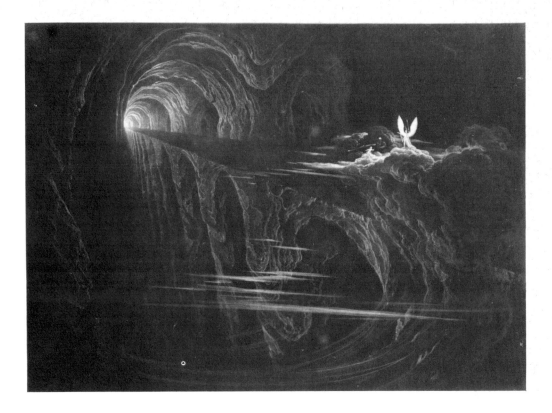

When you enter at one end, the farther end appears only like a little speck of light. You go all the way in darkness, but the way is straight, you cannot miss. . . . You now burst into open day again and behold the broad landscape—All is light, and the fresh air cheers you, while all the fears of the mountain falling in and burying you alive, are laughed at as quite silly.[12]

In this way Martin represented Sin and Death building a path from Hell, a bridge over Chaos, or viaduct within a tunnel, within nothingness (Pl. 53):

> . . . and the mole immense wrought on
> Over the foaming deep high arched, a bridge
> of length prodigious . . .[13]

In 1824, at the time that Martin was illustrating Milton's underworld, Isaac Brunel began to bore the first tunnel beneath the Thames:

> Virgil, Dante their descents to Hell
> Might make through tunnels made by Sieur Brunel.[14]

This Herculean project in defiance of nature brought to mind such ancient feats of construction as the tunnel said to have been built under the Euphrates by Semiramis and the original Suez canal of Pharaoh Nikau II. Simultaneously the first railway engineers were developing horsepower out of the elements of fire

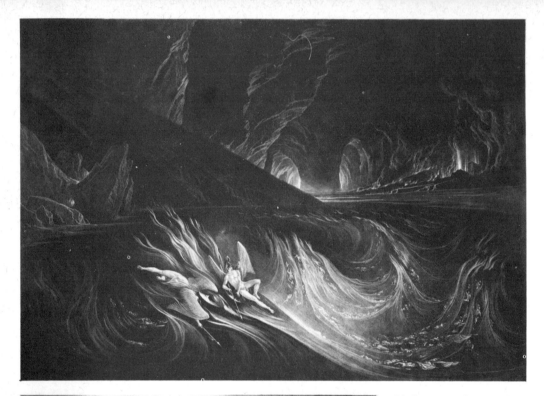

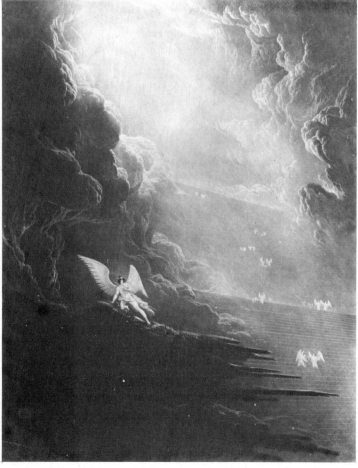

54. Satan on the Burning Lake. Mezzotint, $7\frac{5}{8}''$ × $11\frac{1}{4}''$, from *Paradise Lost*, Bk. 1, l. 192 (first series).

55. Satan viewing the Ascent to Heaven. Mezzotint, $11'' \times 7\frac{5}{8}''$, from *Paradise Lost*, Bk. 3, l. 501 (first series).

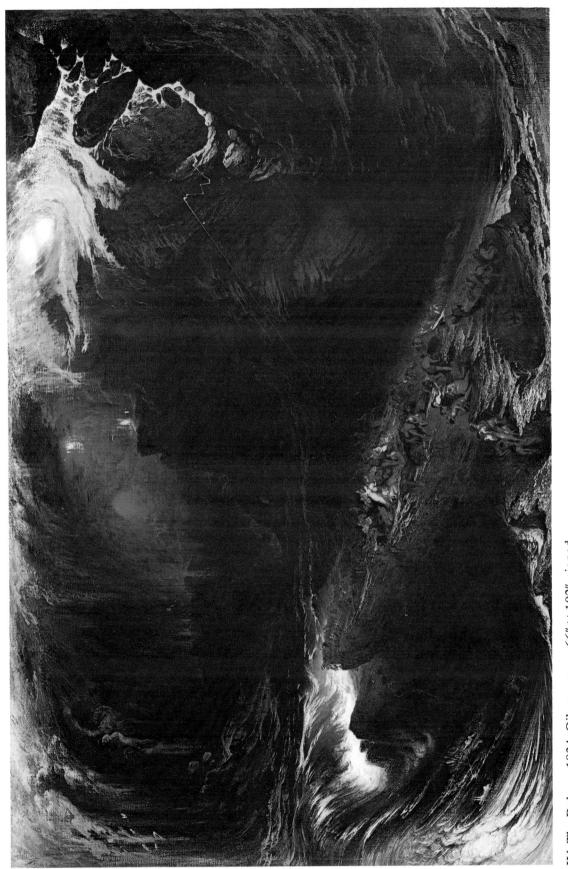

IV. The Deluge, 1834. Oil on canvas, 66″ × 102″, signed.

and water, establishing fresh works of Bel, machines with which to challenge the forces of nature and to race against time.

Satan is the crucial figure in *Paradise Lost*, the arrogant sophisticate (Pl. 54) who rails against established law and order and looks askance at the angels climbing the precipitous flight of steps to the Courts of God (Pl. 55); a phosphorescent luminary who created Pandemonium to challenge the Almighty and suit his fancy—the sort of character, indeed, whom Byron and the Romantic-minded could not help but admire. Martin's resounding sublimities in lamp-black[15] are vivid manifestations of this Satanic frame of mind. Drawn in certain respects from Martin's surroundings, they also provide the shapes and outlines of things to come. By 1841, when Martin painted a further version of *Pandemonium*, the hell he envisaged had become, quite clearly, a busy terminus, a palace, as it were, for an over-confident railway king, spread beneath a bubble dome which, appropriately in the age of railway mania, seems likely to burst at any moment.

The scenes from the second half of *Paradise Lost*—in which Adam and Eve wander in all innocence until, ambushed by Satan, they fall, pathetically, into temptation—lack the enormity and intensity of the scenes in Hell. The Garden of Eden first appears as a trim, tranquil, arboretum (Pl. 56), where waterfalls harmonize with weeping willows and angels stand sentinel on the surrounding cliffs. However, as the clouds thicken, darkness descends. First Eve and then

56. Adam and Eve: the Approach of the Archangel Raphael. Mezzotint, $7\frac{1}{2}'' \times 10\frac{3}{4}''$, from *Paradise Lost*, Bk. 5, l. 308 (first series).

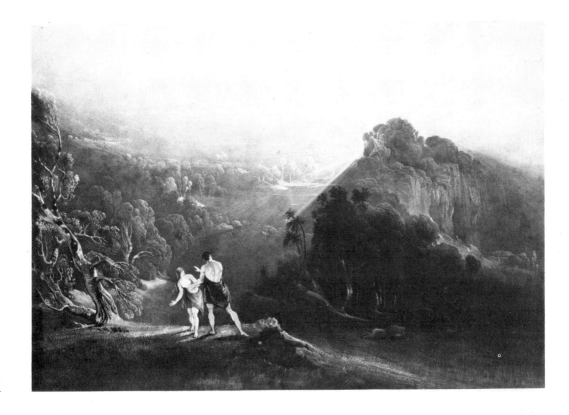

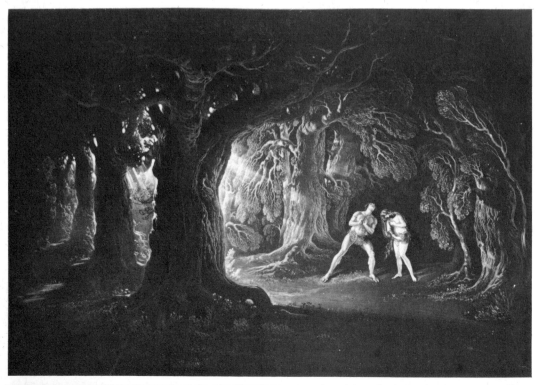

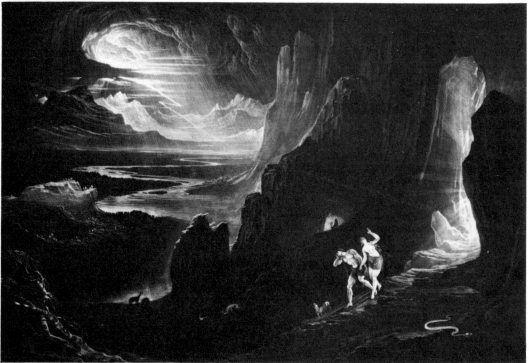

57. Adam hearing the Voice of the Almighty. Mezzotint, $7\frac{1}{2}'' \times 10\frac{2}{3}''$, from *Paradise Lost*, Bk. 10, l. 108 (first series).

58. The Expulsion. Mezzotint, $7\frac{1}{2}'' \times 11\frac{1}{4}''$, from *Paradise Lost*, Bk. 12, l. 641 (first series).

59. Heaven—The
Rivers of Bliss.
Mezzotint, $7\frac{1}{2}''$ ×
$10\frac{2}{3}''$, from *Paradise
Lost*, Bk. 11, l. 78
(first series).

Adam debase themselves and feel ashamed; the oaks writhe sympathetically
(Pl. 57). The illustrations end with the Expulsion (Pl. 58), the unhappy couple
passing through the rock ramparts and entering the murky everyday world of
prehistory, where monsters roam and a wide river meanders towards a faint
sunset gleam of hope. As the Archangel explained to Adam and Eve, the Celes-
tial City may after all be attainable, over the distant horizon, at the other end of
time (Pl. 59).

Prowett published *Paradise Lost* in four versions—folio and octavo and two
quarto sets—between March 1825 and 1827. Individual prints could be bought
for 10*s*. 6*d*. and 6*s*. The designs are very unequal, the large plates being, in
general, greatly superior to the second, smaller, versions in which Martin's im-
patience or over-hastiness is sometimes revealed in discordant underlays of
etched lines which harshly accentuate tufts of foliage and the leading edges of
rocks, destroying the essential homogeneity of mezzotint. Nevertheless, the
Paradise Lost illustrations were a startling achievement. From Creation to
Expulsion, from the Rivers of Bliss to the Burning Lake, Martin has assembled
his own unmistakable, if imitable, visionary repertoire.

The success of the project encouraged him to set up his own printing shop, in
order to render his stock of imagery readily available to a wide public. His work
was already being copied and pirated, so for the sake of his reputation and

pocket it was logical to issue mezzotints of his most popular paintings. 'Large historical pictures such as Haydon's have this disadvantage—that they are beyond the scale of private purchase; those of the size of Martin's are more readily disposed of,' Wilkie explained. 'You see, Mr Martin has always contrived to make his pictures profitable, either by sale, by exhibition, or by engraving them.'[16] Leopold describes how Martin built 'his first painting room, with outlet into a back lane, and subsequently, upon its foundation when re-built, a substantial private printing establishment and convenient painting-room, attached to the house by a long gallery supported by iron pillars',[17] and fitted it out with 'fly-wheel and screw presses of the latest construction; ink-grinders, glass and iron; closets for paper French, India and English; drawers for canvas, blankets, inks, whiting, leather shavings, &c; out-door cupboards for charcoal and ashes —in fact, every appliance necessary for what my father was converting into a fine art.'[18]

His first large mezzotint, *Belshazzar's Feast* (Pl. 60), was published in June 1826, and he subsequently produced prints nearly every year until 1838. Each plate demanded quite as much time and effort as the painting on which it was initially based, and although he employed assistants, he closely supervised the printing and, according to Leopold, experimented with various etched effects and with unusual ink mixtures: 'At the outset he would pull a plain proof of the plate, using ordinary ink; then work or mix the various inks. First he made a stiff mixture in ink and oil; secondly, one with oil and less ink; and thirdly, a thin mixture both of ink and oil. Lastly he worked up various degrees of whiting and oil with the slightest dash of burnt umber, just to give a warm tint to the cold white.'[19] The rewards of these labours were considerable. In aesthetic terms each big plate represented an advance on the painted master-work. Martin, it was remarked, laboured at an advantage: 'By doing it himself, more spirit must of necessity be infused into his works from the greater con amore (if we may use that expression) attendant upon the reworking of the artist's own designs.'[20] They were profitable too: by 1829 the mezzotints had become his main source of income. His account book[21] shows how, in dealings with Ackermann, Colnaghi, and provincial printsellers (notably in Manchester and Liverpool), he made nearly £3,000 between June 1826 and December 1827 from *Belshazzar* and *Joshua*. The price varied from 10 guineas for an unlettered proof of *The Deluge* to one guinea for a run-of-the-mill impression. His most ambitious project, the mezzotint *Illustrations of the Bible*, which in 1831 he intended to publish and distribute himself in twenty parts, was a commercial failure and in 1838 he was obliged to sell both stock and plates for £500 to Charles Tilt, the dealer in remainders.[22] By 1843 he was counting on large exports to America for the print of *The Eve of the Deluge*,[23] but he miscalculated and the edition had to be sold off at cut price. Martin blamed this decline not on his haphazard business sense, or his waning interest or skill in the art, so much as on the defective copyright laws: 'my property being so constantly and variously infringed, that it became ruinous to con-

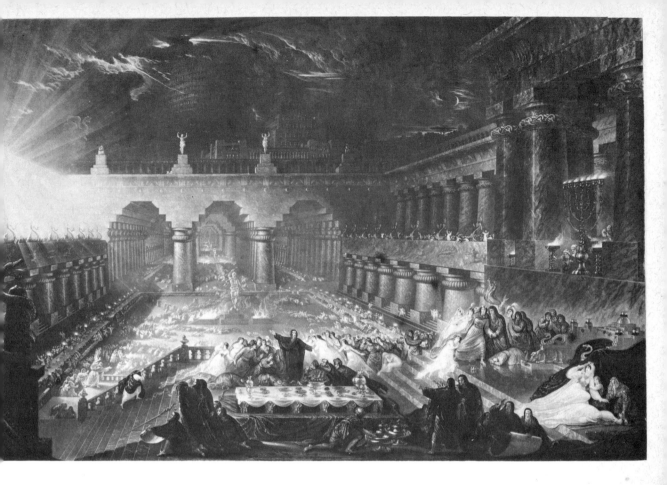

60. Belshazzar's Feast, 1826. Mezzotint (first plate), $18\frac{1}{4}'' \times 28\frac{1}{2}''$, dedicated to George IV.

tend with those who robbed me; I was, therefore, driven from the market by inferior copies of my own works, to the manifest injury of my credit and pecuniary resources.'[24] Some of these 'inferior copies' were, however, his own work. With some exceptions such as *The Destruction of Sodom and Gomorrah*, the mezzotint *Illustrations of the Bible* were lame, makeweight designs.

Before moving from Allsop Terrace to Lindsey House in Chelsea in 1848, Martin closed his workshop and dispersed its contents. He had made well over £20,000 from his prints between the Prowett commission and the close of the account book in 1840. Through his prints Martin became art's Household Word, as famous in his time as Cruikshank; both were predecessors in popular terms to Landseer and Leech, Frith and Doré. For the few who might see Martin's work in the Royal Academy or British Institution there were hundreds of thousands who bought the prints or the Bibles and *Keepsakes* that contained his illustrations.

On the strength of these, Martin became better known abroad than any other British artist, Turner or Lawrence possibly excepted. French visitors to London, Michelet and Berlioz, for instance, were so conditioned by Martin's architectural effects that they could only see the terraces and docks of Nash, Telford, and Hartley as Babylonic and 'martinien' (Pl. 61).[25] His mezzotints supplied a key-

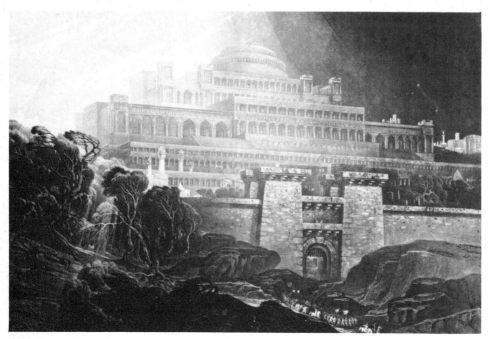

61. Joshua Commanding the Sun to Stand Still, 1827 (detail). Mezzotint, 17″ × 26¾″ (complete), dedicated to Prince Leopold of Saxe-Coburg.

note, a sublime darkness over all the land. Like Hogarth, Martin was most admired for his convincingly staged narratives, for the dramas of decline and fall, failure and salvation, for themes easy to grasp, easier still to recognize. Both saw the process of translation from paint to print as an opportunity to insert extra detail, to substitute reading matter, as it were, for the impact of large-scale values. 'Hundreds thus also are delighted with, and taught to admire the genius of a Hogarth or a Martin by means of their engravings, who never saw one of their original pictures: and so will artists find that their truest policy is not to trust the perpetuating of their reputation to other hands than their own.'[26]

Martin's mezzotints were concentrated and, in certain respects, intensified reproductions. The armour-plated soldiery of the 1831 engraving of *The Fall of Babylon* (Pl. 27), for instance, were more resolutely developed and disposed than in the earlier painting, while the balustrades and roof tops of Belshazzar's festal palace fitted the description in *The Last Days of Pompeii* of 'galleries, not wholly dark but dimly lighted by wandering and erratic fires, that, meteor-like, now crept (as the snake creeps) along the rugged and dank soil; and now leaped fiercely to and fro, darting across the wild gloom in wild gambols'. Hence the disappointment and, indeed, over-reaction with which some French critics, accustomed to the printed images, greeted the originals. Théophile Gautier was greatly surprised when he saw *The Deluge* at the Paris *Salon* in 1835; he found it 'fabuleusement mauvais' and came to the conclusion that Martin, 'comme peintre, il est nul'.[27] By dint of 'darkness visible' Martin's mezzotint carried more conviction than the painting, which, on rigid *Salon* terms, looked, evidently,

inadequate: a *Raft of the Medusa* perhaps, reduced to a frenzy. A generation later Ernest Chesneau expected from the mezzotint to find *Belshazzar's Feast* gripping and marvellous; instead, when faced with the painting (which had been considerably damaged, however, since its first appearance), he saw nothing but 'a dark yellow surface; uniform, monotonous, altogether ugly, vulgar and tame'.[28]

While working on the *Paradise Lost* illustrations Martin continued to produce major paintings, though he turned from the extravagances of satanic or man-made architecture to the occasion when, by Divine providence, land and sea were established in their appointed places. In 1824 he painted the exact moment when recorded time began and God set sun, moon, and stars

> High in the expanse of heaven, to divide
> The day from night; and let them be for signs,
> For seasons, and for days, and circling years[29]

Judging from the mezzotint versions (Pl. 62)[30] *The Creation*[31] was a formidable evocation of the unveiling, when darkness was swept aside and wide fermenting wastes were first illuminated, when all the world was a stage and God the only living being.

62. The Creation of Light. Mezzotint, $7\frac{1}{2}'' \times 11''$, from *Paradise Lost*, Bk. 7, l. 339 (first series).

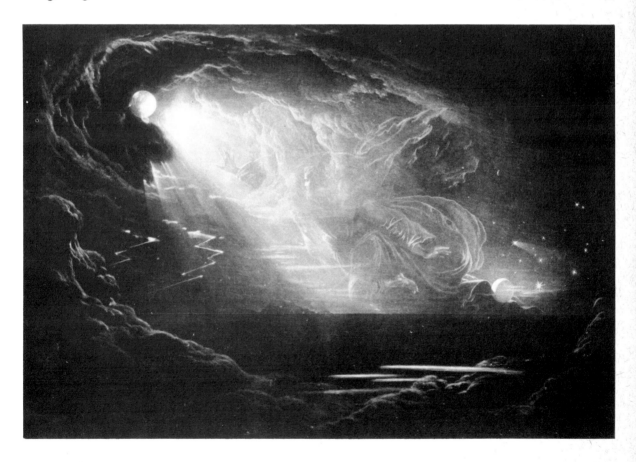

Haydon mocked Martin's *Creation* for its impossible scale:

No effort of the mind can entertain such a notion; besides, it is the grossest of all gross ideas to make the power and essence of the Creator depend on size. His nature might be comprehended in an ordinary-sized brain, and it is vulgar to make Him striding across the horizon and say the horizon is 50 miles long.

As usual, Haydon was excessive in his strictures:

There is nothing grand in a man stepping from York to Lancaster; but when he makes a great Creator fifteen inches, paints a sun the size of a bank token, draws a line for the sea and makes one leg of God in it and the other above, and says: 'There! That horizon is twenty miles long, and therefore God's leg must be sixteen relatively to the horizon,' the artist really deserves as much pity as the poorest maniac in Bedlam.[32]

Were Haydon to have considered the matter carefully instead of worrying over his point that 'No being in a human shape has ever exceeded eight feet', he would have recognized the respectable sources for Martin's painting in the Creation frescoes of Raphael and Michelangelo in the Vatican. These provided him with the image of God in man's likeness, in flowing Old Testament robe and beard, passing through a world which (in Raphael's design, executed by Giulio Romano) had shrunk beyond Haydon's wildest criticisms into a paltry globe:

> ... This earth a spot, a grain
> An atom, with the firmament compared
> And all her numbered stars.[33]

As far as Northcote was concerned, Martin's literal representation of the situation was contemptible. Paintings like this were, he maintained, 'mere tricks and not historic art—the work of young beginners'.[34] Eighteen years before, Northcote had similarly castigated those painters who 'instead of looking at nature as their guide, assisted themselves almost entirely from the poets and the stage, which has given to all their historical paintings ... the exact air of a scene in an opera'.[35] On occasion this was a suitable approach. Martin's representation of God trailing clouds of glory over the seas is an almost literal rendering of the wonders described in the first chapter of Genesis. Like so much of Martin's imagery it belongs to a middle order of taste, suspended between simplistic *naïveté* on the one hand and studied refinement on the other, and fortified by a sense of blithe effrontery.

Martin's painting effectively represents the origin of all things, the state of primeval flux and chaos which was to re-echo throughout history in deluge and volcanic eruption (such as the eruptions around Pompeii, during which the bowels of the earth would open, disgorging molten streams that would harden into rock formations), local apocalypses that would settle down into a fresh order of creation. A fundamental, universal, natural law being that there is nothing new under the sun, all man-built structures (indeed all the cities that Martin envisaged) are descended from such natural prototypes as the rock for-

mations which make their first appearance in the foreground of Martin's *Crea-*

tion. Gandy illustrated this idea in his drawing 'Architecture: Its Natural Model'[36] which he made in 1838 and intended to be the first of a series of a thousand drawings covering the entire history of world architecture, a chock-a-block compendium of basic structures, vaults, buttresses, and pillars assembled around a high-and-dry Noah's ark, ready for the world's new start after the Flood. Prominent among these architectural *objets trouvés* are the massed basalt columns of Fingal's Cave on the Isle of Staffa, which, ever since its discovery in 1772 had been invested with mythological overtones and, like the Caves of Elephanta, an almost religious significance as a source of structure. Turner visited the island in 1831, and the painting he made from the sketches[37] (shown at the Royal Academy in 1832) compares closely with Martin's *Creation*, especially with the more rock-strewn mezzotint version of 1831. Turner introduced a steamboat in place of the Almighty, but the compositions have the same synchronized sweep of cliffs, clouds, and waves: an almost identical sense of the beginning of the world at the far ends of the earth.

However, the aims and means of Martin's *Creation* could not be reconciled to the prevailing climate of the Royal Academy. 'As I progressed in art and reputation,' Martin complained, 'my places on its walls retrograded.'[38] His downright showmanship, his independent success meant that he was the sort of artist who could be considered a challenge, even an affront, to established interests. In1825, as if in response to a desire for an artist to outbid Martin and provide equivalent, if rather more respectable, sublime effects, Francis Danby sent his *Delivery of Israel out of Egypt* (Pl. 63) to the Academy, where it 'enflamed the walls of Somerset House'.[39]

Born in County Wexford in 1793, Danby had spent seven years in Bristol before achieving his first success, in 1820, when he showed *The Upas Tree* at the Royal Institution. Encouraged by Lawrence, he moved to London around 1824 to try his fortune, and assumed a Martin manner in designing his first epic, *The Delivery of Israel*, which was bought by the Duke of Sutherland and led within months to his election as an A.R.A., a rapid elevation that he was later to call 'the only degrading circumstance of my life'.

'Danby', M. W. Bürger remarked in *L'École anglaise* (1863), 'est une sorte de pendant de Martin.' He was clearly promoted by the Academicians as a countercheck to Martin. During the years that they worked in rivalry each was accused of poaching and pirating the other's ideas; the charges and countercharges (mainly voiced by partisan friends) were, strictly speaking, irrelevant to their work. Both indeed were described by Haydon as 'men of extraordinary imagination, but infants in *painting*';[40] both began as topographers and spent only a period of their lives on epic subject-matter. Inevitably much of their work coincided: one of Danby's earlier paintings, *Disappointed Love* (1821), in which a Jane Austen heroine grieves over some cold, heart-breaking Darcy beside a pool, was virtually a modern-dress version of Eve bewailing the Fall.

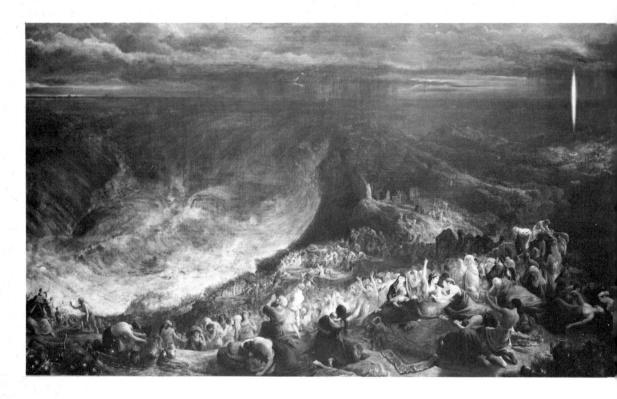

In 1828 Danby showed *The Opening of the Sixth Seal* at the Academy, where it was bought by Beckford for 1,000 guineas. He showed two more apocalyptic paintings the following year, missed R.A. status by one vote (losing to Constable), and went off to Geneva in a marital tangle; there followed a period of exile and eclipse that more or less coincided with the period Martin spent promoting his civil engineering schemes. He made a comeback in 1840 and briefly resumed his competition with Martin, showing a pallid, spuming *Deluge*[41] at the time that Martin was exhibiting his own Deluge sequence at the Royal Academy. After 1841 Danby abandoned apocalypse and settled for the sunset tranquillity of paintings like *The Enchanted Castle* and *The Evening Gun*.[42]

He was concerned with only one aspect of Martin's art: that of figures in mighty landscapes. He made no attempt to match Martin's more original achievements in historical landscape or architectural reconstruction. The rivalry was limited to a few years and to specific subject-matter. Danby's epic paintings were, perhaps, rather too knowingly contrived, tidied and polished off until they became matters of overwhelming routine. Martin, at any rate, generally succeeded in preserving some sense of energy and surprise.

Danby's *Delivery of Israel* was specifically designed as an exhibitionist demonstration—'A piece painted for effect in the style of Martin', as Dr. Waagen described it[43]—to qualify Danby for competition with Martin or Turner. He took his Red Sea setting from Martin's *Herculaneum*, placed similar,

63. Francis Danby
The Delivery of
Israel out of Egypt,
1825. Oil on canvas,
$58\frac{3}{4}'' \times 94\frac{1}{2}''$

though slightly better-built figures on the foreshore, and added thrashing waters and distant pyramids like those on the horizon of Martin's *Seventh Plague*. When Martin came to deal with *The Destruction of Pharaoh's Host* (Pl. 64) and *The Crossing of the Red Sea* (in the *Illustrations of the Bible*), the preceding Danby shone through his treatment, as clear a guide as Moses' own pillars of fire and cloud. Danby's *Israelites Led by the Pillar of Fire*[44] was, for a time, attributed to Martin; so too was a stained-glass window in Redbourne church, Lincolnshire, which is a translation into bloodshot light, by the Collins workshop, of Danby's *Opening of the Sixth Seal*.

Full credit for developing the motifs of falling rocks and parted waters rests with neither Danby nor Martin but with Turner. Both Danby and Martin owed a good deal to Turner's interpretations of *Sodom and Gomorrah*, *Hannibal Crossing the Alps*, and *The Deluge*. Such tumultuous material was in any case confusing. One cataclysm tended to melt into the next; thus, when Miss Rigby visited Turner's studio in 1846 she saw a painting 'with all the elements in an uproar, of which [she] incautiously said: "The End of the World, Mr Turner?" "No, Ma'am; *Hannibal Crossing the Alps*."'[45] When treatment surpassed subject-matter and motif, when apocalypse became a free for all, questions of originality and copyright were of next to no account.

64. The Destruction of Pharaoh's Host, 1830. Water-colour, $22\frac{1}{2}''\times32\frac{1}{2}''$, signed.

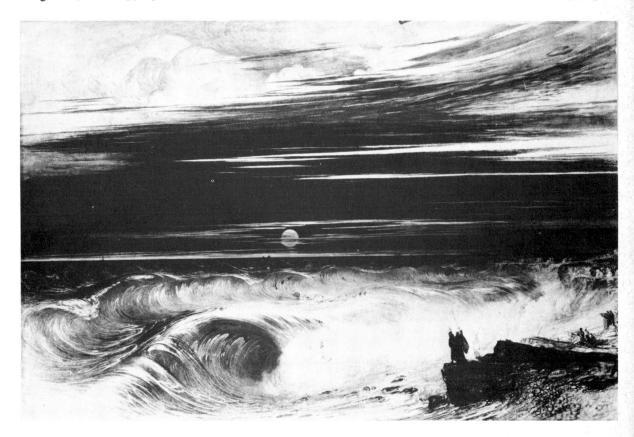

Thomas Lovell Beddoes described Martin's *Deluge* as a 'rascally plagiarism upon Danby',[46] claiming, without any good reason, that Martin had seized on Danby's idea for *The Opening of the Sixth Seal*, a batch of life-class *poseurs* caught on a tilting Giant's Causeway in a shower of boulders. Martin was also reputed to have based the rockfalls in his *Deluge* on a load of coal; but they derive, more probably, from sketches made during a three-week holiday in North Wales and from conventional stage representations of earthquake. Martin first used the composition in his illustrations to Edwin Atherstone's *A Midsummer Day's Dream* in 1824, before Danby attempted anything in that vein.[47] Thomas Banks's Academy Diploma sculpture, *The Falling Titan* (1784) in the foothills of which tiny humans dash to avoid the shivering shock of the god's collapse, together with the avalanche paintings of de Loutherbourg and Turner provided him with a more than adequate supply of precedents, special effects which thereafter passed from Martin and Danby into the standard repertoire of the epic cinema, to sequences showing San Francisco shaken to pieces and, in parody, to the posse of bouncing plaster rocks which gives chase to Buster Keaton in *Seven Chances*.

As far as Martin was concerned, *The Deluge*, shown at the British Institution in 1826, was a careful reconstruction of a historical event. He noted on a copy of the accompanying pamphlet that 'relative to the scale of proportion, viz. the figures and trees, the highest mountain in the Picture will be found to be 15,000 Ft., the next in height 10,000 Ft., and the middle-ground perpendicular rock 4,000 feet.'[48] Despite the regrettable lack of precise evidence in Genesis, Martin did his best to make the topography as accurate and as detailed as the environs of his Herculaneum, Pompeii, and Babylon. Inevitably, though, he availed himself of poetic licence, quoting in his pamphlet from Byron's *Heaven and Earth:*

> Ye wilds that look eternal,
> Where shall we fly?
> Not to the mountains high,
> For now their torrents rush with double roar
> To meet the ocean.

The poem ends with a stage direction: '*The Waters rise: men fly in every direction; many are overtaken by the waves; the chorus of mortals disperses in search of safety up the mountains; Japhet remains upon a rock, while the Ark floats towards him in the distance.*'

The painting returned, unsold, to Martin's studio after the British Institution exhibition. He produced a mezzotint in 1828 (Pl. 65a), with a further descriptive pamphlet,[49] and it was probably on the strength of this superbly articulated print that he made another, larger, version signed and dated 1834 (Colour IV, p. 80).[50] This painting[51] was, evidently, altogether more coherent and stupendous than the earlier version. Martin himself described it, in 1841, as his 'favorite picture'.[52] It was shown in the Paris *Salon* of 1835, and Martin was awarded a gold medal

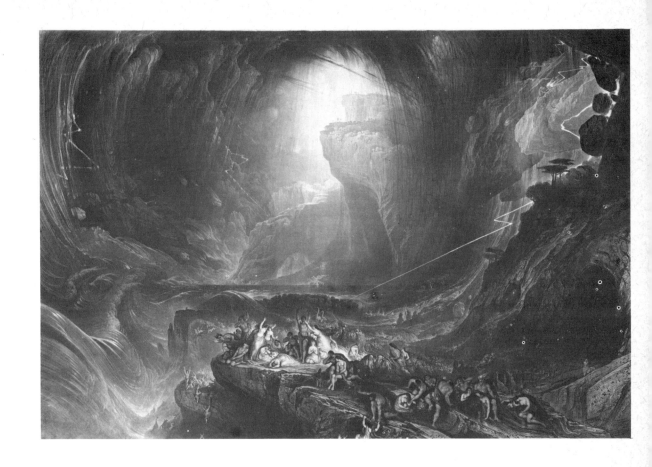

65a. The Deluge,
1828. Mezzotint,
$18\frac{1}{2}'' \times 27''$,
dedicated to Tsar
Nicholas I of
Russia.

65b. 'Lo, a fierce
conflagration.'
Untitled illustration
engraved by G.
Cooke after John
Martin, $2\frac{3}{4}'' \times 3\frac{7}{8}''$,
plate ii from *A
Midsummer Day*'s
Dream, a poem by
Edwin Atherstone,
1824.

by Louis-Philippe amidst what Gautier described as 'un concert unanime d'éloges, l'on se récria, l'on fit des oh! et des ah! admirable talent, talent biblique, apocalyptique, etc, etc.'[53] Judging from the print, some—Gautier, for instance—had come to expect a more starkly defined set piece.

They found instead a frenzied, tawny composition, a swirling relay of cliff, cloud, and water around a diagonal shelf of rock to which cling the remnants of mankind, including the 969-year-old Methuselah ('Mr. Martin strictly adheres to the evidence of Holy Writ,' the pamphlet accompanying the mezzotint pointed out), a 'family in silent despair', a 'blasphemer: his wife placing her hand upon his mouth to prevent his imprecations', and 'a den of ferocious animals'.[54] The painting has to be studied carefully before the ark can be identified, perched on a distant peak, high above the one patch of level water, a time capsule, just about to float over the great watershed divide between the antediluvian world and the second start of history. Though following Byron's stage directions and demonstrating that, in the words of Genesis chapter 7, 'the fountains of the great deep [were] broken up and the windows of heaven were opened', Martin was anxious to show that the Deluge had been brought about by an extraordinary conjunction of sun, moon, and comet, all combining to turn the natural order of time and tide into chaos: day mingled with night; the earth opened to swallow its parasitic inhabitants; boulders arrested in mid-air like petrified cumuli; waters acting volcanically; sky and sea blended into shaggy veils of tempest. The caves are now traps rather than bolt-holes. In the left corner a woven life-raft carries swooning passengers, together with the serpent of original sin, the cause of man's first fall, down the sluice into a section of canvas, beneath the rock, where all signs of life and energy, in line or impasto, drain away into a smooth black void.

Baron Cuvier, the French naturalist and geologist, visited Martin's studio while he was working on the second version of the painting and 'expressed himself highly pleased' that Martin and he were in agreement over the scientific explanation of the flood.[55] The striated valley floor was to become a repository for the bones of all the creatures that perished in the flood; laid down in a thick stratum of mud, they would fossilize and eventually provide evidence of antediluvian life in the lost, washed-out world. Bulwer-Lytton observed in *England and the English* that 'Poussin had represented before [Martin] the dreary waste of inundation, but not the inundation of a world'[56]; in both theoretic terms and actual appearance Martin's painting is radically different from its predecessors. It concentrates on the powers of God and the forces of nature, relegating mankind to the humiliatingly insignificant role of topdressing on a rock of ages. The 'somewhat overstrained attitudinising' remarked on by the *Newcastle Courant* in 1838[57] was necessary if the vain gestures, upflung arms, and smitten brows were to be distinguishable in the general hubbub. The figures, neatly and firmly painted, are fit representatives of the dying race, and the central huddle is picked out by an unerring stab of lightning which cuts

diagonally across all the confusion and serves as a decisive counterpoint to the circling engulfing rhythms (Pl. 66 and Colour Va).

The scene of *The Deluge* recurs in several other works, predictably in Martin's compositions on the theme of the Crossing of the Red Sea. The rock platform, Martin's standard foreground, ended up, strewn with corpses, as a podium for the Christ-like figure of *The Last Man* (Pl. 67)[58] a subject set in the distant future, but reflecting back to the original *Deluge* and linked by the same glowering sun. To judge from a later water-colour version, an oil-painting of *Manfred*, shown in 1826 at the Society of British Artists,[59] was set in a similar, Alpine valley. Byron's hero Manfred, having climbed towards the everlasting purity of the snowy mountain tops, stood poised ready to hurl himself into oblivion—down into the valley where, several millennia before, the ground had opened and waters had turned the landscape into an unfathomable lake. *The Fallen Angels Entering Pandemonium* (Pl. 68), a fiery monochrome, may have been painted by Martin at the time he was engaged on *The Deluge*, in the interval between his two mezzotints of *Pandemonium* (1825 and 1832).[60] Here the stage effects

95

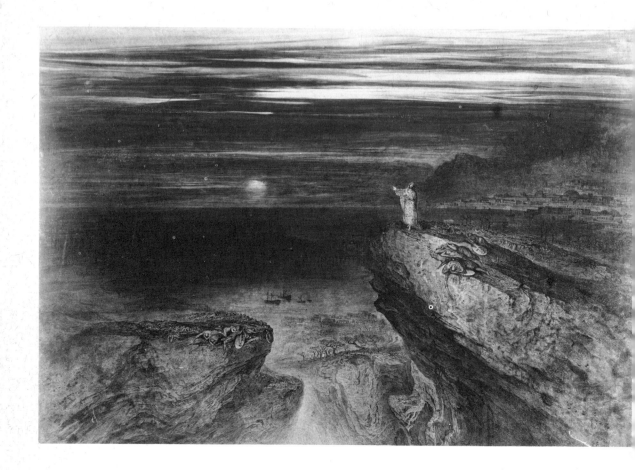

of an incantation scene from *Der Freischutz* and flying pumice-stones, equivalents to the great cloud chariots which sweep the blessed up into the dizzying heaven of baroque domes, appear as a brittle, over-heated travesty of Martin's mature work but, arguably, give some idea of the appearance of the first version of *The Deluge*.

In the course of its long evolution into the form that eventually pleased him, *The Deluge* became a composition of central, crucial importance to Martin. Bernard Barton, who kept pace, in poetry, with Martin's paintings, was moved to write a long poem entitled 'Recollection of Martin's Deluge' (1828) some of which was printed in the pamphlet issued with the mezzotint:

> The Awful Vision haunts me still
> In thoughts by day, in dreams by night:
> So well hath Art's creative skill
> There shown its fearless might.
>
> The floodgates of the foaming deep
> By pow'r supreme asunder riven,

67. The Last Man, *c*. 1832. Watercolour, 18¼" × 27¾

The dark, terriffic, arching sweep
Of clouds by tempests driven,

The beetling crags, which, on the right
Menace swift ruin in their fall,
Yet rise in Memory's wistful sight
And Memory's dreams appal![61]

Barton also produced a poem on Marcus Curtius at about the time that Martin painted the same subject. In this painting Martin reverted to cityscape—an area in which Danby never attempted to challenge him; he transformed mountain tops back into citadels, cliff faces into arcades, volcanoes into Pandemonium. His preoccupations, however, remained much the same. Marcus Curtius was a young Roman who sacrificed himself on behalf of his fellow citizens by jumping into a chasm that had opened in the city forum, on the understanding that it would thereupon close over him and leave Rome intact. Several versions of Martin's painting survive (Pl. 69),[62] all set against an Augustan backdrop which was to recur with only slight modification as Tyre, Troy, and Jerusalem and which derived, for all its neo-classical and Claudian-seaport trimmings, from the townscapes of Newcastle and, in particular, of Edinburgh—described by William Bewick on his first visit, in 1823, as 'massed in piles upon piles of rock,

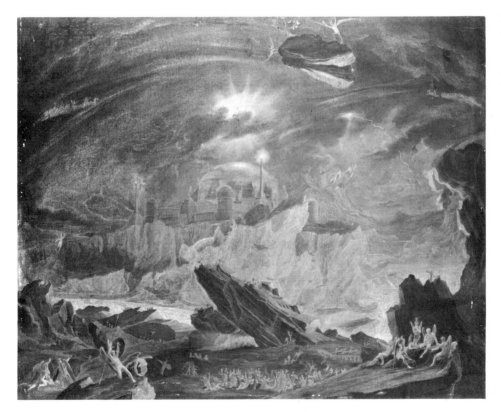

68. The Fallen Angels Entering Pandemonium. Oil on canvas, $24\frac{1}{2}'' \times 30\frac{1}{8}''$. Possibly the work of one of John Martin's imitators.

97

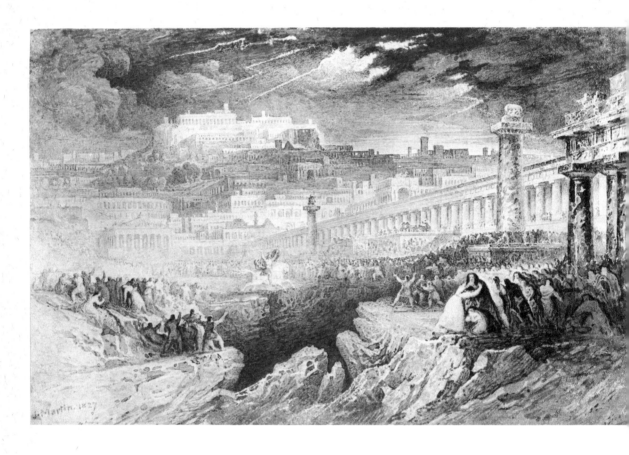

backed by mountains that tower upwards either by gradual ascent or precipitous erections'.[63] Like Satan's Pandemonium, such man-made landscapes, proud imitations of natural architecture, were follies. As shown by Martin, Marcus Curtius was a hero and, like Sadak or Adam, the Last Man, was both scapegoat and human sacrifice, swallowed by a gap in time.

Marcus Curtius was painted at the time Martin issued the first of his plans for water supply and other urban improvements, altering the direction of his artistic efforts in an attempt to benefit society. By then Martin had represented almost every conceivable ordeal a city could suffer: inundation, plagues of hail and lightning, earthquake, and military assault. Contemporary events such as a *Great Fire in Edinburgh*[64] or the inundation of St. Petersburg of 1824 (engraved and included as a topical coloured supplement to the *Literary Magnet* for April 1825) (Pl. 45) were represented in Martin's terms. An unfinished *Burning of Rome*[65] is lapped in the same unflagging flames that, kindled by Jonathan Martin in 1829, destroyed the Choir of York Minster,[66] that burnt down Nottingham Castle in the Reform Bill riots (to be painted by Henry Dawson, then one of Martin's most devoted emulators), and subsequently, in 1834, burst out of the old Houses of Parliament setting Haydon and Turner beside themselves with

98

excitement, the stuff of history crackling and leaping before their very eyes. Paintings of such scenes were a form of epic reportage: eyewitness immediacy being more desirable than artistic refinement.

Where *Marcus Curtius* was concerned with a hero consigning himself to oblivion for the sake of his community, *The Fall of Nineveh*, Martin's final and most ambitious venture into the business of reconstructing an ancient city, represented the destruction of an entire city around the funeral pyre of the feckless King Sardanapalus. Having besieged Nineveh for three years, the enemy, under their leaders Arbaces, Beleses, and Rabsaris, broke into the city to find a dense mass of drunken soldiery and distracted courtiers, while Sardanapalus consigned himself, his harem, and accumulated treasury to a funeral pyre. 'He had bravely resisted the strength of human foes,' Martin wrote in the explanatory pamphlet, 'but against the Gods he felt that opposition must be vain'. He showed the king's earthly goods stacked up on the left side of the painting, a vast Regent Street drapery display:

> A dazzling mass of gems, and gold, and glitter,
> Magnificently mingled in a litter.[67]

ready for burning in the corner that Martin usually set swirling and awash with waves and cliff faces:

> a light
> To lesson ages, rebel nations, and
> Voluptuous princes.[68]

According to a note in the *European Magazine* of 1822, *The Fall of Nineveh* was planned as 'a work of perhaps greater sublimity and difficulty of execution than he has hitherto painted' and as an immediate sequel to *Belshazzar's Feast*. It was no doubt postponed, because of Prowett's commission and was eventually painted shortly after Martin had completed the *Paradise Lost* plates. A photograph of the painting (which is at present untraced)[69] suggests that it was altogether lighter and more expansive in treatment than the huge mezzotint dated 1829 and published in July 1830 (Pl. 70),[70] remarkably soon after the first exhibition of the painting 1828. There is an air of well-rehearsed and predictable strain about it. The Tigris is an elbowing intrusion on an impossibly widescale spread of colonnades and terraces. A heaven-sent streak of lightning marks the overthrow of an immense 'ruined wall, thrown down in parts by the flooded river, the wall of breadth sufficient to allow three chariots abreast to drive upon its summit' (Pl. 71).[73] The invading army streams through the gaps and swirls round the

> blazing palace
> And its enormous walls of reeking ruin[71]

and the statues of serpent and rhinoceros which stand marooned above the human tide.

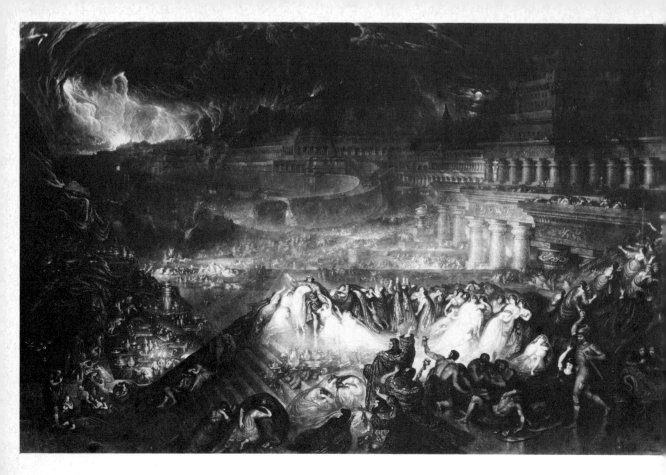

70. The Fall ·
Nineveh, 182
Mezzotin
$21\frac{1}{8}'' \times 32$

Martin was already planning to turn the Thames into another tamed Tigris by lining it with barrages and embankments, lit, like the bridge of Nineveh, with naphtha lamps; and he was at pains to show that the mighty civilization of Nineveh was founded on the strength of great containing walls which, for a while, preserved the city from flood. However, the reckoning came to Nineveh, just as, later, in their turn

> Athens, and Rome, and Babylon, and Tyre,
> And she that sat on Thames, queen of the seas,
> Cities once famed on earth, convulsed through all
> Their mighty ruins, threw their millions forth.[72]

Martin decided to show the painting in the Western Exchange at the end of the Burlington Arcade, so as to earn admission fees by making it an exhibition in itself. In his catalogue he described the scene grandiloquently: 'Seen through the mist of ages, the *great* becomes *gigantic*, the *wonderful* swells into the *sublime*.'[73] Haydon on this occasion agreed and wrote on 22 May 1828: 'There's really nothing like Martin's picture in the world. If he got Nature for his small figures his work would be complete, but he does his figures as well as his architecture from Idea.'[74] This time Martin was prepared to admit to having enlarged

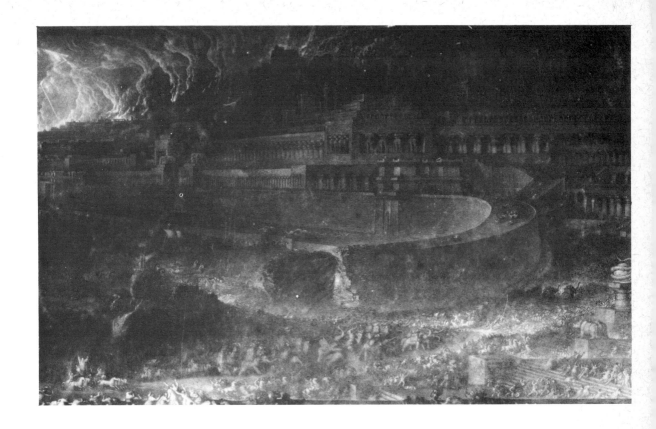

71. The Fall of
Nineveh, 1829
(detail). Mezzotint.

somewhat upon verified antiquity: 'The mighty cities of Nineveh and Babylon have long since passed away. The accounts of their greatness and splendour may have been exaggerated. But where strict truth is not essential, the mind is content to find delight in the contemplation of the grand and the marvellous.'

Whereas Delacroix's *Death of Sardanapalus* of 1829 concentrated on the lavish array of royal possessions heaped around an elephantine day-bed and was essentially a matter of painterly concern, Martin's broad view of the entire capital in disarray was altogether more comprehensive, a reunion of all the most successful ingredients of his previous successes. It is undoubtedly the most congested of Martin's epic history paintings. His evident need to outbid himself from one extravaganza to the next meant that eventually, inevitably, his machinery would break down. *The Fall of Nineveh* is remarkable rather than sublime, gigantic rather than great. Seen through the mist of ages and the obscurity of a photograph the whole composition appears swollen, distended, and, for all the activity, essentially vacuous.

The painting was intended, as Dr. Waagen suggested, to 'unite, in a high degree, the three qualities which the English require, above all, in a work of art, effect, a fanciful invention, inclining to melancholy, and topographic historical truth'.[75] And, as passing proof of the quite exceptional status he now enjoyed as

101

72. Portrait of John Martin, from *Public Characters*, 1828.

an artist, Martin was the only painter, besides Lawrence, to be included in *Public Characters of the Present Age* (Pl. 72); the article summarizes *The Fall of Nineveh* well enough: 'Everything springs out of the main operation and advances the dreadful catastrophe. A story on canvas was never better told.'[76]

Edwin Atherstone, meanwhile, wrote both a poem in thirty books on the subject and an article which appeared in the *Edinburgh Review*. Though criticizing some of his weaknesses—his defective sense of flesh-colour and his occasional 'almost feeble neatness'—Atherstone praised Martin at length for 'his power of depicting the Vast, the Magnificent, the Terrible, the Brilliant, the Obscure, the Supernatural and, sometimes, the Beautiful. No painter has ever, like Martin, represented the immensity of space; none like him made architecture so sublime, merely through its vastness.' Atherstone then defined the essential quality of all Martin's epics: a power of expression 'by which every part of a picture is made, as it were, in one grand harmony to sound the chord of that emotion which is to it as the soul by which it lives; it is the convergence of every ray towards the one burning point; the bowing-down of every subject-part before the throne of the one ruling sentiment.'[77] A good example of this is *The Destruction of Pharaoh's Host* (Pl. 64)[78] where the waters of the Red Sea have just closed over the Egyptian army and Moses gazes impassively as a few limbs and chariot wheels surface momentarily. The themes of both *The Deluge* and *The Fall of Nineveh* are here combined into the ruling sentiment of *The Last Man*.

102

In 1830, Martin succeeded in obtaining an invitation to send *The Fall of Nineveh* to Buckingham Palace for inspection by William IV, who took one glance and said 'How pretty.'[79] Moreover, in addition to the two and a half thousand notables who came to the Private View, the painting was seen by Joseph Bonaparte, who presented Martin with a pair of ormolu and steel candlesticks (rumoured to have been designed by Cellini and to have belonged to Napoleon) and asked him to dinner. In 1839 Louis Napoleon visited Martin's studio, examined *Nineveh*, and expressed the hope that one day he would be in a position to grant him the Légion d'honneur. Leopold, King of the Belgians from 1830, invited Martin to send the painting to the Brussels *Salon* of 1833 and gave him a gold medal, a bust of himself, and a knighthood of the Order of Leopold. *The Fall of Nineveh* retained its appeal among royalty, as it was last heard of in the Farouk collection in a royal palace in Cairo.

Meanwhile Martin consolidated his work by the issue of prints. *Belshazzar's Feast*, *Joshua*, and *The Deluge* were all published before 1829, and he planned to make mezzotints of every major work, including *Sadak*, before others could take advantage of him and exhaust his market. He wrote to William Manning in December 1827 asking permission to engrave the *Sadak* he had bought as a large mezzotint.[80] Another version of it, owned by R. J. Lane, was reproduced in the *Keepsake* for 1828. For some years parlour-table gift books were to provide Martin with a steady income. Henry Le Keux's engraving of *Marcus Curtius*, which appeared in the *Forget me not* for 1829, sold over 10,000 copies; Le Keux also engraved *The Crucifixion* in the *Amulet* for 1830 and a *Repentance of Nineveh* in the *Keepsake* for 1832. According to Leopold Martin's not altogether reliable account, these prints were especially popular in China.[81] It hardly mattered if Martin's paintings failed to sell so long as the print version was a success. *The Fall of Nineveh*, priced at 2,000 guineas, lingered for years in Martin's studio like some abandoned blueprint or prototype; indeed, later paintings, notably *The Last Judgment* trilogy, were initially intended to serve only as designs for engravings.

Martin took some trouble to distribute proof impressions in the right quarters. He dedicated most of his prints to kings, dukes, or other appropriate potential patrons, and in return received appreciative letters and presents. Nicholas I gave him a gold medal and diamond ring, probably following his dedication of the *Deluge* print in 1828. In 1835, in acknowledgement of Martin's gift of six prints, Louis-Philippe offered him some Sèvres porcelain. The trinkets and correspondence were put on show or filed away in the labelled drawers of a specially built black cabinet, which stood, a suitably imposing presence, in the studio where he received visitors, earned his commissions for new or replica paintings, and promoted his finished, unsold works (Pl. 73). The cabinet recorded his honours and achievements and indicated, with some exaggeration, the social standing Martin had attained. But he had to struggle to maintain his

73. Side view of
John Martin's
cabinet.

high reputation. He was obliged to emphasize constantly that he was the great
original and that the public should beware imitators, however well-intentioned
and even flattering their emulation, because by 1831, at the height of his fame, he
was also, naturally, plagiarized. 'Mr. Martin will have much to answer for at the
bar of Taste, if he shall ever be called to account for having led so many astray
by the magical effect of his imagining!'[82]

Surprisingly perhaps, Martin had only two known pupils to be so influenced.
One, William Geller of Bradford, is chiefly remembered for having been admired
by Branwell Brontë because of his connection with Martin, who, as Edward de
Lisle of Verdopolis, the painter of Babylon, had served alongside Byron, the
Duke of Wellington, Bonaparte, and a box of toy soldiers as a leading figure in
Brontë juvenilia.[83] The other was John St. John Long from Limerick who,
suspecting that Martin stencilled his figures, approached him around 1823 and
became his pupil, hoping to hit upon the 'secret' of his painting. He made little
mark as an artist beyond painting a few landscapes and an *Allegorical Scene in
Ireland* which was shown at the Society of British Artists in 1825. So, like de
Loutherbourg, he turned to medicine, setting himself up in Harley Street as a
society cure-all with a treatment involving corrosive liniments and friction rubs.

This led to a denouncement by the *Lancet*, several caricatures, and a man-slaughter charge in 1830. Fined £250, Long was driven away from court in Lord Sligo's curricle, unabashed and ready to counter-attack the *Lancet* with 'A critical Exposure of the Ignorance and Malpractise of certain Medical Practitioners'.

Though Long failed to learn it, Martin's 'secret' was thoroughly explored and exploited by others. Besides the Brontë translation of Martin's architecture into 'Glass Town', many fashion-conscious provincial painters tried their hand at historic landscapes with Martin rather than Turner supplying phantasmagoric skies and ready-made vistas. John Rawson Walker of Nottingham (1796–1873) showed a *Feast of Eleusis* at the Academy in 1817, *The World before the Flood* in 1826, *Sodom and Gomorrah*, and a *Mount of Paradise*[84] in 1829, and a *Garden of Eden* in 1839. James Ewbank (1799–1847), who spent most of his working life in Edinburgh, painted *The Entrance of Alexander the Great into Babylon* in 1825, an untraced but unmistakable Martin which he failed to sell. 'The scene' he wrote, 'is witnessed from one of the wings of the Queen's imperial palace, just after Alexander has crossed the bridge over the Euphrates. On that part of the palace, in the foreground, is one of the royal baths, and near to it the astrologers foretelling the downfall of Alexander, and the Queen welcoming him into the city.'[85] Henry Dawson (1811–78) was inspired to turn from figure-study to landscape by the engravings of *Belshazzar's Feast*, *Nineveh*, and *The Deluge*. 'For a time', he said, 'I could think and talk of nothing else.'[86] *Pilgrims in Sight of the Celestial*

74. Henry Dawson: Pilgrims in Sight of the Celestial City, 1854. Oil on canvas, 30″ × 42″, signed.

105

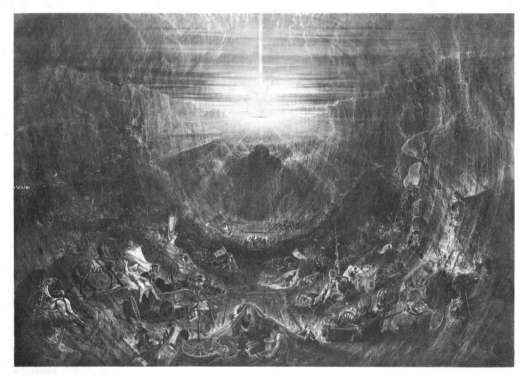

75. Samuel
Colman: The
Delivery of
Israel out of
Egypt, *c.* 1830
Oil on canvas,
53¾″ × 78¾″.

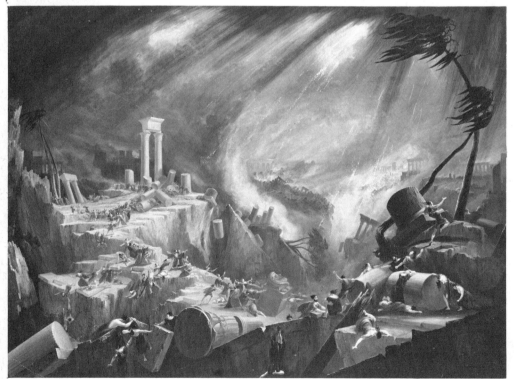

76. George
Miller: The E[
of the World,
1830. Oil on
canvas, 35″ ×
49½″, signed.

106

City (Pl. 74) is the best surviving example of Dawson's work in the Martin idiom. Although his later painting tended to be concerned with Highland cattle, he died with the print of *The Deluge* hanging, at his request, beside his bed. K. W. Brown of York who made a portrait of Jonathan Martin in prison[87] also, with equal opportunism, exhibited *A Conception of the Opening of the Sixth Seal* in York in March 1829 to coincide with the Martin trial.

Martin's influence was probably at its height in the early 1830s when David Roberts painted a huge *Departure of the Israelites from Egypt* (1832) and repeatedly plagiarized Martin. Samuel Colman's *Delivery of Israel out of Egypt* (Pl. 75) placed Moses at the calm centre of a great concentric funnel of flood and bodies. George Miller's *End of the World* (Pl. 76) was a combination of *The Deluge* and Danby's *Opening of the Sixth Seal*. However, his most important follower at this time was Thomas Cole (1801–48) who emigrated from Lancashire to America in 1819, to become one of the founding fathers of American painting. He had already painted an *Expulsion*, a rather congested amalgamation of two of Martin's *Paradise Lost* prints, before visiting Europe in 1829.[88] After lodging for a while in Claude's studio in Rome, he came to London and spent several evenings with Martin on C. R. Leslie's introduction. Soon afterwards

77. Thomas Cole: The Course of Empire (Consummation), 1836. Oil on canvas, 51″ × 76″, signed.

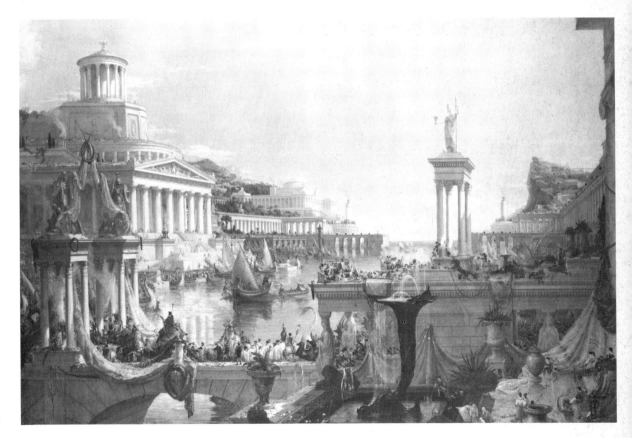

107

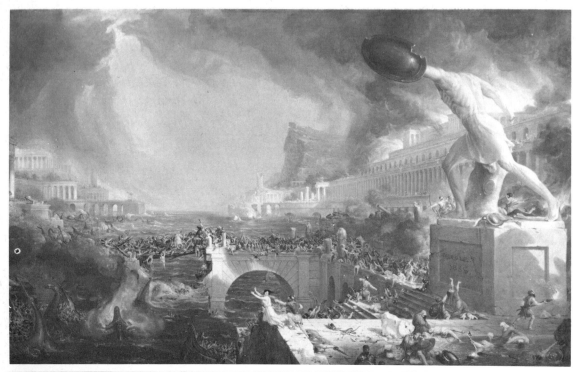

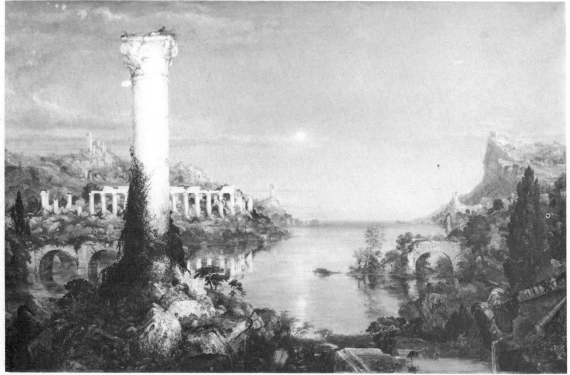

he planned *The Course of Empire* (Pls. 77–9),[89] a cycle of paintings showing a valley at four stages in history as it passed through *The Savage State, Consummation*—a marble hall panorama like some banker's daydream—and *Destruction* to *Dissolution*, where the buildings have crumbled and fallen, swept under nature's carpeting foliage. Though the architectural scheme as a whole derived from Schinkel, the overseer of the enlargement of Berlin to imperial proportions, and the series resembles in outline James Barry's Society of Arts murals on *The Culture and Progress of Human Knowledge*, the treatment—the arcadian pink-and-green formula of the first painting, the jutting rock of ages that survives civilization and broods upon the final moonlit desolation, and in particular the scene of horrendous dissolution—is heavily dependent on Martin's scheme of things.

Cole later produced a Gothic *Departure* and *Return*, and, in 1840, *The Architect's Vision* (Pl. 80), which showed an architect reclining on a pedestal surrounded by neo-classical façades, architectural canyons rising and stretching beyond anything the most megalomaniac town-planner could imagine. Though comparable to the more fanciful designs of Schinkel or Gandy, the painting amounts to a vastly amplified projection of the plans that Martin must have described to Cole during their meetings six years before.

In 1839 Cole began his most ambitious series, *The Voyage of Life*, which included *Youth*[90] and *Manhood*;[91] finally, in 1847, he painted *The Cross of the*

78. Thomas Cole: The Course of Empire (Destruction), 1836. Oil on canvas, $39\frac{1}{4}'' \times 61''$, signed (see opposite; top).

79. Thomas Cole: The Course of Empire (Desolation), 1836. Oil on canvas, $39\frac{1}{4}'' \times 61''$, signed (see opposite; bottom).

80. Thomas Cole: The Architect's Vision, 1840. Oil on canvas, $54'' \times 84''$, signed.

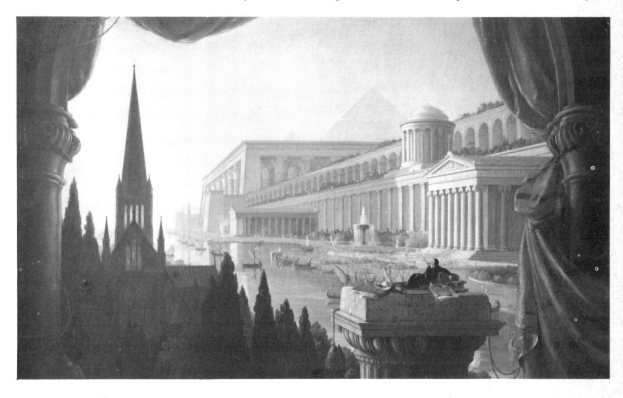

World,[92] a vast allegory in which an entire countryside is set about with meaningful details: buttressing rocks, cockle-shell boats, and a guiding angel. In general terms Cole's landscapes were undoubtedly Claudian. His symbolic content was Germanic and pervaded every detail in an obvious way, as though the works of Friedrich had been specially adapted for Sunday School use. But Cole's epic sense, indeed his whole popular appeal, was virtually the same as Martin's. Half a million people, it was estimated, went to see his paintings when they were taken on tour in the United States. Print versions, engraved by James Smillie, sold by the thousand and became regular front-parlour fittings. Like Martin, Cole found that, despite their success as prints, it was difficult to find buyers for his allegorical or historical landscapes. He made his living from the sale of panoramic views of the Catskills and the Hudson River.

Cole and his followers, Frederick Church in particular, came to represent the New World, from the Appalachians to the Rockies, as a limitless wonderland—Martin's Eden, shipped across the Atlantic[93] to become part of the cult of the great outdoors.

So, in a sense, while Martin devoted his middle age to prints and proposals, and interrupted his sequence of major paintings, Cole redeveloped his themes in *The Course of Empire*, *The Architect's Dream*, and *The Voyage of Life*. Martin, rather than Turner, Claude, or Friedrich, supplied the main precedent for what was to become a pervasive American tradition.

Between 1827 and 1834 Martin provided many illustrations for *Keepsakes*, *Amulets*, *Gems* (Pls. 81 and 82) and *Literary Souvenirs*. On this tiny scale he was most easily imitated. H. C. Selous, who was later successful in the competition for the redecoration of the new Houses of Parliament, designed a *Destruction of*

81. The Crucifixion, 1830. Engraving by Henry Le Keux after John Martin, from *The Amulet*, $2\frac{7}{8}'' \times 4\frac{3}{4}''$.

110

82. Ruins of
Trionto, 1830.
Engraving by
W. R. Smith after
John Martin, from
The Gem, $3\frac{1}{8}'' \times 4\frac{1}{4}''$.

Babel (Pl. 83) for the *Literary Souvenir* of 1831, staged, flatteringly perhaps, in Martin's Babylon. However, Martin turned the other cheek with a vengeance by incorporating the best part of the Selous design into his own illustration of Babel three years later.[94] J. G. S. Lucas both copied and imitated Martin's work, starting in 1831 with two 10 × 12 in. mezzotints: *The Destruction of the Cities of the Plain*, clumsily skewered by lightning, and *Sampson taking away the Gates of Gaza*, which showed Sampson trotting across a mountainside, the gates across

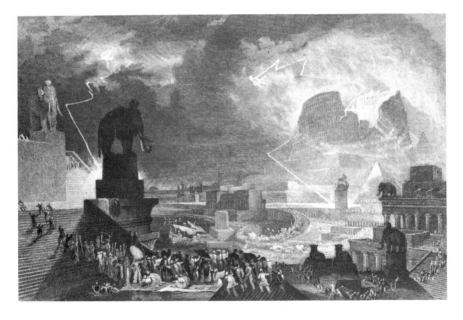

83. The Destruction
of Babel, 1831.
Steel engraving
by H. C. Selous, from
the *Literary Souvenir*,
$3'' \times 4\frac{5}{8}''$.

his back, as though taking part in a mountain rescue contest. Arnold's *Library of the Fine Arts* commented: 'Of his school, however, this is not an unfavourable specimen; and Mr Lucas, by being the engraver of his own design, has followed the example of his "great original", which we could wish to see done more generally.'[95] Another slightly hysterical mezzotint, *The Last Day of Pompeii*,[96] dedicated to Bulwer-Lytton, was printed in Paris, along with versions of Martin's *Earthly Paradise*, *Passage of the Red Sea*, and *Crucifixion*.

There can be no doubt that the copies and imitations of his work, which included at this time Hippolyte Sebron's *Belshazzar's Feast* diorama at the Queen's Bazaar in Oxford Street and versions of his work marketed as peep-shows, broadsheets, and children's book illustrations (Pl. 84),[97] taken from emphatically etched plates increasingly clogged with ink, all served to coarsen his reputation.

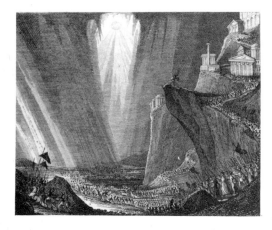

84. Joshua Commanding the Sun to Stand Still, *c.* 1827. Anonymous etching, from *Stories from the Scriptures* by the Revd. J. Bourne Hall Draper, 2⅝″ × 2⅛″.

It is arguable that Martin's work had to be imitated if it was to pass into artistic currency and establish him firmly in the eyes of his contemporaries. His compositions were abrupt and direct enough to be virtually indestructible, no matter what liberties were taken with them. However, in the long run his prints were devalued and the sheer excess and incoherence of his imitators hastened the reaction against him. During the 1830s in any case tastes in art began to veer away from the epic and heroic veins. Cotman advised his sons, in 1834, to discontinue historical landscape and turn to the painting of domestic figures;[98] and so to shift their attitudes towards the backyard and inglenook genre of the more homely Dutch; to emulate de Hooch, for instance, rather than Rubens or Titian, Danby, Turner, or Martin. Even Haydon made essays in the new fashions with subjects that ranged from the genre of *Chairing the Member* or *Waiting for the Times* to *The First Child of a Young Couple—very like Papa about the Nose and Mama about the Eyes*—subjects specially contrived to suit the soft eyes and heart of Dora Copperfield.

Martin remarked to the Select Committee on the Arts in 1836 that, though he

could 'rarely hazard painting a large picture; when I do so I am obliged to exhibit in foreign countries or on my own account'. He was dependent, in other words, on the long-standing patronage of Prince Leopold and on the advance reputation his prints had secured him. Predictably, his fame rested on those compositions that were most copied. The Lucas prints were published in Paris in 1835 to meet a demand; French writers frequently referred to him: evidence in itself that the Martin idiom was already well known to the writers' audience and that he was regarded as the originator of a peculiarly thrilling missionary mode that could be adapted by all and sundry. Thus Hugo's *Le Feu du Ciel* (1829) demonstrates the Miltonic–Byronic imagery of *Paradise Lost* and *Heaven and Earth*, which Martin had translated into mezzotint, reconstituted as verse:

> La nuée éclate!
> La flamme écarlate
> Déchire ses flancs,
> L'ouvre comme un gouffre,
> Tombe en flots de soufre
> Aux palais croulants,
> Et jette, tremblante,
> Sa lueur sanglante
> Sur leurs frontons blancs![99]

On such grounds Gustave Planche could describe Martin as 'the painter of poets, the poet of painters'; however, on seeing *The Deluge* at the 1834 *Salon*, he added disparagingly, 'He's neither a painter nor a poet.'[100] Martin's influence on Victor Hugo waned after 1830, though his image of the Tower of Babel looming over Belshazzar's palace survived in Hugo's use of the tower as a symbol of urban civilization and the human condition.[101]

Martin, meanwhile, took to direct intervention. 'His constant idea seemed to be that he had mistaken his vocation,' Leopold Martin recalled. '"Oh! my boy," he had lamented, "if I had only been an engineer! Hundreds with me would then have been thousands. Instead of benefiting myself and a few only, I should have added to the comfort, prosperity and health of mankind in general."'[102]

CHAPTER VI

Plans and Inventions

MARTIN'S FIRST plan was published in 1827, and from then on his schemes occupied, he later reckoned, about two-thirds of his time and the greater part of his income.[1] It was not altogether extraordinary for Martin to concern himself so deeply in invention and planning, for his whole career up to that point had been a struggle to master one profession after another: painting, print-making, and publishing. He had always been involved in inventive scheming, and had sketched on request engines, mine ventilation systems, and spring balances for William, his eldest brother. He was well aware that a bright idea (such as William's design for a spring weighing-machine) could be conceived, registered with the Society of Arts, and, given good luck, rewarded with medals, congratulations, and fame.

In the 1820s invention was still very much an amateur and even haphazard activity, conducted in terms of happy accidents and improvization rather than concentrated programmes of research, although the lists of 'discoveries and improvements' in the *Repertory of Arts and Manufactures*[2] show a marked quickening of pace around this time, as specialized expertise was developed to exploit the possibilities afforded by steam power and civil engineering. The inventors of the age seemed to share Count Frankenstein's ambition to reproduce life by mechanical means, to contrive working manikins and such forebears of the computer as the automaton chess player or Babbage's Calculating Machine, which by 1839, after fifteen years' development, could cube eighteen 'in thirteen seconds by merely *grinding*, or rather by moving a handle backwards and forwards twice'.[3] Their goal, pursued with somewhat satanic spirit, was to contrive machinery with which to harness and overpower the forces of nature. Mechanical devices, from an improved patent bootjack to apocalyptic smelters were conceived, promoted, and marvelled over to such a degree that Carlyle reckoned:

Were we required to characterise this age of ours by any single epithet, we should be tempted to call it, not an Heroical, Devotional, Philosophical or Moral Age, but, above all others, the Mechanical Age. It is the Age of Machinery, in every outward and inward sense of that word. . . . Nothing is now done directly, or by hand; all is by rule and calculated contrivance.[4]

A child of his age, Martin too was sometimes suspected of working with stencils by some 'secret method',[5] a latter-day development perhaps from Matthew Boulton's mechanical pictures machine or the lathes James Watt had designed to reproduce sculptures.

'We are going on very well in England in a political sense,' Thomas Donaldson wrote in 1824, 'and so rich that the great Capitalists know not how to employ their money—Project after Project, Bubble after Bubble rises, has its day and then sinks to Nothing.'[6] Nash, 'a Londoner first, a contriver second, and artist third',[7] dominated the architectural redevelopment of London; while the railway kings, the empire-builders of civil engineering, the Brunels and the Stephensons in particular, supplied their society with new, profitable, altogether marvellous perspectives. Engineers emerged as the most startling and inventive artists of the age: in a sense Martin's greatest rivals. In this climate it is not surprising that Martin considered he had mistaken his vocation, possibly seeing himself as another Robert Fulton, panorama-painter turned inventor, as a Papworth or, ideally, a Michelangelo, architect as well as painter, sculptor, and poet. He could aim to be a new Renaissance man, a Leonardo: an intervening and guiding figure sprung to life from one of his own canvases.

London meanwhile remained far from ideal. The refuse tips and shanty towns on its fringes, the slums in its heart were a startling contrast to the streets and terraces, gas-lit, drained and paved in Babylonic manner, which served as social and architectural corridors from Regent's Park to St. James's, from one glamorous part of the Metropolis to the other. Further roads, from Kensington to Bloomsbury, for instance, were planned. Trafalgar Square was opened out and the National Gallery built between 1832 and 1838 on the site of the old Royal Mews. Carlton House was demolished in 1827 to make way for the grandstand of Nash's Carlton House Terrace overlooking the freshly landscaped St. James's Park. In 1825 Augustus Pugin designed London's first Necropolis (later Kensal Green and Brompton cemeteries) where death was laid out of sight beneath mausoleums, urns, and weeping marble waits in assorted Greek, Egyptian, and Roman styles.[8] But the living, rather than the dead, had to be housed and given basic amenities of open spaces, a supply of pure water, and safe disposal of human wastes.[9] New drains for floodwater and sewage were needed as the Great Wen threatened to spread beyond control, obliterating farms, small holdings, and orchards.

Before he took to publishing his plans, Martin's great and indisputable contribution to his age had been his reconstructions of ancient capitals, authenticated with quotations from suitable authorities and with statistical footnotes. More even than Sir William Gell and Joseph Gandy he had made Pompeii live. He had inspired a whole generation of admirers, from Victor Hugo to the children in Haworth parsonage, with the cloud palaces of his Babylon,[10] and had even anticipated, with some success, the findings of A. H. Layard at Nineveh.[11] Since science was still virtually free of any stifling or impenetrable safety curtain of

professional qualification and since all art ranked as philosophy or as invention, the Society of Arts could award prizes for achievements in painting, engineering, sculpture, or natural philosophy without invidious distinctions. Painters such as Martin could serve as architects of ideas, as artiste-performers, as philanthropic-reformers, as preachers, as entertainers. Just as Dickens, the parliamentary reporter turned novelist, became in middle age a social critic, mountebank-actor, and concert-hall performer, so Martin, having consolidated his painting achievements, thereupon widened his interests. For over twenty years, as the dated labels on his cabinet demonstrate, this self-imposed public service became an obsessive concern.

With the campaign for parliamentary reform, the years around 1830 appeared a turning-point in the political affairs of the new Babylon. Convulsive social changes were feared by the land-owning classes and eagerly awaited by radicals —among them Martin, who 'took violently to politics' at this time, claiming in an argument with William Godwin: 'We have had march of intellect, progress of education, intellectual development, throwing off of prejudices, and now the Nation, the People, thinks.'[12]

As Nash's plans and rebuilding moved to completion, the first cholera epidemic broke out in London, a latter-day Tenth Plague spreading through the rookeries behind dazzling white stucco façades, threatening panic and breakdown irrespective of class or person:

> For the Angel of Death spread his wings on the Blast
> And breathed in the face of the foe as he passed.[13]

In 1830 George IV, the Belshazzar of his time, passed away:

> The mould of Form
> And glass of Fashion
> Food but for the worm.[14]

William IV's altogether more austere reign was launched with a cut-price coronation. Manners were changing. The extravagant romanticism of Martin and Turner had already become something of a survival; mighty phantasmagoric pictures and matching poetry and prose drifted out of fashion, closed down for the duration like Brunel's Babylonic Thames-tunnel project, that 'most magnificent undertaking and the pride of the Empire',[15] as one shareholder described it, which, celebrated with a banquet in the underground workings in 1827, sprung devastating leaks soon after and was thereupon abandoned for seven years.

Two steel engravings from designs by Martin were included in Southey's edition of *The Pilgrim's Progress* published in 1830. In the first, Christian stands, lone and forlorn, in the flooded caverns of the Valley of the Shadow of Death (Pl. 85). The second shows him within reach of Heaven, posed beside Hopeful in a heavenly Hyde Park, gazing over the waters of the Serpentine towards the

85. The Valley of
the Shadow of
Death, 1830. Steel
engraving by W. R.
Smith after John
Martin, from *The
Pilgrim's Progress*,
$4'' \times 5''$.

gleaming walls of the Celestial City. These illustrations reflected Martin's plans which, in their turn, amounted to a complete scenario for which his earlier topographic and history painting had served as prophetic, isometric projections. When he came to design his embankments and sewers, the ghostly outlines of his view of ancient civilizations were superimposed upon them (Pl. 90). In . *Perspective View* submitted to a Select Committee on Metropolis Improvements (1838) he showed Egyptian barges tying up at his Thames Street below a bridge inscribed in honour of Nelson and the Battle of the Nile (Pl. 92). He preferred the Cleopatran imagery to the actual paddle steamers already plying the river.

Martin's eccentric eldest brother William clearly had some influence on his plans and inventions. He too published a stream of pamphlets in which he recorded in a frenzied, exclamatory style his flashes of inspiration: the plans for his safety lamp (Pl. 86), which he described as 'a noble and safe one' compared to Humphry Davy's 'infernal Machine of Destruction'; a self-righting life-preserving suit with a hook on the leather helmet to help haul the unfortunate from the water into a flat-bottomed Martin lifeboat; and schemes to set the poor to work, to put alarm bells in railway carriages, and to streamline railway engines.[16]

The pamphlets appeared under headlines, laid out in such a way as to appear to be typographical diagrams of typical Martin compositions (Pl. 87). Some,

86. Sketchbook,
page 14, Study of
Safety Lamp
invented by William
Martin, c. 1818.

for instance his *Important suggestions respecting the Whale Fishery, the War with China, the proposed Bridge across the Tyne and other subjects: by the Christian Philosopher* were obviously the product of an imagination run amuck, others contained original and indeed feasible ideas. William Martin's main strength lay in his zeal, his complete disregard for received opinions. John clearly respected him for such inventions as the safety lamp and for his mine ventilation system, and attempted to promote them alongside his own schemes.[17] He took his brother more than half seriously and discussed his ideas and projects with him. In any case, despite his influential social contacts and his ability to write in standard English rather than Tyneside dialect, John had little more success in getting his ideas accepted than had William, who wandered around Newcastle for years selling his pamphlets, in a tortoiseshell cap and with the silver medal from the Society of Arts dangling on his chest, before moving to London in 1849 to live off John's charity for the brief remainder of his life. Each proved in the long run to be the other's most loyal supporter and critic. 'Indeed I would snub my brother John, if I was sensible he was wrong,' William Martin wrote in 1839, adding later: 'My brother is obliged to make use of the talent that is given him the same as myself, as we are sent on earth to enlighten the world and those talents are not to be hid under a bushel.'[18]

118 Martin apparently withdrew his first *Plan for supplying the Cities of London*

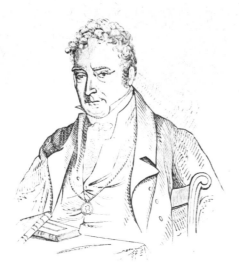

THE

THUNDER STORM

OF

DREADFUL FORKED LIGHTNING :

GOD'S JUDGMENT

AGAINST ALL FALSE TEACHERS,

THAT CAUSE THE PEOPLE TO ERR, AND THOSE THAT ARE LED BY
THEM ARE DESTROYED, ACCORDING TO GOD'S WORD.

INCLUDING

AN ACCOUNT OF

The Railway Phenomenon,

THE WONDER OF THE WORLD!

BY WILLIAM MARTIN,

THE CHRISTIAN PHILOSOPHER,

Who will clearly prove that all Colleges throughout the civilized
World are ignorant of natural Causes; and will also prove to the
British Government, and King William upon his Throne, that
all our grand Masters basely teach Lies instead of God's divine
Truth. And if the Philosopher cannot prove it by this small
Publication, he will suffer the British Government to burn him
at the Stake, the same as Bishops Ridley and Latimer, and other
Christian Martyrs that are recorded in History.

Newcastle upon Tyne:
PRINTED BY PATTISON AND ROSS, 48, PILGRIM STREET.

1837.

WILLIAM MARTIN,
CHRISTIAN PHILOSOPHER.

THE SPIRITUAL
THUNDER-STORM
OF DIVINE TRUTH
UPON
INFIDELS AND MOCK CHRISTIANS,
WHOSE CONDUCT IS AN INSULT UPON THEIR MAKER;
SHEWING THAT THE PLAY-HOUSE IS MORE ESTEEMED THAN
GOD'S DIVINE PLACE OF WORSHIP.

and Westminster with Pure Water from the River Colne (1827) and quickly substituted a similar scheme, drawing water from higher up the Colne, at Denham instead of Cowley. He reissued his pamphlets over the years in much the same way as he produced replicas and revisions of his more important paintings. The general principles of water supply, regularized river flow, the building of docks and embankments, and sewage disposal remained constant; but he modified details to suit circumstances and, whenever possible, steal a march on his critics. Indeed, he so switched and altered his proposals, dodging round each rejection, that it became evident that it was the basic themes and ideals he had in mind, rather than the actual implementation of the plans, that caused most offence among his opponents. Whereas Martin had been harmlessly employed envisaging great palaces and embankments by the waters of Babylon as art essentially for art's sake, contemporary London contained far too many vested interests, notably among the quarrelsome private water companies and wharf owners, for his demands for widescale improvements to be acceptable, quite apart from their practicability.

87. Pamphlets: *The Spiritual Thunderstorm of Divine Truth* and *The Thunder Storm of Dreadful Forked Lightning*, 1837, by William Martin.

119

Martin's approach was, he readily admitted, aesthetically motivated. He 'chiefly aimed at the public good by super-adding beauty to utility'.[19] Chancing upon 'a pleasant valley between Hanger Hill and Harrow', he had considered it so beautiful that he 'thought it only needed a river to make it complete'. Thus his Pure Water Supply plan[20] stemmed, in part at least, from the desire to improve those stretches of the Home Counties where he used to go sketching and to bring this idealized countryside to town.

The pure water was to be channelled from Denham by tunnel, aqueduct, and canal into a reservoir at Bayswater where the bulk would be stored to supply west London. Martin considered it 'indeed a scandal upon the greatest metropolis in the world that the only place near it in which the public can bathe is an open drain to a populous district, the filtering bed of which when disturbed by even a single bather, causes the most unwholesome and disgusting effluvia imaginable'[20] To eliminate this health hazard he proposed feeding the overflow from the reservoir into a series of pools large enough for a thousand people to bathe in. The water would thereupon pass through the Serpentine, under Hyde Park Corner, through a 'natural cavern' in Buckingham Palace Gardens to Green Park, St. James's Park, and into the Thames. At intervals it would leap into fountains or tumble in waterfalls. The resulting landscape would have resembled the setting he had contrived for *Alexander and Diogenes* (Pl. 88): a green belt in the heart of

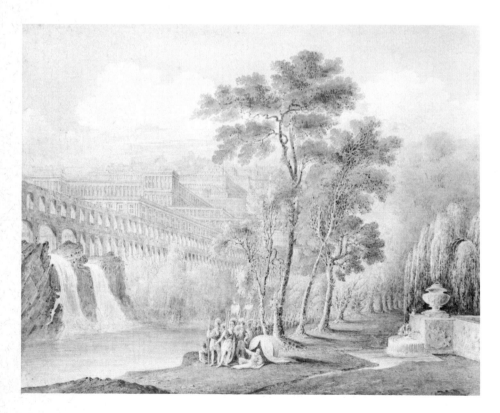

88. Alexander and Diogenes, *c*. 1826. Water-colour, $9\frac{7}{8}''$ \times $12\frac{3}{8}''$. This water-colour is related to the engraving made by E. Finden for the *Literary Souvenir* in 1827.

a city, the sort of place in fact that he represented in a water-colour of *Athens*[21] made about this time, an arcadian retreat where philosophers ponder.

Martin included outline etchings and lithographs with the pamphlet, showing vantage points along his watercourse: a tamed upper Tyne valley, a sort of Paradise, *Peaceable Kingdom*,[22] or *Island of Calypso*[23] planted with specially imported rocks and weeping willows (Pl. 89). In picturesque terms Martin's scheme was a clear improvement on anything previously suggested. William Matthews (a mouthpiece of the opinions of the private water companies) suggested the scheme would fail because there was not enough water in the Colne to sustain the various uses to which Martin intended it to be put.[24] Martin denied this; for he had measured the water flow with an American 'current-meter'.[25] His plan was reinforced with diagrams of sluices, locks, and filters: everything was to be under control. A haphazard assortment of royal parks, public spaces, and polluted ponds was to be made orderly and productive, to be cultivated as an arterial landscape.[26]

There, for a time, he left the water-supply problem and turned to the issues of pollution and flood control. The artist who, in Dr. Waagen's words, had 'undertaken to place before our eyes the fates and the destruction of entire nations'[27]

89. Imaginary scene of ornamental water in the grounds of Buckingham Palace. Etching, $4\frac{1}{4}'' \times 6\frac{1}{4}''$, page 15 of *Mr Martin's Plan for Supplying with Pure Water the Cities of London and Westminster and of Materially Improving and Beautifying the Western Parts of the Metropolis*, second edition 1828.

saw the Thames running foul as the Nile had once flowed red, warning the Egyptians of plagues to come.

Around 1830 the Thames could still rank as London's main highway, not yet challenged by the railways and their approach roads. Some of the buildings facing the river, each with its steps down to the high-water mark, were impressive. William Chambers's Somerset House, completed in 1831 with the addition of Sir Robert Smirke's King's College, was built on waterfront arcades, while the Adams' Adelphi, planned as the start of a long line of embankments, was mounted on huge arched vaults, sheltering 'a little subterranean city'[28] where cows were stabled and coals hauled. But, apart from the new bridges and the promising commercial prospects of Telford and Hardwick's St. Katharine's Docks (opened in 1828), London was, in effect, turning its back on the river at the time Martin started to concern himself with it. Nash's plans were designed for the most part to contrive a new spacious heart for the metropolis; the river front would be abandoned, leaving it a mess of soap factories, gas-works, distilleries, and private wharves lining wide muddy reaches, up and down which the tides slopped twice daily. He had, indeed, hoped to open up the river front by 'making the whole of the London side of the Thames one continued terrace from London Bridge to Westminster Bridge'.[29] As Martin had learnt from Herodotus, the greatness of all the ancient capitals was founded on their rivers: the Tigris and Euphrates, tamed, dammed, and channelled, had nourished an entire civilization; the Nile brought fertility with each spring's flood; and as soon as they allowed their sewage to be washed downstream, the great civilizations had declined.[30] The Thames, key to London's greatness, could well bring about the city's downfall.

By means of one compendious enterprise Martin believed it possible to transform London; he proposed to take advantage of historical perspective and transpose his architectural fantasies into river frontages as elegant and spacious as those of ancient Babylon or Carthage, and to add, for good measure, a regulated pure water supply, special built-in sewers, and streets and walkways stretching from Millbank to the Tower.

Martin readily admitted, that his idea of a Thames embankment was not altogether original. Following the great fire of London in 1666, Sir Christopher Wren had proposed 'a commodious Quay on the whole bank of the river from Blackfriars to the Tower', and among the many plans for the new London Bridge Telford's design had involved immense approach roads along the river bank and George Dance had suggested imposing flights of steps and piazzas. Nash's idea for a new river frontage was taken up in 1825 by Colonel F. W. Trench, a dedicated committee-man and planner, who had already suggested using Buckingham Palace to house the British Museum, or as 'a laundry for officers on half-pay'.[31] The Thames Quay, however, was his most elaborate project; it was designed by Benjamin and Philip Wright with Sir John Rennie as

consultant engineer, backed by an impressive management committee which included the Dukes of Wellington and Devonshire and the Chancellor of the Exchequer, and published with descriptions and a panoramic folding view of the full length of the Quay.[32] The Quay was designed to stretch eastwards from Charing Cross, to improve navigation, and provide 'an airy healthful and beautiful Promenade for all classes of the community'.[33] Six acres of river-bed were to be reclaimed, and wet docks were to be set in the gaps between the embankment and the original shoreline. Sewage was to be discharged through pipes straight into the river, and beyond the Temple Gardens steps the embankment was to become a 20-foot-wide river-wall with warehousing above. Trench estimated the cost at precisely £638,491. A cheaper version, without fountains and decorative trimmings, would have cost only £408,000 and he reckoned it to be a potentially profit-making enterprise. It was rejected by Parliament owing to the efforts of Temple Benchers and those Strand shopkeepers who saw in it the ruin of their prospects and trade.

Martin's first embankment design, published in 1828 and broadly similar to the Trench plan, consisted of a quay running on columns beside the Thames, 'for converting the banks of the Thames into a continued useful range of Doric corridors with walks over them'.[34] But in 1829 he proposed a more elaborate structure which appeared, almost as an afterthought, in his *Outlines of Several New Inventions for Maritime and Inland Purposes*.[35]

By 1832 Martin had become determined to extend the embanked and tideless reach of water to below the Tower and thus create 'a beautiful calm sheet of water navigable at all times up to Teddington',[36] like the mirror surface of the far stretches of the Euphrates shown in the mezzotint of *The Fall of Babylon* published in 1831. Sewers would run parallel to the river, inside embankments built up to two feet above the highest tide-level, so as to prevent their being flooded by the river and, incidentally, to accommodate a transport system: 'Railroads should be used where it is possible for the use of agriculturalists as being eventually the cheapest mode of conveyance' (Pl. 90).[37] These would carry sewage, mixed with lime to reduce the smell, to the open fields. If a railway system was considered too daring he was prepared to allow the sewage to be moved by barge. Later he modified this part of the plan, observing that liquid sewage could be most conveniently fed through a network of pipes and sprayed over fields in Surrey.

Eventually, in 1834, he decided that the water supply should come from above Teddington lock and be pumped up Richmond Hill to a reservoir. This was to 'be made ornamental, and a fountain of water, about halfway down the hill, might be made highly picturesque by falling into a basin formed of rocks, and, by gushing out of the rocks might form many smaller falls'.[38] The height of the reservoir would ensure enough pressure to supply water, ducted across the Thames on a cast-iron bridge, to all parts of London, as far north as Regent's Park. Richmond Park, one of his favourite sketching places, would be beautified

into the bargain and would become a live version of the setting of his *Alpheus and Arethusa*.[39]

90. Explanator
plate from *A Pla
for Improving th
Air and Water c
the Metropolis b
John Martin, 183

This scheme was declared impracticable by a Select Committee on Metropolis Water in 1834. Undeterred, Martin went on to develop his embankment into 'a Magnificent Promenade', a gas-lit, walk-through realization of the river walls of Babylon, surpassing any effect the diorama builders could contrive. He even improved on Nash, in concept at any rate, by producing an environment, complete in every detail—above and below ground, designed for the good of all classes ('the Public would be admitted gratuitously on Sundays and at the smallest rate of charge on every other day of the week'), and capable, it appeared, of almost infinite adaptation and refinement.

The style of architecture best adapted to my Plan is either Tuscan or Doric; but the buildings on and near the public walks, should be suited to the locality: for instance, the Corinthian Order should be adopted to carry on and compose with Somerset House. The western side of Waterloo should be Tuscan, since that noble structure is of that order; and near the Houses of Parliament Gothic should be used so as to harmonize with them and Westminster Abbey. Thus there would be grandeur, simplicity, varied interest and complete harmony, without monotony. There should, likewise, be handsome landing places, with terraces and beautiful gardens, with fountains, where there are spaces fit for the purpose.[40]

Martin intended his embankments to overshadow such contemporary wonders as the aqueduct system designed to bring water from the Ourcq to Paris;

124

this had been authorized originally by Napoleon in 1802 and was nearing completion in 1828 when Martin produced his first water supply scheme. All the time he measured his plans against the marvels of the ancient world, as he had envisaged them: among them the hanging gardens in Belshazzar's palace, the walls of Jerusalem, the harbours of Carthage (Pl. 91) and Thebes, and the causeway built by Alexander the Great during the siege of Tyre: Martin included this feat of military engineering[41] among the *Illustrations of the Bible* of 1835 (immediately after the *Fall of Babylon*) on the grounds that Alexander's capture of Tyre and the subsequent crucifixion of 2,000 prisoners was the fulfilment of an Old Testament prophecy; he also made an oil version in 1840 (Pl. 128) in which the cliff-top town overlooks the causeway and port and the glassy heaving seas. However, the clearest example of Martin's simultaneous preoccupation with past and future remains the great river wall of Nineveh, the bastion of defence and survival (as wide as Martin's proposed embankment), the breaching of which had marked the end of civilization as Sardanapalus, at any rate, knew it.

91. Caius Marius mourning over the Ruins of Carthage, 1828. Water-colour, $4\frac{5}{8}''\times7\frac{3}{4}''$, signed. The design was used for the *Keepsake* in 1833.

> . . . It has been said
> For ages, 'That the city ne'er should yield
> To man, until the river grew its foe.'[42]

In March 1836 a large voluntary committee was set up at the Institute of

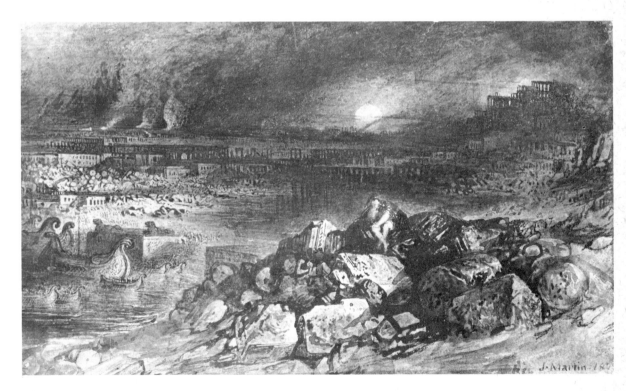

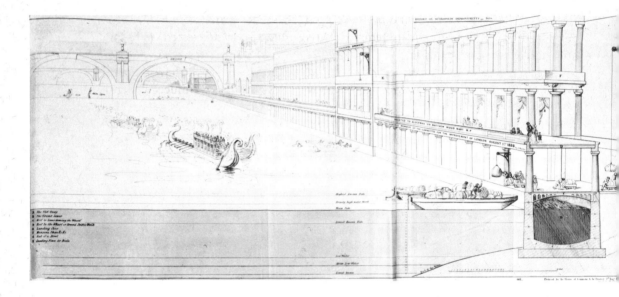

92. Perspecti
View and Elevatic
of Propose
Improvements
the River Thame
1838. Lithograp
16″ × 48″, fro
Report of Sele
Committee
Metropo
Improvemen
183

British Architects to inquire into Martin's plans and to compare them with other projects, including proposals for filtration put forward in 1829 and Colonel Trench's Thames Quay. After seven meetings spent in examining filtration projects and aqueduct designs, the committee (which was chaired by Lord Euston and included among its members Faraday, Wheatstone, Britton, Eastlake, Etty, and Turner) declared that 'it was given to the genius of Mr. Martin to devise the simplest, as well as the most completely effectual, plan'[43]—and one of the cheapest, since its estimated cost was less than £1,500,000 and there was potential profit in tolls, rents, and the resale of sewage; while that 'gallant officer' (Colonel Trench), 'declared Mr Martin's plan to comprise more than his own, to be greatly superior in usefulness to the public'[44] neither did it afford 'injury to the rights and interests of the water companies' (Pl. 92).

But despite this praise, Martin's scheme remained unfulfilled.[45] Seven years later he had to plead for a hearing from the Royal Commission on Metropolis Improvements established to decide on a suitable embankment. They heard him out, briefly, one afternoon and eventually reported: 'The claims were not considered equal to those of other plans.'[46] Thomas Page, the acting engineer of the Thames Tunnel, maintained that: 'Until the value of sewage as manure shall be more evident, and a proper system adopted for using it, the Thames must continue to be, as it has often been designated, the great drain of London.'[47]

Meanwhile the private water companies attacked Martin and all others who criticized the existing system. William Matthews claimed that God has provided 'special organs to prevent one from being poisoned with water', and spoke of the alarm and despondency that anyone raising the issue of pollution was likely to provoke: 'Deplorably extensive is the mischief which such persons have the power and the opportunity of producing in family circles, and so, frequently,

have their dismal looks and pestiferous tales strongly affected the minds and depressed the spirits of delicate females.' Most illnesses, he suggested, were 'an affection of the imagination'.[48]

However, the cholera outbreaks grew worse until, in 1853, the Lambeth Water Company moved its water intake up-river, as Martin (and indeed others) had suggested more than twenty years before. Thereupon the cholera rate in the area the company supplied fell from 130 per 1000 to 37 per 1000. In 1846 the Metropolitan Sewage Manure Company, founded by Martin, was empowered by Parliament to build a containing sewer; but the scheme met baffling opposition; Martin quarrelled with the other directors and had nothing more to do with the company after 1851. Public works rather than private enterprise were to provide the sewage disposal system eventually adopted in London, but although the sewage manure came to nothing, the disposal network turned out to be much as Martin had proposed. Intercepting sewers were built to take all effluent to settlement tanks at Dagenham, whence the liquid was pumped out to sea, while solids were taken by barge to be dumped off the mouth of the Thames. The northern intercepting sewer was built beneath the Victoria embankment.

Martin's obsession with sewage manure, his desire to waste nothing and to contrive an ordered, balanced, virtually self-sufficient society can be related to the ambitions of many engineers and other innovators of his age who planned to build subways to contain gas and water pipes and to centralize power supply[49] and control the development of natural resources.[50] Joseph Bramah, the inventor of complex locks, the hydraulic press, and a water closet, had suggested in 1811 the establishment of mains supplies of water by abolishing the rival companies and constructing a uniform network of pipes with stop-valves in each street.[51]

In a similar master-planning spirit, Martin proposed the construction of a short-cut channel across the Isle of Dogs, past a strangulated bend in the Thames.[52] Then, in 1845, following the report of the Metropolitan Improvements Commissioners, he mapped out a 'London Connecting Railway',[53] a circular line joining the railway termini, with stations for each district and links to his riverside promenade (Pl. 93). This plan, one of the many produced at the height of the railway mania and again comparable to Trench's proposals, was commended by the Railway Termini Commissioners a year later, when Martin also added an underground railway to his Thames Street, with road and promenade above. By these means he hoped eventually to remove 'noxious manufactures and objectionable trades' from Central London. To this end he wrote an essay on 'The Importance of Preserving Open Grounds in the Vicinity of Large Towns' and made a survey of the history of Hyde Park to back his ideas for a green belt or linear park system.[54]

Nothing, as far as Martin was concerned, came of these suggestions. But every one was to be developed and implemented in some form; several of them, as it turned out, by Joseph Paxton who, as an imaginative designer and for many years untutored rank outsider, held strikingly similar views.

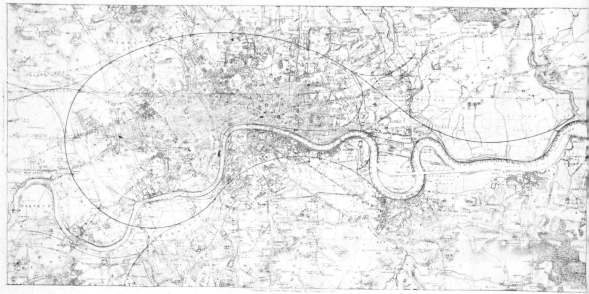

PLAN OF THE LONDON CONNECTING RAILWAY & RAILWAY TRANSIT ALONG BOTH BANKS OF THE THAMES,
WITH AN OPEN WALK FROM HUNGERFORD TO THE TOWER, AND FROM VAUXHALL TO DEPTFORD.
METROPOLIS IMPROVEMENT PLAN. BY JOHN MARTIN. SEPTᴿ 1845.

Paxton's design (proposed in 1855) for a 'Grand Girdle Railway and Boulevard under Glass', a trunk route enclosed in a glazed tunnel and containing both an atmospheric railway and a road, was intended to suit studies of traffic flow from Westminster to Southwark and incorporated arcades of shops, separated from traffic and centrally-heated in winter. Had this 'Great Victorian Way' been erected, it would have loomed over London: a segment of Martin's Pandemonium come to pass. Paxton drained land and laid out parks in Birkenhead, Halifax, and Glasgow, and sat on the Select Committee of 1860 which recommended a fresh-water supply for the Serpentine (by then nine feet deep in black mud) to flow, on Martin's lines, through Buckingham Palace Gardens and St. James's Park, into the Thames.

From 1860 the northern side of the Thames from Chelsea to the Tower was embanked and laid out with gardens, roads, and public walks. Today, much as Martin suggested, a stretch of the Inner Circle Line runs underneath, past the arcades of Somerset House. In 1878 Cleopatra's Needle, shipped from Alexandria in a gigantic cigar case, was mounted with attendant guardian sphinxes on the Victoria Embankment. While this Egyptian ensemble is the nearest the London planners ever approached to the spirit and letter of Martin's suggestions, the bleak embankment muddle on the south side of the river—from Lambeth Palace to the arts complex of Festival Hall, Hayward Gallery, National Carpark and Theatre, and Shell Tower of Babel—demonstrates, if only by default, how necessary comprehensive plans such as Martin's really were.

93. Plan of th[e]
London Connectin[g]
Railway by Joh[n]
Martin, Septemb[er]
1845. Engravin[g]
$21\frac{1}{4}'' \times 34$

Martin greatly resented the fact he received virtually no official recognition for his ideas:

In 1832, 1834, 1836, 1838, 1842, 1843, 1845 and 1847 I published and republished additional particulars—being so bent upon my object and I was determined never to abandon it; and though I have reaped no other advantage, I have, at least, the satisfaction of knowing that the agitation thus kept up, constantly, solely by myself, has resulted in a vast alteration in the quantity and quality of the water, supplied by the companies, and in the establishment of a Board of Health, which will, in all probability, eventually carry out most of the objects I have been so long urging.[55]

The only material evidence of all his efforts, apart from a few asides and footnotes in commission reports, contemporary periodicals, and civil engineering histories, lies in his pamphlets.[56] Many of these contain perspective views and diagrams, stocked with eager public servants tugging at pulleys, regulating sluices, and standing around as scale units. There are close-ups of technical details—stink-keys, traps, and sewer outlets—cross-sections of Thames Street, and idyllic scenes on his parkland watercourses. These diagrams hark back to the waters of Babylon and reflect forwards to present-day London. They link the elements of fact and fantasy in Martin's work.

Martin's plans are an integral part of his artistic achievement, an attempt to make something practical and useful of his visionary epics. In pamphlet form they are as valid in terms of creative imagination as any other form of the art of supposition. Indeed, while historic monuments soon decline and are demolished and buried to make way for the needs of later generations, insubstantial projects, visions, and ideas such as Martin's can survive either to be vindicated in the course of time or to be admired as sublime follies or conceits. For Martin, like Boullée before him, the concept had to suffice. It was, perhaps, just as well that this was so. Ideas, in the planning stage, tend to have a coherence and verve which can vanish in the course of execution. In any case, by 1838 Martin's attempt to straddle the widening gap between the professions of art and science had left him poised, another Marcus Curtius, over a gulf of bankruptcy and despair.

CHAPTER VII
'The Destroying Angel'

FOR NEARLY fourteen years, from 1824 to 1837, Martin showed nothing at the Royal Academy. 'The general treatment I have had at the Academy is this: my pictures have been placed in such disadvantageous situations as to do me great injury,' he said in his evidence to the Select Committee on the Arts in 1836. 'In general the R.A.'s have so many places for themselves (the number is eight for each Academician, and I believe the Associates have the same number) that sufficient space is not left to give any other artist a fair chance.' But Martin Archer Shee (once described by Haydon, Martin's leading fellow witness, as 'the most impotent painter in the solar system')[1] poured studied balm on Martin's criticisms, suggesting that if he had continued to exhibit, instead of taking offence, he was 'convinced Mr Martin would long since have become a full member of the Royal Academy'.[2] Martin went on to complain that, having abandoned hope at the Academy, he had turned to the British Institution, which had been reputed to have a more open attitude, only to find himself 'almost shut out of that place' by the press of academicians sending works round for a second showing or else exhibiting their society portraits under assumed allegorical titles so as to comply with the British Institution's regulations.

As an alternative outlet Martin tried sending mezzotints and paintings, including *The Deluge*, to the Royal Scottish Academy in 1828 and 1829[3] and paid 25 guineas to become an honorary member. He also exhibited in the various art institutions that flourished in the provinces during the 1820s, notably in Newcastle, Liverpool, and Manchester. If he had little hope of selling *The Deluge* or *The Fall of Nineveh*, he was able to promote print versions and water-colours (Pl. 94).

His most ambitious professional venture in the early 1830s was his *Illustrations of the Bible*. He had planned to issue forty mezzotints of Old and New Testament subjects, publishing in twenty parts, and had hoped to repeat the success of *Paradise Lost*, while keeping the entire publication and the expected profits to himself.[4] He aimed, he declared in the prospectus, to bring 'before the eye the vast and magnificent edifices of the ancient world, its forests, wilds, interminable plains, its caverns and rocks and mountains, by freely employing the aid of its

powerful and primitive elements of fire and water'.[5] This said, however, most of
the illustrations proved to be repetitions of earlier designs. Only a few—*The
Creation, Moses and the Burning Bush* (Pl. 95), *Sodom and Gomorrah* (Pl. 96),
its companion piece, *The Fall of the Walls of Jericho*, and the sombre illustration
to Psalm 137, *By the Waters of Babylon* (Pl. 97), in which harps hang dolefully
on weeping willows and the Tower of Babel blocks the skyline—show any sign
of fresh invention. Several other plates, such as *The Deluge* and *The Destruction
of Pharaoh's Host*, are replete with doughy forms and humdrum gestures, al-
together too reminiscent of Danby and riddled with disconcerting etched lines
which destroy the tonal values of the subsequent mezzotint. The considerably
revised *Expulsion* represents Adam and Eve, Raphaelite figures, larger than any
he had previously attempted in print, stepping across a rocky shelf, Adam a
dancing master launching a hesitant pupil. A lion mauls a deer in the
shadows (Pl. 98). This plate in particular shows how cumbersome and flaccid
Martin's work could become when he consciously attempted to interpret the

94. Entrance to the
Gorge. Water-
colour. 8½″ × 11″.

131

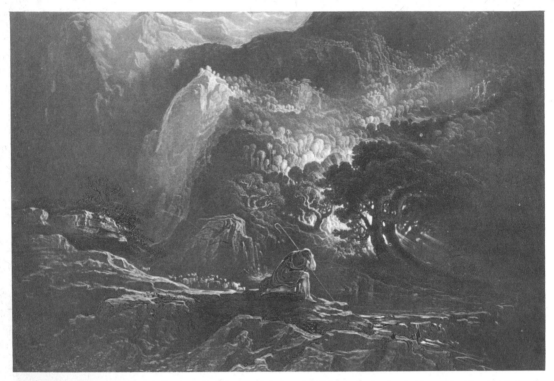

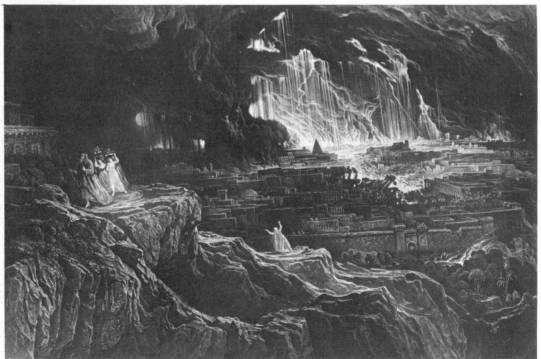

132

95. Moses and the Burning Bush. Mezzotint, $7\frac{3}{8}'' \times 11\frac{3}{8}''$, no. 10 from *Illustrations of the Bible*, published 1833.

96. Sodom and Gomorrah. Mezzotint, $7\frac{3}{8}'' \times 11\frac{3}{8}''$, no. 8 from *Illustrations of the Bible*, published 1832.

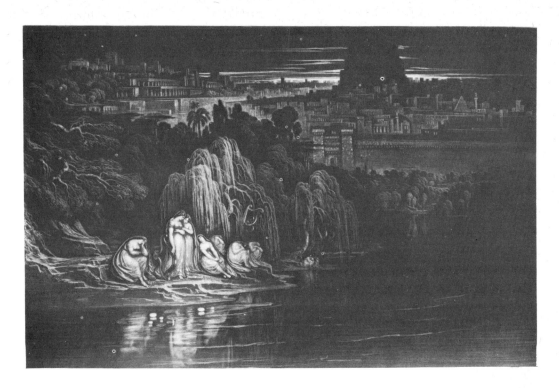

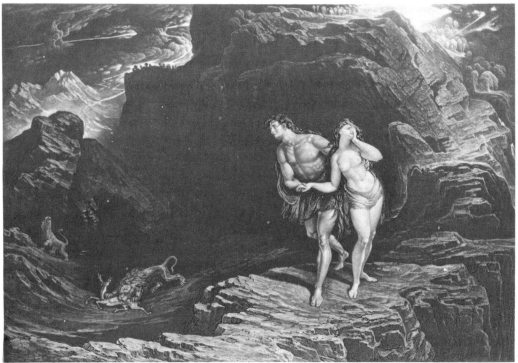

97. Psalm CXXXVII, By the Waters of Babylon. Mezzotint, $7\frac{3}{8}'' \times 11\frac{3}{8}''$, no. 17 from *Illustrations of the Bible*, published 1835.

98. The Expulsion. Mezzotint, $7\frac{3}{8}'' \times 11\frac{3}{8}''$, no. 4 from *Illustrations of the Bible*, published 1831.

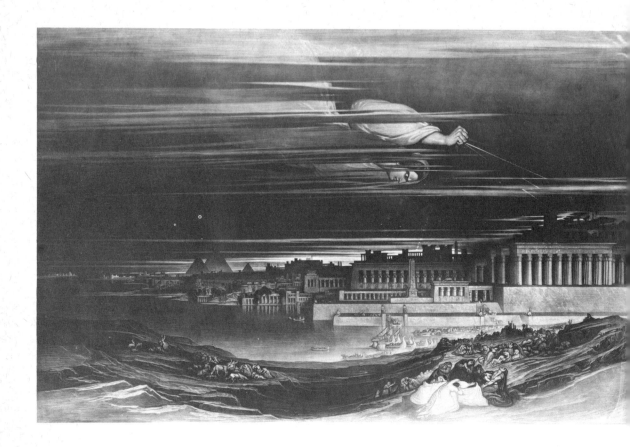

Old Testament through the eyes of the old masters or his more respectable con-
temporaries. Here indeed he proved himself 'weak in all those points in which he
can be compared with other artists', as Wilkie had observed in 1821.[6] Only iso-
lated details of mountain tops and cloud formations and Martin's last three
major mezzotints, the *Crucifixion* (1834), *The Destroying Angel* (1836; Pl. 99),
and the *Death of the First Born* (1836), show anything of the dramatic sense
which had sustained the *Paradise Lost* illustrations.[7]

The whole publication was an almost unredeemed failure, largely because
Martin evidently had neither the time nor the ability or inclination to promote it.
Charles Tilt, who bought up the remaining stock in 1838, was probably correct
in suggesting that the circulation of these prints was 'confined almost entirely to
Mr. Martin's personal friends'.[8]

Martin's first version of *The Crucifixion* (engraved by Henry Le Keux for the
Amulet of 1830)[9] had inspired a friend of his, the Revd. Dr. George Croly,
to write a poem which was included in the descriptive catalogue of the mezzotint

134 in 1834:

This was the earth's consummate hour;
For this had blazed the prophet's power;
For this had swept the conqueror's sword,
Had ravaged, raised, cast down, restored;
Persepolis, Rome, Babylon,
For this ye sank, for this ye shone.[10]

Martin saw the crucifixion, the last great turning-point in history, in the context of all perishable civilization, epitomized, in this instance, by the towering fabric of the earthly Jerusalem: palaces, theatre, hippodrome, and temple paraded in all their splendour behind the rock-strewn hillside of Golgotha, the Place of the Skull, where 'the graves were opened; and many bodies of the saints which slept arose'.[11] The sun is fading into eclipse behind the Mount of Olives; darkness is descending over the land; the innermost sanctum of Herod's temple is being struck by lightning, its veil rent in twain.

The print (Pl. 100)[12] was designed to provide a 'historically correct' view of Jerusalem as described by Josephus. As always, Martin laid great stress on the exhaustive accuracy of his reconstruction, from the leading characters (among them a 'Jewish Chief, thrown by the fright of his horse at the thunder and the earthquake, being a type of the Fall of Jerusalem') to the palace of Agrippa,

100. The Crucifixion, 1834. Mezzotint, $18\frac{1}{2}'' \times 28''$.

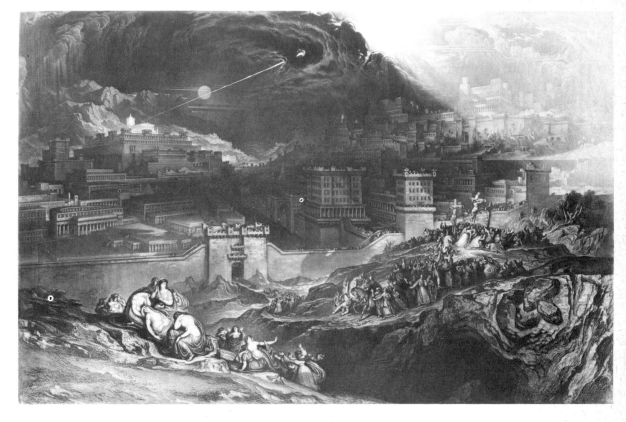

facing Herod's temple across a heavily built-up valley and 'The Valley of Jehoso-
phat with the Brook Cedron winding its way to the Dead Sea'. He showed the
'outer walls of the City, crowded with the Spectators of the Crucifixion. Sup-
posing the figures each to be six feet high the proportionate scale of the buildings
of the city will be found to be historically correct; and by reference to the map
the exact situation of each object will be seen to be equally correct.'[13] Besides an
outline diagram of the print Martin included a plan of Jerusalem showing
precisely how he had established his viewpoint from Mount Goreb.[14] The
pamphlet is dated 1 June 1834, and the following day he signed a perspective
view of his embankment scheme.[15]

Martin's imaginative reconstructions and proposals here coincided; his various
concerns overlapped and merged. The Crucifixion print is undeniably compli-
cated; as in *The Destruction of Pompeii*, Martin was faced with an overwhelming
amount of historical data and thematic material. In later versions[16] the cruci-
fixion itself was more strongly emphasized and the architectural setting, now
subdued, was left a mere accumulation of arcades and citadels comparable to
those in *Marcus Curtius*.

The great strength of the print is its sense of momentous occasion; and the
contrast between the stark, deathly instant of halted time and the supposed
permanent, man-made order of Herod's temple, in which 'the inward parts were
fastened together with iron, and preserved the joints unmoveable for all future
times'.[17] Meanwhile Martin planned to redevelop the banks of the Thames and
make them everlastingly clean and palatial, as broad and grand as the 'Street
leading from Herod's House to Calvary'.[18]

In *A Treatise on Isometrical Drawing*, published in 1834, Thomas Sopwith
argued:

This mode of drawing fills up the space between the picture and the plan; between the
picturesque beauty of the painter's canvass, and the formality of the designs of
the mechanical draughtsman and if it does not introduce the plans and elevation of the
engineer and architect actually within the sphere of the Fine Arts, it most assuredly
gives them a strong impress of pictorial beauty.[19]

If Martin's drawing was not precisely isometric, it was near enough to serve; for
the 'Key to Mr. Martin's Print of the Crucifixion' with its accompanying ground
plan is an obvious linking device connecting his fine-art skills with his civil-
engineering concerns.

Martin's designs for the Westall and Martin *Illustrations of the Bible* included
The Crucifixion and further views of Jerusalem at various stages in its Course of
Empire: triumphant at the Dedication of the Temple and fallen into ruin in the
engraving of *Nehemiah mourning over Jerusalem*. 'In the print the artist has
supposed him to have arrived at midnight before Jerusalem,' the Revd. Hobart
Caunter explained in his commentary to the *Illustrations*,[20] 'when, beholding its
external desolation, its walls broken down, and many of its gorgeous edifices

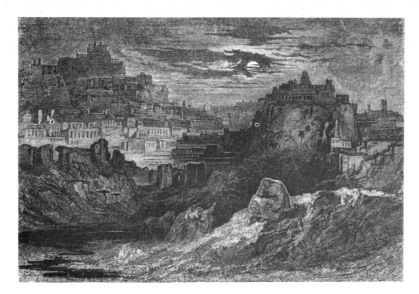

101. Nehemiah mourning over Jerusalem. Wood engraving, $2\frac{3}{4}'' \times 4\frac{1}{8}''$, no. 72 from *Illustrations of the Bible* by Westall and Martin, 1835.

overthrown, he goes apart upon an elevation where he can overlook the holy city, and pours out his soul in tears!' Nehemiah is seated on the spot where the crucifixion was later to take place (Pl. 101).

Between 1831 and 1836 Martin made seventy-two sepia drawings (many of which survive) (Pl. 102) for the *Illustrations of the Bible* published in monthly

102. The Walls of Jericho, 1834. Sepia, $3\frac{1}{2}'' \times 5\frac{1}{2}''$, initialled.

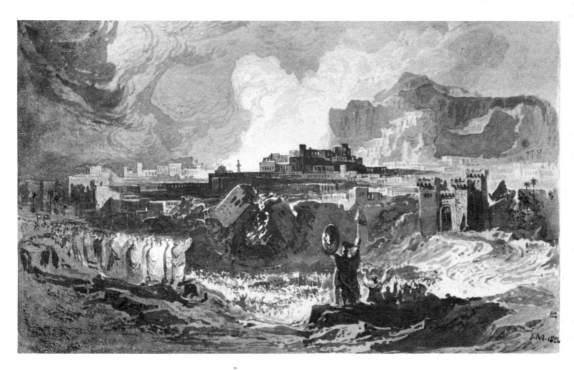

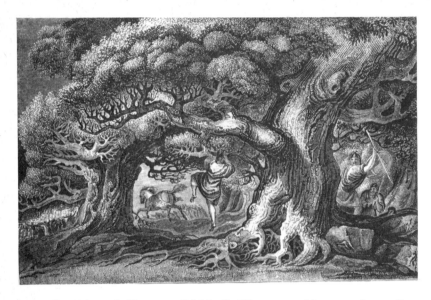

103. The Death of Absalom. Wood engraving, $2\frac{3}{4}''$ × $4\frac{3}{10}''$, no. 61 from *Illustrations of the Bible* by Westall and Martin, 1835.

parts by Edward Churton (1834–6). He was paid ten guineas for each of the designs, which were engraved, faithfully enough, by Jackson, Powis, Mosses, and other leading wood-engravers of the period (Pls. 103, 104, and 105).

In the two volumes Martin's work alternates with the trim compositions of his collaborator, Richard Westall; his earthquakes, revelations, and mighty death throes upstage at every turn Westall's correct gestures and airs of impending ballet. Each of Martin's illustrations is a tableau, framed in rock formations and decisive cloud effects. The world is a stage on which cause and effect, prophecy and fulfilment are spelt out with the utmost precision.

The work went through many editions, and, according to William Rossetti,

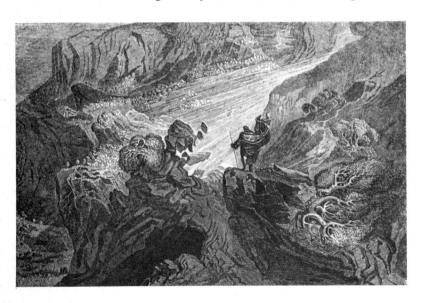

104. Elijah and the Earthquake. Wood engraving, $2\frac{3}{4}''$ × $4\frac{1}{4}''$, no. 67 from *Illustrations of the Bible* by Westall and Martin, 1835.

105. The Raising of Lazarus. Wood engraving, $2\frac{3}{4}''$ × $4\frac{1}{4}''$, no. 33 from *Illustrations of the New Testament* by Westall and Martin, 1836.

became a favourite, formative influence on his brother Dante Gabriel who 'continued throughout his life to regard this artist as a man of remarkable powers of invention'.[21] A compendium of Martin's Biblical repertoire, it amounts to a complete mid-term retrospective of his work as a popularizing illustrator. The pointed contrast with Westall's thoroughly restrained designs (representative of an older generation of taste) demonstrates the continuing and persistent surprise value of Martin's work. More important, it shows how effectively he could adapt his designs to any scale and to suit any medium of expression. Considering the fizzing vitality and sense of over-all order in these illustrations it is difficult to see what Ruskin meant when he wrote in 1840 that Martin 'never made a design yet which the eye could endure, if reduced to a small size'.[22] Certainly in terms of miniature compression the best of the *Bible Illustrations* compare well with vignettes that Turner designed for Samuel Rogers's *Italy*, which were 'the first means' Ruskin 'had of carefully looking at Turner's work'.[23] Martin's imagery was so decisive and durable it could survive almost any degree of interpretive treatment: and was, indeed, positively enhanced by some of the stiff, harsh contrasts characteristic of wood engraving.

Preoccupied with plans and engravings, Martin exhibited no new oil-paintings between 1829 and 1833, though several came up for sale at Sotheby's in January 1832.[24] With many unsold works on his hands, including *Clytie* which he painted over to become another metamorphic subject, *Alpheus and Arethusa*, *Leila*, which met with 'unqualified censure and reprobation',[25] and *The Deluge*, 'enlarged', according to a label on Martin's cabinet,[26] in 1832, he cast around in his mind for reasons for their failure to sell and found an explanation of sorts. 'I am going full tilt against our self-styled patrons of the Fine Arts who endea-

vour to ruin my independence,' he wrote to the editor of the *Literary Gazette*, William Jerdan, in March 1833 and explained that, as his rooms were not very convenient 'and as they will not give me the opportunity of showing my works decently at *their* exhibition,[27] I have determined on setting up for myself, and am on the eve of showing all my works at present in my possession in the Lowther arcade.'[28] This, the Adelaide Gallery, was an exhibition hall for all manner of applied arts and machines, a private enterprise extension of the idea of the National Repository of Arts which had been established in 1829 by order of George IV as a showplace for art objects or scientific novelties, such as convenient, inflatable pocket globes and Rolff's patent self-acting piano which were exhibited in 1830 alongside paintings and Thorwaldsen's highly refined sculpture, the *Triumph of Alexander*. The National Repository had to make way for the new National Gallery on the same site in 1832, and the Adelaide Gallery also closed through lack of support.[29] It is very likely that Martin thought better of this desperate resort for a showing as there was no mention of an exhibition of his work in the press.

A few months later, in June 1833, the dioramic version of *Belshazzar's Feast*, by Hippolyte Sebron, was shown at the Queen's Bazaar in Oxford Street and Martin attempted to get a court order to close the exhibition.[30] He was also especially vexed at this time by printmakers such as J. G. S. Lucas who adopted and plagiarized his mezzotint designs. However, setting aside such infringements of copyright and good conduct (about which he complained to the Select Committee on the Arts in 1836), Martin continued to sympathize with schemes to exhibit the creations of art and science together in the spirit of perpetual give and take.[31]

For most of his career Martin was readily identified with analogous writers. When, in 1835, Henry Crabbe Robinson wrote that Wordsworth 'spoke severely of Martin (not even sparing Turner) and of the analogous artists in poetry',[32] the latter no doubt included Ralph Waldo Emerson who, a few years later, after a moonlight stroll, wrote in his Journal: 'Then we see that Martin's Creation picture was true & that the Man who has seen the moon break out at night, arising, has been present like an Archangel at the Creation of the Light of the World.'[33] Emerson was capable of appreciating an image which had appeared beneath contempt to such artists as Northcote and Haydon.[34]

It is significant that Martin's closest friends and sympathizers tended to be literary and scientific men rather than painters, though he was, of course, acquainted with the painters of his day.[35] According to J. H. Anderdon, 'all persons of "ton" or distinction as well as the artistic fraternity' could be found at Martin's weekly at-homes held during this period; while S. C. Hall maintained that 'Martin has had no emulation in his laudable efforts to make the author aid the artist, the artist aid the author and to bring science as an assistant to both.'[36]

When James Hogg, the Ettrick Shepherd, visited London for three months in 1832 he met Martin, whom he had admired for several years following the

recommendation of John Wilson (Christopher North) who had written, in 1827, 'That Martin to my fancy's the greatest painter o' them a''.[37] After Hogg had returned to Scotland, Martin made a drawing from his poem *The Queen's Wake*, and wrote to Hogg: 'I have not taken the passage you wished, for I was afraid to venture "the light of a sunless day" on canvass. Indeed there are some subjects that appear distinctly in the "mind's eye" of the poet which are most difficult if not impossible to delineate with the matter of fact pencil.'[38]

Martin's idea of art was based on the combination of forces, or co-operation between poet and painter. His friendships with writers and scientists, cultivated at Alaric Watts's Pot-Luck Club for example, extended beyond mere sociability; and later at the Athenaeum[39] he no doubt also met the wide assortment of lawyers, archbishops, bishops, and lesser divines who, as Leopold put it, became his 'dear and great friends'. His contacts could serve to provide him with ideas and material. So, besides persuading Tom Moore to sing some of his 'Irish Melodies' during an at-home in honour of Hogg, at which he himself obliged with 'The Fair Maid of Wallington' and joined in the toasts raised by Tom Hood to 'the painters and glaziers' and by Charles Landseer, in response, to 'the paper stainers', Martin made several ventures into a more formal collaboration between artist and writer. The poet, critic and art dealer Edwin Atherstone claimed 'we have consulted together, and disputed together, but have trodden each upon his path' in producing simultaneously paintings and poems concerned with Pompeii, the Deluge, and Nineveh: Martin's imagery of the Celestial City, Pandemonium, and Deluge first appeared in his illustrations to Atherstone's *A Midsummer Day's Dream* (1824). Similarly Thomas Hawkins, an eccentric poet-geologist, worked with Martin on some of the sewage schemes and Martin's last mezzotints were frontispieces to Hawkins's *Wars of Jehovah* (1844), the most extraordinary and verbose of all the epic poems produced in the Martin idiom.

If in retrospect it becomes clear that Hawkins, like the ineffable Bernard Barton, simply extruded poetry in the Martin idiom, others, including William Godwin, Leigh Hunt, Campbell, Moore and Atherstone in particular, had a more pronounced influence: arguing with him, feeding him lines to illustrate, shaping his subject-matter and interests. Martin in return tended to stand in their eyes as the only contemporary artist of significance. Bulwer-Lytton was quite bedazzled by him. His *Last Days of Pompeii* closely reflects Martin's terms of reference (and was indeed taken up as a subject by J. G. S. Lucas for that very reason)[40] and in 1849 Martin drew on his poem *King Arthur* for *Arthur and Aegle*, a painting Lytton, to his great regret, could not afford to buy. He described Martin in *England and the English* (1833) as

the greatest, the most lofty, the most permanent, the most original genius of his age. I see in him, as I have before said, the presence of a Spirit which is not of the world, the divine intoxication of a great soul lapped in majesty and unearthly dreams. Vastness is his sphere, yet he has not lost nor circumfused his genius in its space; he has chained and wielded and measured it at his will; he has transfused its character into narrow

limits; he has compassed the Infinite itself with mathematical precision. Martin has borrowed from none. Alone and guideless he has penetrated the remotest caverns of the past and gazed on the primeval shapes of the gone world.[41]

Frith, only slightly less effusive, thought him 'one of the most beautiful human beings' he had ever seen.[42] Dining with Cruikshank in about 1835, Martin met Dickens who 'indeed looked upon his introduction to a known artist as a compliment'.[43]

Martin's most ambitious collaboration began in 1833 with the publication of John Galt's *The Ouranoulogos or The Celestial Volume* which he planned to run to twelve numbers, each containing a mezzotint, with line engraving by Martin, illustrating one of history's greater watersheds, a matching story by Galt, and supporting textual extracts. The first subject, 'The Eve of the Deluge' (which Martin was to repeat on a larger scale, supposedly on the Prince Consort's suggestion, in 1839), had already appeared in outline in Galt's *Wandering Jew* of 1820 which, in its instructively entertaining way, had aimed for much the same time-travelling topographic effect that Martin liked to achieve in his epic paintings. The scene was that described by Byron in *Heaven and Earth* (i.ii.65–8):

> The earth's grown wicked;
> And many signs and portents have proclaimed
> A change at hand, and an o'erwhelming doom
> To perishable beings.

Galt's words and Martin's composition were in complete harmony:

The sun had just set, and all the vernal earth around was goodly and glorious; music swelled from afar on the ear, like mingled fragrances to the smell, and below a crowd of bridal dancers had spread their pavilions, untired in their revels; but in the midst of this serenity and pleasure, here and there on the peaks and summits of the neighbouring rocks clusters of aged men stood perplexed, speaking gravely to one another, and pointing with outstretched hands, to phantasms in the air, where clouds, adversely careering, betokened unbridled tempests.[44]

The first number of *The Ouranoulogos* was also the last. In accordance with Lamb's belief that sister arts 'should sparkle apart', it failed; the collaboration underlined the similarities between pictorial and literary expression, but neither was significantly reinforced in the process.

Nevertheless Martin was drawn into a closing circle of imagery, each theme affecting the next, rebounding among the arts of literature and painting and engineering. The fires from the Lymington glassworks on the Tyne, which he had seen as a boy, and later 'Wolverhampton and the Black Country seemed to his mind the ideal of the infernal Regions. None of his attempts to depict the grand descriptions of Milton gave him satisfaction when he recalled to mind the startling effect produced by the furnaces as seen at night in and about Wolverhampton.'[45] Ebenezer Elliott, the 'Corn-law rhymer', took up this theme in 1833 with 'Steam, At Sheffield':

'Fair is the bow that spans the shower,' thou says't,
'But all unlovely; as an useless skull,
Is man's black workshop in the streeted waste.'
And can the city's smoke be worse than dull,
If Martin found it more than beautiful?
Did he, did Martin steal immortal hues
From London's cloud or Carron's gloomy glare?[46]

Martin made Carlyle's Machine Age (which Peacock ridiculed through Dr. Folliott in *Crotchet Castle* as 'The March of Mind and Steam Intellect Society') his raw material, raising warehouse, dockyard, and iron foundry to aesthetic distinction by citing Babel and the blazing fiery furnace (Pl. 107) as formal and symbolic precedents for the transformation of the face of the earth and its natural resources into satanic 'fabrics huge' (Pl. 106).

Cross-references between ancient and modern were commonplace by this time. In 1835 George Vivian reviewed Thomas Hope's 'Historical Essay on Architecture' in the *Quarterly Review*: 'The aqueducts, the harbours and the sea-port moles of modern times—the gates and towers and other parts of military architecture—the docks of Ferrol and Sheerness, Smeaton's Eddystone Light-house and such grand architectural enterprises, are equal in their kind to the

106. After Thomas Allom: Lymington Glassworks on the Tyne, 1832. Steel engraving by James Sands, $3\frac{7}{8}'' \times 6\frac{1}{8}''$, from *Durham, Westmoreland, Cumberland and Northumberland Illustrated*, vol. iii, 1835.

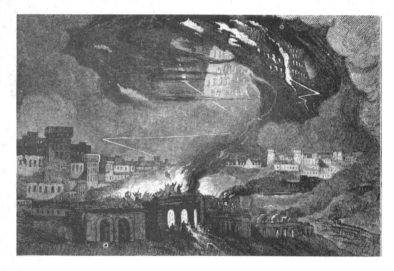

107. The Tower of Babel. Wood engraving, 2½″ × 4″, no. 10 from *Illustrations of the Bible* by Westall and Martin, 1835.

most celebrated of antiquity'.[47] Even Haydon could be inspired by the New Post Office ('Bought 6d. notebook to record it! a great addition') which he turned into Agammemnon's Palace.[48] Ten years later, when Emerson visited London he wrote: 'The smoke of London, through which the sun rarely penetrates, gives a dusky magnificence to these immense piles of building in the West part of the City, which makes my walking rather dreamlike. Martin's pictures of Babylon &c are faithful copies of the west part of London, light, darkness, architecture and all.'[49]

Martin's excited reaction to the incidental drama of industry, his delight in prodigious scale, in the repetition of constituent parts and the controlled, artificial light of industrial Britain was shared by Schinkel on his visit to England in 1829. Because Martin saw the ancient world in terms akin to those of the developing industrial age,[50] his architectural suppositions helped the railway builders envisage triumphal tunnel portals and Babylonic vistas grand enough to match their achievements of surveying, digging, and embanking as each new line was driven through the country into the heart of the cities, overcoming geography and short-cutting time and distance.

In the mid 1830s the Newcastle to Carlisle railway was built through Haydon Bridge. John Dobson's designs for Newcastle Central Station, in Ionic manner, won him a medal at the Paris *Salon* of 1836. The new technology elbowed aside the past: in both Newcastle and Conway, Robert Stephenson ran the railway within inches of the old castle keeps. Such was the spate of railway building, it began to look as though there would be 'railroads, and locomotives all over the kingdom, whirling, and whizzing, and fizzing, rout tout a tout, throughout and about, in every possible and impossible direction'.[51]

If Brunel's designs both for the Clifton Bridge competition of 1830 and for the architectural details of the Great Western Railway reflect Martin's renderings of Egypt and Babylon and the wide smouldering cutting in front of the Palace of

144

Pandemonium, his debt to Martin was repaid certainly when he invited him, along with Charles Wheatstone, to take part in speed trials on the railway in 1841. Leopold Martin accompanied them:

With Mr. Brunel's eye on the steam pressure gauge and hand on the safety valve, we were off, and in half a mile we were running at 'top speed,' the time-keepers busily at work. To the great satisfaction of Mr. Brunel and the astonishment of all, it was discovered that the distance of nine miles from the Station at Slough had been run in six minutes, or at the rate of ninety miles an hour.[52]

Sadly, from Martin's point of view, the trials did not involve going through any of the tunnels whose portals proclaimed victory over the darkness visible within. However, the live, headlong dioramic scene through the thick plate-glass windscreen, as streaking perspectives dashed up and over him from the twinkling vanishing-point to the volleying immensity of embankments, cuttings, and bridges flashing by, must have seemed to him a realization of his Old Testament imaginings. According to Leopold's generally reliable account, Martin believed trains were capable of almost infinite speed. But it was Turner who recorded the sensation of *Rain, Steam and Speed: the Great Western Railway*[53] in 1844. The only train Martin ever painted was an express plunging into the Valley of Jehoshaphat on the Day of Judgement; current affairs counted for nothing in his eyes unless they could be related in some way to endless vistas of history and futurity.

Fuelled by the accumulated backlog of centuries' worth of tally-stick accountancy stored in the cellars, the old Houses of Parliament burnt down in 1834. The design and interior decoration of the new buildings was to become a matter of controversy for the following thirty years. A. W. Pugin eventually designed most of the details of the new buildings; in his *Contrasts: Showing the Present Decay of Taste* (published in 1836) he ridiculed the classical stucco façades that were thrown up to disguise gas works and lunatic asylums, just as later in his *Apology for the Revival of Christian Architecture in England* (1843), he mocked the Egyptian mode and the other related tastes that Martin had popularized for a quarter of a century.[54] Martin's standards of authenticity were to be brought into question as history and archaeology developed into specialized sciences. His credibility was to founder on *Modern Painters* (1843–59) and *The Stones of Venice* (1851 and 1853) and on the bas-reliefs, 'the gorgeous and striking scenery',[55] unearthed by Layard at Nineveh.

In the 1830s, at the time he was most enthusiastic in pressing forward his plans several of Martin's scientist friends attempted to help him: Faraday and Wheatstone served on the committee under Lord Euston in 1836.[56] Faraday notably expressed faith in Martin's schemes,[57] as did Thomas Sopwith, the surveyor and mineralogist who ran the Allendale lead mines for some years. He heard Thomas Donaldson, the Secretary of the Institute of British Architects, lecture approvingly on Martin's plans in March 1833.[58]

But Martin's most useful contacts with science were those in which his own expertise and interest coincided with fresh fields of study. His influence on the styling of railways was little more than an interesting side issue; his ventures into the underworld and prehistory in the company of mining engineers and geologists were more significant.

In the summer of 1834, for instance, Dr. Gideon Mantell obtained the recently discovered fossil remains of the great Maidstone iguanodon and noted in his diary for 27 September:

Among the visitors who have besieged my house today was Mr. John Martin (and his daughter) the most celebrated, most justly celebrated artist, whose wonderful conceptions are the finest production of Modern art. Mr. Martin was deeply interested in the remains of the Iguanadon etc; I wish I could induce him to portray the Country of the Iguanadons: no other pencil but his should attempt such a subject.[59]

Mantell was an eminent palaeontologist who followed up Baron Cuvier's discovery of the fossil bones of vertebrates by reconstructing the skeletons of extinct species from bones which he found in chalk-pits near his home in Sussex. The dragons of fairy tale and mummer's play, which Turner had shown sprawled along the narrow mountain ridges surrounding the *Garden of the Hesperides*,[60] were thus scientifically and historically accredited; and so there developed an awareness of antediluvian ages stretching back before Bishop Ussher's definitive dating of the start of the world at 2004 B.C.

William Martin, predictably, dismissed such theories as nonsense—like most people at the time he could conceive of fossils only as relics of the Deluge itself; when, for instance, in 1829 an 'antediluvian tree' was unearthed in the Northumberland village of Wide-Open, he inspected it and noted with some satisfaction that 'its roots lie West–East in line with the direction of the Flood.'[61] John Martin, however, readily accepted the implications of Mantell's discoveries and eventually, in 1838, Martin's illustration of *The Country of the Iguanodon* (Pls. 108 and 109) appeared as frontispiece for Volume I of Mantell's *Wonders of Geology*; it was apparently based on a painting, since Mantell mentions that Martin had 'rescued from the oblivion of countless ages and placed before us in all the hues of nature, its appalling dragon-forms, its forests of palm trees and tree-ferns, and all the luxurious vegetation of a tropical clime.'[62] He made a variant mezzotint, *The Sea Dragons as they lived* (Pl. 110), as the frontispiece to Thomas Hawkins's *The Book of the Great Sea Dragons: Ichthyosauri and Plesiosauri* (1840), showing a foreshore laden with glowering pantomimic monsters founded on scientific data but, for all that, unmistakably, if distantly, related to the dragon Cadmus slew.

These designs are arguably Martin's most far-sighted illustrations; in them he made prehistory credible, made dry bones live, clothed them with flesh, and dredged the Jurassic age from the waters of oblivion. He rejected traditional descriptions of the dawn of history, believing that the world was first peopled

108. The Country of the Iguanodon. Steel engraving, $3\frac{1}{2}'' \times 5\frac{3}{4}''$, frontispiece from *The Wonders of Geology*, vol. i by Gideon Mantell, 1838.

109. The Country of the Iguanodon. Mixed mezzotint, $3\frac{1}{2}'' \times 5\frac{3}{4}''$, frontispiece from *The Wonders of Geology*, vol. i by Gideon Mantell (seventh edition).

with inferior animals, then with a grade superior, and finally with man. Ralph Thomas, his staunchly conservative confidant, considered this 'ridiculous enough but he said he got it all from geology; for there were no bones to be found of man, though there were bones of all sorts of other animals'.[63]

As Martin's stock of imagery extended beyond the bounds of the Old Testament and the architectural wonders of the ancient world, his apocalyptic imagery was correspondingly enlarged. His designs for the Book of Revelation, from the Westall–Martin *Illustrations of the New Testament* (1836), pass from the *Opening of the Sixth and Seventh Seals*[64] to *The Great Day of His Wrath*, in which the world is shown cracking up around the last man, who watched as the angel 'laid hold on the dragon, that old serpent, which is the Devil, and Satan, and bound him a thousand years, and cast him into the Bottomless Pit' (Pl. 111). By setting his great sea dragons writhing in prehistory's equivalents of the Dark Ages and the Slough of Despond, Martin reconciled antediluvian theory with divine revelation.

The most vivid illustration of the impact of this work is the set of prehistoric monsters made, after Mantell's theories and under Richard Owen's supervision, by Waterhouse Hawkins and installed in the gardens below the rebuilt Crystal

Palace at Sydenham; the huge, gloss-painted monsters (the lower half of the biggest iguanodon once housed a dinner-party for twenty-two people) still dominate the ornamental ponds and shrubberies beside the suburban railway: Martin and Mantell's own lost world in London, S.E. 20.

Martin's preoccupation with the underworld, that complex of tunnels down in the Valley of the Shadow of Death through which Christian groped his way in the hope of reaching light and fresh air,[65] dated back to the lead-mines and coal-pits of Tyneside which had been part of his childhood background, to the sketches and plans for a railway to carry coals from the month of a pit to the sorting screen which he had made for William Martin in 1805, and to the drawing of William's safety lamp in his sketch-book of 1818 (Pl. 86). He had visited Newcastle in 1828, shortly after completing the *Paradise Lost* plates with their images of the satanic underworld, and, presumably following discussions with William, produced a *Plan for purifying the Air and preventing Explosion in Coal Mines* as the fifth of his *Outlines of Several Inventions.* (1829). Then, and in 1835, in evidence to the Select Committee on Accidents in Mines, he praised his brother's lamp but went on to suggest that the risk of explosion could only be eliminated by means of thorough ventilation. Martin clearly regarded the mines as 'the hollow deep of Hell', a labyrinth of darkness which could explode into the horror of Satan's Burning Lake. His plans 'to ameliorate the condition of the poor suffering workmen'[66] stemmed, as he readily admitted, from William Martin's long-standing interest in the pits of Jarrow and of Wallsend, his home-town.

The 1835 Committee asked Martin to explain himself to George Stephenson, the most obvious expert, but when he mentioned the accumulation of foul gases in the recesses of Jarrow Colliery, Stephenson 'flatly contradicted' him, asserting that 'all parts were equally ventilated'. Martin was thereupon asked to stand

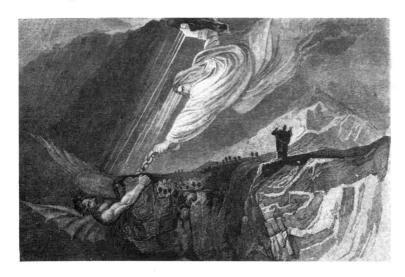

111. Satan bound in the Bottomless Pit. Wood engraving, $2\frac{3}{4}'' \times 4\frac{1}{4}''$, no. 48 from *Illustrations of the New Testament* by Westall and Martin, 1836.

down, though he appealed later to John Buddle, 'the principal coal viewer in the kingdom', who agreed with him and said that he was 'the best amateur coal-viewer he had met with &c'.[67]

Martin maintained that all safety lamps were a liability, that if shafts and passageways were so arranged as to force fresh air past the coal face no danger of gas accumulation would arise. He accused mine owners of placing 'a premium on danger' by introducing the Davy lamp. But, as so often happened, he found it was assumed that 'Mr. Martin, not being a "practical" man, could know nothing about these matters'. However, he noticed that 'the coal-owners in common with most who are not "practical men" are doubtful as to their competency to pass judgment on plans which may be submitted to them.' A solution, he suggested, would be to make 'drawing (especially ground plans, elevations and perspective) a principal branch of education in our colleges and other schools, in order that our legislators may be enabled to understand and to judge for themselves.'[68] Art could serve as the link between engineers and those they served. The ready-reference outline engravings or ground plans of Martin's paintings were all part of a perspective of the world and its history.

Martin, as usual, had to rest content with the fact that he had at least stated his case: 'in the earnest hope of drawing some effectual attention',[69] and, for that matter, he had used the underworld of mine shafts and tunnels for his own artistic purposes. However, the schemes and diagrams of an artist (and, he insisted, a 'practical man') could point ways to salvation for both body and soul.

'Men of strong passions and imaginations must always care a great deal for anything they care for at all, but the whole question is one of first or second. Does your art lead you or your gain lead you?'[70] Ruskin once asked in an address to members of the Architectural Association on 'the Influence of the Imagination on Architecture'. On this Martin was quite decided. He had always vigorously rejected any suggestion that he advanced his plans for personal profit: 'Mr. Martin, begs first to disclaim all motive but that of the public good: he has no desire, in any manner whatever, to reap a private advantage from the realization of his designs.'[71]

Up to 1835 he appeared prosperous, to Haydon at any rate, who noted in July 1832: 'Poor Martin! Martin is beginning to feel wealthy and to love accumulation'[72] and, characteristically, immediately asked him for a loan. Five months later he remarked on Martin's anxiety to be repaid: 'Out, on Martin's balance, to beg for time, and got it. It is cruel of Martin to press me now, opulent as he is.'[73] But this was a false assumption. The demand for Martin's prints, still, supposedly, his main source of income, was dwindling. During 1837 he made altogether only £146 out of his stock of prints. By the autumn of 1837 he had sunk into gloom and told Ralph Thomas:

I feel myself a ruined, crushed man, I shall sink now: there are no more bright days in store for me. My eyes have been opened to the state of my affairs and I am a pauper. I

am dishonoured. I know not what will become of us. I have never attended to money matters and this is the consequence. I have earned £20,000 in a few years and I am now not with a penny. I have been plundered and deceived.[74]

He was, Thomas added, 'a mere child in the business of life. All his mind and energies being engrossed in his profession, and in his hobby projects, he has left all his money matters to others.'[75] Martin blamed importunate acquaintances such as Haydon, his solicitor Burn (to whom he lent and lost £500), his relatives, and his brother Richard in particular, who had borrowed without repaying, (he died in 1837) 'bringing me down to disgraceful ruin at a time when I hoped all my projects were ripening into practical operation'. Changing tastes were also partly to blame; for only sixty copies of his mezzotint *Marcus Curtius* which he published in July 1837 were sold. He put his plates and paintings in pawn and made some attempt to raise money by a lottery of his paintings. By the beginning of 1838 Thomas found him 'disposed to give up working altogether, he does nothing but mourn and despair'.[76]

The threat of total bankruptcy, the break-up of his household, the sale of his goods, the loss of position and respect, and the apparently inevitable decline into a debtors' prison was enough, as Mrs. Martin said to Thomas in March 1838, to make her fear he 'would go out of his mind'.[77] The following August his nephew Richard, a diffident, talented youth who had lived with the family since 1829 and had the year before exhibited *The Bard's Lament* at the Academy, cut his throat in the belief that his breath was turning the family black and died in Middlesex Hospital; his state of depression was apparently brought about by the death of his father, Jonathan Martin, in Bedlam three months before.

Martin continued to pursue his planning concerns and was so insistent in impressing his views on all his friends that by 1840 Thomas confessed himself bored 'to a dead headache by the old story of the Patent Rope Cable, Stink Keys, and Sewers etc. I am so fond of the company of Martin that I can't help going, but if he gets upon that, all is over with me. He couldn't sleep last night and he thought of something new as to sewerage backing, etc. Everything he does, too, is borrowed or stolen from him, so his time is absolutely lost upon those subjects.'[78] As these plans failed, or became tiresome and monotonous through sheer repetition, Martin began to concentrate once more on painting, this time as a refuge and security rather than as the instrument of prophecy. His financial situation thereupon gradually improved.

A *Battle Scene* (Pl. 112),[79] dated 1837, marks the renewal of Martin's positive and inventive interest in painting. A frenzied knot of soldiers and horses struggle on the same tilted shelf of rock that served as the last resort for mankind in *The Deluge*. Some fall into the black stream, while on a higher promontory a single warrior makes commanding gestures, like the Bard beside the Conway, or Satan surveying the building of Pandemonium, or Paul undergoing conversion.[80] The central tangle of activity (Pl. 113) in a driving swirl of water, sky, and rock formations that anticipates the dizzying pace of Turner's *Snowstorm—Steam-*

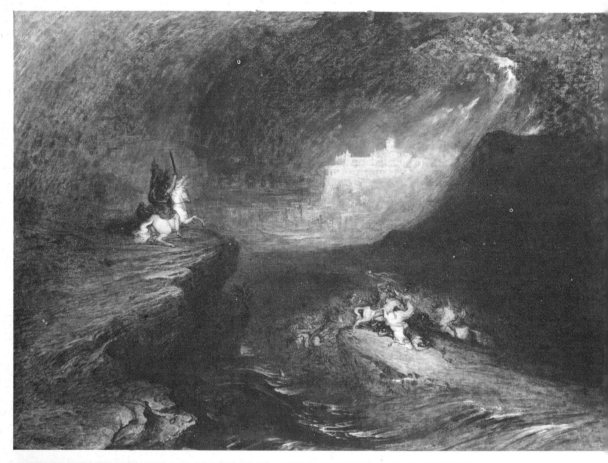

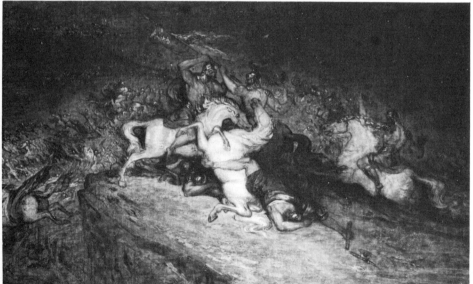

112. Battle Scene,
1837. Oil on canvas,
$35\frac{1}{4}'' \times 47\frac{1}{8}''$, signed.

113. Detail of
Plate 112.

boat off a Harbour's Mouth (exhibited in 1842), is the only fully focused and and elaborated part of the painting.[81] The rest is darkness broken only by pin-pricks of flame and a distant citadel, rinsed in light from a crack in the clouds.

In this period of readjustment Martin used designs which he had made in the first place for the Westall–Martin Bible illustrations. They included *Rebeccah at the Well*,[82] *The Death of Jacob*, and *The Death of Moses*.[83] According to Martin's note in the Academy catalogue, *The Death of Moses* was a panoramic view from the top of Mount Pisgah showing Moses gazing over an eternity of Promised Land, encompassing every Biblical landmark from the Dead Sea to the Mediter-renean, from Bethlehem to Calvary. Similarly, in a water-colour version of *Manfred on the Jungfrau* (Pl. 114)[84] the suicidal necromantic hero pauses on the brink of a precipice, in a setting of autumnal russets and seasonless evergreens, and gazes at the far, sublime mountain peaks while preparing to launch himself into oblivion. Restrained at the last moment by a passing hunter, Manfred descends to the valley where he is introduced to the spirit of the mountains, who appears in a drawing, *Manfred and the Witch of the Alps* (Pl. 115);[85] here, in a zone of rock and water far below the tree-line and eternal snows, the spirit, encircled by a rainbow, spells out Manfred's likely fate. The situation is striking-ly similar to that of *The Bard*.

The two *Manfred* water-colours, *The Last Man* (Pl. 67),[86] and *Demosthenes Haranguing the Waves* are as richly worked as any Baxter colour print and every bit as elaborate in design and implication as Martin's largescale oil-

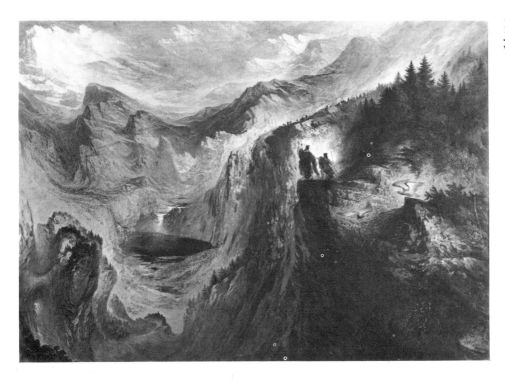

114. Manfred on the Jungfrau, 1837. Water-colour, 15″ × × 21¼″, signed.

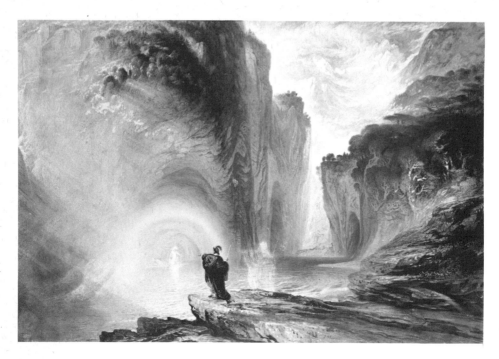

115. Manfred and
the Witch of the
Alps, 1837. Water-
colour, $15\frac{1}{4}'' \times 22''$,
signed.

paintings; and although he made oil versions of at least two of these subjects,
the *Manfred* water-colours in particular must stand as his definitive rendering
of the theme.

Martin made an increasing number of landscape studies from this time on-
wards: views of hayfields, hedgerows, crooked stiles, and church spires nestling
in speckled foliage of gold and green with pale blue shadows were to become his
stock-in-trade in the 1840s. These scenes in Richmond Park and Shepherd's
Bush, in Wales, Yorkshire, Sussex (Pl. 116), and the Isle of Wight (Pl. 117) are
comparable to the topographic water-colours of Copley Fielding, or Samuel
Palmer in his post-Shoreham days. Ideally suitable as designs for steel engrav-
ings and, in many instances, softened into haze around the margins so as to lie
at ease on the paper, they invite the onlooker to become absorbed, by almost
imperceptible degrees, into the central and fully formulated area of each com-
position.

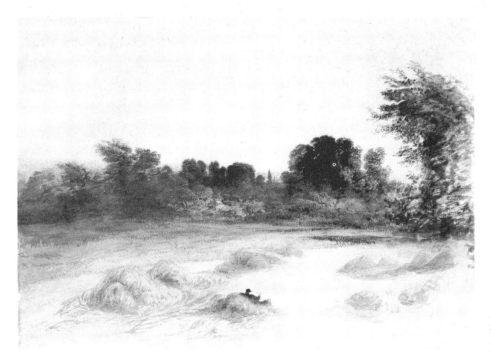

116. Harvest Field.
Water-colour, $9\frac{3}{10}''$ ×
$13\frac{3}{4}''$, signed.

117. The Needles,
Isle of Wight, 1839.
Water-colour, $3\frac{3}{8}''$ ×
$4\frac{7}{8}''$, signed.

CHAPTER VIII

Coronation and Pandemonium

VICTORIA'S CORONATION on 28 June 1838 was in no way as elaborate as George IV's Babylonic festivities seventeen years earlier. Under Lord Melbourne's stage management the ritual challenge offered by the King's Champion at the coronation feast in Westminster Hall was abandoned, and the disappointed Champion, Archibald Montgomery, 13th Earl of Eglinton, arranged a neo-medieval tournament the following summer on his Ayrshire estate. Eighty thousand spectators gathered to see armoured notables assemble and feint around, as though enacting Martin's illustration of the tournament in *Ivanhoe* (Pl. 118), until rain put a stop to the pageantry and everybody splashed away under umbrellas. Despite this anticlimax, the Eglinton Tournament was arguably the point at which neo-Gothic became high fashion. Meanwhile Martin had decided to paint the coronation ceremony. This, his one known venture into contemporary history painting,[1] was both a bid for attention from potential patrons and his début as a painter of Gothic sublimities.

118. The Tournament. Steel engraving by J. R. Willmore after John Martin, $2\frac{7}{8}''$ × $4\frac{1}{4}''$, from the *Literary Souvenir*, 1830.

Traditionally such state-occasion paintings were filled with a featureless and nondescript host of onlookers, all attention being focused on sovereign, archbishop, and a handful of leading dignitaries. It struck Martin, however,

that to introduce portraits into this work would give it interest. Nothing daunted by his want of experience or reputation in this line of art, but feeling he could do that, or anything else if he tried, he set about writing to all the distinguished personages that attended this interesting ceremony, hoping to induce them to sit for him. And his hope was realised.[2]

The most obvious precedent for Martin's *Coronation* was Haydon's painting, commissioned by Earl Grey, of the *Reform Bill Banquet*[3] (held at the Guildhall in 1832); it took eighteen months to complete and contained over a hundred portraits, based, for the most part, on studies made in his studio and even including 'Those noblemen which were invited but did not come'[4] to the banquet. The outcome was a thoroughly uneasy, piecemeal assembly of recognizable faces which anticipated the most elaborate and disjointed of all group-portraits, *Signing the Deed of Demission and Act of Separation*, the formation of the Free Church of Scotland in 1843, recorded by David Octavius Hill with heads, including Hill's, based on calotypes. Far from being an unwieldy composite, Martin's *Coronation* was an exultant celebration. He enlarged upon an incident during the ceremony when the elderly Lord Rolle stumbled while coming forward to do homage. The Queen had moved forward to help him, thus obliging the entire congregation to rise to its feet in the 'sort of feathered, silken thunder'[5] that Haydon had remarked on when the crowds stood for George IV's entry into Westminster for his coronation in 1821. He could have shown the disturbance as a 'vulgar huddle of consternation',[6] (as Lamb had described the melodramatic affright in *Belshazzar's Feast*). Instead he made it a sunlit transformation scene.

When he visited Westminster Abbey to make preliminary drawings he heard the organ playing and the choir sing:

The effect was magical: he was awe-stricken: in all his life he never felt so truly religious or more inclined to devotion to his Maker. He cast his drawing from him, sinking in the deepest prayer on his knees, overpowered by a truly natural feeling of religion. Work was over with him for the day [and he] wandered out of the Abbey into the parks, spending the rest of the day and evening in solemn communion.[7]

He would work from five o'clock each morning and accomplished well over a hundred portraits, some taken from prints and paintings but the majority, with help from his son Charles,[8] from life: 'He succeeded beyond his most sanguine expectation. They came, they sat, they painted. And when they came they saw the works hanging on the walls or in his gallery, and admired them. One bought one, another bought another.'[9]

Apart from the portraits, Martin's *Coronation* (Pl. 119), his first large-scale architectural painting since *The Fall of Nineveh*, makes virtually no concessions to the nineteenth century. It is a ceremonial costume-piece, concerned with a

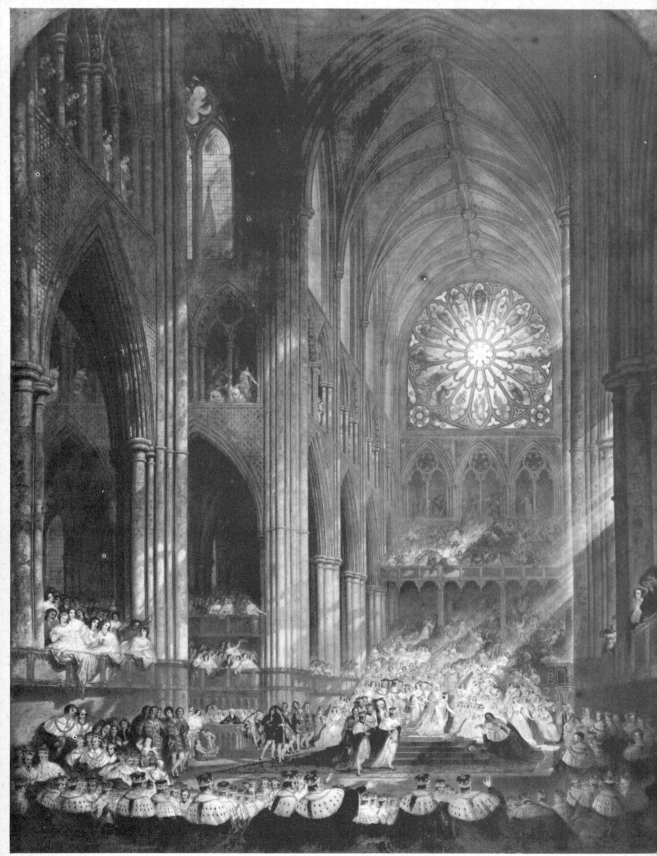

119. The Coronation of Queen Victoria, 1839. Oil on canvas, 92½″ × 71½″, signed.

ritual dating back to the First Book of Kings. The congregation, in silks and ermine, are clustered, like thistledown, in triforium and transept, poised as though about to swarm upwards in the streaming sunlight towards the great rose window;[10] they are accumulated, tier upon tier, like the choirs of charity children assembled in St. Paul's on Maundy Thursdays, singing with 'harmonious thunderings, the seats of Heaven among',[11] a spectacle which so moved Berlioz, when visiting London in 1851, that he later dreamed he was back inside the cathedral, 'the setting of Martin's famous picture' (the Hall of Pandemonium), 'the sunlight and innocence turned glaring, artificial and menacing. Instead of the archbishop on his throne, I saw Satan enthroned; instead of the thousands of faithful grouped around him, hosts of demons and damned darted their fiery glances from the depths of visible darkness.'[12] While St. Paul's could be darkened in the Romantic imagination, into Martin's Hell, Westminster Abbey was, incontrovertibly, his vision of a Gothic celestial city. Beyond the rose window lie the Plains of Heaven.

Martin's painting is a remarkable blend of the melting incandescence of Turner's paintings of this time (Petworth interiors, for instance) and formalized impressions of current affairs, such as those which began to appear a couple of years later in the *Illustrated London News*. But its closest rival was the colour print of the ceremony which George Baxter published in 1841 (Pl. 120) together with a view of *The Opening by Queen Victoria of her First Parliament*.[13] Baxter included over 200 portraits in the Coronation print, which he listed on a key diagram, and went to Buckingham Palace on at least two occasions to draw the Queen in her robes. The prints were dedicated to the Royal family and were advertised with a list of patrons that included the Duchess of Kent, the Dukes of Sussex and Cambridge, the King of Prussia, and the Archbishop of Canterbury.[14] However, despite this useful approval, Baxter failed to sell enough prints to cover his costs.[15] *The Coronation*, one of his largest and most ambitious ventures, was, like Martin's painting, an attempt to force himself and his technique on the attention of potential patrons and subscribers. Given royal support, both Baxter and Martin hoped to be able to cultivate a wide market. Baxter's colour prints were thus, in a sense, a continuation of Martin's mezzotints: works designed as a substitute for oil-paintings, intended to appeal to popular tastes, and therefore produced in large numbers.[16] In the Coronation painting and print their aims and points of view more or less coincided. But while Baxter produced a painstaking and stiff arrangement of figures, Martin burst all formal, commemorative restraints and, 'going on in glory, and working indefatigably', as Ralph Thomas put it,[17] made the ceremony in Westminster Abbey appear a midsummer day's dream.

The painting, mentioned in the *Athenaeum* as 'effective' and as 'painted with more than his customary care'[18] was taken to Buckingham Palace, but Victoria preferred and bought C. R. Leslie's thoroughly seemly and orderly representation of the Communion service towards the end of the coronation. Martin's

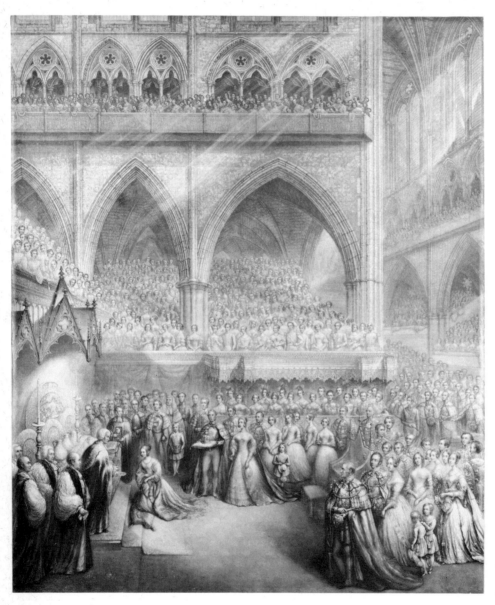

120. George Baxter:
Her Most Gracious
Majesty receiving
the Sacrament at her
Coronation, 1841.
Sepia print, 21¾″ ×
17⅜″, used to
advertise the colour
print of the same
subject.

painting remained unsold until its first public showing in 1844, when the Art
Union pronounced it 'a brilliant transcript of a scene which, although occurring
in our own time, may claim something of the licence of romance', and one likely
to appeal, the critic added, 'to those whose imaginations figure forth a subject
far more grand, exciting and imposing than the cold copies of "bits" of the
ceremony by Leslie, Parris and Hayter.'[19] The painting had, however, attracted
useful attention while still in the making. 'A special satisfaction was received
from one visit,' Leopold Martin remarked: Prince Albert came, examined *The*

Va. The Deluge, 1834 (detail). Oil on canvas, signed.

Vb. The Assuaging of the Waters, 1840 (detail). Oil on canvas, signed.

Deluge, offered 'enlightened criticisms'[20] and, more to the point, asked Martin to paint for him *The Eve of the Deluge*, an enlarged version of the mezzotint in Galt's *Ouranoulogos*. The Duchess of Sutherland, the Queen's Mistress of the Robes, followed his example and commissioned as a sequel *The Assuaging of the Waters*.

'I have found it impossible to express my conception of the subject in one simple design,' Martin explained in the pamphlet he issued to go with the paintings. 'I have, therefore, in order more fully to work out my ideas, given three scenes, illustrating different periods of the event.'[21] *The Deluge*, lingering unsold, or, as Leopold Martin put it, 'still to some extent being repainted', in 1839, was the centre-piece of the trilogy represented the moment of truth when ordered time-scales broke down and chaos reigned for forty days and forty nights.[22] Mankind, caught between rockfalls on the one hand, suffocating waters on the other, with sky above, void below, is shown reduced to total insignificance. The only hope of safety lies in the ark, as far away on its elevated launching spot as the faintest speck of light and hope at the end of a tunnel. The two companion paintings offer significant contrasts, *The Eve of the Deluge* being filled with many signs and portents' proclaiming

> A change at hand, and an o'erwhelming doom
> To perishable beings,[23]

while *The Assuaging of the Waters* shows a few pathetic relics of the antediluvian world preserved, like trinkets, on the slowly surfacing peaks of Mount Ararat. Altogether the three paintings amount to a history of the world, summarized in the terms of documentary mythology and dioramic episodes, compressed into three scenes—evening, midnight, and daybreak. The circling death throes of *The Deluge* reverberate faintly through the other compositions.

The setting of *The Eve of the Deluge* (Pl. 121) is the bland, widespread parkland which always served as Martin's Eden, Plains of Heaven, and Rivers of Bliss. The face of nature is still idyllic; the lower, mundane half of the composition is quite distinct in tone and treatment from the upper, airy regions of sky and mountains where God's signs have already appeared. A comet is plunging down past the moon towards the sun, sunk and trapped in a bed of mist. The mountains too are becoming obscured, and Noah's ark, stuck, as it then appeared, far above any conceivable high-water mark, is a distant irrelevance to the revellers down in the valley who, having pitched their tents in the reassuring evergreen shade of a cedar grove, are dancing the antediluvian age away.

'None except the righteous and Godly can interpret the word of God,' Martin wrote in his *Description of the Picture Belshazzar's Feast* (1821), and the elders, 'some Patriarchs and the family of Noah, anxiously gathered around Methuselah'[24] are attempting, with little more success than the astrologers of Belshazzar's Babylon, to spell out God's signs. While ravens, angels of ill omen, wheel in from the sea and a giant (for 'there were giants in the earth in those days')[25]

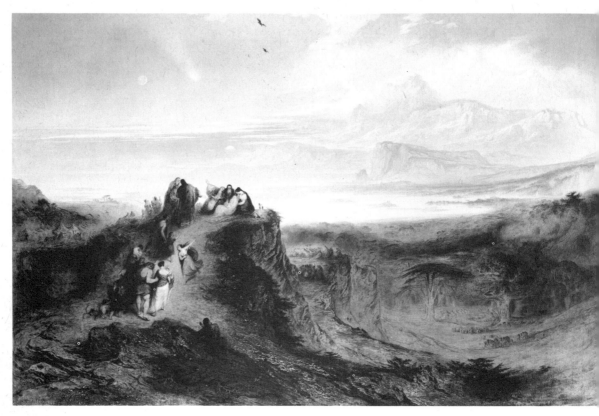

121. The Eve of t[...]
Deluge, 1840. (
on canvas, 56½″
85[...]

hurries to see what is going on, Methuselah, consulting the scroll of his father
Enoch, 'at once perceives the fulfilment of the prophecy—that the end is come,
and resigns his soul to God'.[26] The seven days of God's warning are about to
expire. Soon the foreground rocks, elaborately worked in wrinkled impasto
relief and common to all three paintings, will be overwhelmed by wind and
flood.

Then, in John Galt's description, 'wild shrieks of lamentation were heard and
a voice crying "All the righteous are dead!"'' The scene changed with 'a shudder
that pervaded the whole world, and towers tottering to their foundations were
hurled in ruins to the ground'.[27]

For *The Assuaging of the Waters* (Pl. 122) Martin chose 'that period after the
Deluge, when I suppose the sun to have first burst forth over the broad expanse
of waters gently rippled by the breeze, which is blowing the storm clouds sea-
ward'.[28] He shows the view from the window of the ark: an expanse of sea
broken only by the first mountain peaks left bare by the sinking waters. The rest
of the world lies drowned beneath the sparkling choppy waves.[29] The paint is
laid down with a palette knife, whipped into creamy impasto in the surf, and in
places hardened into gnarled and seaweed-strewn rocks which rear up like petri-
fied breakers. A vivid pink-throated shell and bits of coral beside a pool repre-

162

sent the remains of the old fossilized order, for antediluvian life has turned to mud or stone, remains almost identical to those lying scattered in the foreground of *The Country of the Iguanodon* and *The Sea Dragons as they lived*.[30] A branch, the driftwood remains of the apple tree of original sin from the Garden of Eden, is jammed in a crack in the rocks, and serves as a perch for the raven which rests, its mission accomplished, with its claws gripping the Serpent, drowned but still coiled round the tree. Noah's dove plucks at an olive twig. Scraps of vegetation survive and two water-lilies float in the rock pool, one in bud, the other already opened (Colour Vb, p. 160).

In this vision of the dawn of a new era, Martin cast back to *The Creation* of 1825: life gradually stirring, in misty blues flushing into warmth, the horizon empty but radiant, as though the Creator had just passed by. He designed a frame for the painting[31] encrusted with gilt shells and wavelets, to reinforce the composition. Superficially the benign horizontals and almost caressing movement of the ebbing waters may seem to anticipate the surfing white horses of chain-store prints. However, the underlying sense of fixed, finished purpose serves as an admirable counterbalance to the succession of omens and outbursts in the other two paintings of the Deluge sequence. The earth is now salvaged in readiness for a new covenant between God and Man. In *Paradise Lost* the

122. The Assuaging of the Waters, 1840. Oil on canvas, 52″ × 80″, signed.

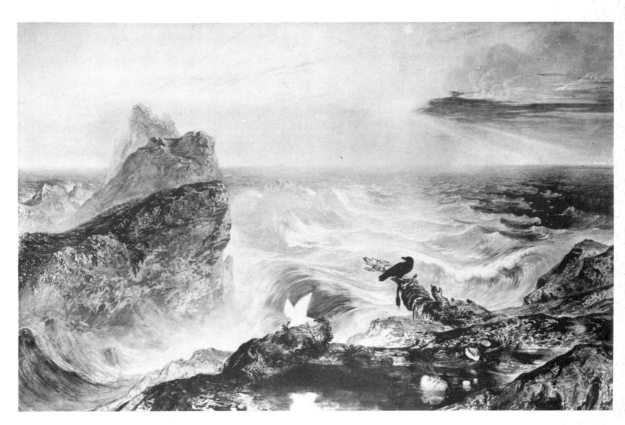

163

Archangel Michael foretells the scene when he warns Adam and Eve that their world will be washed

> Down the great river to the opening gulf,
> And there take root, an island salt and bare,
> The haunt of seals, and orcs, and sea-mews' clang;
> To teach thee that God attributes to place
> No sanctity, if none be thither brought
> By men.[32]

Martin showed *The Eve of the Deluge* and *The Assuaging of the Waters* in his studio on the afternoon of 4 April 1840[33] before sending them to the Royal Academy. Thackeray, in the course of a long perambulatory essay on the exhibition for *Fraser's Magazine*, rather grudgingly remarked: 'A couple of Martins must be mentioned—huge, queer and tawdry to our eyes, but very much admired by the public, who is no bad connoisseur, after all.'[34] Returning to the subject several pages later, to praise Danby's rendering of the Deluge, Thackeray claimed that neither 'Poussin's picture at the Louvre, nor Turner's Deluge,[35] nor Martin's, nor any that we have ever seen, at all stand a competition with this extraordinary performance of Mr. Danby. He has painted *the* picture of "The Deluge".'[36] This painting (Pl. 123)[37], a curiously inert, colourless torrent with bland, white figures groping sluggishly for safety, was exhibited in a private room at 213 Piccadilly; as Martin well knew, a major painting was generally shown to better advantage by itself, without the risk of being skied or eclipsed on the Academy walls. *The Deluge* was Danby's last essay in the epic-cataclysmic manner of Géricault's *Raft of the Medusa*, strained by this time beyond endurance, and owing little or nothing to Martin.

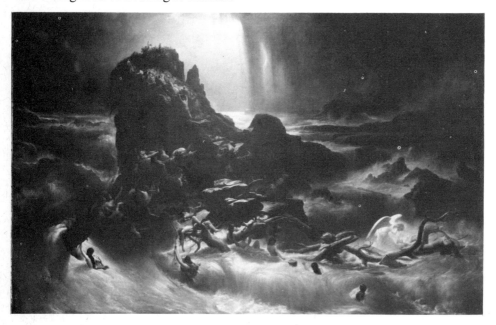

123. Francis Danby: The Deluge, 1840. Oil on canvas, 112″ × 178″.

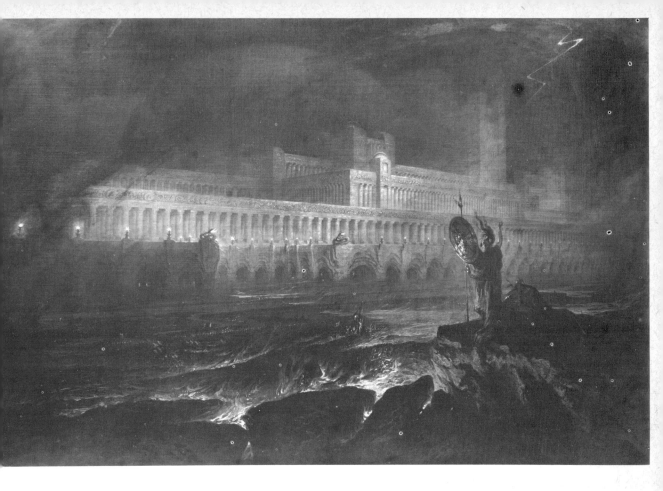

Pandemonium and *The Celestial City and River of Bliss*[38] summarize themes in *Paradise Lost* which had always preoccupied Martin: the ideal contrasted with nightmare satanic cityscapes. Like *The Deluge* trilogy and the majority of Martin's subsequent paintings they represent a refurbishing of compositions which had originated as mezzotints or designs for wood engravings.

Pandemonium had served for years as the climax of firework shows, stage spectacles, and panoramas. Phillip de Loutherbourg had made it the most memorable of his Eidophusikon scenes: 'Here, in the foreground of a vista, stretching an immeasurable length between mountains, ignited from their bases to their lofty summits, with many-coloured flame, a chaotic mass rose in dark majesty, which gradually assumed form until it stood, the interior of a vast temple of gorgeous architecture bright as molten brass, seemingly composed of unconsuming, unquenchable fire.'[39]

Deep in the seventh layer of Hell Martin widened the rough-hewn arches[40] which had stretched along the tunnel in the *Paradise Lost* mezzotint of the *Bridge over Chaos* and made them serve as the foundations of a Pandemonium domed and terraced and set within a void so vast that lightning appears from nowhere and the extremities of the building are lost in the enveloping gloom. In general terms the *Pandemonium* of 1841 (Pl. 124) is much the same as the mezzo-

165

tint of 1824, though Satan has shed his wings to stand clothed, marshalling and reviewing his troops, a domineering figure, like Joshua in front of Jericho, or Gideon, or Moses by the Red Sea. Martin also modified the architecture of Hell, replacing such extravagant details as the Hindu elephants paraded in niches with a serpentine frieze and lowering the profile of the whole range of buildings on to a relatively austere Doric colonnade. For the intimidating batteries of fire-cracker dragons he substitutes more ordinary gas lights, some in the form of serpents but all readily identifiable as early Victorian standard lamps. Martin clearly intended this version of *Pandemonium*[41] to appear founded on fact. Painted in the firm, methodically detailed manner of all his later work, with marked contrast between the handling of rock formations and general atmospherics, *Pandemonium* looks thoroughly convincing, so well resolved that it might almost have been painted from life.

Indeed Martin painted *Pandemonium* about the time that he gave his evidence on mine ventilation to the South Shields Committee,[42] prepared his plans for digging a channel through the Isle of Dogs (to improve navigation on the Thames) and for centralized railway termini, and revised his embankment and drainage schemes.[43] Satan, surveying the scene and giving orders to his minions who swarm like navvies in the molten cutting beneath the embankment of his palace, has become a master-builder or railway king supervising civil-engineering schemes rather more stupendous than anything Martin had ventured to propose in reality.

The whole complex, risen 'like an exhalation',[44] is a dream-fulfilment of the riverside public walk and warehouses that Martin had proposed, fruitlessly, in 1832, 1834, 1836, and 1838; and it bears a distinct resemblance to Charles Barry's perspective plans[45] for the new Houses of Parliament to be built, similarly, on an embankment, with the great Victorian tower at one end and council chamber within. The fiery gulch in front of the palace is a reminder of the Euphrates river-bed, drained on the night of the fall of Babylon, leaving the city, for all its pomp and fortification, ultimately defenceless.

In *The Celestial City and River of Bliss* (Pl. 125) on the other hand, all is sweetness and light. Beyond a hillside founded on natural columns which serve, like those in the underworld, to accentuate scale and form in an almost sculptural sense, the landscape sweeps down towards an ocean of tree tops and the wide River of Bliss, trailing into transcendent infinity where mountains and Celestial City are intermixed. The painting represents the transition from the grave to eternal light, from the foreground, where there are implicit suggestions of death, in the sepulchral caves[46] across the open spaces of Paradise to the shining domes and courts of the heavenly Jerusalem, of which Pandemonium is a mere impious travesty.

Though the painting was based on Milton,[47] within a few years Martin himself had become uncertain as to 'the exact passage of *Paradise Lost* which I intended to illustrate',[48] and the painting draws on other related sources:

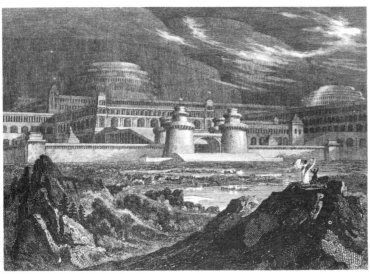

125. The Celestial City and
River of Bliss, 1841. Oil on
canvas, $48\frac{1}{2}'' \times 65\frac{1}{2}''$,
signed.

126. 'Upon the farther
shore, a City stood of
inconceivable splendour'.
Frontispiece engraved by
G. Cooke after John
Martin, $2\frac{3}{4}'' \times 3\frac{7}{8}''$, from
*A Midsummer Day's
Dream*, a poem by Edwin
Atherstone.

Martin's own panoramic views of *The Wye from the Wynd Cliff*, looking over the Severn estuary (Colour VI, p. 178),[49] and his illustrations, 'The city of inconceivable splendour' for Atherstone's *A Midsummer Day's Dream*, of 1824 (Pl. 126) and *The Celestial City*, for Southey's edition of *Pilgrim's Progress* in 1830. Martin's native valley,[50] widened perhaps in retrospect, is the paradise of his childhood

> When, in the light of Nature's dawn
> Rejoicing, men and angels met
> On the high hill and sunny lawn.[51]

Two figures, one angelic, the other human, soar effortlessly above the hillside, the Archangel Michael escorting Adam perhaps, or Christ, the second Adam, or Bunyan's Christian, rising on a trace of almost ectoplasmic cloud. The painting is an allegorical representation of the transition from the temporal to the eternal:

> A death-like sleep
> A gentle wafting to immortal life[52]

the highest form of expression of the romantic sublime.

In *The Excursion of a Spirit: with a survey of the Planetary World, a Vision* (author unknown), published in 1832, the soul of a dead man flies around the solar system with 'the departed Spirits of the Righteous' reconciling 'the idea of a plurality of worlds with the doctrines of our faith':

We took our flight over the most beautiful and delightful country I had then seen, abounding with every variety that nature could bestow, and replenished with an infinite number of happy spirits, reposing or amusing themselves in different groups or parties; whilst others were moving in various directions . . . spread all over the sides of the mountain, which was of gentle acclivity, amongst the most delightful groves imaginable: the verdure being also of a beautiful green to the very summit, where on we finally alighted.[53]

Robert Pollok employed virtually identical imagery in *The Course of Time*, published in 1827:

> So saying, they, linked hand in hand, spread out
> Their golden wings, by living breezes fanned,
> And over heaven's broad champaign sailed serene,
> O'er hill and valley, clothed with verdure green
> That never fades; and tree, and herb, and flower,
> That never fade; and many a river, rich
> With nectar, winding pleasantly, they passed;
> And mansion of celestial mould, and work
> Divine. (i.312–20)

Writing such as this represented Milton's landscape as something of a tourist attraction; and Martin similarly opened out and enlarged his mezzotint illustrations to Milton in these paintings, his meticulous telling details offset by broad,

empty, sunny stretches. The satanic architecture retains its power largely because it so closely reflected Martin's actual planning interests. Although it did serve as a useful, indeed essential, link between the evergreen Eden of Martin's first paintings and engravings of *Paradise Lost*, the Arcadia of Ovid's *Metamorphoses*, and the Muslim heaven of Moore's *The Loves of the Angels*, *The Celestial City* fails to carry much more sense of inspired conviction than the breathless travelogue of *The Course of Time*.

When in 1831 Benjamin Disraeli described, in a letter to his sister Sarah, his first impressions of Jerusalem, he saw the place, as it were, through Martin's eyes:

A Variety of domes and towers rise in all directions; the houses are of a bright stone. I was thunderstruck. I saw before me apparently a gorgeous city. Nothing can be conceived more wild, and terrible, and barren than the surrounding scenery, dark, strong and severe . . . Jerusalem in its present state would make a wonderful subject for Martin, and a picture from him alone could give you an idea of it.[54]

A decade later, although the prospectus for the *Imperial Family Bible* could still describe Martin as one 'whose name and paintings must ever stand in happy connection with the Sacred Volume',[55] inside its ornate covers the steel engravings after Leonardo, Raphael, Poussin, and Martin were interspersed with prosaic landscapes drawn by scene-painters such as H. C. Selous and William Telbin from on-the-spot sketches made by others.

Martin's largely imaginative views of the Holy Land (Pl. 127) were open to challenge on factual grounds. Recognizing the need to strive for as high a degree

127. Titus before Jerusalem. Steel engraving by W. F. Starling after John Martin, $3\frac{1}{2}'' \times 5\frac{5}{8}''$, from *The Cabinet of Modern Art*, 1837.

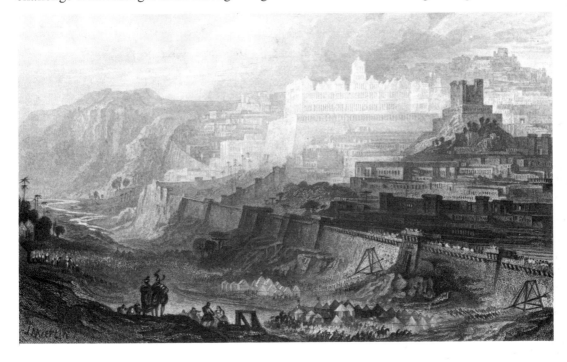

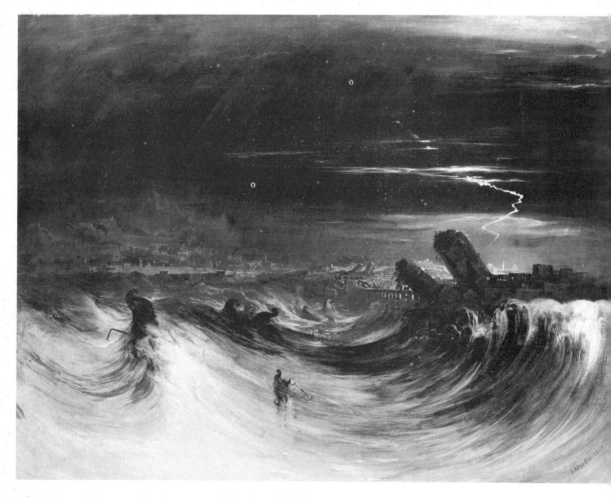

of topographic exactitude as possible, he did his best to come to terms with advances in knowledge. His *Destruction of Tyre* of 1840 (Pl. 128), a sea-piece with ships plunging and rearing like rocking-horses, was developed from the sweeping design in the Westall–Martin *Illustrations of the Bible* which he had based on Turner's rendering of a *Storm over Sidon*, one of 'a series of *matter of fact* views of places mentioned in the Bible as they now exist' published as Murray's *Illustrations to the Bible* in 1834.[56] Part of the reason for the failure of Martin's mezzotint *Bible Illustrations* must have been the competition from publications such as this. Although Martin had mapped out ancient Jerusalem, down to the smallest architectural detail, in the *Crucifixion* mezzotint of 1834, he had never seen the place. His reconstruction had been assembled from a variety of more or less vague and unreliable secondary sources. This, given a certain amount of interpretive licence, had seemed perfectly adequate to Martin and his admirers, Disraeli included. Indeed, working on the principles of Martin's researches and combining military procedures and wishful thinking, General

128. The Destruction of Tyre, 1840 Oil on canvas, 33 × 43⅓″, signed

170

Gordon claimed, in 1883, to have found the true sites of Golgotha and the Holy Sepulchre.[57] But, just as Rome and Pompeii had become the haunts of artists wishing to reconstruct their former glory on paper, Jerusalem and the Middle East became increasingly popular throughout the 1840s with a rising, venturesome generation of historical topographers. The view-painters of Palestine and Egypt—Charles Barry, David Roberts, and the others who supplied sketches for *Finden's Bible Illustrations* (1834–6) for instance—were now joined by artists who wanted to paint Biblical events on their actual sites. Even Sir David Wilkie, the painter of homely genre, arrived in Jerusalem in 1841. Richard Dadd visited Cairo in 1842, and J. F. Lewis worked there for years, while Thomas Seddon and Holman Hunt began their exhaustive expedition in search of truthful Biblical imagery—*Jerusalem and the Valley of Jehoshaphat*, the *Scapegoat*, and *The finding of Christ in the Temple*—in 1851.

As archaeology developed and became popularized, Martin found himself cast in the role of a paternal or prophet figure, like Methusaleh who had been able to read the signs of approaching deluge from the scroll of his father Enoch.[58] Martin's son-in-law, Joseph Bonomi, published an account of Nineveh and its palaces in 1848. A. H. Layard, who made his discoveries at Nineveh in the 1840s, unearthing winged bulls and other marvels, wrote in the introduction to his *Popular Account of Discoveries at Nineveh* (1851):

The architecture of Nineveh and Babylon was a matter of speculation and the poet or painter restored their palaces and temples, as best suiting his theme or his subject. A description of the temple of Belus by Herodotus led to an imaginary representation of the tower of Babel familiar to us from the illustrations adorning almost the opening page of that Book which is associated with our earliest recollections.[59]

These were, unmistakably, Martin's views.[60] Similarly Charles Kean announced, on a playbill for a production of Byron's *Sardanapalus*, at the Prince's Theatre, Oxford Street in June 1853: 'Until the present moment it has been impossible to render . . . Sardanapalus upon the stage with proper dramatic effect, because, until now, we have known nothing of Assyrian architecture and costume.'[61]

So Martin's cloud-capp'd towers faded and came to appear incredible; his enthusiasms were construed as madness, his reconstructions as fancies and follies. The whole character of historical landscape painting underwent transformation. Dreams became sites, excavated, explored, and ransacked. By the 1850s Ruskin was demanding history paintings that preserved the present for all time rather than reconstructed the past, an art of meticulous record rather than theatrical revival of dead days.

Martin's first concern in *The Flight into Egypt* (1842)[62] (Pl. 129) was to stress the exposed and lonely predicament of the Holy Family, the atmosphere of the hurried journey into alien lands rather than the actual route taken. But he also clearly hoped the painting would appear topographically convincing, that, as he noted in the catalogue entry for 'the original design' of *The Death of Moses*,[63] all

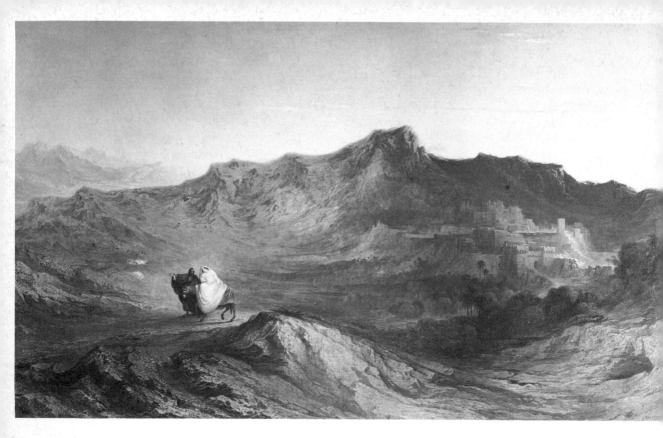

the landmarks would be 'locally correct, according to our existing knowledge of the country'. A comparison between the Bethlehem of *The Flight into Egypt* and the citadel of Gibeon in *Joshua Commanding the Sun to Stand Still* of 1816 shows the extent to which he had revised his architectural ideas in his efforts to paint Biblical landscapes not so much to astonish or surprise as to inform.[64] Bethlehem, dramatized but recognizable enough as a Palestinian hill town, merges into the landscape as the clear sky fades, the moon rises, and a few wispy streaks of cloud point towards Egypt. Shadows run ahead of the fugitives, emphasizing their isolation on the shrivelled complex of the foreground rock-face. Indeed, looking beyond dioramic production values and events and the regulated textures characteristic of steel engravings, *The Flight into Egypt* represents, without doubt, an attempt to convey something of the spiritual intensity of Bellini's *Agony in the Garden* with an almost daguerrotype enactitude. As Martin wrote to Bulwer-Lytton a few years later: 'There are few capable of justly appreciating the *sentiment* in imaginative pictures, the judgment of the less refined critics being limited to the material detail, whilst the higher spiritual aim is entirely overlooked.'[65]

Photography had been publicly introduced to England early in 1839 by Faraday when he announced the successful experiments of Daguerre and Fox Talbot; and although some time passed before the photographer became as mobile as the ordinary artist, the influence of photo-imagery upon the style and the degree of finish considered necessary in a painting soon became apparent.[66] The only

129. The Flight into Egypt, 184[Oil on canvas, 5[× 83", signed

172

written evidence of interest or involvement, comparable to that of Turner, on Martin's part is the label 'Photography' on his cabinet; though certain water-colours made during the last years of his life, notably the tilting composition and lurid contrasts of *The Thames opposite Pope's Villa at Twickenham* (Pl. 130), suggest the influence of the camera. The fogged, soft-focus treatment of the waves in the second version of *Christ Stilleth the Tempest* of 1852 may have been influenced by the milky floodwaters of Danby's *Deluge*; but it is also arguable that Martin, like so many others, was impressed by the smooth, almost oily, appearance of running water photographed with a long exposure.

All the same, Martin's attempts to adapt to new modes of history painting were half-hearted. *The Flight into Egypt* is indeed a 'wild rocky scene, but of every careful execution', as G. F. Waagen described it.[67] The air of almost obsessive thoroughness in the precise foreground, the 'leaning strata artful ranged',[68] that had become evident in the *Deluge* trilogy and in *The Celestial City* reached a degree of nicety bordering on the absurd in *The Destruction of Sodom and Gomorrah* of 1852. For when Martin deployed his mannerisms to serve simply as an end in themselves, his paintings became an easy target for ridicule.

In *Modern Painters*, for instance, Ruskin described *Christ Stilleth the Tempest*[69] as

. . . a black picture of a storm, in which there appeared on the near sea, just about to be overwhelmed by an enormous breaker curling right over it, an object at first sight liable to be taken for a walnut shell, but which, on closer examination, proved to be a ship with mast and sail, with Christ and his twelve disciples in it. This is childish exaggeration, because it is impossible, by the laws of matter and motion, that such a breaker should exist.[70]

He later wrote in *The Stones of Venice* (but deleted the remark before publication): 'Workmen such as John Martin . . . I do not regard as painters at all.

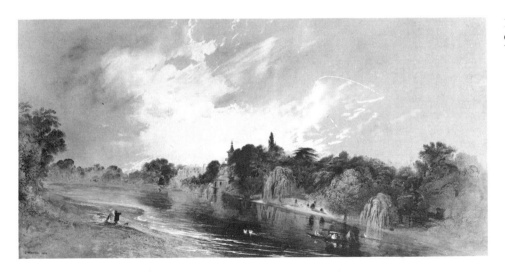

130. The Thames opposite Pope's Villa at Twickenham, 1850. Water-colour, $11\frac{3}{4}'' \times 24''$, signed.

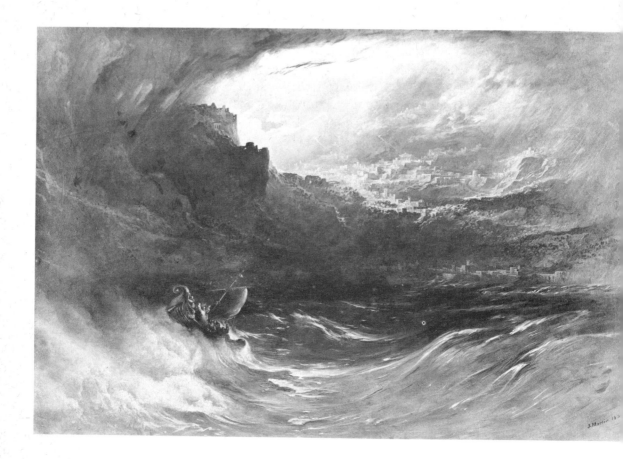

Martin's works are merely a common manufacture, as much makeable to order as a tea-tray or a coal scuttle—such may be made and sold by the most respectable people, to any extent, without the least discredit to their characters.'[71] On this occasion Ruskin was using Martin as a convenient lightning conductor through whom to channel the 'ignorant unmeasured vapid abuse of Turner in the periodicals'.[72]

The original painting which aroused Ruskin's derision is now untraced, but a later, smaller version (Pl. 131) is excessive in virtually every respect, with the city of Capernaum struggling up a mountain-side over several false horizons and eventually disappearing in the mists. The scene, first painted in 1843, the year of the first performance of *The Flying Dutchman*, is of course no ordinary boating incident on the Sea of Galilee. It is, instead, a miracle; a startling, supernatural, and mannerist event in itself:

> Man marks the earth with ruin—his control
> Stops with the shore.[73]

Martin shows the boat swooping at the watershed moment when the waves are starting to subside. The Son of Man can achieve all things, can assuage the

131. Christ Stille[
the Tempest, 185[
Oil on card, 20″
30″, signe[

174

waters and make them stand still, like the Red Sea which, following Moses'
command, had parted to allow the faithful through, subsequently to drown the
infidels. Ruskin's strictures are almost entirely irrelevant; for paintings of
miracles have to disobey all ordinary earthbound rules and make a virtue of
excess. In contrast to Turner's paintings of storms at sea—most notably *Snow-
storm: Steamboat off a Harbour Mouth* (exhibited in 1842)—Martin's tempes-
tuous effects rarely appear to have been based on first-hand experience, but are,
instead, story-tellers' devices.

Ralph Thomas reported that by 1843 Martin claimed to be 'better off now
than ever in his life; he only owes four or five hundred pounds,' and added that
'he had a deal of property by him, and immediate power over such a sum and
more.'[74] Though sales of his prints had virtually ceased, there was some demand
for paintings: *The Flight into Egypt* was bought for £400 by the Art-Union
Committee in 1842 as the prize chosen by its lottery winner,[75] and in about 1845
his largest paintings, *Nineveh*, *The Deluge*, and *The Coronation*, were sold for
2,000 guineas[76] (probably through the agency of Edwin Atherstone)[77] to Charles
Scarisbrick, a young landowner who amassed a fortune in land development in
Southport and employed A. W. Pugin between 1837 and 1852 to rebuild Scaris-
brick Hall, near Ormskirk in Lancashire, in a late Gothic style.[78] It became, in
many respects, more a Victorian Fonthill than a Deepdene, a vast retreat from
the world.

Scarisbrick was Martin's most important patron; he commissioned a replica

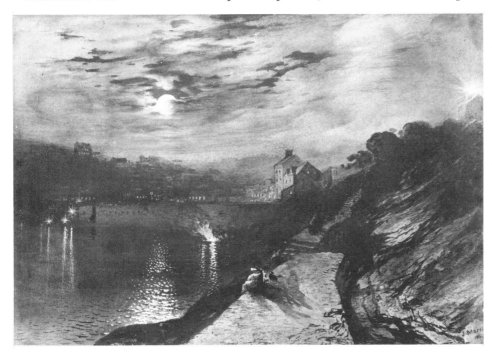

132. A Port:
Moonlight, 1827.
Water-colour, 9¼″
× 13½″, signed.

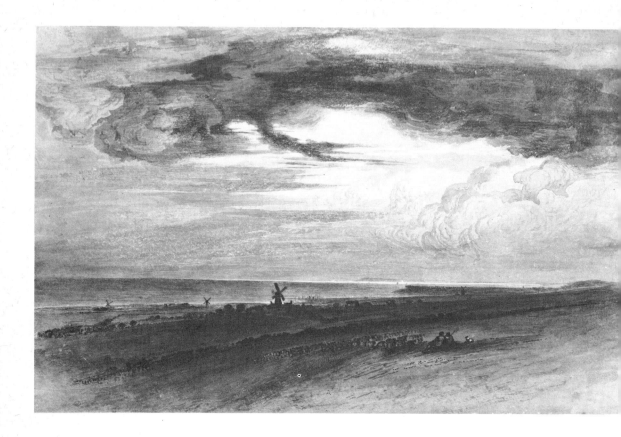

133. Coast Sce
and Thunderstor■
Water-colour, 6■
× 9½″, initialle

of *Joshua Commanding the Sun to Stand Still* in 1848[79] and acquired more than thirty works, including *The Curfew Time*[80] of 1842, *Solitude* (1843) (Pl. 138),[81] *The Hermit* (1843),[82] *The Fall of Man* (1845),[83] and *The Paphian Bower* (1823),[84] which were sold with the rest of Scarisbrick's huge collection, at Christie's in May 1861, for over £23,000.

Though the price paid by Scarisbrick was much less than Martin had originally hoped (he had apparently asked, 2,000 guineas for *The Fall of Nineveh* alone when it was first exhibited),[85] it was enough to restore him to a semblance of prosperity. There was also, it appeared, a ready sale for his water-colours and small oil-paintings, their price 'regulated by the amount of work rather than by their size',[86] whether repeat versions of paintings like *Marcus Curtius* or drawings of picturesque spots along the South Coast: *A Port: Moonlight* (Pl. 132),[87] a *View of Eastbourne*,[88] or a *Coast Scene and Thunderstorm* (Pl. 133).

In *The Lonely Sea Shore* (Pl. 134), perhaps the most impressive of these elongated compositions, a storm flag waves over a distant cluster of huts as the clouds drain away, leaving a fresh pale sky and a sea assuaged in the calm of dawn. *Canute Rebuking the Flattery of his Courtiers* (Pl. 135)[89], painted on the same shoreline, is every bit as considered and as elaborated as an oil-painting; the sky is awash with long drawn out streaks of clouds like those in earlier

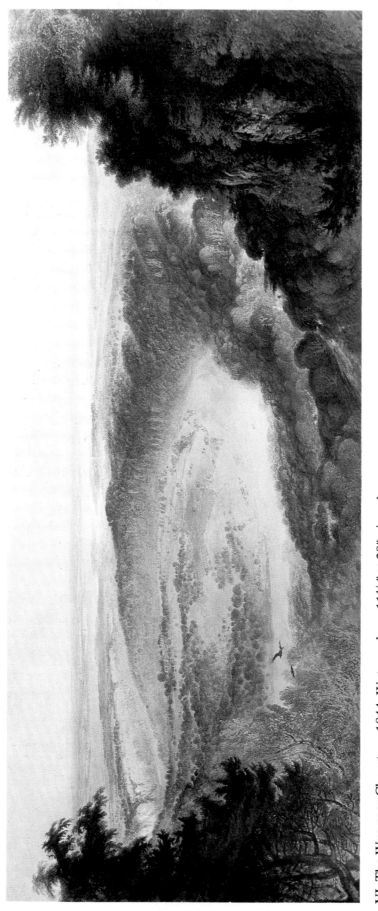

VI. The Wye near Chepstow, 1844. Water-colour, 11½″ × 28″, signed.

scenes of this sort, for example, *The Last Man* and *The Destruction of Pharaoh's Host*. The whole scene is ominously still. The waves are leaden, the rolling surf, the King and Queen's robes, and the trail of shingle and seaweed dribbling up the beach forming a surging controlling rhythm. Canute has challenged time and tide but, as he well knows, the sullen waves will not hold back, for he has no Divine Right to interfere with God's established order. Confronted with the endless empty seas of time, he turns demonstratively to harangue his nonplussed courtiers, as Martin's Last Man rebuked the dying, glowering sun.

Every detail in *Canute*, as in the comparable *Assuaging of the Waters*, has purpose and meaning. Indeed, in these paintings Martin anticipated, to a considerable degree, Ruskin's demands for a trustworthy knowledge about a place rather than a reconstruction of the past. Both are historical landscapes rendered in the terms of contemporary topography; for, just as he superimposed his views of ancient Babylon on his Thamesbank perspectives, Martin now made little

134. The Lonely Sea Shore, 1842. Water-colour, 11″ × 30¾″, signed.

135. Canute Rebuking the Flattery of his Courtiers, 1842. Water-colour, 12¼″ × 32½″, signed.

distinction between the two genres. *The Lonely Sea Shore* is more than a prepara-
tory background to *Canute*. A view of *Richmond Park* (Pl. 136), containing
similar implications, shows the artist reclining pensively in a sunny glade shel-
tered with bracken, his book, perhaps a copy of Thomson's *Poems*, set aside:

136. Richmon
Park, 1843. Wate
colour, 11″ × 27⅞
signe

> Perhaps from Norwood's oak-clad hill,
> When meditation has her fill,
> I just may cast my careless eyes
> Where London's spiry turrets rise,
> Think of its crimes, its cares, its pain
> Then shield me in the woods again.[90]

Above Chepstow, where he painted the River Wye (Colour VI, p. 177) curving in
a lazy, beguiling way below the wooded Wynd cliff towards the gleaming Severn
estuary, the landscape served as a reminder of childhood scenes: the Allendale

137. The Valley
the Tyne, n
Native Count
from near Hensha
1842. Water-colou
10¼″ × 26¼″, signe

gorge near Staward Peel and the broad Plains of Heaven of *The Valley of the Tyne, my Native Country from near Henshaw* (Pl. 137)[91] which he exhibited at the Royal Academy in 1841 with a quotation from the *Lay of the Last Minstrel:*

> Still, as I view each well-known scene,
> Think what is now, and what hath been,
> Seems as, to me of all bereft,
> Sole friends the woods and streams were left;
> And thus I love them better still
> Even in extremity of ill.

Solitude (Pl. 138)—a ruminative figure, standing on a hillside bathed in the glow of the sun—appeared with the lines:

> Ye woods and wilds, how well your gloom accords
> With my soul's sadness.

This and other paintings on similar themes—*The Curfew Time* from Gray's *Elegy*, Goldsmith's *Hermit*, a *Morning* and an *Evening in Paradise*,[92] *The Judgment of Adam and Eve* and *The Fall of Man*—were all bought by Scarisbrick.

The *Athenaeum* described *The Hermit* as '. . . one of those landscapes which show without parallel or archetype . . . The light that lingers upon the wood-crowned heights to the left of the scene, the depth behind depth of shadow, which have enfolded the valley, the solemn retirement of the path leading up-ward to the hermitage, are all in our artist's best manner: the two figures, it may

138. Solitude, 1843. Oil on canvas, 20″ × 34½″, signed.

139. The Judgment of Adam and Eve, 1843. Water-colour 9⅛″ × 13⅛″, signed.

be added, not in his worst.'[93] Two other figures, in a water-colour version of *The Judgment of Adam and Eve* (Pl. 139)[94] standing at the mouth of a cave and plunged in darkness and despair, cling to each other, deprived of any other support. The sense of bitter-sweet regrets and impending oblivion implicit in such paintings was, of course, something of a romantic commonplace: 'In every breeze the Power of Philosophic Melancholy comes.'[95] If Martin's imagery was modishly distressed and thus all the more saleable, it nevertheless reflected his continuing anxiety and increasing sense of isolation and disappointment.

Martin was now in his mid-fifties. His eyesight was weakening and no longer fit for the strain of engraving (his last mezzotint, *The Flood*, in Thomas Hawkins's marathon poem *The Wars of Jehovah*, was published in 1844),[96] and although he continued to press his plans, republishing the sewage and embankment schemes virtually every year until 1850, he still received no concrete success and little recognition. At his own particular request he gave evidence, briefly, to the Royal Commission on Metropolis Improvements of 1843, only to have his ideas, predictably, dismissed.

That year, in much the same spirit of last-ditch optimism, he also decided to enter the competition for commissions to decorate the interior of Barry and Pugin's new Palace of Westminster. He chose as his subject King Canute demanding punishment for himself on a charge of murder; for it he adopted, according to Ralph Thomas,

. . . [a] style quite new to him, foreign to all his previous studies. His great success was in architectural perspective; besides which he has, in late years, wonderfully succeeded

180

in pure landscape, now in oil, now in watercolour. And now he's working at the highest flight of the art, an historical life-size figure-picture. Nothing daunted by the difficulty of the work and the novelty of the labour, he has bought bones and figures and set to work with heart and soul to study anatomy. The attempt is noble, and to fail is no disgrace.[97]

His two cartoons, *The Trial of Canute*[98] and a related study of two heads,[99] were exhibited alongside fifty-five other designs in Westminster Hall in July 1843. Like Dadd's *St. George and the Dragon* and Haydon's *Edward the Black Prince* they were rejected from further competition,[100] while scene painters, such as Edward Armitage and Henry Selous, who both in their time imitated Martin, took several of the awards. The most successful entries, by Dyce and Maclise, were Germanic in style and spirit, rather different from Martin's idea of 'an historical life-sized figure picture'. Ruskin condemned Martin's painting for largely irrelevant reasons and attacked him (in the second edition of *Modern Painters*) for 'this Denner-like portraiture of sea foam', and suggested, '. . . if the time which he must have spent on the abortive bubbles of his *Canute* had been passed in walking on the sea-shore, he might have learned enough to enable him to produce, with a few strokes, a picture which would have smote, like the sound of the sea, upon men's hearts for ever.'[101] A comparison between Martin's design of *Moses: the Giving of the Law*, on the title-page of the *Imperial Family Bible*, and the large, suave composition by J. R. Herbert chosen for the Peers' Robing Room in 1847 shows something of the gulf that had developed between the fading generation of romantics—Martin, Haydon and, indeed, Turner—and the younger, differing talents of Dyce and Maclise and the prodigious Millais.[102]

Haydon, who had exhibited a painting of *Curtius Leaping Into the Gulf* at the British Institution a few months before, was even more depressed than Martin at this crowning humiliation in Westminster Hall. According to William Bell Scott, he 'suddenly changed into an aged man'[103] and took to painting Napoleons at a desperate rate for as little as £5 a head. In 1846 he exhibited *Nero Burning Rome* and *The Punishment of Aristides* at the Egyptian Hall, only to find his work totally eclipsed by Tom Thumb, the 31-inch dwarf, on show next door. A month after the exhibition closed he killed himself.[104] 'Every competition has its dark side, dark, with the red light of the nether pit staring through it,' Bell Scott later remarked.[105]

At the time of Haydon's death Martin was preoccupied with the Metropolitan Sewage Manure Company Bill, intended to give the Company the right to build a sewer alongside the Thames. Despite objections, from the water companies in particular, the Bill was passed; but the scheme later ran into opposition from the Thames Navigation Committee. Complaining that his ideas were overruled[106] and that the enterprise was mismanaged Martin left the company for good in 1851. He produced his last pamphlet in 1850, intending thereby to establish his 'claim to originality of designs, which just now bids fair to be smothered by a

host of newly-created competitors'[107] and, though he could make no public mention of it, Martin no doubt also hoped to secure, by way of recognition, a civil list pension.[108]

The setbacks probably explain Martin's move, in 1848, from Allsop Terrace, where he had lived for thirty years, to Lindsey House in Cheyne Walk near Battersea Bridge, a building part-occupied, at different periods, by Joseph Bramah, the Brunels, and Whistler. Though imposing, No. 4 Lindsey Row, the central section of the house, was smaller than 13 Allsop Terrace. But by then Martin's household had decreased considerably. With the exception of Isabella, who acted as his secretary, his daughters were married and his sons employed and independent.[109] Lindsey House had no specially built studio or work-room, but, as he had disposed of his print-making equipment some years before (probably around 1841), this imposed no difficulties, and his studio, on the first floor, was large enough to accommodate his last paintings, *The Last Man*, 1849, *The Destruction of Sodom and Gomorrah*, 1852, and the *Last Judgment* trilogy, 1851–3, which gradually developed into a major project three years later. His drawing-room, next to the studio, overlooked Greaves's boatyard and the Thames. The view became a source of inspiration: 'On fine moonlight nights Greaves, or his father when they were out late and there was a fine sky, at Martin's request, would knock at his door and the old man in his nightcap would appear on the balcony and go to work at the skies for hours.'[110] In much the same vein Leopold Martin, describing a visit with his father to Turner's hideaway, a 'squalid place' at 6 Davis Place, a little further up the river, mentions Turner pointing and saying: 'Here you see my study—sky and water. Are they not glorious? Here I have my lesson night and day.'[111]

The night sky in *King Arthur and Aegle in the Happy Valley* (Pl. 140), probably the first of Martin's Chelsea paintings and his nearest approach to a large-scale *plein air* composition, appears to be the product of direct and sustained observation on Martin's part. The subject came from *King Arthur*, by Bulwer-Lytton, whose praise of Martin as 'the greatest, the most lofty, the most permanent, the most original genius of his age'[112] no doubt deserved some sort of complimentary response. Despite all Lytton's disclaimers, and features borrowed from every romantic quarter, the poem (published in 1848) emerges as the sort of epic he imagined Milton would have written 'had he prosecuted his original idea of founding a heroic poem upon the legendary existence of Arthur'.[113] King Arthur himself, the Dark Age hero, belongs to both classical mythology and medieval legend. Some of the scenes are obviously couched in Martin's idiom. Icebergs, for instance, crash together like the mountains of Martin's *Opening of the Sixth Seal*[114] and in the fifth book Lancelot climbs a cataract in pursuit of a dove and, like Sadak,

182

He gains at length the inter-alpine bed,
Whose lock'd Charybdis checks the torrent's way,
And forms a basin o'er abyssmal caves,
For the grim respite of the headlong waves.
Torrents below—the torrents still above![115]

140. King Arthur
and Aegle in the
Happy Valley,
1849. Oil on canvas,
$48\frac{1}{4}''$ × $72\frac{1}{2}''$, signed.

Rather than illustrate these too obviously appropriate set pieces[116] Martin chose to represent the Happy Valley—a retreat founded by Etruscans as a sanctuary from the empire-building aggression of the Romans—a timeless place, a Garden of the Hesperides, where

> Alp on Alp shuts out the scene
> From all the ruder world that lies afar.[117]

Arthur has been waylaid, brought to the valley to marry the Queen, get her with child, and thereupon be executed. However, for a while, love prevails,

> . . . as Night gently deepens round them, while
> Oft to the moon upturn their happy eyes—
> Still, hand in hand, they range the lullëd isle[118]

83

Total darkness is creeping across the painting; for the bliss of the Happy Valley proves to be only a passing episode for King Arthur, a temporary escape out of time, while the stars spell out their warning:

> Each astral influence unrevealing shone
> O'er the dark web its solemn thread enwove.[119]

As always, Martin followed his set text faithfully, adding his own blend of almost visionary memories and straight observation:

In endeavoring to illustrate the poetry I have represented a lovely night I saw some twenty years ago, which was so remarkable for the exceeding clearness of the air and splendor of the heavenly bodies as to have never been effaced from the mind. If I have failed in doing justice to the poet I trust, at least, that I shall please the astronomers, as I have taken every pains to make my picture astronomically correct.[120]

Arthur and Aegle is difficult to decipher: not through any significant deterioration in the painting itself but because, like so many of Martin's works, it has 'to be placed with the horizontal line on a level with the eye and in a strong light'.[121] Under these conditions the landscape gradually takes shape in the inky obscurity[122] and, although the two lovers stand stilted in their embraces, the snowy peaks of the mountains, the gleaming fleeces of cloud, and the moon and stars intercede on their behalf, mapping out and sustaining the prevailing mood.

Far from being areas of preconceived turmoil, with wheeling cloud formations and fizzing lightning, the skies of both *Arthur and Aegle* and the oil-painting of *The Last Man* (painted later in 1849) were clearly based on observation from the balcony of Lindsey House and added to the ready-darkened land like the moonlit superimpositions of early photography. 'It is a wild preternatural affair,' the *Athenaeum* commented in 1849; 'In the world which Mr Martin has here represented the critic can have no possible place,' to which Martin responded in a letter to Lytton: 'There are few capable of justly appreciating the *sentiment* in imaginative pictures, the judgment of the less refined critics being limited to the material detail, whilst the higher spiritual aim is entirely overlooked.'[123]

In *The Last Man* (Pl. 141),[124] a sombre, weather-beaten nocturne in silver, blue, and smouldering crimson, Martin represented God's creation disarrayed, stilled, and turned ashen beneath flurried, livid clouds. An old man, the body of a girl beside him, calls the sun to witness the end of all things. 'A grand, wonderful picture,' Charlotte Brontë described it, 'showing the red sun fading out of the sky and all the soil of the foreground made up of bones and skulls.'[125] In the previous water-colour version of the subject[126] bodies, like smothered, petrified inhabitants of Herculaneum, had been heaped around the headland where a Christ-like, beseeching figure stood alone:

> The sun had a sickly glare,
> The earth with age was wan,
> The skeletons of nations were
> Around that lonely man . . .[127]

But in the painting of 1849 further literary references complicated the scene. In her novel *The Last Man* published in 1826, the year of Martin's first and now untraced composition on the theme, Mary Shelley describes the wanderings of an ever-diminishing handful of survivors. Eventually, after his daughter's death, the hero finds himself alone. He loads a boat with provisions, the few books he needs, Homer and Shakespeare among them, and together with his dog embarks on a final macabre Grand Tour: 'Thus around the shores of deserted earth, while the sun is high, and the moon waxes or wanes, angels, the spirits of the dead, and the ever-open eye of the Supreme, will behold the tiny bark, freighted with Verney—the LAST MAN.'[128] With this in mind Martin presented

> . . . a dead great city's grave,
> Where, when the moon is at her full, behold
> Pillar and palace shine up from the wave!
> And o'er the lake, seen but by gifted seers,
> In phantom bark a silent phantom steers.[129]

The derelict seaport in the distance is comparable to Macaulay's description of a future London in which a visiting New Zealander sits on London Bridge and gazes across the stagnant Thames to a city of empty warehouses and a crumbling St. Paul's.[130]

141. The Last Man, 1849. Oil on canvas, $54\frac{1}{2}'' \times 84\frac{1}{2}''$, signed.

Like Goldsmith's Traveller, Coleridge's Ancient Mariner, or Galt's Wandering Jew, the Last Man is the perennial outsider, the tourist scale-figure employed by topographers to measure up against the wonders of the world, the time-traveller who sees events of past and future all imprisoned in an everlasting present. However, although Martin's imagery was based in part, at least, on literary precedents, the universal death of Campbell's poem and of Mary Shelley's novel was brought about by plague, and his renewed interest in the subject may have been further stimulated by the cholera of 1849, the worst in England since the first outbreak eighteen years previously.

In June and October 1849 Charles Kingsley visited the East End districts where the cholera was raging and, infuriated by the immovable vested interests of the private water companies, whose supplies were largely responsible for the epidemic, preached three sermons on the subject (subsequently published under the title *Who Causes Pestilence?*). Later, and perhaps to greater effect, in *Alton Locke* he described Jacob's Island in Bermondsey:

The light of the policeman's lantern glared over the ghastly scene . . . over strange rambling jetties, and balconies, and sleeping sheds, which hung on rotting piles over the black waters, with phosphorescent scraps of rotten fish gleaming and twinkling out of the dark hollows, like devilish grave-lights—over bubbles of poisonous gas, and bloated carcasses of dogs, and lumps of offal, floating on the stagnant olive-green hell broth.[131]

Kingsley's terms exactly correspond with Martin's painting, which, in its turn, sets the idea of a conclusive Black Death within an awe-inspired perspective of time.

Adam, the First Man, had observed the Great Sea Dragons of the Crustacean age sprawled over antediluvian foreshores, exhausted by their climb on to land from one epoch into the next. Noah had seen mankind clambering frantically to escape the flood. Surrounded by death, the Last Man's only reaction is impotent rage and, eventually, resignation. Despite the brave statement in his letter to the *Illustrated London News* of March 1849 that he was resolved 'never to abandon his projects',[132] and more than twenty years after he had drawn up his original plans for untainted water supply, Martin, finding the obstacles more insuperable than ever, himself adopted the role of the Last Man. Pointing his finger, he anticipated the rhetorical question of *Who Causes Pestilence?* by taking up Thomas Campbell's words:

> I saw a vision in my sleep
> That gave my spirit strength to sweep
> Adown the gulf of Time!
> I saw the last of human mould
> That shall Creation's death behold
> As Adam saw her prime.[133]

186 Martin represented death as a vast silence spread over land and sea. The bodies

are already merging with the bedrock, like the iguanodon in the frontispiece to the first edition of Mantell's *Wonders of Geology*[134] and the seaweed draped on the mountain peaks of *The Assuaging of the Waters*. The Last Man is a lamenting Methusaleh, a man in God's image, a puny imitation of the Creator who had swept along the horizon of *The Creation of Light*, now about to pronounce an end to history and, like the Bard, plunge to his own death in universal darkness:

> The world was void,
> The populous and the powerful was a lump,
> Seasonless, herbless, treeless, manless, lifeless,
> A lump of death—a chaos of hard clay.[135]

CHAPTER IX

The Last Judgment

FROM 1848 to the end of his life Martin spent part of every year in the Isle of Man, staying with his brother-in-law, Thomas Wilson, a draper. The island (probably the furthest he ever travelled from the shores of England) became his summer retreat and, eventually, his burial place. During these last years he continued to produce paintings, such as *The Enchanted Castle*[1] and *Twilight in the Woodlands* (Pl. 142),[2] on the perennial theme of solitary vigil with intimations of mortality. Though effortlessly picturesque, Martin's means of expression remained heartfelt, closer to the ruminative intensity of Dyce's *Gethsemane* of 1850 than, say, the views Samuel Palmer produced around this time of a sunkissed, Ruritanian Italy.

In 1851, besides exhibiting the original design for *The Death of Moses on Mount Pisgah*[3] at the British Institution (and painting a no doubt related story of *Joshua Spying out the Land of Canaan* (Pl. 143), in which Joshua looks over a chasm towards a distant, prophetic figure, kneeling below a cross), Martin supplied an illustration for Goldsmith's *Traveller* (engraved by Leopold Martin for an Art-Union publication). The design was commonplace, though the subject ideally suited Martin: a world-view,

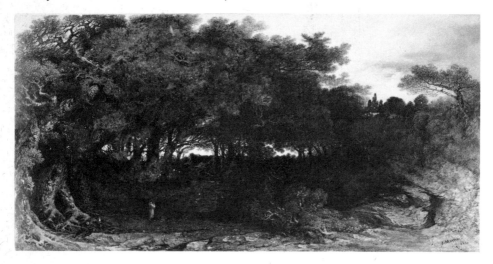

142. Twilight in the Woodlands, 1850. Oil on paper laid down on board, 14½ × 29½″, signed.

. . . where a hundred realms appear;
Lakes, forests, cities, plains extending wide,
The pomp of kings, the shepherd's humbler pride.[4]

A water-colour (Pl. 144),[5] closely related to the illustration but far more impressive, is dominated by a mass of rock which, by blocking half the composition, like the foreground linking devices to a panorama, greatly increases the impact of the vista and serves as a gateway to the Happy Valley or the Plains of Heaven.

143. Joshua Spying out the Land of Canaan, 1851. Water-colour, 14″ × 29″, signed.

144. The Traveller, 1851. Water-colour, 15″ × 30″, signed.

145. Christ's Gloriou[s] Coming. Water-colour, $4\frac{3}{4}'' \times 7\frac{3}{5}''$, signed. Unused study for *Illustration[s] of the Bible* by Westall and Martin.

In June 1851 Martin signed an agreement with Thomas Maclean[6] authorizing a steel engraving of *The Last Judgment* to be made by Charles Mottram from his design. Two outline drawings,[7] dated 1845, suggest that, some years before, he had planned to produce a pair of paintings or engravings, linking the Crucifixion and Christ's Second Coming; while an even earlier study, *Christ's Glorious Coming* (Pl. 145), probably intended for the Westall–Martin *Bible Illustrations*

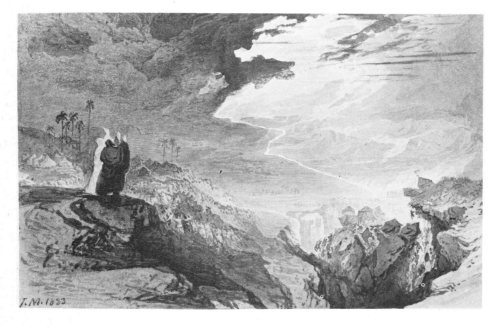

146. The Rebellion of Korah, 1833. Sepia, $3\frac{3}{8}'' \times 5\frac{1}{2}''$, signed.

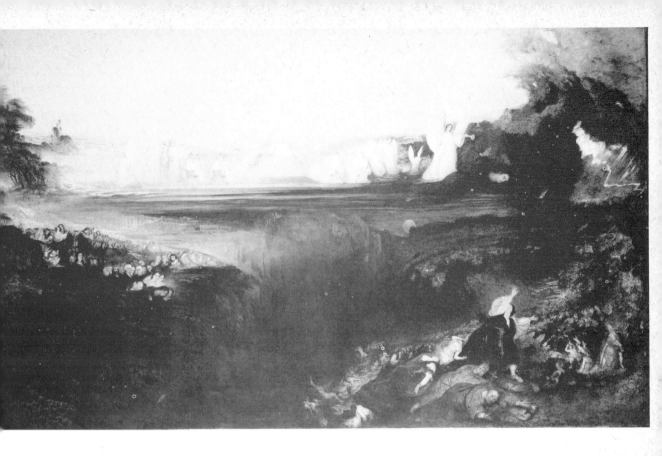

147. The Last
Judgment, 1853. Oil
on canvas, 78″ ×
128″, signed.

but not used, shows the righteous assembled beneath the Judgement Seat watching awestruck, like the bystanders in *The Destruction of Pharaoh's Host* or *The Rebellion of Korah* (Pl. 146),[8] as the damnèd spill into oblivion. The painting of *The Last Judgment* (Pl. 147), Martin's most ambitious composition, is a recital of all the alternatives that had concerned him throughout his career, themes developed long before ranged in final confrontation: the world of the righteous and that of Satan torn along a decisive lightning-stroke dividing-line. The last bridge over the Valley of Jehoshaphat[9] is collapsing. A handful of figures dash across it, to the relative security of Jerusalem. The bridge proves to be the one Satan had built to last for all time, over chaos. Unregenerate sinners grovel as the world falls apart. Herodius' daughter, 'arrayed in purple and scarlet',[10] with a rosary dangling from her wrist, supplicates in vain; others still cling to their symbols of office—a crown, a crucifix, and an episcopal staff—as they scrabble for survival (Pl. 148). The armies of Gog and Magog fight to the death; elephants, horses, an entire railway train tumble into the bottomless pit. Above, the hawk-eyed Avenging Angel hurls himself into action, redoubling the terror, the weeping and gnashing of teeth. Meanwhile, across the great divide, the 'nations meeting in universal brotherhood'[11] are ranked on the slopes of Mount Zion, wreathed in royal cedars, awaiting the call to appear before the throne. Martin derived this head-and-shoulders assemblage from James Barry's mural *Elysium: or the state of final retribution* (Pl. 150) at the Society of Arts and produced a

191

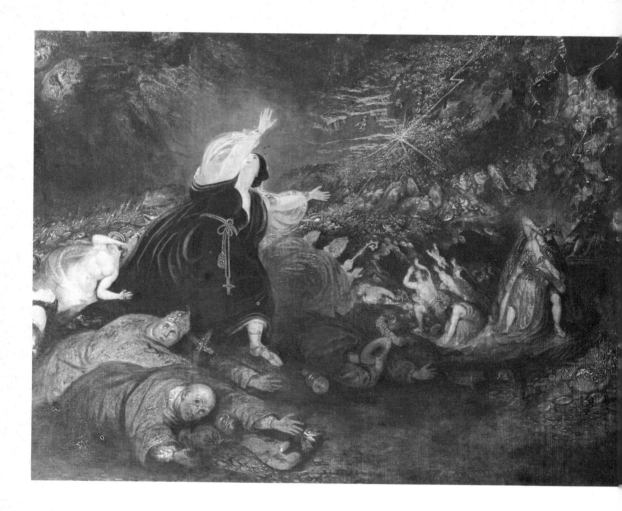

148. The La
Judgment, 185
(detail): th
Damne

piecemeal effect resembling the composite photographs of eminent personages which began to appear at this time.

The long list of Martin's choice immortals includes Wyclif, Luther and Ridley (Martin's 'great ancestor'—as his mother had impressed on him),[12] Dante, Gower, Milton, Shakespeare, Michelangelo, Rubens, Dürer, and Wilkie. Newton (whom Martin could insert without protest following the death of William Martin, 'the Anti-Newtonian Philosopher', early in 1851), Galileo, Franklin, and Watt represent the scientists; Canute, Colbert, Hampden, and Washington the patriots. Behind them, fading into anonymity in the distance, hosts of 'Holy Martyrs, Christians &c, Philanthropists and Worthies . . . and Holy & Virtuous Women' wander towards the high plateau of heaven where, beside the crystal palaces of the New Jerusalem, elders, seated on benches in the sea of glass and wearing crowns encrusted with jewels, witness the passing of judgement (Pl. 149). Having sounded the last trump, the four Archangels, posted at the corners of the throne, survey the end to all perishable things far below.

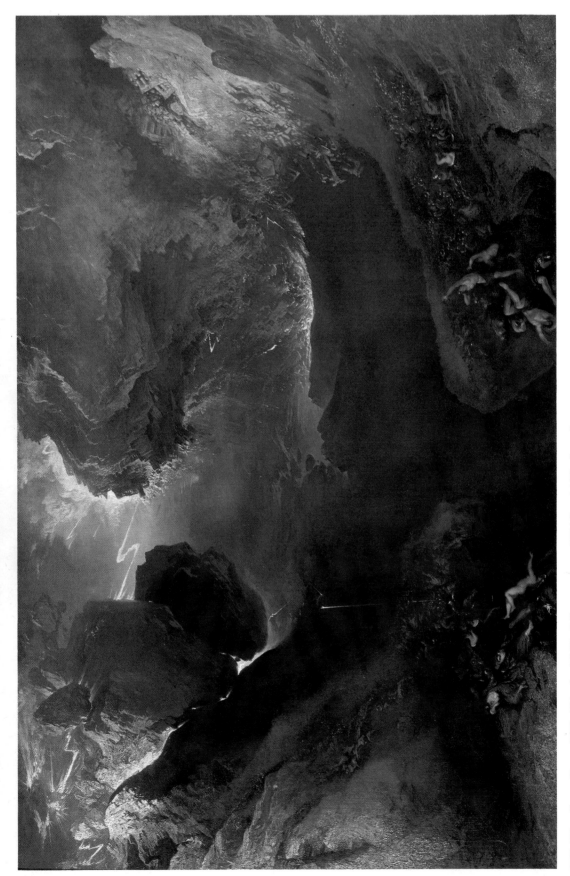

VII. The Great Day of His Wrath, 1852. Oil on canvas, 75½″ × 118″, signed.

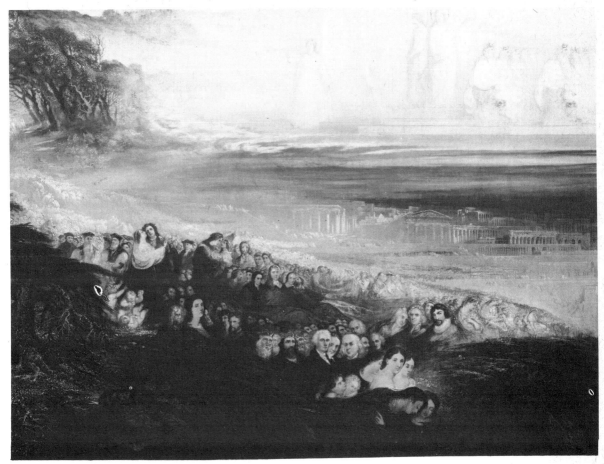

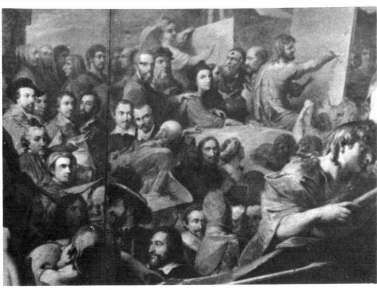

149. The Last
Judgment, 1853
(detail): the Blessed
and the New
Jerusalem.

150. James Barry:
Elysium (detail),
from mural at the
Royal Society of
Arts, *c.* 1784.

Unwieldy and, indeed, as complicated as Martin's double-decker versions of his embankment schemes, designed with a multiplicity of ends in mind, it is not altogether surprising that *The Last Judgment* needed more detailed exposition, by means of a key-diagram, than any of Martin's earlier paintings and that, nearly a hundred years later, one owner decided to cut the painting into four strips to cover a screen. The extremes of horror and bliss, the entire course of history from the age of Gog and Magog to that of the railway are contained, diagrammatically, in a series of vignettes. Martin's sense of cohesive order is evident in the predominant, tawny maroon tone of the land mass, the unearthly purity of the heavenly sphere, and the balancing, sloping curves leading from each side towards the central void; though the splutter of rocks on the right-hand side, the confusion of scales between the Avenging Angel and the worthies on the lush slopes of Mount Zion give a strained, cobbled air to the painting.

The Last Judgment was Martin's attempt to reconstitute in his own, nineteenth-century terms the visionary authority of Tintoretto's *Paradise*[13] or Dürer's engravings of the Apocalypse. The no man's land of fire and brimstone was based, Leopold Martin maintained, on 'the glow of the furnaces, the red blaze of light' observed by his father in Wolverhampton and the Black Country.[14] Jerusalem was laid out with neo-classical streets and citadels like the New Town and Castle Rock of Edinburgh. But Martin's chief problem—whether to attempt to treat the subject in terms of the authentic topography of a Finden Bible illustration, or to plunge wholeheartedly into the realms of mystery play—was left only half resolved. Details that proved particularly troublesome or occurred to him as after thoughts were painted on paper and added to the canvas; for the painting was primarily intended, after all, to serve as a guide for the engraver. Though it lacks the sombre, oppressive quality of the painting, Charles Mottram's engraving is a clarified rendering of the design, considerably reduced, in both scale and impact, from a sermon to a tract.

Early in 1852 Martin completed a large, oil version of *The Destruction of Sodom and Gomorrah* (Pl. 151).[15] Though undoubtedly influenced by Turner, the painting is more closely related to apocalyptic productions like the *Lisbon Earthquake*, a cyclorama which opened at the Colosseum in 1850.[16] Just as the diorama painters treated each catastrophic incident, whether storm, whirlwind, or earthquake, as a set of special effects to be either superimposed on or inserted within the fixed scenery, with only sound effects or the flickering play of light on strategically disposed rocks or buildings to connect the dynamic action to the static display, Martin represented the disaster from a fixed point of view, well beyond the footlights. The towers, like those in *The Destruction of Tyre*, melt and fall well within the perimeter of the distant, self-contained, picture plane, masked by silhouetted perimeter walls and palm-trees.[17] Like the shaggy tempest of *Stormy Sea and Burning Town* (Pl. 152) (an oil sketch probably dating from this period), the firestorm rages out of all proportion. Lot hurries with his daughters across the hard-baked foreground of what proves to be a fiery version of the

151. The Destruction
of Sodom and
Gomorrah, 1852.
Oil on canvas, $52\frac{1}{2}''$
$\times 82\frac{1}{2}''$, signed.

152. Stormy Sea and
Burning Town. Oil
on canvas, $13\frac{1}{2}'' \times$
$21\frac{1}{2}''$.

setting of *The Last Man* towards the shelter of the city of Zoar, while his wife, glancing back at the collapsing cities behind her, is struck by lightning, turned to salt, and planted in the middle of the composition as a focal warning, pointing up the enormity of the destruction.

On 23 June 1852 Martin signed a second agreement with Thomas Maclean, authorizing print versions of two further subjects from the Book of Revelation on which he had already begun work: The End of the World and The Plains of Heaven.[18] The Judgment pictures thus developed, like the earlier Deluge trilogy from the middle composition outwards, into an all-embracing panorama. For, while *The Last Judgment* had inevitably emerged a confused phantasmagoric medley, the others involved no half-measures, no compromises.

With *The Great Day of His Wrath* (Colour VII, p. 193)[19] Martin achieved a more stupendous, convulsive sense of terror than ever before. There were precedents: in the falling rocks of Danby's *Opening of the Sixth Seal*[20] and his own *Deluge*, in the terror of Sadak struggling along on the lip of the precipice, and the heroic death-leap of Marcus Curtius. They resounded in an almighty cataclysm:

> On spacious canvass, touched with living hues,
> The conflagration of the ancient earth![21]

Martin's outlook sank from the vantage point of all his previous paintings into the pit. The key figure of St. John the Divine, who had appeared in Martin's earlier representations of the Apocalypse,[22] vanished; for the painting represents the end, the moment of truth when the entire human race, including even prophets, artists, seers, must be overwhelmed. The wrath pours down on all alike, on figures taken from the Laocoön and Michelangelo's *Last Judgment*,[23] on 'the devoted heads of the awe-stricken multitudes'[24] who 'said to the mountains and rocks, Fall on us, and hide us from the face of him that sitteth on the throne, and from the wrath of the Lamb'.[25] With flags still flying on the overturning citadels, the man-made wonders of the world, together with the rocks of ages, explode (Pl. 153),

> The bottom of the mountains upward turned,[26]

and appear suspended opposite the shattered mountain peaks of natural architecture, a split second before crashing head on (like the sun, moon, and comet racing into conjunction beyond), collapsing in fragments, obliterating mankind, an avalanche

> . . . filling up
> The ripe green valleys with destruction's splinters.[27]

Recent cleaning of the painting, involving the removal of deliberately blackened coats of varnish, has revealed the full extent and significance of the vacuous central area. This black void (the 'sublimity of lamp black' which Ruskin had scornfully remarked upon in 1840)[28]—the outer darkness of the *Paradise Lost* mezzotints, the gaping sluice of *The Deluge*, the opening chasm in *The Last*

Judgment—is the true subject of the painting: the blank heart of the storm into which all creation, all matter—people and buildings represented in perfunctory dots and dashes of cream, mauve, and scarlet—will shower like dust and ashes, vanish into anti-matter, reverting to the state of things before time began, when 'the earth was without form, and void; and darkness was upon the face of the deep'.[29]

Where *Sodom and Gomorrah* had been a peepshow with inset convulsion, and *Christ Stilleth the Tempest* and *The Destruction of Tyre* had been stabilized by the concentration on details in the middle of each picture, leaving the borders only vaguely energetic, Martin's final representation of catastrophe was large enough physically to engulf the onlooker. The valley walls on the edges of the canvas, sides, bottom and top, are painted so forcibly, in globs of pigments laid on with a palette knife, so streaked, scrambled, furiously agitated (Pl. 154) that, far from being a peripheral blur, the cascading rocks loom overhead with almost stereo-

197

scopic effect. For lack of any central focus for his attention, the onlooker finds himself swept, confused and disorientated, into the inner circle of the painting towards some dislocated perspectival vanishing-point—a black hole in space.

While the ruddy glare of *The Great Day of His Wrath* can be traced back to *Sadak* and to the mine shafts, ironworks, and kilns that Martin had come across in childhood, *The Plains of Heaven* (Pl. 155) is the dream landscape of his native Tyne valley, his Eden and Arcadia, his Xanadu and Isle of Cytheria. Here the blues and greens of tranquillity fade into ethereal infinity. The beckoning, tree-lined vistas on the left-hand side of *The Last Judgment* led directly into the Plains of Heaven. Long before he came to paint it in 1853, Martin had identified his scene:

> Adown the cedarn alleys glanced the wings
> Of all the painted populace of air,
> Whatever lulls the noonday while it sings
> Or mocks the iris with its plumes,—is there.[30]

The Plains of Heaven is an extension of the landscape of *The Celestial City and River of Bliss* of Atherstone's 'City of inconceivable splendour', and the related mezzotint in the *Paradise Lost* illustrations with the great domes of 'the new Jerusalem coming down from God out of heaven, prepared as a bride adorned for her husband',[31] a mirage in the haze, swimming above deep ultramarine

154. The Great Day of His Wrath, 1852 (detail).

wáters, over plains, valleys, and mountains. Most of the details had appeared in previous compositions—the waterfalls in the water-colour of Goldsmith's *Traveller*, the elegant glades in *Richmond Hill*, 1851 (Pls. 156 and 157), the angels and cherubs chasing butterflies in *The Paphian Bower*—but never before on such a startling, transcendental scale. Every line, from the horizontal spread of the cedars on Mount Zion to the clusters of angelic figures barely hovering above the lawns, floats in harmony; the face of nature has been rendered timeless, and so, inevitably perhaps, the roses, flourishing so brightly in the foreground, look waxen (Colour VIII, p. 208).[32]

Martin's painting is the grand finale of the age of the sublime and the picturesque, the last flowering of the gardens of Sezincote and Fonthill, the Campagna of Claude and Turner. It was inspired above all by the Miltonic tradition, the paradise, for instance, visited by Moore's Epicurean:

Vistas opening into scenes of indistinct grandeur, labyrinths of flowers, leading by mysterious windings, to green spacious glades full of splendour and repose. Over all this, too, there fell a light, from some unseen source, resembling nothing that illumines our upper world—a sort of golden moonlight, mingling the warm radiance of day with the calm and melancholy lustre of Light.[33]

In 1861 Mrs. Henry Wood described *The Plains of Heaven* in *East Lynne* in terms which convey something of the impact the painting first made:

Oh, you should have seen it! There was a river, you know, and boats, beautiful gondolas they looked, taking the redeemed to the shores of heaven. They were shadowy figures in white robes, myriads and myriads of them, for they reached all up in the air to the holy city; it seemed to be in the clouds, coming down from God. The flowers grew on the banks of the river, pink and blue and violet; all colours, but so bright and beautiful; brighter than our flowers are here.[34]

Unified by theme, by the sweeping, curving transition from the thunderous earthbound horror on one extreme to limpid tranquillity at the other, the Judgment paintings were best seen as a single panorama, brilliantly lit from above, in a draped and darkened room, so as to appear all the more revelatory and astonishing. As George Wilson, who owned the paintings for a while,[35] wrote in a pamphlet intended to reintroduce the paintings to an increasingly indifferent public:

The rising generation will hardly understand the *furore* these extraordinary Pictures created when they were first exhibited in 1854. I remember the crowd of visitors waiting to be admitted to the Exhibition, and when I at length entered the darkened chamber, and noted the effect produced upon the multitude, and how all seemed to be carried away from worldly thoughts, and, as it were, intoxicated by the solemn, the lofty, and the majestic inspirations of the master mind of the great Artist, youth that I was, I would have rather been John Martin than King of England.[36]

Survivals from the age of phantasmagorias and the Picturesque in the age of the calotype and of Thomas Seddon's on-the-spot view of *Jerusalem and the Valley of Jehoshaphat* of 1854, incongruous in the year Frith's *Ramsgate Sands* and Holman Hunt's *Awakening Conscience* and the *Light of the World* appeared at the Royal Academy—almost as though the Prince Regent had come to haunt the Crystal Palace—the three Judgment paintings are, none the less, Martin's masterpieces. *The Last Judgment* is little more than a remarkable and unwieldy cartoon. But the two other paintings contain Martin's most characteristic qualities: his startling command of scale, his skill in combining sweeping areas of gestural paint with precise, stylized detail; his ability to sustain belief beyond normal bounds, to make the inconceivable seem possible.

Having completed *The Plains of Heaven*[37] Martin went to stay on the Isle of Man, and there suffered a stroke, 'the result of an over wrought brain', according to his friend Dr. Elliotson, the mesmerist, who added, 'With him ten years were equal to a life-time with those of average mould. Nothing could be done; he might linger for a month or two, but there was no hope.'[38] In December he signed a will with his mark. Speechless and with his right hand paralysed he refused food, '. . . giving his attendants the impression that in so doing he was acting upon some principle which he had accepted in his own mind, though he had no longer the power to explain the why and wherefore.'[39] Thereafter he 'sat during the day and part of the night with a fixed gaze on the sea and sky, watching the effects of light and shade'.[40] Charles Martin made a drawing of him in

156. From Richmond Hill, 1851. Oil on paper laid down on canvas, $20\frac{1}{4}'' \times 36\frac{1}{4}''$, signed.

157. The Plains of Heaven, 1853 (detail).

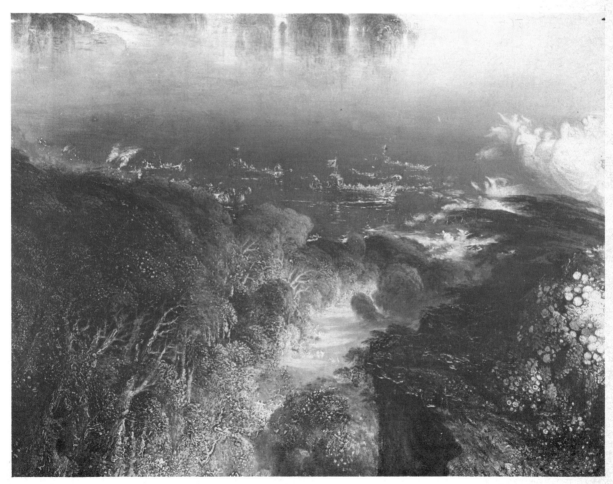

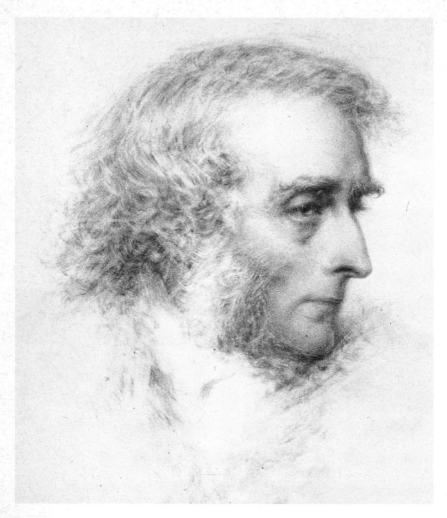

158. Charles Martin:
John Martin, 1854.
Chalk, $23\frac{3}{4}'' \times 19''$.

this state (Pl. 158), a couple of weeks before his death on the evening of 17 February. 'His end', Isabella Martin wrote, 'was most tranquil and beautiful. He passed away without effort or apparent pain, and was conscious to within an hour of his death. He seemed perfectly aware that he was dying, but to have no fear of death.'[41] He was buried in the Spittall vault in Kirk Braddan churchyard on the island. *Mona's Herald*, the local newspaper, predicted that 'Strangers from all parts of Europe, landing on these shores, will, like pilgrims journeying to some far-famed distant shrine, visit the grave of Martin.'[42] The Spittall vault was bricked up in 1914.

Appropriately enough, at the time of his death the Judgment paintings had been brought to Newcastle to be exhibited for a month at the Victoria Rooms in Grey Street, the centre of John Dobson's neo-classical redevelopment of the town. 'Comment is useless,' the reviewer in the *Newcastle Courant* had concluded; 'The mind must fill up what the pen fails to describe.'[43] Maclean subse-

quently showed them in many provincial towns, including Birmingham, Leicester, and Chester. In the spring of 1855 they were put on show in the Hall of Commerce in Threadneedle Street.

The *Art Journal* reported:

These pictures have made the tour of the country and grave doctors of Oxford, sober-minded merchants of Bristol and enterprising manufacturers of Manchester have hurried from solitary chambers and marts of business to inspect these nondescript works of Art, and enter their names as subscribers to the engravings preparing from them. Surely there is something most unhealthy in this exhibition of the public taste.[44]

It went on to suggest that Martin's 'mind was, no doubt, thrown off its balance during the last years of his life, when these pictures were painted; it had so long dwelt among the unearthly, that he had lost all control over it in his works.' The reaction of the *Illustrated London News* to the paintings was more typical: 'At the touch of his pencil, as of a magician's wand, earth and heaven are riven, resolved, as it were, into chaos, out of which a magnificent structure of his own creation is reared.'[45] In July 1855 the paintings were transferred to the West End. The *Athenaeum*'s Fine Art Gossip for 7 July described them in a carping way, stressing their archaic, even quaint, characteristics:

Three of Martin's greatest pictures, after much noisy puffing in the City, have now moved westward, and are exhibiting in the Hanover Square Rooms. 'The Great Day of Wrath' seems to us by far the best. 'The Last Judgment' is full of feeble and mannered drawing; and 'The Plains of Heaven' is too material for anything but the Elysian Fields. With all respect for the memory of Mr. Martin—for his imagination and his religious feeling—we could not resist smiling at the tide of incongruous heads floating along the foreground of 'The Last Judgment,'—bag-wigs, ruffs, and a variety of feeble and stiff portraits, from Franklin to Raphael. This picture has all Barry's faults, with little of his genius. Mr. Martin's Heaven is a place of blue sky, blue water, and many acres of roses and peonies, all of which might be lotted out in a small catalogue, in spite of the appearance of infinity, in which the poet-painter delighted. . . .[46]

Following the publication of the engravings in 1857,[47] the three pictures were taken to the United States and on their return were shown once again in most of the larger towns of England. They appeared at Hexham, the nearest suitable exhibition place to Haydon Bridge, in 1872.

George Wilson, who presumably inherited the paintings shortly after, was apprehensive about exhibiting them in the heyday of Poynter, Leighton, and Alma Tadema: 'How will they be received now? I confess to some feeling of fear that the religious element that in my youth was so strong in our midst, has, in a measure, passed away. The Nanas, White Slaves, and similar Pictures, seem now to be the fashion, and I ask myself, is the change for the better?'[48] So, inevitably, the Judgment paintings became cumbersome embarrassments. They hung for a while in Alexandra Palace, then in the Doré Gallery in Bond Street. *The Plains of Heaven* was shown in the 'Victorian Era' exhibition in 1897. Eventually

having been taken off their stretchers and put into store for years, they were sold at auction on 17 October 1935 for under £7, almost exactly a hundred years after the *Library of the Fine Arts* had spoken of: 'The marvellous imaginations of Martin, which, though they astonish the eye, do not affect the feelings, and therefore, not being based upon nature, have no lasting hold on our affections'[49] This was the lowest point in the decline in Martin's reputation.

The Seventh Plague, The Last Man, and several of Martin's water-colours were included in the great Manchester Art Treasures Exhibition of 1857.[50] J. B. Waring, writing in the *Manchester Guardian*'s *Handbook to the Exhibition*, said, reasonably enough: 'Martin stands alone—a psychological . . . rather than a pictorial phenomenon—a strange hybrid between arithmetician and artist. That his works have certain great qualities of vastness and effect cannot be denied—and they are like nothing else.' But, for all their unique distinction, no works by Martin appeared in the 1887 Jubilee Exhibition, and Madox Brown, whom Martin had encouraged as a young man and who had no doubt seen *The Fall of Nineveh* in Brussels where he had been an art student in 1833, wrote to protest to the *Magazine of Art* in 1888: 'I cannot know the reason for these omissions, but they require explanation.' The Editor explained that Martin's paintings 'were said to be in a ruined condition'.[51]

The reaction, or rather revulsion, against Martin's art was spontaneous and complete; for popular tastes inclined towards new forms of the Ideal, propagated in reproduction: Hunt's *Light of the World*, Poynter's *Faithful unto Death*, Watts's *Hope* cringing on top of the globe. Where Martin's work was remembered at all it was generally considered something of a childhood taste, lingering in Bible picture books.[52] Sickert remarked:

My uninfluenced interest certainly went out, first of all to Martin's *Belshazzar's Feast*, and then to Cruikshank's *Bottle* in the South Kensington Museum. It is only when the mist and the driving rain of intellectual snobbishness, coinciding more or less with the period of puberty, and the consequent 'urge' to compete in agreeing with old ladies a little older than ourselves, reach us, that we become ashamed of our true loves and fidget from novelty to novelty after the will o' the wisp of authority.[53]

Writing in 1906, Sir Wyke Bayliss maintained that, for largely historical reasons, Martin deserved better of posterity:

I am not now considering what I like or dislike. When Martin was engaged upon his first picture, Turner was painting his 'Crossing the Brook.' When Martin was finishing his last picture, Millais was beginning his 'Christ in the Carpenter's Shop.' I may prefer the Millais, or the Turner. That is not the question. My point is that *no Landmark in Art should be allowed to disappear*. Why have we no example of Martin's art in our National collection? Is imagination so poor a thing or so common—that we can safely cast it aside?[54]

Until 1972 no major painting by Martin was put on permanent display in a national collection in Britain.[55]

CHAPTER X

Martin: 'the astonished gaze'

'IF IN his life-time Martin was over-praised, he was certainly unjustly deprecated afterwards,' said Richard Redgrave.[1] All too often Martin's achievement has been measured against strictly limited aesthetic regulations; as the *Library of the Fine Arts* predicted in 1831,[2] he has had 'much to answer for at the bar of Taste'. Any excessive nineteenth-century apocalyptic painting that comes up for auction is still more than likely to be identified as the work of 'Mad Martin', the leading nickname to spring glibly to mind in what tends to be considered a peculiarly English eccentric tradition: an art of fits and starts and false alarms. Authentic Martins, however, in particular the paintings that he chose to exhibit, are precisely established scenes and visions. Others, notably the perfunctory oil sketches for the *Paradise Lost* illustrations, were only intended as working studies, to establish the general disposition of tones in the mezzotint. Martin's reputation as a printmaker has suffered similarly, both from debased reprints and from mannerist copies or interpretations of his style. But, once separated from the surrounding chaff, the proof impressions of his mezzotints emerge complex, forceful, and coherent. It rapidly becomes apparent that there was method in Martin's so-called madness. His invention was carefully reasoned, but governed by what he described as 'the higher spiritual aim'.[3]

Martin deliberately designed *Belshazzar's Feast* to 'make more noise than any picture ever did before':[4] the words of an artist determined to make his name and fortune by means of visual assault and battery. Far from being a megalomaniac's fantasy or an opium-eater's dream, the painting was a calculated risk. Its successors—*The Destruction of Herculaneum, The Deluge, The Fall of Nineveh*— were developed on the same lines, each one intended both to surpass the preceding work and to overcome competition from other artists and scene-painters. 'Perhaps since Michael Angelo startled Rome with his *Dies Irae*, in the Sistine Chapel, no painter has ever so arrested the attention of a nation,' Sir Wyke Bayliss wrote, from distant recollection, in 1906.[5] But Martin's immense popular success—estimated by the circulation of his prints, his household name, rather than by the sale of individual paintings—was bound to be succeeded by a period of eclipse. However much he attempted to modify and update his novelty values in the successive phases of his career, the time inevitably came when 'men of taste'

regarded his art, and indeed all Regency romanticism, as an archaic, emotive sham. Like Ward, Haydon, Etty, and, indeed, Turner, Martin lived to see his preoccupations and means of expression outmoded and, it may have appeared, invalidated. By 1845 Thackeray was observing mockingly in *Fraser's Magazine* that 'Grave old people, with chains and seals. look dumbfoundered into those vast perspectives and think that the apex of the sublime is reached there.'[6]

The sense of scale and authenticity that made Martin's paintings so extra-ordinary in their heyday—like dramatized Canalettos for would-be time-travellers—was easily discredited in the light of fresh, on-the-spot evidence. Layard's excavations at Nineveh in the late 1840s served to make Martin's historical landscapes appear utterly fanciful. Meanwhile trespassers into Martin's preserves (his brother William was among the foremost with his version of *Belshazzar's Feast* of 1826) trampled over his imagery, turning his 'expression of the contrast of finity with infinity'[7] into simplistic toy-town extravaganzas. J. P. Pettitt's *Golden Image in the Plain of Babylon*, exhibited at the Royal Academy in 1854, was described at the time as 'an attempt to portray Nineveh, partly from Mr. Layard's book, partly from Mr. Charles Kean's scenery, arranged after the architectural vagaries of the late John Martin ... An image as high as our cathedral of St. Paul appears surrounded by miles of palaces, thousands of priests, millions of votive fires, and billions of an Assyrian population.'[8] As J. B. Waring remarked in 1857: 'When we have learnt the secret—the recipe—for them, [Martin's paintings] they will be found (if we are not mistaken) to require for their production but little of what is commonly understood by imagination.'[9] The 'poet-painter',[10] the engineer of idea, was revealed as something of a confidence trickster.

Martin's secret or 'trick', which his pupil John St. John Long had been so anxious to learn, was, essentially, the updating and revision of themes traditional in Flemish and Italian painting: Christ in Glory, Paradise and Hell, Jerusalem and Babel; landscapes, from Vesuvius to the Netherlands, which Martin, of course, knew only through the eyes of other artists—Berghem, Brill, Vernet, Claude, Turner, and Wilson. And, although it was obviously in his interest to let it be known that a painting such as *Belshazzar's Feast* was entirely original in concept, the fact remains that Martin's 'decisive interpretation'[11] of the prophet closely resembles the figure of Daniel in Benjamin West's earlier version of the subject.[12]

Martin's early attempts to win recognition were conducted according to established procedures. His extravaganzas fell within the approved limits of the 'terrible' and the 'sublime'. But his conclusive rejection by the Royal Academy in 1820 (when he received no votes in support of his candidature) caused him to venture beyond the bounds of artistic respectability into the wide, and more obviously commercial, world where, more famous than an Academician but less secure, he, like Haydon, nursed his grievances and became determined to prove the art establishment wrong.[13]

In *Belshazzar's Feast* Martin forced the spectator to follow the story through the stages outlined in the catalogue: from the initial view-halloo impression of *The Subject* and *The Scene*, through the various acts of the drama—*The Protasis* and *Epitasis*—to face, at length, the *Catastrophe*, spelt out on the wall and in the sky. This, far more than the crystal-clear prospects of the painting of *The Fall of Babylon*, proved Martin as 'eminently strong in what no other artist has attempted while weak in those points in which he could be compared with others'[14] —with Barry, Fuseli, and Turner. Even when Danby appeared a few years later as a serious rival, Martin took precedence; for he simply had to state his own terms, whereas Danby, somewhat self-consciously, was obliged to follow suit.

At this point Martin, in a sense, passed beyond compare. Ten years later the author of the essay on 'The Genius of John Martin' argued that: 'It would be worse than false to attempt to set up a standard of artistical comparison between John Martin and any other artist of the present day, or between his work and the work of any other artist. In this respect he resembles Sir Joshua Reynolds; he can be judged if only by himself and not by comparison with another.'[15]

Martin's paintings were never quite as outrageous as his more jocular critics liked to make out. For many years they were considered acceptable and impressive enough to hang at Deepdene, Stowe, Howick, and Buckingham Palace.[16] The small version of *The Destruction of Herculaneum* at Tabley House, commissioned by Sir John Leicester, one of the few Martins to be seen in its original setting, is a fitting companion to paintings by Fuseli, Ward, and Turner. Even the glass-painting of *Belshazzar's Feast*, produced for advertising purposes, ended up at Syon House.

However, Martin did find difficulty in finding buyers for some of his most important works. *Joshua*, *The Fall of Nineveh*, and *The Deluge* lingered for years, unsold, only suitable for public exhibition. Had it not been for two patrons in the 1840s, J. M. Naylor and Charles Scarisbrick, these paintings would have remained on his hands, cumbersome evidence of the hazard of spending a year or more on a single work which might draw the crowds but failed to attract an individual wealthy enough to buy it. The investment of time and effort on a large mezzotint was almost as great but, for Martin, the rewards (up to the 1830s at any rate) were more assured. The illustrations to *Paradise Lost* established him as the leading popular artist of the day, renowned for dramatic imagery rather than painterly skills. The prints made his name in the provinces, in France, and in America, and thereafter his reputation as a painter was left stranded.[17]

Martin had few successors; indeed he exhausted his own painting tradition and, for all their magnificence, the three Judgment paintings have a left-over air, like Great Sea Dragons from a lost world. From time to time such unremarkable painters as Edward Armitage and Albert Goodwin revived his themes in works predestined to an eternity of reproduction in Sunday school reward books.[18]

Gustave Doré, who held his first London exhibition at the Egyptian Hall in

1868, was the only artist who approached Martin in terms of showmanship. His Scripture Gallery in Bond Street included such immense paintings as *The Fall of Babylon*, *The Christian Martyrs*, and *Christ Leaving the Praetorium*. But these vast, slick, empty canvases, exhibited with footlights and hushed commentaries, have little in common with Martin's paintings, which are generally remarkably small in relation to the sizeable impression they create.[19] Of course Martin's imagery can be traced further, in Symbolism and Surrealism.[20] He anticipates Böcklin, Bresdin, and Ensor, the Pompeian Brussels of Delvaux's surrealism and Magritte's matter-of-fact castles in the air. But these resemblances are superficial. The imaginative documentary interests which had led Martin to collaborate with John Galt and which had excited Bulwer-Lytton's wild admiration were developed further by writers rather than painters—by Rider Haggard, Conan Doyle, Jules Verne, and H. G. Wells.

Heavily dependent on chosen texts, designed to be studied with the help of catalogue notes, Martin's compositions were essentially diagrams fleshed out in paint or mezzotint. His graphic work, from the *Characters of Trees* to the Westall–Martin Bible illustrations, amounted to a complete range of visual schemes which he and his imitators extended and redeveloped until they became so familiar they lost all sense of invention.

'In painting one picture he paints a thousand,' *Arnold's Magazine of the Fine Arts* observed in 1833: 'If one large picture were to be cut up into several smaller ones, they would each form a most exquisite and beautiful bit of art and, if our memory serves us right upon this subject, such an idea as this was at one time contemplated.'[21] Martin's *Album*[22] is his *Liber Studiorum* and, in a much wider sense, his manifesto. He probably made it towards the end of his concentrated period of printmaking, in the early 1830s, assembling about 150 choice details: the fruits of all his labours laid out as he wished to see and use them. So, following, as it were, the numbers and arrows on the key diagrams, which had indicated the correct sequence whereby each composition was to be examined, explained, and assimilated, Martin dissected his mezzotints, abstracting momentary observations and isolating cause from effect (Pls. 159–63). Singled out in this way the tumbling boulders of *The Deluge* appeared all the more overwhelming (Pl. 163) and this no doubt encouraged Martin to redouble the rockfalls in *The Great Day of His Wrath*. The orchestration of lightning, thunderclouds, and torrents anticipates the black-and-white morality, the shattering metamorphoses, the headlong flights from normality into mannerist fantasy of the comic-strip code in which whole galaxies explode and Clark Kent, transformed into Superman, flies, a bullet-headed Avenging Angel, to wreak havoc on the foe.[23] Seen simply as 'a reckless accumulation of *false* magnitude', Martin's designs become undeniably tedious and repetitive; but studied in detail, through the eyes of an audience accustomed to reading such compositions[24]—to spending an hour or more watching diorama shows—they were compelling.

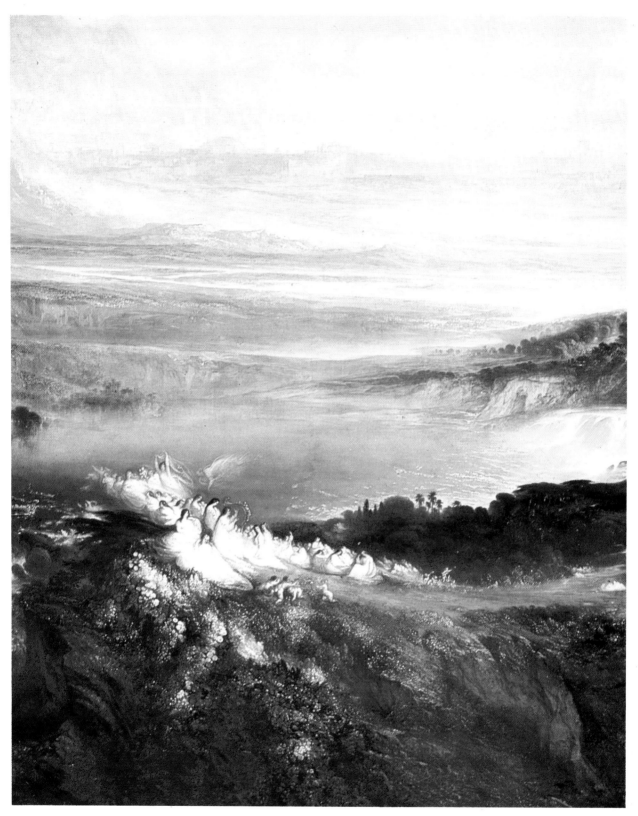

VIII. The Plains of Heaven, 1853 (detail). Oil on canvas, signed.

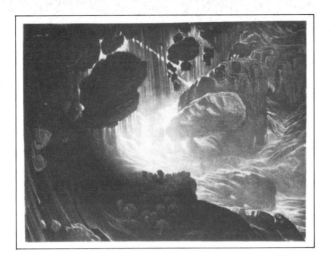

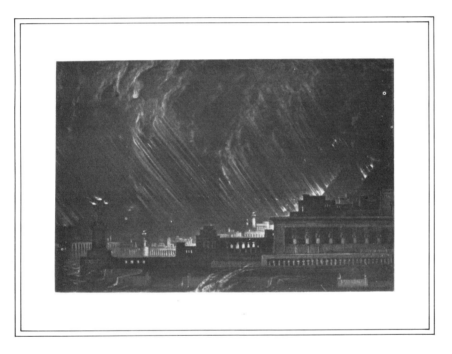

159. John Martin's
Album, page 29,
with details from his
mezzotints, selected
and pasted down
by himself.

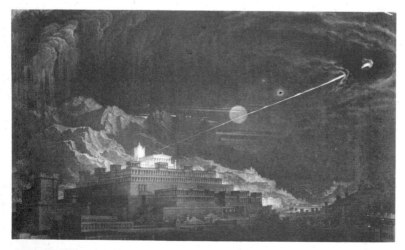

160. Detail of page 68 in John Martin's Album showing Herod's Palace from his mezzotint of 'The Crucifixion', 1834.

161 and 162. Details from pages of John Martin's Album from his mezzotint of 'Belshazzar's Feast', 1826.

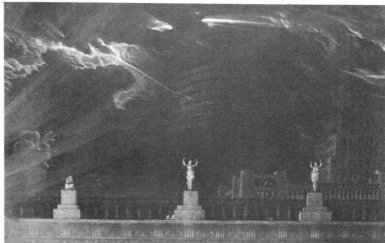

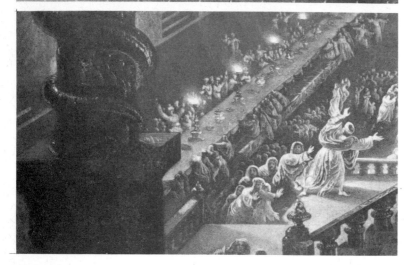

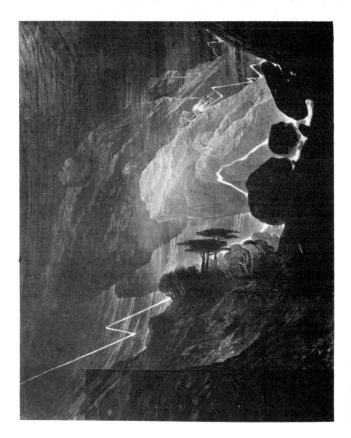

163. Detail from a page of John Martin's Album showing section of his mezzotint 'The Deluge', 1828.

Each picture or print was required to be an exhibition in itself; for, as his obituary notice in the *Illustrated London News* argued:

No doubt his art was theatrical. He addressed the eye rather than the mind. He produced his grand effects by illusion—perhaps, by imposition; —but it is not to be concealed that he did produce effects. Possibly it was scene painting—sleight of hand; but it was also new. If easy the style was his own. Nobody else had caught the trick by which he ravished the senses of the multitude and sometimes dazzled the imaginations of calmer men.[25]

Eighty years after the excitement at the British Institution caused by the perspectives of *Belshazzar's Feast* and the transparency version in the window of Collins's shop in the Strand, primitive film shots of rivers in spate and trains bearing down upon the captive audience provoked much the same avid consternation. While the static arts of panorama painting gradually died down under the impact of the early cinema and were reabsorbed into the conventions of stage design, Martin's compositions served, on at least one important occasions, as the source of cinematic imagery and expression. For film, the cinematographers quickly realized, offered the opportunity to make history come alive; and the subject-matter, crammed with miracles and catastrophes, catered for the same

tastes, in an audience that was the equivalent of the crowds who had so admired Martin's work: a public that liked to feel it was being edified and instructed and, not least, entertained. As John Galt, with much the same aim in mind, explained at the end of *The Wandering Jew*: 'We have not addressed ourselves to the wise and the learned and the latter would be offended if we presumed to think they required our comments.'[26]

Aiming, as Martin had done in 1820, at absolute authenticity and artistic respectability, D. W. Griffith staged several key scenes in *The Birth of a Nation* as tableaux reproductions of existing paintings, and subsequently, in the far more ambitious project of *Intolerance*, he based set designs of Jerusalem and Babylon on a scrapbook of archaeological and Biblical illustrations assembled by his assistant Joseph Henabery.[27] Prominent among these was an engraving of *Belshazzar's Feast*.

Griffith took some liberties with Martin's imagery. He replaced the serpents

164. A scene of t[...]
fall of Babyl[o...]
from D. [W...]
Griffith's fi[lm]
Intolerance, 191[...]

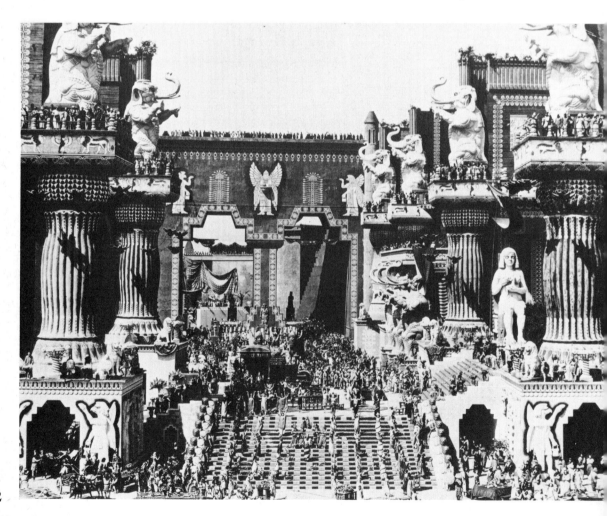

212

with elephant statuary, and the 254 acres of his Babylon sets were more fanciful on the whole than anything Martin would have countenanced. However, when 'the High Priest looks down upon the city he seeks to betray to Cyrus',[28] the hanging gardens and riverside walks of Babylon appear behind him, lying exactly as Martin had first shown them in *The Fall of Babylon*; while the slow descending shot over the palace steps in the Belshazzar's Feast scenes represents Martin's whole epic tradition, the narrative terms laid down in his descriptive catalogues and *Album*, cranked into life (Pl. 164).[29]

Total authenticity could no more be achieved in epic cinema than in Martin's compositions, but the attention of the audience could be directed more forcefully than ever. As each catastrophe approached, details, like those in Martin's *Album* —a panic-stricken face in the crowd, a commanding figure, seething waves— suggested rising tension, until, in the climactic, long-held master-shot, time stood still in the instant of crisis, as the waters parted and the earth trembled. Martin's successive views of Babylon, his charted and isometrically disposed Jerusalem, are comparable to the permanent sets, erected on Hollywood back-lots, of an Ancient Rome which could be transformed, within days, into Jerusalem or Athens, Medieval Paris or Dickens's London. And the publicity descriptions are virtually identical. In Martin's catalogue notes for *The Destruction of Herculaneum* 'the reader is referred to the maps and plans which are in the exhibition room and which show the attention that has been given to every known object in its true situation according to the best authorities.'[30] Similarly, describing his production of Byron's *Sardanapalus* in 1853, Charles Kean announced that 'No pains have been spared to present to the eye the gorgeous and striking scenery, that has been so unexpectedly dug from the very bowels of the earth.'[31] And the same epic claims persist today: the publicists for William Wyler's *Ben Hur* of 1958 boasted:

It took three hundred sets, five years of research and fourteen months of labour to turn back the historical clock to the years 1AD and 31AD. Forty-five fountains fed through 8·9 miles of special pipe provided the background for the colorful party hosted by Arrius. Covering a twenty-block area, complete with homes and business districts, the set representing the streets of Jerusalem was large enough to accommodate thousands. A feature of this set was the huge Gate of Joppa, reaching seventy-five feet into the sky. On one hundred and forty-eight acres, art directors William Horning and Edward Cafagno created the glory that was Rome and the grandeur that was Jerusalem.[32]

Historical reconstruction is a way to challenge time, and apocalypse comes as a fitting climax to any film epic; indeed, at one stage in the planning of *Zabriskie Point* Antonioni asked Douglas Trumbull, his special-effects expert, to explode the entire United States in a Great Day of Wrath. Sublimity, in cinematic terms, soars beyond time and space, over the lost horizon to Shangri-la and the intermingled past and future of *2001*. The First and Last Man, the traveller in Wells's time machine, is now an astronaut.

Because Martin's Babylonic paintings (like the dioramas and subsequent spectacular films) were all designed to attract a paying audience of patrons and subscribers, they had to be entertaining. But the dramas could not be allowed to spill off the screen or over the footlights, and so they failed to satisfy Martin's underlying ambitions. His frustration at being a powerless artist and not 'an engineer and practical man'[33] like Stephenson or Brunel can have been little assuaged by evidence of his influence on railway architects. The schemes for pure water supply, sewage manure, mine ventilation, and all the other inventions and suggestions were attempts to make his art function more directly as a creative force, not simply by setting his paintings to work as blueprints for reality but also by arguing, in pamphlets and committee rooms, to secure his ends. Predictably he failed to secure acceptance for his schemes or recognition for his efforts. But they are none the less significant, not so much in public terms, as in the context Martin created for himself. They add meaning to his perspectives.

Rather than be simply a great popularizer or a profitable dreamer, Martin made his bid to handle the controls. He never lost the restless energy of the apprentice who defied his master to secure his release from the carriage-painting trade, who had maintained his case in front of the magistrates, and who had refused to be browbeaten. 'Men of genius are not frequently thrown into our system by Providence,' he wrote in his own publicity. 'But, whenever they appear they infallibly bestow an honour on the country to which they belong; create new epochs in the age they live in.'[34] No doubt a more thoroughgoing professional artist, a 'Practical Man', would have prudently repressed such immodest words. But Martin, the self-made man, had little sense of discretion. He was determined to be as free-thinking in his art as in his politics and his religion. They were all one to him. He saw his art in a social context and his society in the echoing perspectives of time. Unless art was both political and moral it was mere aesthetics, so much wind and wall-paper.

Martin's greatest achievement was to flourish between the cultures: not just as a painter and printmaker but as artist and engineer. Imitable but unsurpassable, he rose above his age with a sense of almost gleeful conviction—and was frustrated. For his plans remained simply ideas—items listed on the drawers of his cabinet—while a good proportion of his paintings and all his graphic imagery survive.

In *Stones of Venice* Ruskin wrote:

It is well, when we have strong moral or poetical feeling manifested in painting to mark this as the best part of the work; but it is not well to consider as a thing of small account the painter's language in which that feeling is conveyed; for if that language be not good and lovely, the man may indeed be a just moralist or a great poet, but he is not a *painter* and it was wrong of him to paint.[35]

Given his preoccupations and distractions it is surprising perhaps that Martin succeeded in producing any admirable or memorable paintings. But, repeatedly,

throughout his career, from *Sadak* and *The Expulsion* to *The Plains of Heaven*, he achieved an intensity of graphic expression in which he often surpassed his literary sources of inspiration. At his best he succeeded brilliantly in blending slight, multifarious details into a forceful whole: 'A thousand dots stand in the place of as many human forms and a dash of the brush covers a wide extent of dominion; yet, if we examine these dots and dashes, we shall find them all finished off with the same careful and cautious touch of the pencil, that the more extended and prominent parts of the picture are.'[36]

Sadak stands as one of the key romantic images: man, in his pitiable human condition, slipping over the precipice like a blob of melting wax. There is no gap between idea and treatment. The same sense of impending loss and desolation persists in *The Expulsion* and *Clytie*. *Belshazzar's Feast*, *The Seventh Plague*, *The Deluge*, and the *Last Judgment* trilogy are still astounding despite a century in which such illustrative extravagance has been made out to look absurd.

Martin's figures never confront the spectator. Instead they look into the paintings, towards the action. They work the sluice-gates, man the coastal lights, struggle to keep a balance between the works of man and the order of Creation.

Martin's own self-appointed task was to attempt to surpass time and forestall catastrophe, like Hareach, the Wandering Jew of Galt's story, who once paused for thought among the ruins of Babylon and felt he

was as a being placed between the world that is, and the world to be. The region of man seemed as at an immeasurable distance. The events of yesterday, even of the day that had passed, were mingled with the earliest impressions of my memory, and the traditions of the most remote antiquity; constituting, as it were, all the past into one dark, ponderous and oppressive thought.[37]

Adopting for himself (Pl. 165) the role of Hareach and Sadak, of Adam, of The

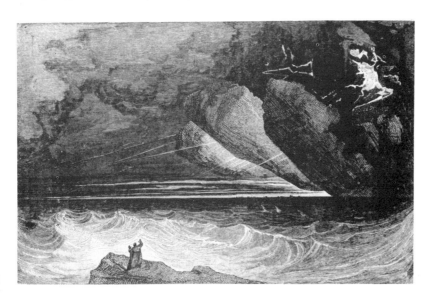

165. The Opening of the Seventh Seal. Wood engraving, $2\frac{3}{4}''\times 4\frac{1}{4}''$, from *Illustrations of the New Testament* by Westall and Martin, 1836.

Last Man, Martin, small, dapper, and enthusiastic, served as both prophet and myth-maker, duty-bound, like Moses and Daniel, to furnish his fellow men with 'decisive interpretation'.[38] He was well aware that anything he designed or promoted was bound to be vainglorious, that paintings are only sermons on canvas, bridges over chaos, temporary solutions to the problems of the day. As he sat, paralysed, in the last weeks of his life, he may have recalled the lines from *Paradise Lost*—the inspiration of his finest work:

> How soon hath thy predictions, seer blest,
> Measured this transient world, the race of time,
> Till time stand fix'd! Beyond is all abyss
> Eternity, whose end no eye can reach.
> Greatly instructed I shall hence depart,
> Greatly in peace of thought, and have my fill
> Of knowledge, what this vessel can contain
> Beyond which was my folly to aspire.[39]

Notes

CHAPTER I

1. 'The Inundation of the Tyne', in William Lee, *Historical Notes of Haydon Bridge* (Hexham, 1876), p. 80.

2. Ibid.

3. *The Life of Jonathan Martin*, 2nd edn. (Barnard Castle, 1826).

4. 'Diaries of Ralph Thomas', quoted Mary Pendered, *John Martin, Painter* (London, 1923), p. 21. Serjeant-at-Law Thomas was an intimate friend of Martin in the 1830s and 40s.

5. Ibid.

6. 'John Martin, Esq.', in (Anon.) *Public Characters. Biographical and Characteristic Sketches, with Portraits, of the Most Distinguished Personages of the Present Age* (2 vols., Knight and Lacey, London, 1828), vol. ii, p. 137.

7. S. C. Hall, *Retrospect of a Long Life* (London, 1883), quoted Balston, *John Martin, 1789–1854: His Life and Works* (London, 1947), p. 159.

8. 'Diaries of Ralph Thomas', Pendered, p. 23.

9. William Lee, *Historical Notes of Haydon Bridge*.

10. *Illus. Lond. News*, vol. xiv, 17 Mar. 1849, p. 176.

11. William Lee, op. cit., p. 13.

12. Martin's 'Autobiographical Notes', *Athenaeum*, 14 June 1834.

13. See Alethea Hayter, *Opium and the Romantic Imagination* (London, 1968), *passim*. There is no direct evidence of the Martins using these household tranquillizers and sedatives, but their visionary extravagances are remarkably similar to those of known opium-eaters.

14. *Illus. Lond. News*, 17 Mar. 1849, p. 176.

15. *Life and Letters of William Bewick*, ed. Thomas Landseer (2 vols., London, 1871). William Bewick (1795–1866), pupil of Haydon and no relation of Thomas Bewick, was brought up in Darlington in much the same circumstances as Martin.

16. *Illus. Lond. News*, 17 Mar. 1849, p. 176.

17. *Life and Letters of W. Bewick*, vol. i, p. 22.

18. 9 × 12 in., oil on panel, unsig., n.d., Laing Art Gallery, Newcastle upon Tyne. The attribution is doubtful as the painting bears no resemblance to Martin's mature work.

CHAPTER II

1. *Life and Letters of W. Bewick*, vol. i, p. 24.

2. De Quincey, *Confessions of an English Opium Eater* (1821), *The Collected Writings of Thomas De Quincey*, (1890), vol. iii, p. 378.

3. *Life and Letters of Washington Allston*, ed. Jared B. Flagg (New York, 1892), p. 73.

4. *The Picture of London for 1806*, ed. and publ. Richard Phillips (London, 1806), p. 301.

5. He advised Constable against the excessive use of green, warned Ward off *Gordale Scar* and interfered with Martin's work on at least one occasion. See Margaret Greaves, *Regency Patron: Sir George Beaumont* (London, 1966), *passim*, and Leopold Martin, 'Reminiscences', ch. 5, *Newcastle Weekly Chronicle* (1889).

6. W. H. Pyne, *Wine and Walnuts* (2 vols., London, 1823), vol. i, ch. 21.

7. *Picture of London for 1806*, p. 170.

8. Ibid., p. 246.

9. It worked on the principle of difference between indoor and outdoor air pressure; a constant draught through a tube made a ball wobble in perpetual motion.

10. 'Diaries of Ralph Thomas', quoted Pendered, p. 51.

11. Ibid., pp. 50–1.

12. *Illus. Lond. News*, 17 Mar. 1849, pp. 176–7.

13. Both paintings untraced.

14. 'Diaries of Ralph Thomas', Pendered, p. 55.

15. *Report from the Select Committee on*

Arts and their Connexion with Manufacture, 1836 (568) ix, 1.

16. *Table Talk*, 31 May 1830.

17. *Report from the Select Committee on Arts*. Musso died in 1824.

18. *Illus. Lond. News*, 17 Mar. 1849, pp. 176–7.

19. The *Sadak*, 30 × 25 in., dated 1812, in Southampton Art Gallery is quite possibly the painting shown at the Academy in 1812. J. H. Anderdon (annotated R.A. catalogues in the British Museum) remembered the painting in 1823, eleven years after seeing it, as '4½ ft. about 3½ wide'. No dimensions were given at the time, but the painting looks larger than it in fact is (much as the Eidophusikon tended to appear larger than its actual size to its audience). Alfred Martin made a mezzotint version of the painting in 1841. A later version of the painting, also 30 × 25½ in., in the Boston Museum of Fine Arts, signed 'John Martin KL' on the back (suggesting it was painted after 1833 when he was made a knight of the Order of Leopold), is more restrained in expression but similar in tone and general execution to *The Expulsion*.

20. James Ridley, *Tales of the Genii* (London, 1762), New edn., Lond., 1783, p. 184.

21. *Descriptive Catalogue of the Picture of the Fall of Nineveh, by John Martin* (London, 1828).

22. Ridley, op. cit., p. 184.

23. Ian Jack, *Keats and the Mirror of Art* (Oxford, 1967), p. 173.

24. *Hyperion*, ii. 7–12.

25. 'Diaries of Ralph Thomas', Pendered, p. 57.

26. Davidson Cook, 'Sadak the Wanderer an Unknown Shelley Poem', *Times Lit. Supp.*, 16 May 1936, p. 424.

27. *Keepsake* for 1828, p. 118.

28. Ibid., pp. 167–9.

29. Oil on panel, 8¾ × 7¾ in., sig. 1816, coll. Marquess of Dufferin and Ava.

30. Where lessons in drawing and transparency painting were given 'by a manner peculiarly easy and unclogged by the usual methods of protraction'. *The Picture of London for 1806*, p. 260.

31. Combe, *The Tour of Dr. Syntax in Search of the Picturesque* (London, 1812), p. 5.

32. Martin made repeat versions of the majority of his paintings, for private commissions and for guidance in making his prints.

33. Coll. Roy Miles. The painting was entitled *George and the Dragon* by Balston (*Burlington Magazine*, vol. xciii, p. 35) but is clearly *Cadmus*, though probably not the original painting given to William Martin.

34. 34 × 45 in. (in frame), untraced. A smaller painting (Pl. 11), exquisite in detail and painted *c.* 1822 (Hazlitt, Gooden & Fox), is probably of this subject.

35. *The Hermit*, 11½ × 17½ in., oil, sig. 1816, coll. Mrs. C. Frank, shown British Institution 1817 (alternatively known as *Edwin and Angelina*), taken from a ballad in Goldsmith's *Vicar of Wakefield*, is very similar to *Clytie* and is a 'happy ending' variant on the theme. Angelina, a Tyneside Lord's lovesick daughter, discovers that the hermit is Edwin, her long-lost lover. Reunited, both recover from their living deaths.

36. 54 × 83 in., sig. 1832, coll. Earl Howick of Glendale. Painted over the version of *Clytie* damaged in 1814, exhib. British Institution 1833, bought by Earl Grey, 1839.

37. R. A. Council minutes, vol. xi, p. 104 quoted in S. C. Hutchison, *The History of the Royal Academy, 1768–1968* (1968), p. 117.

38. Balston, *John Martin*, p. 38, mentions a drawing dedicated to West by Martin.

39. Conversation with Constable in 1833, recorded by Ralph Thomas (Pendered, p. 180).

40. Carried out with the Prince Regent's usual style, these included the transformation of Hyde Park with a pagoda and Chinese bridge over the Serpentine and a revolving Temple of Concord, all designed by Nash, and performances of Dibdin's version of *Sadak*, an 'Asiatic Spectacle', at Covent Garden.

41. Quoted in Joanna Richardson, *My Dearest Uncle* (London, 1962).

42. The *Athenaeum*, 14 June, p. 459, quotes this anecdote from the *Bookseller's Advertiser* of New York, and prints Martin's rejoinder.

CHAPTER III

1. For example, *Mountain Landscape*, 10 × 14 in., unsig., n.d. (*c.* 1815), V. & A.

2. Martin, *Illus. Lond. News*, vol. xiv, 17 Mar. 1849.

3. 'Essay on the Barrenness of the Imaginative Faculty in the Productions of Modern Art', *Last Essays of Elia* (1833), *The Life, Letters and Writings of Charles Lamb*, ed. P. Fitzgerald (6 vols., 1886), vol. iv, p. 96.

4. J. Northcote, in the *Artist*, no. 20, July 1807, p. 2.

5. Exhib. R.A. 1812, Tate Gallery.

6. Exhib. R.A. 1815, Liverpool University.

7. National Gallery.

8. Martin, *Illus. Lond. News*, 17 Mar. 1849.

9. It remained in his studio until his exhibition at the Egyptian Hall in 1822; see above, p. 55.

10. The composition was also issued as a lithograph by R. J. Lane, and as one of Martin's mezzotint *Illustrations of the Bible* (1831–5).

11. One, 18¾ × 24½ in., n.d., indistinctly sig., private coll.

12. 59 × 92 in., sig. 1848, Dewsbury Town Hall.

13. Ward's *Triumph of the Duke of Wellington* won a premium of 100 guineas at the British Institution in 1816.

14. Thomas Gray, 'The Bard' (1st publ. 1757), I. i.

15. A sepia drawing ($7\frac{1}{4}$ × 10 in., labelled 'Orpheus the God of Music' (coll. W. A. Brandt). The figure posing wild-eyed with his lyre and closely resembling the Bard, is more probably *Fear* from Collins's 'Ode to the Passions', equally concerned with the powers and charms of music.

16. As Barry had illustrated in one of his Society of Arts murals.

17. See F. I. McCarthy, 'The Bard of Thomas Gray, its Composition and its use by Painters', *National Library of Wales Journal*, xiv (1965), 111.

18. Laing Art Gallery (Pl. 16) and 50 × 40 in. (Paul Mellon coll.), both undated.

19. $31\frac{1}{2}$ × $26\frac{1}{2}$ in. See Arthur S. Marks, 'The Source of John Martin's *The Bard*', *Apollo*, lxxxiv (Aug. 1966), supp., 'Notes on British Art'.

20. The oaks, emblems of pagan longevity, are almost identical to those he drew and etched for Ackermann in a set of *Six Characters of Trees* (Pl. 15), published in 1817.

21. *Shipwreck*, $9\frac{3}{10}$ × $13\frac{3}{4}$ in. (1816), Fogg Art Museum, Harvard Univ.

22. 'Diaries of Ralph Thomas', Pendered, p. 80.

23. Thomas Moore visited him there, recording in his diary for 4 June 1819: 'walked with Richard Power and Corry to Alsop's Buildings, Baker Street, and saw some paintings by Martin; most remarkable works, particularly one on the subject of Joshua bidding the sun to stand still. He means to paint a subject from Lalla Rookh.' *Memoirs, Journal and Correspondence of Thomas Moore*, ed. Lord John Russell (8 vols., 1853), vol. ii, p. 321.

24. Daniell and his nephew, William, published large numbers of illustrations of Indian landscape and architecture which served to establish Hindoo features alongside Egyptian and Classic manners and Chinoiserie as Regency style. Daniell also painted Sezincot.

25. H. Repton, 'An Enquiry into the Changes of Taste in Landscape Gardening' (London, 1806), p. 96. See Dorothy Stroud, *Humphry Repton* (London, 1962), pp. 138 and 145.

26. Rendered tonal in aquatint by F. C. Lewis, 'Engraver to the late Princess Charlotte'.

27. Ashmolean Museum, Oxford.

28. Probably his modification of William Martin's design for the competition that won Humphry Davy £2,000 and immortality, largely, it was rumoured, through his influential friends. George Stephenson's lamp was preferred in the north, and William Martin's, tested by the waste-men at Willington Colliery, was in their opinion best of the three (see below, p. 230, n. 67). Rudolph Ackermann (1764–1834), Martin's publisher, invented and patented a movable carriage axle in 1818.

29. $7\frac{4}{5}$ × $10\frac{1}{2}$ in. (1817), Ashmolean Museum. Repeated in a more elaborate water-colour version ($9\frac{7}{8}$ × $12\frac{3}{8}$ in., V. & A.) (Pl. 88). and a small oil (9 × $13\frac{1}{2}$ in.), formerly coll. Col. M. A. Grant.

30. Sold Christie's, 1937, for 2 guineas, subsequently untraced.

31. *Examiner* (1819), quoted Balston, *John Martin*, p. 48.

32. Letter, C. R. Leslie to Washington Allston, 6 Feb. 1819, quoted J. B. Flagg, *Life of Washington Allston* (New York, 1892), p. 85.

33. 'Diaries of Ralph Thomas', Pendered, p. 89.

34. The Revd. T. S. Hughes's poem *Belshazzar's Feast* was awarded the Seatonian prize at Cambridge and, in its epic, but annotated, sweeping attitudes, influenced Martin's *Belshazzar*. See Martin's 'Autobiographical Notes', *Athenaeum*, 14 June 1834, p. 459.

35. *Childe Harold's Pilgrimage*, Canto IV, st. 3.

36. Sir William Gell's *Pompeiana* with illustrations by Gandy was published in 1817.

37. De Quincey, *Confessions of an English Opium Eater* (1821), *The Collected Writings*, vol. iii, p. 435.

38. *A Descriptive Catalogue of the Destruction of Pompeii & Herculaneum; with other pictures, painted by John Martin, Historical Landscape Painter to his Royal and Serene Highness the Prince Leopold of Saxe-Coburg, now exhibiting at the Egyptian Hall, Piccadilly* (London, 1822), p. 30. A note in his 1817 sketch-book reads: 'There were stones in the walls of Jerusalem 10 cubits long, 10 cubits broad and 5 cubits in depth, cubit is 1 ft. 6 inches.' His reconstituted Jerusalem first appeared in the *Amulet* for 1830.

39. Though he does not mention it, Humphrey Prideaux's *The Old and New Testament Connected in the History of the Jews and Neighbouring Nations* (2 vols., 1716–18), quite probably served as his compendium source. The Revd. H. H. Milman describes it as 'perhaps the best English account of Babylon' (introd. to *Belshazzar: a Dramatic Poem*, 1822).

40. *The Life of Jonathan Martin*, 2nd edn., p. 4.

41. Rich had brought back a few fragments of sculpture, and these were in the British Museum, but, as Layard remarked (*A Popular Account of Discoveries at Nineveh*, 1851, p. xi), 'A case scarcely three feet square

enclosed all that remained, not only of the great city, Nineveh, but of Babylon itself!'

42. The Revd. W. Beloe, *Herodotus Translated from the Greek* (4 vols., 2nd edn. corrected and enlarged, 1806), vol. i, pp. 246–7. A copy of Beloe's Herodotus was in Martin's Library. See Catalogue, Lindsey House Sale, Christie's, 4 July 1854, and also above, p. 171.

43. *A Description of the Picture BELSHAZZAR'S FEAST Painted by Mr. Martin, lately Exhibited at the British Institution . . . by John Martin*, London, 1821.

44. *Descriptive Catalogue of . . . pictures, painted by John Martin, now exhibiting at the Egyptian Hall, Piccadilly*, 1822, p. 29.

45. See Norah Monckton, 'Architectural Backgrounds in John Martin', *Architectural Review*, vol. civ, Aug. 1948.

46. For example, Gaetano Lundi, *Architectural Decoration: A Periodical Work of Original Design Invented from the Egyptian, the Greek, the Gothic etc. for Exterior and Interior Decoration*, which ran for one number only, in 1810, and included a design for a 'Grand Egyptian Hall'.

47. Ian Jack, *Keats and the Mirror of Art*, p. 172.

48. Keats, *Hyperion*, i.179–82.

49. H. H. Milman, *Belshazzar: a Dramatic Poem* (1822), p. 159.

50. Pseudonym of John Galt, with whom Martin was to collaborate on the *Ouranoulogos or The Celestial Volume* in 1833. *The Wandering Jew, or the Travels and Observations of Hareach the Prolonged* (1820) is an eyewitness account of some of the greatest events of world history. In the preface Galt claimed that 'with all the characteristics of a romance, this story of the Wandering Jew may lay some claim to be considered as a work of fact and history'. Hareach visits the remains of Babylon as described by Rich, and of Mount Ararat, Egypt, India, and Jerusalem and is, in effect, the time-traveller whose point of view Martin adopts.

50. See Bernard Hanson, 'D. W. Griffith: Some Sources', *Art Bulletin* (New York), Dec. 1972, and above, pp. 212–13.

52. Drawing in Princeton Univ. Art Museum. See R. Rosenblum, *Transformations in Late Eighteenth Century Art* (Princeton, 1967), p. 160. At about this time Jonathan Martin designed a monument to Napoleon, representing him standing, like a Colossus of Rhodes posing as the Statue of Liberty, straddling a harbour, with ships passing between his legs.

53. Nash himself made ten designs in response to the Government Committee's open invitation of 1817 to artists to submit suggestions.

54. 68 × 96 in. This version is untraced. Two smaller paintings survive: in the National Gallery of Scotland (Pl. 30) and at the Royal Shakespeare Theatre, Stratford-upon-Avon (panel, 12 × 18½ in.). A mezzotint was made by Thomas Lupton in 1828 (9½ × 14 in.).

55. John and Charles Sobieski claimed descent from Charles Edward Stuart, the Young Pretender, and later published a standard work, *Costumes for the Clans* (1843).

56. Leopold Martin, 'Reminiscences', ch. 4, Jan. 1889.

57. Leslie to Allston, 3 Mar. 1820, quoted in Flagg, *Life of Washington Allston*.

58. Ibid.

59. See F. Antal, *Fuseli Studies* (London, 1956), p. 148 *et passim*.

60. 'Thoughts on Landscape Painting', *Library of the Fine Arts*, publ. M. Arnold, vol. iii (1832), p. 23.

61. *Athenaeum*, 14 June 1834, p. 459.

62. Now in the Boston Museum of Fine Arts.

63. A Description of the Picture *Belshazzar's Feast . . .* (London, 1821).

64. A. Cunningham, *The Life of Sir David Wilkie* (2 vols. 1843), vol. ii, p. 56.

65. 'Essay on the Barrenness of the Imaginative Faculty in the Productions of Modern Art', *Last Essays of Elia* (1833), *The Life, Letters and Writings of Charles Lamb* (1886), vol. iv, p. 93.

66. *The Bible of Amiens* (1884), *The Complete Works of John Ruskin*, ed. E. T. Cook and A. Wedderburn, 39 vols., vol. xxxiii, 1908, p. 157.

67. *The Diary of Benjamin Robert Haydon*, ed. W. B. Pope (5 vols., Cambridge, Mass., 1960–3), vol. ii, p. 350.

68. Mrs. French in Frances A. Gerard, *Some Fair Hibernians* (London, 1897), pp. 137–8.

69. The only glass-painting after his design known to survive; now at Syon House.

70. *A Description of the Picture Belshazzar's Feast . . .* (1821).

71. Victor Hugo remarked that the tower had been destroyed long before the age of Daniel (Juste Olivier: *Journal*, 23 June 1830, quoted C. W. Thompson, *Victor Hugo and the Graphic Arts* (Geneva, 1971), p. 76, footnote).

72. It was damaged while being returned from an exhibition in 1854. See below, p. 237, n. 17.

73. Richard and Samuel Redgrave, *A Century of Painters of the English School* (2 vols., 1866), vol. ii, p. 429.

74. *Belshazzar: a Dramatic Poem*, p. 104.

75. 37½ × 47½ in., oil, dated 1820, Paul Mellon coll. A large copy (60½ × 78 in.), undated, in the Mansion House, Newcastle, is garishly painted, the courtiers formalized like Staffordshire figurines. Another version (32 ×

47 in.) is in the Wadsworth Athenaeum, Hartford, Conn. A small rough sketch (12 × 15½ in., coll. Mrs. C. Frank) is probably a study for one of the mezzotint versions.

76. The *Mirror*, founded in November 1822, quickly reached a circulation of 150,000 copies an issue, and rival periodicals, such as the *Literary Magnet*, were soon started.

77. Mezzotints (1826, 1832), *Illustrations of the Bible* (1835), and another version in the Westall–Martin *Illustrations of the Bible* (1835–6) and *The Imperial Family Bible* (1844). The painting was toured around the country, and appeared in Bristol, for instance, in 1825, in Glasgow, Edinburgh, and Newcastle.

78. William Martin advertised his version in 1826 in a postscript to a broadsheet, 'Lines on a Safety Lamp' (Newcastle, 1827), as 'a very splendid picture, designed and executed in the short space of one month', and in 1831 he issued a tin-plate print in which he melted down his brother's angularities, leaving the scene curiously muffled.

79. See F. D. Klingender, *Art and the Industrial Revolution*, 2nd edn. (1968).

80. *A Descriptive Catalogue of the Destruction of Pompeii and Herculaneum with other pictures . . . now exhibiting at the Egyptian Hall Piccadilly* (1822), pp. 3–4. Martin mentions a poem by Edwin Atherstone, 'The Last Days of Herculaneum', published in 1821. Atherstone produced an epic *Fall of Nineveh* in 1828, which coincided with Martin's painting in what Martin described as 'an interchange merely of encouragement and enthusiasm' (*Descriptive Catalogue of the Picture of the Fall of Nineveh*, 1828), but see also below, Chap. V., notes 33 and 60.

81. Ibid., p. 24.

82. Ibid., p. 12.

83. Ibid., p. 17.

84. 58¾ × 78 in., n.d., National Gallery of Scotland.

85. 1740–93.

86. No. 270, publ. 23 Mar. 1822. Martin supplied a drawing of this for *Pompeii* by W. B. Cooke and T. L. Donaldson (London, 1827); see above, p. 141.

87. 64 × 99 in. Sold 1848, bought for the nation 1869, written off 1928; see p. 236, n. 55. A water-colour (26 × 38 in., n.d.), perhaps a preparatory study with a more open foreground, belongs to Mrs. R. Wright.

88. See Douglas Hall, 'Tabley House Papers', *Walpole Society*, vol. xxxviii, p. 84: 'Balance due on Picture £50 of Pompeii', 3 July 1826.

89. *Descriptive Catalogue of . . . pictures, painted by John Martin, now exhibiting at the Egyptian Hall, Piccadilly*, 1822, p. 12.

90. T. Moore, *Lalla Rookh* (1817), lines 429–31.

91. Bulwer-Lytton, *Last Days of Pompeii* (1834).

92. *Ackermann's Repository*, vol. xiii (Apr. 1822).

93. Leopold Martin, 'Reminiscences', ch. 10, Mar. 1889.

94. *The Wandering Jew* (1820), p. 3.

95. *Report of the Trial of Jonathan Martin* (London, Baldwin & Cradock; York, Barclay, 1829). See below, p. 98, n. 66.

CHAPTER IV

1. Quoted H. A. N. Brockman, *Caliph of Fonthill* (1956), pp. 36–8.

2. Beckford paid three visits to the British Institution in 1819 to see *The Fall of Babylon*: 'Oh, what a sublime thing!' (*Life at Fonthill, 1807–1822, With Interludes in Paris and London, from the Correspondence of William Beckford*, transl. and ed. Boyd Alexander (1957), p. 279.)

3. Three drawings by Martin were engraved for John Rutter's *Delineations of Fonthill and Its Abbey* (Shaftesbury, 1823) and another, a distant view from the south-west, for *Graphical and Literary Illustrations of Fonthill Abbey, Wiltshire* by John Britton (London, 1823).

4. Quoted Brockman, op. cit., p. 201.

5. *Paradise Regained*, ii.293–7. See also Robert J. Gemmett, 'Beckford's Fonthill: the Landscape as Art', *Gazette des Beaux-Arts*, Dec. 1972, pp. 335–55.

6. Shown Royal Academy 1823, whereabouts unknown, engraved by G. H. Cooke in the *Atlantic Souvenir*, vol. vii (Philadelphia, 1832), p. 54.

7. Milton, 'Arcades', lines 84–5.

8. *Literary Examiner, Commonplaces*, no. 70 (1823).

9. 'Conversations of James Northcote' no. xii, *New Monthly Magazine* (1827).

10. Coleridge, *Kubla Khan*, lines 6–11.

11. In 1823 Martin also started work on the *Paradise Lost* mezzotints with a set of preparatory oil sketches. For *Salmacis and Hermaphroditus* see above, p. 23, n. 34.

12. 1800, Herran Art Museum, Indianapolis.

13. 9½ × 14½ in., sig. 1823, coll. Mrs. C. Frank.

14. He produced a rather leaden version as no. 11 of his mezzotint *Illustrations of the Bible* (1835).

15. A painting of the subject by Daguerre (82 × 100 in., 1824) is in the Walker Art Gallery, Liverpool.

16. 'Diaries of Ralph Thomas', Pendered, p. 180.

17. As Lawrence had described him at the 7th Anniversary Dinner of the Artists General

Benevolent Institution in 1821 (Leopold Martin, 'Reminiscences', ch. 13, Mar. 1889).

18. Pendered, p. 98.

19. *A Plan for Improving the Air and Water of the Metropolis . . . by John Martin*, 1833. John Fordyce, Surveyor-General of his Majesty's Land Revenue, asked the same question twenty years before (see J. Summerson, *John Nash*, 1935).

20. See above, p. 185.

21. J. Michelet, *Journal*, ed. Viallaneix (1959), vol. i, p. 122.

CHAPTER V

1. *Life and Letters of W. Bewick*, vol. i, p. 71.

2. Catalogued as 'the property of J. Belisario Esq.' Balston (*John Martin*, p. 42) suggests convincingly, that Belisario, a dealer, was acting as an agent for its sale. He also held two series of drawings (*Landscape Compositions*) and *The Hermit*.

3. The print was not published until 1827.

4. $6\frac{7}{8} \times 10$ in.

5. $10\frac{1}{2} \times 8\frac{3}{4}$ in.

6. For discussion of Milton's illustrators see Marcia R. Pointon, *Milton and English Art* (Manchester, 1970), pp. 174–97.

7. *Quarterly Review*, vol. xxxvi (1827), p. 51.

8. Each *c.* $18\frac{1}{4} \times 26\frac{1}{2}$ in., formerly coll. T. R. Laughton, dispersed 1964 (Sotheby's, 18 Mar.). *Adam and Eve mourn the Loss of Paradise* is in the V. & A.

9. *Art and the Industrial Revolution*, pp. 210–14.

10 *Paradise Lost*, i.711–13.

11. From anon., *Babylon the Great or Men and Things in the British Capital*, publ. Robert Mudie (2 vols., London, 1825), vol. i, p. 4. A companion volume, *The Modern Athens* (Edinburgh), appeared in 1822.

12. The Revd. Isaac Taylor, *Scenes in England for the Amusement and Instruction of little Tarry-at-Home Travellers* (London, 1822), p. 54.

13. *Paradise Lost*, x.300–2.
Martin may have been influenced by a watercolour, *The Falls of the Villa Maecenas, Tivoli* by Louis Ducros (then in the collection of Sir Richard Colt Hoare), a remarkably similar composition with underground rock arcades receding in deep perspective and foliage and waterfalls, anticipating Martin's clouded, light-streaked void. Martin may have visited Stourhead (where Hoare kept his collection) when visiting Fonthill in 1822. The water-colour is repr. in K. Woodbridge, *Landscape and Antiquity: Aspects of English Culture at Stourhead, 1718 to 1830* (Oxford, 1970).

14. Anon., *Mystification, a Poem*, publ. Moxon, 1836.

15. According to Ruskin (1840), 'his chief sublimity consists in lamp-black' (*Works*, vol. i (1903), p. 243).

16. *Life and Letters of W. Bewick*, vol. i, p. 267.

17. Leopold Martin, 'Reminiscences', ch. 7, Feb. 1889.

18. Ibid., ch. 10, Mar. 1889.

19. Ibid.

20. *Library of the Fine Arts*, publ. M. Arnold, (1831), vol. ii, p. 75.

21. Quoted Pendered, pp. 158–60, and Balston, *John Martin*, pp. 101–4.

22. By 1853 David Bogue (Tilt's successor) was offering the *Illustrations of the Bible* and *Paradise Lost* at 2 guineas each.

23. Letter to G. Linnecar, 22 May 1843, quoted Pendered, pp. 160–1.

24. *Illus. Lond. News*, vol. xiv, 17 Mar. 1849, p. 177.

25. Jean Seznec, *John Martin en France* (London, 1963), p. 29.

26. *Library of the Fine Arts*, vol. ii (1831), p. 75.

27. Seznec, op. cit., pp. 37–9.

28. E. Chesneau, *La Peinture anglaise* (1882), p. 100 (Seznec, p. 40).

29. *Paradise Lost*, vii. 340–2.

30. Plate 16 of *Paradise Lost* (1825) and Plate 1 of *Illustrations of the Bible* (publ. 1831).

31. 42×68 in., exhib. Society of British Artists 1825, untraced.

32. The *Diary of Benjamin Robert Haydon*, ed. W. B. Pope, vol. iii, pp. 10–11, 7 Mar. 1825.

33. *Paradise Lost*, viii. 17–19. Martin's illustration to his friend Edwin Atherstone's *A Midsummer Day's Dream* (London, 1824), n. 62 ('Vast arches, fiery pillars shooting up at once from earth to heaven, all possible shapes'), includes architectural rock formations.

34. *The Conversations of Northcote and Ward* (1825), ed. E. Fletcher (London, 1901), p. 248.

35. *The Artist*, no. 20, 25 July 1807, p. 9.

36. 28×42 in., Sir John Soanes Museum.

37. Coll. Gavin Astor. See also Turner's frontis. to vol. x of *Scott's Poetical Works* (1832–3), 'The Lord of the Isles', and Robert Rosenblum, 'The Abstract Sublime', *Art News*, vol. 59, no. 10 (Feb. 1961).

38. *Illus. Lond. News*, 17 Mar. 1849, p. 177.

39. G. Grigson, 'Some notes on Francis Danby', *Cornhill Magazine*, no. 968, 1946, p. 101.

40. *The Diary of B. R. Haydon*, vol. iii, p. 276, 9 May 1828: 'The Public, who are no

judges of the Art as an Art, over-praise their invention, and the Artists, who are always professional, see only the errors of the brush. Thus neither are just.'

41. Tate Gallery. See above, p. 164.

42. For a full survey and discussion of Danby's work see E. Adams, *Francis Danby: Varieties of Poetic Landscape* (London, 1973), and F. Greenacre, *The Bristol School of Artists: Francis Danby and Painting in Bristol 1810–1840* (Bristol, 1973).

43. G. F. Waagen, *Works of Art and Artists in England* (3 vols., London, 1938), quoted Balston, *John Martin*, p. 186.

44. Nottingham Castle Art Gallery.

45. Quoted Finberg, *Life of J. M. W. Turner*, p. 414.

46. T. L. Beddoes, *The Letters of Thomas Lovell Beddoes*, ed. Gosse (1894), p. 96.

47. *A Midsummer Day's Dream*, p. 62.

48. MS. note by Martin on p. 4 of *The Deluge* (pamphlet), n.d. (*c.* 1825), Sir John Soane's Museum.

49. *A Descriptive Catalogue of the Engraving of The Deluge by John Martin*, 1828, 8 pp. Other print versions include a wood engraving by W. H. Powis (Westall–Martin *Illustrations of the Bible*, 1835) and a steel engraving by J. Rogers (Churton edn. of Milton, 1836). *The Deluge* in the mezzotint *Illustrations of the Bible* (1832) differs considerably from these and is altogether more commonplace.

50. A label on his cabinet reads '1832 Deluge Enlarged'; see above, p. 103.

51. Infra-red photographs reveal that the picture was not 'repainted' or 'worked up', as Ralph Thomas and Leopold Martin suggest (see Pendered, p. 134, Balston, *John Martin*, p. 91). This second painting was shown at the Royal Academy in 1837. A photograph in the Tate Gallery archives, taken *c.* 1922, of an oil-painting similar in design to the mezzotint may represent the original *Deluge*.

52. Letter to Edwin Atherstone, 12 Nov. 1841, Somerset County Museum.

53. Quoted Seznec, op. cit., p. 38.

54. *A Descriptive Catalogue of the Engraving of The Deluge*, 1828.

55. 'Diaries of Ralph Thomas', Pendered, p. 133, and Leopold Martin, 'Reminiscences', ch. 4, Jan. 1889.

56. Bulwer-Lytton, *England and the English* (2 vols., 1833), vol. ii, p. 214.

57. *Newcastle Courant*, 19 Oct. 1838.

58. Martin first used the subject (from the poem by Thomas Campbell published in 1823) in 1826. This may be the water-colour ($18\frac{3}{4} \times 27\frac{3}{4}$ in.) in the Laing Art Gallery. Another version was shown at the Society of Painters in Water Colour in 1822 (untraced).

59. The oil-painting is now untraced.

60. See also Martin's two illustrations, 'A city of inconceivable splendour' in Atherstone's *A Midsummer Day's Dream* (1824): a frontispiece and plate facing p. 127, engraved by G. Cooke.

61. Barton wrote to Martin: 'A few brief stanzas sometimes written under the strong excitement of such recollection, tell better than the most elaborate efforts deliberately sate down to with a determination to write something very fine—so I send it thee "piping hot".' *A Descriptive Catalogue of the Engraving of The Deluge*, 1828.

62. A water-colour, $4\frac{3}{4} \times 7\frac{1}{8}$ in. (1827), an oil, $32\frac{1}{4} \times 47\frac{1}{4}$ in. (both Laing Art Gallery); another, $27\frac{3}{4} \times 37\frac{1}{4}$ in., coll. Sir Leigh Ashton (Pl. 74), and an oil sketch, 17×25 in., coll. Lord Kinross, all undated. Haydon painted the subject in 1842.

63. *Life and Letters of W. Bewick*, vol. i, p. 155.

64. An oil-painting of this subject, possibly by Martin, 36×25 in., unsig., n.d., is in the Shipley Gallery, Gateshead.

65. $30\frac{1}{2} \times 42\frac{1}{2}$ in., unsig., coll. Mrs. C. Frank.

66. Having perceived on the night of 2 February 1829 that 'the Lord was determined to have me shew his people a way to flee from the wrath to come', Jonathan Martin climbed into York Minster and spent hours getting a fire going, using prayer-books and furnishings from the choir for kindling. Then, carrying the tassels from the canopy of the bishop's throne, he made for home and sanctuary in the Tyne Valley near Hexham, where he was arrested four days later. No mention was made of John during the two-day trial, though the event was widely reported at the time, but he evidently paid the costs of the defence and, subsequently, Jonathan Martin's living expenses in Bethlem Hospital to which he was committed as criminally insane. He spent the rest of his life quiet, harmless, preoccupied with anti-clerical stratagems and apparently quite happily resigned to his condition until, characteristically, he made a dramatic attempt to escape and was placed under restraint until shortly before his death in 1838. The Bethlem Sub-committee minutes for 1 June 1838 included the transcription of a letter of thanks from Martin in which he mentions 'the grateful sense I have of the treatment pursued towards my poor Brother' and says that 'if there are any drawings or other little articles belonging to him which his keeper may be desirous to retain I doubt not that my Nephew will hand them over to him in accordance with my wish.'

67. Byron, *Don Juan*, Canto v, st. 93.

68. Byron, *Sardanapalus* (1821), Act V, sc. i, ll. 440–1.

69. 84×134 in., sig. 1829, formerly coll.

King of Egypt. Reproduced in Balston: *John Martin* (Pl. 6).

70. An impression of Martin's initial outline engraving is in the B.M. print room.

71. Byron, *Sardanapalus*, Act V, sc. i, ll. 480–1.

72. Robert Pollok, *The Course of Time: a Poem in Ten Books* (2 vols., Edinburgh, 1827), Bk. vii, ll. 501–4.

73. *Descriptive Catalogue of the Picture of the Fall of Nineveh by John Martin* (1828).

74. *Diary of B. R. Haydon*, vol. iii, p. 121, 22 May 1828.

75. G. F. Waagen, *Works of Art and Artists in England* (1838), vol. ii, p. 162.

76. *Public Characters of the Present Age*, vol. ii (1828), p. 144.

77. *Edinburgh Review*, vol. xlix, June 1829, p. 469.

78. Water-colour, $22\frac{1}{2} \times 33\frac{1}{2}$ in., 1830, formerly Leger Gallery:

... With perfidious hatred they pursued
The sojourners of Goshen, who beheld
From the safe shore their floating carcasses
And broken chariot wheels.
(*Paradise Lost*, i.308–11.)

79. Leopold Martin, 'Reminiscences', ch. 9, Mar. 1889.

80. Letter from Martin to Manning, 6 Dec. 1827, preserved in J. H. Anderdon's set of R.A. Catalogues, vol. vii, British Museum.

81. Leopold Martin, 'Reminiscences', ch. 16, Apr. 1889: 'In China ... Mr. Ackermann informed us, he had found a large sale for works by John Martin, such as Belshazzar's Feast, Martin's architecture being most popular, and his perspective looked upon as wonderful.'

82. *Library of the Fine Arts*, vol. ii, no. 7, 1831, p. 75.

83. W. Gérin, *Branwell Brontë* (London, 1961), p. 145 *et passim*.

84. Formerly in the possession of Derby Art Gallery.

85. Catalogue, *Northumberland Institution* (1825), p. 11.

86. Alfred Dawson, *The Life of Henry Dawson* (London, 1891), p. 14.

87. Oil, 32×42 in., 1829, York City Art Gallery.

88. See Louis Noble, *The Life and Works of Thomas Cole*, ed. Elliot S. Vessel (Cambridge, Mass., 1964). *The Expulsion* (39×54 in.) is in the Boston Museum of Fine Arts.

89. New York Historical Society Museum.

90. 52×78 in., coll. St. Luke's Hospital, New York.

91. 52×78 in., 1840, coll. Munson–Williams–Proctor Institute, Utica, New York.

92. Brooklyn Museum, New York.

93. See above, p. 221, n. 6.

94. Westall–Martin *Illustrations of the Bible*, 1835, no. 10.

95. *Library of the Fine Arts*, vol. ii, no. 7, 1831, p. 75.

96. Publ. Rittner and Goupil (Paris, 1835), Tilt and Ackermann (London, 1835).

97. For example, the Revd. Bourne Hall Draper's *Stories from the Scriptures* (London, 1827). Preliminary drawings for illustrations of 'Joshua Commanding the Sun to Stand Still' and for 'Moses at the Red Sea' are listed under Martin in the Prints and Drawings department at the V. & A.

98. Quoted A. P. Oppé, *Early Victorian England*, ed. G. M. Young (2 vols., 1934), vol. ii, p. 150.

99. Illustrated in the Martin style by Hugo's friend Louis Boulanger (1808–47). Hugo's drawings were considerably more high-flown than Martin's. See C. W. Thompson, 'Le Feu du Ciel de Victor Hugo et John Martin', *Gazette des Beaux-Arts* (Apr. 1965).

100. Planche, *Le Salon de 1834*, quoted Seznec, p. 16.

101. See C. W. Thompson, *Victor Hugo and the Graphic Arts 1820–1833* (Geneva, 1970), pp. 74–95.

102. Leopold Martin, 'Reminiscences', ch. 13, Mar. 1889.

CHAPTER VI

1. *Illus. Lond. News*, vol. xiv, 17. Mar. 1849, p. 177.

2. Renamed the *Repertory of Patent Inventions* in 1823.

3. B. W. Richardson, *Thomas Sopwith* (London, 1891), p. 171.

4. 'Signs of the Times', *Edinburgh Review*, vol. xlix (June 1829), pp. 441–2.

5. Richard Redgrave, *A Century of Painters of the English School* (1866), ch. 30. p. 32.

6. Letter to Robert Finch, 18 Apr. 1824, Finch MSS., Bodleian Library, Oxford. Donaldson, Secretary of the Institute of British Architects, lectured on Martin's plans at the Royal Institution in March 1833. Martin's 'Laminated beam' (timber reinforced with layers of iron) was later brought to the attention of the R.I.B.A. and cited in a lecture by W. S. Inman, 10 July 1837. (See Balston, *John Martin*, p. 274.)

7. J. Summerson, *John Nash* (1935), p. 180.

8. In 1838 Gandy put forward a plan for a cast-iron Necropolis: a cellular pyramid in which coffins were to be stacked like cloves in a pomander, a subterranean temple with a lighthouse on top.

9. One intake point of the Grand Junction Waterworks Company was only three yards from a large outfall drain.

10. Martin's Celestial City in the *Paradise Lost* illustrations may have inspired the 'incan-

descent palace' of Queen Claudia in Jane Webb's Utopian novel, *The Mummy* (1827), set in a future, air-conditioned, landscaped London where the Thames runs with pure water. The horticulturist and friend of Martin, J. C. Loudon, greatly admired the book, met Jane Webb in 1830, and married her soon after. Isabella Martin became a close friend of both Jane and her daughter Agnes. It is possible that this fantasy of London in the year 2126 helped inspire Martin's water-supply schemes. (See Bea Howe, *Lady with Green Fingers*, London, 1961.)

11. See above, p. 171.

12. Charles MacFarlane, *Reminiscences of a Literary Life* (London, 1917), quoted Balston, *John Martin*, pp. 164–5.

13. Byron, *Hebrew Melodies*, 'The Destruction of Sennacherib', st. 3.

14. *Trivia Rediviva* (1836).

15. 'Report of Meeting of Shareholders', 29 Jan. 1828, in *Repertory of Patent Inventions*, vol. vi (1828), p. 135. Nitocris, Belshazzar's mother, had ordered the building of a tunnel under the Euphrates, 12 ft. high, 15 ft. wide, wide, sealed by a 6-foot layer of bitumen (Herodotus I).

16. A surviving drawing of his design of 1845 for a double-decker bridge over the Menai Straits (a project he claimed to have conceived years before Robert Stephenson's almost identical Newcastle High Level Bridge of 1846–9) shows a train crossing on the upper level, ships scattered on the Menai waters far below, and, on the road deck, carts drawn by elephants. Reproduced in *Proceedings of the Society of Antiquities*, Newcastle, series iii, no. 4 (1928).

17. He described Upton and Roberts's safety lamp as 'a palpable copy of my brothers', in his *Plan for Ventilating Coalmines* presented to the Select Committee on Accidents in Mines (1835). He also tested Davy's lamp, together with William Martin's and his own: 'The former exploded when neither of the others did so; but on trying the same lamps, with the same gas, at the same place but on another day, the whole three exploded.' See above, pp. 149–50.

18. William Martin, *The Follies of the Day or The Effects of a Gold Chain*, pamphlet (Newcastle, 1839), p. 8.

19. Samuel Rogers and Augustus Pugin, similarly inspired, suggested joining Hyde Park to Regent's Park (see Benjamin Ferrey, *Recollections of A. Welby Pugin* (London, 1861), p. 50). In January 1827 Nash had been ordered by the Treasury to start work on building Carlton House Terrace and landscaping St. James's Park; he planned a large covered fountain to stand at the end of Lower Regent Street overlooking the park (Summerson, *Nash*, pp. 243–5).

20. *Mr. Martin's Plan for Supplying with Pure Water the Cities of London and Westminster and of Materially Improving and Beautifying the Western Parts of the Metropolis*, 2nd edn. (1828).

21. $7\frac{1}{2} \times 10\frac{1}{4}$ in. (Agnew's, 1972).

22. Illustration in *The Imperial Family Bible* (1844).

23. Water-colour, $21\frac{1}{2} \times 32$ in., sig. 1833, formerly coll. Mrs. C. Frank.

24. W. Matthews, *Hydraulia* (London, 1835), p. 347.

25. Leopold Martin, 'Reminiscences', ch. 8, Feb. 1889.

26. Robert Peel wrote to the Grand Junction Water Works Company on 22 June 1829 (letter reprinted in the Company's report), suggesting that 'a competent engineer should be selected by the government to make the necessary survey and to report whether a sufficient quantity of water for the use of the north western part of the metropolis can be taken either from the Thames above Richmond or from the River Colne.' The Grand Junction Company failed to reach agreement on this suggestion and thereupon determined to take water from the Thames above Richmond, 'so many miles above the reach and influence of the London drainage, as for ever to set at rest all queries as to the purity of their source of supply'. In 1834 Thomas Telford produced an alternative but virtually matching scheme for a 'useful and decorative water-course', taking the water supply from the valleys of the Ver and Wandle to the north of London. Martin subsequently gave way to the objections that there was not enough water in the Colne (though he protested that the Grand Junction Company was able to fill an 'immense reservoir' from the 'miserable Brent Brook' and the Ruislip stream, 'truly little more than trickling ditchwaters') and suggested that water could be piped instead from the relatively clean stretches of the Thames above Teddington. *A Plan for Abundantly Supplying the Metropolis with Pure Water from the River Colne* (1834).

27. Waagen, *Works of Art and Artists in England*, vol. ii (1838), p. 161.

28. Thomas Miller, *Illus. Lond. News*, 20 Apr. 1850, p. 280.

29. Nash, 'Collection of Papers relating to the Thames Quay' (1827), quoted D. Pilcher, *The Regency Style* (London, 1947), p. 111.

30. See above, p. 46.

31. Summerson, *Nash*, p. 268. Trench later took it upon himself to present ornately bound Bibles every year to Queen Victoria.

32. *A Prospectus of Proposed Improvements on the Banks of the Thames*, Feb. 1825. A view and description of the embankment were also published in the *Monthly Journal*, 2 Apr. 1825.

33. F. Trench, *Prospectus of the Proposed Improvement on the Banks of the Thames* with lithograph by T. Dighton (1825).

34. William Martin, *The Follies of the Day*, pamphlet (1839), p. 8.

35. The pamphlet was partly inspired by a voyage from Newcastle where Martin had been visiting his brother William in September 1828: 'About ten o'clock I left the deck, pleased with the hope that the next rising sun would bring London within our view. On arising in the morning I was greatly disappointed at finding that the vessel had been anchored five or six hours, it being so dark that the captain could not see the buoys which mark the sandbanks.' To remedy such dangers and delays, Martin suggested that 200 'suspended light towers' on tripods anchored in iron boxes on the sea-bed be installed along the coast. The pamphlet included a design for an Elastic Iron Ship, its hull held tense by metal hoops, with wool and tar packing between the ship's timbers and its iron cladding and a double keel to enable it to rebound off rocks: a dodgem ark or dreadnought, designed to be proof against both decay and 'shoals, rocks, tempests, artillery and lastly against fire'. He also proposed an 'Elastic Chain Cable', each link containing shock-absorbent spring; and a *Plan for Purifying the Air and Preventing Explosion in Coal Mines* (a modification of an idea William Martin had evolved years before).

36. *A Plan for Improving the Air and Water of the Metropolis* (1833).

37. *A Plan for Abundantly Supplying the Metropolis with Pure Water, from the River Colne* (1834). Here he also suggested a cambered track running on top of an aqueduct: 'The road, on which the rail is, should be sloped inwards so that the carriages should have the same position that a man takes in turning quickly when skating.'

38. *A Plan for Abundantly Supplying the Metropolis with Pure Water* (1834).

39. 54 × 83 in., sig. 1832; see above, p. 218, n. 36.

40. 'Architectural Outline of the Intended Range of Wharfs and Public Walks', *Report of the Committee appointed for the Purpose of taking into consideration Mr. Martin's Plan for rescuing the River Thames from every Species of Pollution*, App. C, no. 1 (London, 1836).

41. Based on Turner's engraving of Tyre in Murray's *Illustrations of the Bible* (London, 1834), see above, p. 170.

42. Byron, *Sardanapalus* (1821), Act V, sc. i, lines 195–7.

43. *Report of the Committee appointed for the Purpose of taking into consideration Mr. Martin's Plan*, (1836).

44. Ibid.

45. The *Architectural Magazine* (vol. iii, July 1836, pp. 360–83), discussing the Committee's Report, noted that Martin's intercepting sewer would create problems on account of its 'unavoidable magnitude' and that, whatever the precautions, there would be a serious risk of flood. The magazine also considered that 'Mr. Martin's colonnade, grand and sublime as we allow it to be, if executed on either, or on both sides of the Thames, would take away the interest and variety which at present attaches to the river.' But see above, p. 124.

46. A set of diagrams was published in App. 6, plans iv, 1–6 of *The First Report of the Royal Commission on Metropolis Improvements* (1844).

47. Trench at this time suggested a railway to run alongside his revised embankment and above a new street from Blackfriars to Whitechapel. In June 1845 The Thames Embankment and City Railroad Co. was advertised. Two months later this became The Thames Embankment and Atmospheric Co. Thomas Page was the engineer.

48. W. Matthews, *Hydraulia*, 1835.

49. Martin suggested 'the creation of a source of power, transferable with certainty to every spot along the whole line of wharfage, and to every manufactory requiring power for every conceivable purpose'. This was to be a supply of steam generated from ventilation fires in the intercepting sewer which would be used to create a vacuum in 'the hollow architrave over the wharfs . . . the hollow pillars and their connections'. 'Mr. Martin's Structure', Nathaniel Ogle maintained, would thereupon become one 'mighty engine'. It would also, indirectly, 'lessen the volumes of smoke which cross the river and pass over London'. (*Report of the Committee on Mr. Martin's Plan* (1836), App. B, no. 1.)

50. Some ventures were considerably more ambitious and far-fetched than Martin's. Shortly after his death a scheme was seriously considered for piping water all the way from North Wales and the Lake District to London, while in 1829 the Universal Gas Company was formed to supply London with ready-purified gas direct from Staffordshire.

51. Hofmann and Blyth, *Report on Metropolitan Water Supply* (1856).

52. Martin's *Thames and Metropolis Improvement Plan* (1842).

53. A *Plan of the Great Metropolitan Connecting Railway and Public Walk by John Martin*, Sept. 1845, is reproduced in Pendered, p. 304. A *Plan of the London Connecting Railway and Railway Transit Along both Banks of the Thames . . . by John Martin*, Sept. 1845 (a 1 in. map of London), was published (copy in R.I.B.A. Library). Martin enlarged upon the idea in part 3 of his *Outline of a Comprehensive Plan for Diverting the Sewage of London and Westminster from the Thames and Applying it to Agricultural Purposes* (1850). In 1853 Fox, Henderson & Co. proposed a central terminus,

in cast iron, to be built in the middle of the Thames.

54. Pendered, pp. 202–4. The papers cited are now untraced. They include a 4-page MS. on 'Means of Safely Making and Storing Gunpowder, and at the same time of establishing an efficient System of National Defences'. The *Gardener's Magazine*, vol. v, 1839, published an article 'On Breathing Places for the Metropolis and other Towns' suggesting half-mile zones of open land encircling London at mile intervals. The magazine's editor was J. C. Loudon, husband of Jane Webb (see above, pp. 224–5, n. 10).

55. *Illus. Lond. News*, 17 Mar. 1849, p. 177.

56. Drawings of his projects, sold at the sale of his effects in July 1854, have disappeared.

CHAPTER VII

1. *Diary of B. R. Haydon*, ed. Pope, vol. iii (1963), p. 419, 29 Jan. 1830. He adds: 'Shee the great founder of the tip-toe school.'

2. 'Though if it were possible to make all the royal academicians into one man, he would still be a lame duck to John Martin, the historical painter' (William Martin, *Follies of the Day*, 1839, p. 8). *Arnold's Magazine of the Fine Arts* (New Series, a continuation of the *Library of the Fine Arts*), vol. iii, no. 2, Dec. 1833, p. 104: 'On the Genius of John Martin': 'The truth stares them, and the whole world, in the face THAT JOHN MARTIN IS NOT A MEMBER OF THE ROYAL ACADEMY. But if this be a blot and an indelible stain of disgrace upon the Royal Academy, what shall we say to those *pseudo*-patrons of British Art, who profess their anxiety to support the FINE ARTS in this country? What shall we say to them, when they own, as own they must, that they never yet gave Martin one single commission, and never yet purchased one of his pictures? The only excuse we can naturally offer for the insanity of their conduct is, that the magnificent conceptions of our artist are of far too exalted a nature for their grovelling comprehensions.'

3. Martin also lent Etty's *Combat* (see above, p. 72) to the Royal Scottish Academy, which eventually decided to buy the painting from him in 1831.

4. Ten parts were published between 1831 and 1835, stopping short at *The Fall of Nineveh*. Each part cost 4 guineas for unlettered proofs, 2 guineas for lettered proofs, and prints 1 guinea, according to Martin. Balston (*John Martin*, p. 140), referring to Martin's account book (which then belonged to Miss Pendered), says 'The sales to the print-sellers had descended to nineteen, twenty-five and twenty for the last three parts.'

5. Prospectus of a 'Series of Prints to illustrate the Old and New Testaments', 1831, quoted Balston, *John Martin*, p. 138.

6. Cunningham, *Life of Wilkie*, vol. ii (1843), p. 56.

7. Two of which, *Pandemonium* and *Satan in Council*, were engraved again by Martin and published in 1832 (21 × 30 in.). *The Death of the First Born* (22 × 31 in.) was published in July 1836 and dedicated to King Louis-Philippe. Around this time Martin's eldest son, Alfred, started producing mezzotint versions of his father's work, including *Christ Walking on the Sea* (5⅜ × 9 in.), 1835, *The Destroying Angel* (10⅝ × 15⅞ in.), 1835, *The Last Man* (9 × 14 in.), 1836, and *Sadak* (16¼ × 12⅝ in.), 1841.

8. Tilt, advertisement for *Illustrations of the Bible*, 1849 (Balston, *John Martin*, p. 141).

9. Water-colour, 5 × 8⅛ in., n.d., Nottingham Castle Museum.

10. *Description of Mr. Martin's Plate of the Crucifixion*, n.d. (*c*. 1834), p. 8.

11. Ibid., p. 4.

12. F. G. Moon, who published Martin's other large mezzotints, bought the plate for £1,000.

13. *Description of Mr. Martin's Plate of the Crucifixion*, p. 6.

14. Martin had begun with a ground plan. John Britton, the antiquarian, had seen Martin 'engaged on the subject of the *Crucifixion*, for which purpose he had formed a ground plan of the city of Jerusalem:—by conceiving himself placed on a commanding situation' ('Report on Britton's Lectures on Architecture given at the Bristol Institution, 2 Oct. 1833', *Arnold's Magazine of the Fine Arts*, vol. iii, no. 1 (Nov. 1833), p. 57). For Britton and his interest in scenic display (he had been hired for 3 guineas a week to write and recite a commentary to de Loutherbourg's Eidophusikon in 1799) see J. Mordaunt Cook, 'John Britton and the Genesis of the Gothic Revival', in *Concerning Architecture* (essays presented to Nicolaus Pevsner), ed. J. Summerson (London, 1968).

15. This perspective view, a lithograph, was published on 1 July, issued with the *Report of a Committee of Gentlemen appointed to take into consideration Mr. Martin's plan for improvement and conservancy of the River Thames* (1836).

16. Water-colour, 6 × 8¾ in., sig. 1840, V. & A.; a mezzotint, 4½ × 6½ in. (1835); steel engravings to Churton's edn. of the *Poetical Works of John Milton* (1836) and the *Imperial Family Bible* (1844); also a small oil-painting, 15 × 21 in., n.d., Paul Mellon coll.

17. Josephus, *Antiquities*, B.15, C.11 (quoted p. 1 of *Description of Mr. Martin's Plate of the Crucifixion*).

18. *Description of Mr. Martin's Plate of the Crucifixion*, p. 3.

19. Thomas Sopwith, *A Treatise on Isometrical Drawing* (London, 1834), p. 237. In

1839 Martin suggested that technical drawing ('especially ground plans, elevations and perspectives') should be taught in schools to help make scientific and engineering data comprehensible to the layman. See above, p. 150.

20. Westall–Martin *Illustrations of the Bible* (1835), p. 72.

21. William Rossetti, MS. note in a copy of Westall–Martin *Illustrations of the Bible* (see Todd, *Tracks in the Snow* (1946), p. 116).

22. Ruskin, *Collected Works*, vol. i (1903), p. 243.

23. Ibid., vol. iii, p. 365.

24. A collection of 'very choice and valuable Drawings and Cabinet pictures by eminent modern artists', assembled by Charles Heath 'for his various publications', sold at Sotheby's on 27 Jan. 1832, included two landscape compositions ('Castles with mountainous scenery'), *The Repentance of Nineveh*, and 'Another Property' (possibly that of Belisario who had acted as Martin's dealer), which included among the oil-paintings 'the finished original sketch, very fine' of *Joshua* and *Macbeth* ('the finished Picture'), *Edwin and Angelina* ('a beautiful gem'), and two views in Kensington Gardens. It is probable that these paintings had failed to sell at his Egyptian Hall exhibition in 1822. The sale also included twelve drawings of 'The Soldiers Progress, ten illustrating Collins' "Ode to the Passions"' (one, *Fear*, coll. W. A. Brandt), *Alexander and Diogenes* (which belonged to Belisario when engraved for the *Literary Souvenir* (1827) and is probably a water-colour, $9\frac{7}{8} \times 12\frac{1}{2}$ in., unsig., n.d., coll. Thomas Balston, V. & A.), and *The Seventh Plague* (probably the water-colour, $9\frac{1}{4} \times 14\frac{1}{4}$ in., sig. 1833, coll. Mrs. C. Frank).

25. *Leila*, 48×60 in., untraced. For *Alpheus and Arethusa*, see above, p. 218, n. 36.

26. Laing Art Gallery, Newcastle.

27. *Arnold's Magazine of the Fine Arts* (Mar. 1833) explains that Martin objected to the way *Alpheus and Arethusa* was hung at the British Institution—'skied', even though it was 'painted like most of Mr. Martin's to be placed on a level with the eye'.

28. Letter to W. Jerdan, 11 Mar. 1833, quoted Pendered, p. 184.

29. Leopold Martin ('Reminiscences', ch. 16, Apr. 1889) says that Martin, 'much liking the idea of education carried on in so popular a manner, at once agreed to render assistance' to Ralph Watson, the promoter of the Adelaide Gallery, 'a kind-hearted philanthropist and a wealthy man' who, shortly after the failure of the venture, cut his throat.

30. H. and A. Gernsheim, *L. J. M. Daguerre: the History of the Diorama and the Daguerreotype* (New York, 1968), p. 45. Versions of *Belshazzar's Feast* and *Joshua* by Hoadley and Oldfield had appeared in an 'Exhibition of Paintings in Enamel Colours on Glass', at Collins, 357 The Strand, March 1832.

31. Towards the end of his life he became involved in an afterthought from the 1851 Exhibition, the 'Royal Panopticon of Science and Art', housed in a Moorish-styled building in Leicester Square. Music was to waft around select craftsmen who demonstrated the arts of hat-making, sculpting, and blacksmithing. Martin invested in the venture in its planning stage but later withdrew and, in any case, died a month before it opened in March 1854. The project failed and the building became the Alhambra Music Hall, where the first British demonstration of the can-can took place in 1870. (See Leopold Martin, 'Reminiscences', ch. 16, Apr. 1889.)

32. *The Diary of Henry Crabbe Robinson*, ed. Derek Hudson (London, 1967), p. 140, 14 Mar. 1835.

33. Ralph Waldo Emerson, *The Journals and Miscellaneous Notebooks*, ed. A. W. Plumstead and H. Hayford (Cambridge, Mass., 1969), vol. vii, 10 June 1838, p. 10.

34. See above, p. 88.

35. He lent money to Haydon, discussed his plans with him, and was intimate with Charles Landseer and William Collins. Leopold Martin describes visits to Constable and Turner. (A pencil sketch of Turner by Martin's third son, Charles, is in the National Portrait Gallery.) Martin also served for a time during the early 1830s as Secretary to the Artists General Benevolent Fund.

36. S. C. Hall, *Book of Memories* (1870), quoted Balston, *John Martin*, p. 167.

37. See Christopher North (John Wilson), *Noctes Ambrosianae*, *Blackwood's Magazine*, Jan. 1827, on *Alexander and Diogenes*. Another dialogue between North and Hogg on *The Paphian Bower* appeared in March 1827.

38. Letter, 29 May 1833, National Library of Scotland.

39. He was put up for membership in 1833 as 'a person of distinguished eminence' by William Brockedon (1787–1854), a topographic writer (e.g. *The Passes of the Alps* and *London to Naples*), a sculptor and painter (including a *Deluge*), and inventor of a means of drawing out gold and silver wire. He also helped Martin to establish and equip his print workshop. For Martin's social contacts see Leopold Martin's 'Reminiscences', *passim*.

40. See above, p. 112. Martin provided a design, 'Eruption of 1822', for *Pompeii*, 'illustrated with picturesque views by W. B. Cooke, letterpress by T. L. Donaldson' (London, 1827), vol. i, p. 25.

41. Vol. ii (1833), pp. 211–12. Bulwer-Lytton also described (p. 230) both the Royal

Academy and 'Royal Academy for Science' as 'the creatures of the worst social foibles of jealousy and exclusiveness'.

42. W. P. Frith, *My Autobiography and Reminiscences*, vol. i (1887), p. 47.

43. Leopold Martin, 'Reminiscences', ch. 9, Mar. 1889.

44. J. Galt, 'Eve of the Deluge', reprinted in his *Stories of the Study*, vol. iii (1833), pp. 321–2.

45. Leopold Martin, 'Reminiscences', ch. 14, Apr. 1889.

46. First published in the *New Monthly Magazine*, vol. xxxviii (1833), pp. 30–1, repr. Elliott's *Poems*, vol. iii (1835), pp. 115–16.

47. Quoted J. Steegman, *Victorian Taste* (London, 1950), p. 108.

48. *Diary of B. R. Haydon*, vol. iv, 2 Sept. 1834, p. 221.

49. Letter to Lucia Emerson, 27 Oct. 1847, *Letters of Ralph Waldo Emerson*, ed. Ralph L. Rush, vol. iii (New York, 1939), Emerson failed to realize that Martin's Babylon paintings if not his prints, anticipated the Nash terraces to which he was no doubt referring.

The Glasgow architect, Alexander 'Greek' Thomson (1817–75) cited Martin as an influence on his idea of townscape. See A. Maclaren Young in the *College Courant* (Journal of Glasgow University Graduates Association), vol. 6, no. 12 (1956), p. 111, and drawings in Mitchell Library, Glasgow, e.g. a 'Design for the Natural History Museum, South Kensington' (1864).

50. Martin's son-in-law, the archaeologist Joseph Bonomi (who married Jessie Martin in 1842), helped his brother Ignatius design a new flax-spinning mill in 1838 (completed in 1842) for Marshalls of Leeds in an Egyptian style, its roof inset with six glass domes to light the work floor.

51. Newspaper cutting, headed 'Delightful Travelling' (unidentified, in author's possession), describing the opening of the London and Greenwich Railway, 'when for the first time, a real railroad was run right into the heart of London'. The track ran on brick viaducts with cast-iron Doric columns supporting the bridges: comparable to the perspective views of Martin's embankment.

52. Leopold Martin, 'Reminiscences', ch. 16, Apr. 1889.

53. Tate Gallery. See John Gage, *Turner: Rain, Steam and Speed* (London, 1972), pp. 27–8. A drawer on Martin's cabinet (Laing Art Gallery) is labelled 'Railways and Railway carriage wheels'.

54. At Scarisbrick Hall (1837–50) Pugin created a setting which held the biggest collection of Martin's work ever assembled. (See above, pp. 175–6.)

55. Charles Kean, Playbill for *Sardana-*
palus (1853). See T. J. Wise, *A Bibliography of the Writings in Verse and Prose of Lord Byron*, vol. ii (1933), p. 101.

56. Leopold Martin, 'Reminiscences', ch. 13, Mar. 1889.

Wheatstone also endorsed Martin's estimate of water-flow in the River Colne in evidence to the Committee on Metropolis Water in 1834; and he introduced Dr. G. F. Waagen to Martin in the summer of 1835. (See Waagen, *Works of Art and Artists in England*, 1838, vol. ii, p. 161.)

Wheatstone, inventor of the submarine cable, the concertina, and other devices that, at the time of development, must have appeared as odd as anything in Martin's pamphlets, demonstrated the principles of his electric telegraph at one of Martin's soirées, which indeed he seldom attended 'without some novel and ingenious model or invention' (Leopold Martin). Wheatstone's stereoscope might almost have been designed to enhance the three-dimensional thrust of Martin's most ambitious paintings.

57. Faraday wrote at least three letters to Martin expressing warm encouragement: see Pendered, pp. 205–6.

58. B. R. Richardson, *Memoirs of Thomas Sopwith* (1891), p. 108.

59. *The Journal of Gideon Mantell*, ed. E. Cecil Curwen (London, 1940), p. 125.

60. As Turner had shown in his painting of 1806 (National Gallery).

61. William Martin, MS. in Newcastle City Library. See also Todd, *Tracks in the Snow*, pp. 106–7.

62. Mantell, *Wonders of Geology*, vol. i (1838), p. 455 (1857, p. 369). In the 7th edn. (rev. T. R. Jones, publ. Bohn, 1857) the line engraving was replaced by an etching on mezzotint ground (also $3\frac{1}{2} \times 5\frac{3}{4}$ in.) which included a distant landscape more typical of Martin and suggesting that he may have made two original designs of the subject. A description of the frontispiece of the 7th edn., printed as an appendix, explains that 'From the materials furnished by the researches of the author in the Wealdean formation of the South-east of England, the eminent painter of BELSHAZZAR'S FEAST (Mr. John Martin) composed the striking picture . . . a country clothed with tropical vegetation, peopled by colossal reptiles. An Iguanodon attacked by a Megalosaurus and Crocodile constitute the principal group; in the middle distance an Iguanodon and Hylaeosaurus are preparing for an encounter.' For comparable developments of the imagery of prehistory see the illustrations by Riou to Louis Figuier, *The World of the Deluge*, 2nd edn. (London, 1867), which include many prehistoric scenes and end with *The Asiatic Deluge* (Plate 33) in Martin's idiom.

63. 'Diaries of Ralph Thomas', Pendered, p. 232.

64. A second version of *The Angel with the Book*, announcing the imminent apocalypse, with St. John watching as Everyman, was published in *The Imperial Family Bible*, 1844 (steel engraving by C. Wands).

65. Frontis. to Southey's edn. of *Pilgrim's Progress* (London, 1830).

66. 'Plan for ventilating coal mines by John Martin Esq.', printed as Appendix A in the *Report of the South Shields Committee appointed to investigate the causes of accidents in coal mines* (London, 1843). Martin published a further almost identical pamphlet in 1849. See also Leopold Martin, 'Reminiscences', ch. 13, Mar. 1889.

67. App. A, *Report of the South Shields Committee . . .* Martin spent the following six weeks at the committee sessions listening to 'evidence of numerous scientific men, whose views . . . fully confirmed' his own, and he presented his plan, in a slightly modified form, to the South Shields Committee set up in August 1839 to investigate mine accidents following an explosion in St. Hilda's Pit near South Shields on 28 June, in which 52 lives were lost. This committee pronounced William Martin's lamp to be 'a most ingenious construction' but 'peculiarly delicate', as it extinguished itself 'almost on the approach of carburetted hydrogen, as was found on trial by the Committee in a foul part of the mine', and, since its main body was a glass cylinder, and it had no wire gauze, it was clearly too fragile for use underground save as a warning device.

68. App. A, *Report of the South Shields Committee . . .*; see also above, p. 136. The Schools of Design were intended to teach such skills.

69. App. A, *Report of the South Shields Committee . . .*

70. Ruskin (1857), *Collected Works*, vol. xvi (1905), pp. 369–70.

71. *Mr. Martin's Plan for Supplying with Pure Water the Cities of London and Westminster* (1828).

72. *Diary of B. R. Haydon*, vol. iii, 24 July 1832, p. 269.

73. Ibid., vol. iv, 28 Nov. 1832, p. 18.

74. 'Diaries of Ralph Thomas', Pendered, pp. 217–18.

75. Ibid., p. 219.

76. Pendered, p. 220.

77. Ibid.

78. Ibid., p. 214. By 1845 Thomas had apparently switched his loyalties to the young Millais to whom he gave a retainer of £100 a year to paint for him on Saturdays. (Millais later considered his contract insultingly small and threw his palette at Thomas's head.) Thomas's interests spanned three generations of taste, as later still he helped Whistler print his etchings and received scant reward. In Whistler's words: 'I wrote to the old scoundrel and he died in answer by return of post—the very best thing he could do.' (H. Pearson, *Whistler* (London, 1952), p. 23.)

79. The subject remains uncertain, for the frame bears the clearly erroneous title *Marcus Curtius*, a misreading, it has been argued (Martin exhibition, Newcastle, 1970, cat. no. 20), of *Mettius Curtius*, who was a Roman who escaped from a battle with the Sabines by forcing his horse to swim a lake. It is more likely that the subject is from Moore's *Lalla Rookh*. Martin exhibited *The Fire Worshippers*, taken from this poem, at the Society of Painters in Water Colour in 1837.

80. Westall–Martin *Illustrations of the New Testament* (1836), no. 36.

81. Here, as in *The Deluge* (in its final state) and *The Destruction of Tyre* (1840), Martin involves the spectator by leaving the periphery vague. During the 1840s Turner experimented with square canvas and circular or oval compositions (e.g. *Light and Colour: The Morning after the Deluge* (1843)). While retaining his customary rectangular format, Martin attempted to achieve a similarly compelling effect in his sea paintings. This development may be traced at an earlier stage between *The Creation of Light* (*Paradise Lost*, 1825) and *The Creation* (mezzotint *Illustrations of the Bible*, 1831).

82. Water-colour, exhib. Society of British Artists 1838.

83. Both untraced, exhib. R.A. 1838.

84. Exhib. Society of British Artists 1838. An earlier version, from Byron's poetic drama of 1817, was shown at the S.B.A. in 1826 (see above, p. 95). For Martin's own passing interest in spiritualism, see 'Diaries of Ralph Thomas', Pendered, pp. 233–4.

85. Exhib. Society of British Artists 1838.

86. Probably exhib. R.A. 1839.

CHAPTER VIII

1. A title on Martin's cabinet, 'Coronation 1830', may refer to a painting, otherwise unrecorded, of William IV's coronation.

2. 'Diaries of Ralph Thomas', Pendered, p. 221.

3. 144 × 96 in., painted 1832–4, coll. Earl Howick of Glendale.

4. *Description of Haydon's Picture The Reform Bill Banquet* (London, 1834), quoted E. George, *Life and Death of Benjamin Robert Haydon*, 1948, p. 210.

5. *Diary of B. R. Haydon*, vol. ii, 19 July 1821, p. 350.

6. Lamb, 'On the Barrenness of the Imaginative Faculties in British Art', *Last Essays of Elia* (1833).

7. Leopold Martin, 'Reminiscences', ch. 10, Mar. 1889.

8. Martin's elder children all assisted him in various ways. Isabella served as his secretary, Alfred made mezzotints (see above, p. 227, n. 7). On 16 Nov. 1832 Martin had written to Joseph Smith, Keeper of the British Museum: 'I am desirous of making a selection from the costumes of every country from the earliest period to the present time and have taken the liberty of applying to you to assist me as I wish my sons to make drawings from any works of the kind that may be in the Museum' (Letter, coll. Westfield College, University of London). Leopold and Charles Martin subsequently published *Civil Costume of England from the Conquest to the Present Period*—'Drawn by Charles Martin from tapestry, illuminated MSS., Monumental Effigies, Portraits &c., etched by Leopold Martin, dedicated to Prince Albert.' 2 vols., 1842.

9. 'Diaries of Ralph Thomas', Pendered, p. 221.

10. In 1840 Martin made a design for new stained glass in the rose window of the south transept, sold in the Lindsay House Sale, 4 June 1854.

11. William Blake, 'Maundy Thursday', *Songs of Innocence*.

12. Hector Berlioz, *Evenings in the Orchestra, 1853*, transl. C. R. Fortescue (London, 1965), p. 210.

13. The two prints each five guineas.

14. Prospectus, repr. C. T. Courteney Lewis, *The Picture Printer of the Nineteenth Century: George Baxter* (London, 1911), p. 171.

15. *The Coronation* needed about thirty separate blocks to achieve the full colour effect.

16. Baxter had engraved a few of Martin's illustrations to the Westall–Martin Bible, e.g. *Joshua Commanding the Sun to Stand Still* and *Jerusalem taken captive into Babylon*, and he copied *The Angel with the Book* for one of his early colour prints.

17. 'Diaries of Ralph Thomas', Pendered, p. 222.

18. *Athenaeum*, 'Our Weekly Gossip', 21 July 1839, p. 565.

19. The *Art Union*, 1 June 1844, quoted Balston, *John Martin*, pp. 200–1. *The Coronation* was sold along with *The Deluge* and *The Fall of Nineveh* to Charles Scarisbrick. (See above, pp. 175–6.)

20. Leopold Martin, 'Reminiscences', ch. 5, Feb. 1889.

Martin had exhibited a water-colour, *The Assuagement of the Waters*, at the new Water Colour Society in 1838. This was subsequently shown in Newcastle with the title, *The Subsiding of the Waters*, together with *The Deluge* (*Newcastle Courant*, 5 and 9 Oct. 1838). Martin had thus developed the scheme of the trilogy and had probably started on the oil version of *The Eve of the Deluge* by the time of Prince Albert's visit.

21. *The Deluge, by John Martin*, pamphlet (1840).

22. Genesis 7:12.

23. Byron, *Heaven and Earth*, Part I, sc. ii, 67–8. See above, p. 142.

24. *The Deluge*, 1840.

25. Genesis 6:4.

26. *The Deluge*, 1840. The painting, Martin added, was based on 'the *Book of Enoch* preserved by the Ethiopians', Hebrews 11:5, Jude 14:15; Adam Clark, and Josephus' *Antiquities*, bk. i, ch. ii.

27. Galt, 'Eve of the Deluge', *The Ouranoulogos or The Celestial Volume* (1833), reprinted in his *Stories of the Study*, vol. iii, pp. 321–2.

28. *The Deluge* (1840). Martin goes on to mention 'the Ark in the full flood of sunlight in the distance'. There is no sign of it in the painting today—Martin probably modified it after writing the pamphlet.

29. Gandy's *Architecture its Natural Model* (R.A., 1838; Sir John Soane's Museum) shows the ark stranded once more, with the waters drained away, revealing all the natural origins of structure—arches, columns, and vaults.

30. See above, pls. 108–10.

31. See below, n. 38.

32. *Paradise Lost*, xi.833–8.

33. Letter to J. Jervis, M.P., 27 Mar. 1840, Westfield College Library.

34. W. M. Thackeray, 'A Pictorial Rhapsody: concluded', *Fraser's Magazine* (July 1840), reprinted *Thackeray: Works*, vol. xxv (1895), p. 154.

35. 1805, National Gallery. Turner's *The Evening of the Deluge* and *Light and Colour, Goethe's theory—The Morning after the Deluge* (R.A., 1843) are subjects or pretexts probably suggested by Martin's paintings.

36. Thackeray, art. cit., p. 160.

37. It was probably painted in Paris where Danby had seen Poussin's *Deluge* in the Louvre and, evidently, had been influenced by the prevailing glossy academic idiom. (See cat. entry in *Tate Gallery Report*, 1970–2.)

38. Both paintings exhib. R.A. 1841. They were bought by Benjamin Hick of Bolton and sold again at auction in February 1843 for £189. Martin designed appropriate frames for both paintings: *Pandemonium* has a dragon motif, while the frame (now destroyed) for *The Celestial City* was dominated by a dove. In a letter to Benjamin Hick (5 Aug. 1842; coll. H. B. Huntington-Whiteley) Martin enclosed a sketch of part of *The Celestial City* frame, adding: 'I have purposely departed but little from ordinary frames as the makers generally fail in represent-

ing my intentions' (quoted R. James, 'Two Paintings by John Martin', *Burlington Magazine* (Aug. 1952), p. 234). The only other frame of note designed by Martin is that for *The Assuaging of the Waters.*

39. W. H. Pyne, *Wine and Walnuts* (1823), vol. i, pp. 281–304, also printed in *The Hive* (n.d., probably 1822) vol. i, no. 4, pp. 49–52 and no. 5, pp. 65–8.

40. See above, p. 149.

41. Previous versions included the two mezzotints for *Paradise Lost* (1824) and the preparatory oil sketch, a further mezzotint ($18\frac{7}{8} \times 27\frac{3}{4}$ in., engraved by Martin and I. P. Quilley) published in 1832 (together with *Satan in Council*) and, evidently, a further painting mentioned in the Lindsey House Sale, 1854: a print, 'Lot 198, *Pandemonium*—an impression touched upon and altered from the picture painted for James Ferguson, Esq.' (Balston, *John Martin*, p. 206). The view of Pandemonium in *The Fallen Angels in Pandemonium* (24×30 in., unsig., n.d., Tate) represents a further modification of the original mezzotint designs; though the style, handling, and general disposition of this painting suggest that it may not be by Martin but an essay in his manner—like the panorama of Pandemonium shown at Burford's (formerly Barker's Panorama in Leicester Square, 1829).

42. See above, pp. 149–50.

43. Martin's *Thames and Metropolis Improvement Plan* (1842).

44. *Paradise Lost*, i.711.

45. R.I.B.A. Library.

46. Cf. *The Raising of Lazarus* (Pl. 105) and *Christ Casting out the Legion of Devils* in the Westall–Martin *Illustrations of the New Testament* (1836).

47. In the Academy Catalogue Martin quoted from Bk. iii, lines 374–5: 'Thee, Author of all being, Fountain of light, thyself invisible'. The comparable plate in the *Paradise Lost* mezzotints, *Heaven—The Rivers of Bliss*, was based on xi.78:

> Their blissful bowers
> Of aramanthine shade, fountain or spring,
> By the waters of life. Cf. Martin's illustration to Edwin Atherstone's *A Midsummer Day's Dream* (1824), p. 125:

> 'Away we flew o'er mountains, plains, and seas,—
> A flight immense through splendours beyond thought,
> And now at length, on the horizon's edge,
> What seemed at first a cloud of dazzling fire;
> . . . A wondrous fabric stood'.

48. Letter, 9 Aug. 1852, to John Hick, son of Benjamin Hick, coll. H. B. Huntington-Whiteley, noted James, *Burlington Magazine* (Aug. 1952), p. 234.

49. Several versions exist, e.g. *The Wye near Chepstow*, water-colours, $23\frac{1}{2} \times 12$ in., sig. 1844, Whitworth Art Gallery Manchester. Oil, private collection.

50. He exhibited a water-colour, *The Valley of the Tyne, my native country from Henshaw*, at the R.A. in 1841. See also pl. 137.

51. T. Moore, *Loves of the Angels* (1823).

52. *Paradise Lost*, xii.435–6.

53. Quotation from review and extracts from *The Excursion of a Spirit*, published in *The Hive*, vol. i, no. 4 (n.d., probably 1822), pp. 54–5.

54. *Lord Beaconsfield's Letters, 1830–1852*, ed. Ralph Disraeli, new edn. (1887), p. 59.

55. Prospectus for Blackie & Son's *Imperial Family Bible* (1844), quoted Balston, *John Martin*, p. 208.

56. Turner's design derived from a sketch made in Palestine in 1819 by Charles Barry. Sketches by W. H. Bartlett, a pupil of John Britton, were engraved for John Carne's *Views of Syria, the Holy Land etc.*, publ. 1836. See T. S. R. Boase, 'Biblical Illustration in 19th Century English Art', *Jnl. Warburg and Courtauld Inst.*, vol. 29 (1966), pp. 349–67.

57. Elton, *General Gordon* (London, 1954), pp. 312–19.

58. *The Deluge*, 1840 (pamphlet).

59. Layard, *A Popular Account of Discoveries at Nineveh* (1851), p. xi.

60. Cf. also the style of the frontis., 'The North East façade and grand entrance of Sennacherib's Palace', restored from a sketch by James Fergusson, in Layard, *Discoveries in Nineveh and Babylon* (1853).

61. T. J. Wise, *Bibliography of Byron*, vol. vol. ii, p. 101. Kean had drawings made to record the stage designs. These include *Nineveh and the River Fairies* by W. Gordon and *The Destruction of the Palace* by I. Days (both pencil and water-colour, 7×10 in., 1853, Victoria and Albert Museum).

62. Previous versions included a mezzotint ($4\frac{1}{2} \times 6\frac{1}{4}$ in., 1835) and a notably impressive design for the Westall–Martin *Illustrations of the New Testament* (1836), no. 2. The painting bears only a titular relation to Turner's *Birth of Christianity: the Flight into Egypt* (1841).

63. 25×41 in., exhib. R.A. 1851 (not located).

64. When Martin painted a replica version of *Joshua* for Charles Scarisbrick in 1848, the architecture remained very much the same as in the original painting, although the towers of the city gateway were squared off as in the 1827 mezzotint.

65. Martin to Bulwer-Lytton, 22 May 1849, Bulwer-Lytton MSS., Knebworth House.

66. Cf. Martin's designs for *Paul at Melita* and *The Angel with the Book* (both 1839) in the *Imperial Family Bible* significantly altered

since their first appearance among the Westall–Martin *Illustrations of the New Testament* (1836).

67. Waagen, *Treasures of Art in Great Britain* (3 vols., London, 1854), vol. iii, p. 242.

68. Thomson, *The Seasons*, 'Autumn' (1730), line 810.

69. 43 × 54 in. (framed), exhib. R.A. 1843, untraced. Also Westall–Martin *Illustrations of the New Testament* (1836), no. 5.

70. *Modern Painters* (1846), *Works*, vol. iv (1903), p. 311.

71. Ruskin, *Collected Works*, vol. x (1904), p. 223.

72. *Diaries of John Ruskin*, 13 May 1843, ed. Evans and Whitehouse, vol. i (Oxford, 1956), p. 241.

73. *Childe Harold's Pilgrimage*, Canto iv. 179.

74. 'Diaries of Ralph Thomas', Pendered, p. 224.

75. Mr. Brookes, holder of the first prize in 1842, chose *The Flight into Egypt*, and the painting was shown subsequently in Whitworth Town Hall, Manchester, to aid the Medical Relief Fund. (See Anthony King, 'George Godwin and the Art-Union of London', *Victorian Studies*, vol. 8 (Indiana, 1964), pp. 100–50.) The Art-Union lottery, a development of the scheme Haydon had employed and which Martin had hoped to try ('against his feeling') in 1838 to raise money on unsold paintings, was discontinued, following a court order, in 1844. The Art-Union, founded in 1837, was intended to promote art through subscription and the distribution of paintings and prints, giving ordinary members of the art-loving public the chance to possess 'Historical Pictures Illustrative of the Bible, British History or British Literature'.

76. The highest price for one of Martin's paintings was probably the 800 guineas paid by the Duke of Buckingham in 1822 for *The Destruction of Pompeii* (resold in 1848 for 160 guineas).

77. Whom he had recommended to Benjamin Hick in 1842 as having two paintings, 'particularly favourable specimens', by Richard Wilson (Letter, coll. H. B. Huntington-Whiteley; see R. James, *Burlington Magazine* (Aug. 1952), p. 234). They fetched only £189 at auction, less than a year after Martin had sold them for a considerable amount to Benjamin Hick of Bolton.

78. See Mark Girouard, 'Scarisbrick Hall', *Country Life*, vol. 123 (1958), pp. 506–9 and 580–3. Humphrey Repton had drawn up plans for rebuilding the Hall in 1803. Pugin's designs, further modified by his son, E. W. Pugin (1862–70), included the prototype for the 'Big Ben' clock tower on the Houses of Parliament.

79. 59 × 92 in., sig. 1848, Dewsbury Town Hall, reproduced *Illus. Lond. News*, 10 Mar. 1849. J. M. Naylor of Leighton Hall, Welshpool, who owned the original version of *Joshua* and *Belshazzar's Feast*, bought *The Flight into Egypt* during the 1840s. (See Waagen, *Treasures of Art in Great Britain* (1854), vol. iii, p. 242.)

80. 52 × 83 in., exhib. British Institution 1842, Scarisbrick Sale, 17 May 1861, lot 374, untraced.

81. 20 × 34½ in., sig. 1843, exhib. R.A. 1846, coll. Mrs. C. Frank.

82. 70 × 102 in. (framed), exhib. British Institution 1843, Scarisbrick Sale, lot 372, untraced.

83. Exhib. R.A. 1845, Scarisbrick Sale, lot 364, untraced.

84. Scarisbrick sale, lot 360, untraced.

85. *Arnold's Magazine of the Fine Arts*, Dec. 1833, p. 104.

86. Letter to J. Fairey, 25 Feb. 1853, Westfield College Library. By then Martin was charging from £15 to £50 for a water-colour and 'could not execute an oil painting for less than £50'.

87. Probably the *View of Ilfracombe*, exhib. R.A. 1848.

88. 8½ × 21½ in., sig. 1842, Towner Art Gallery, Eastbourne.

89. Exhib. R.A. 1843 (probably the painting which was awarded the silver medal at the Liverpool Academy).

90. Thomson, *Hymn on Solitude* (1727), lines 43–8.

91. Untraced. Possibly the water-colour, 'The Valley of the Tyne', described in the *Athenaeum*, 22 May 1854, p. 657, as 'a cold, black, drear looking spot, but to him no doubt fairer than Cashmere and Avoca'. A 'Moorland Scene' (10¾ × 26½ in. sig. 1842. Private Collection) may be a repeat version of this painting.

92. Both 60 × 86 in. (framed), exhib. R.A. 1844, Scarisbrick Sale, 17 May 1861, lot 364, untraced.

93. *Athenaeum*, 25 Feb. 1843, p. 195.

94. Newcastle exhibition (1970), cat. no. 62, entitled *The Expulsion*.

95. Thomson, *The Seasons: Autumn* (1730), lines 1004–5.

96. Eleven mezzotint illustrations; all but *The Flood* engraved by Alfred Martin.

97. 'Diaries of Ralph Thomas', Pendered, p. 223.

98. 120 × 169 in., chalk on paper, untraced—presumably destroyed.

99. 31 × 45 in., chalk on paper, untraced—presumably destroyed.

100. T. S. R. Boase, 'The Decoration of the New Palace of Westminster 1841–63', *Jnl. Warburg and Courtauld Inst.*, vol. 17 (1954). The figures in Martin's *Arthur and Aegle* (see

above, p. 183) are remarkably similar to those in Dadd's cartoon (see David Greysmith, *Richard Dadd* (London, 1973), Pl. 38).

101. *Modern Painters*, 2nd edn. (1844), *Collected Works*, vol. iii (1903), p. 38.

102. After 1844 Ralph Thomas makes no further mention of Martin in his diary (see above, p. 151 and 230, n. 78). Thomas acted as a dealer in a shop at 39 Old Bond Street, and (see J. G. Millais, *The Life and Letters of Sir John Everett Millais* (London, 1899), vol. i, pp. 33–4). Thomas's portrait by Millais (1848) is in the Tate. (See M. Bennett, Cat. of Millais exhibition, Liverpool, 1967, p. 34, and Ralph Thomas, *Sergeant Thomas and Sir John Everett Millais* (pamphlet, London, 1901).)

103. William Bell Scott, *Autobiographical Notes* (1892), vol. i, p. 171.

104. Leopold Martin remembered being sent by his father, in response to an appeal for money, to Haydon's house, where he saw 'the destitute artist at the dinner table, on which, together with many choice things, were French and other costly wines, and many items of luxury usually found but on the tables of the wealthy. To my mind my father's benevolent aid seemed out of place.' They both returned the next day to find 'the house in the most frightful disorder. Disappointment, together with anxiety, had turned and quite crushed an overworn brain, and in a frenzy he had terminated his existence' (Leopold Martin, 'Reminiscences', ch. 11, Mar. 1889). This anecdote is credible but uncorroborated.

105. Op. cit., p. 171.

106. See *Objections to the Tunnel Sewer proposed by the Metropolitan Sewage Manure Company by their new Bill* (1847).

107. *Outline of a Comprehensive Plan for Diverting the Sewage of London and Westminster from the Thames and Applying it to Agricultural Purposes* (1850). Among the many similar designs for a Thames Embankment at this time were two proposed by the topographic artist Thomas Allom. Perspective drawings of these, exhibited at the Academy in 1846 and 1848, are now in the V. & A. (see John Physick and Michael Darby, *Marble Halls: Drawings and Models for Victorian Secular Buildings* (London, 1973), cat. no. 9).

108. At about this time he also issued a *Reprint of the Report of the Committee appointed to take into consideration Mr. Martin's Plan for rescuing the River Thames from every species of Pollution* (n.d., c. 1850).

109. Charles Martin went to the United States in 1848 to make portraits, returning to England shortly before his father's death. Mrs. Atkinson (Martin's sister Anne) was probably still living with Martin in 1848. She is mentioned in an obituary notice in the *Newcastle Courant*, 17 Feb. 1854. William Martin came to live at

Lindsey House in 1849 and died in 1851 (see above, p. 118).

110. 'Memoirs of Oliver Brown', quoted E.R. and J. Pennell, *The Whistler Journal* (Philadelphia, 1921).

111. Leopold Martin, 'Reminiscences', ch. 11, Mar. 1889, J. Lindsay (*Turner*, London, 1966) casts doubts on Leopold's account; for Turner took the house, in Mrs. Booth's name, in October 1846, while Leopold mentions that Turner was 'at work upon his well-known picture "The Fighting Temeraire"' at that time, which suggests a date *c*. 1838. However, apart from this detail, the rest of the anecdote is plausible.

112. *England and the English* (2 vols., 1833), vol. i, p. 211, Martin gave Lytton copies of his prints (now at Knebworth House).

113. *King Arthur*, Preface, p. 2, in *Poetical and Dramatic Works of Bulwer-Lytton* (1853), vol. ii.

114. In the Westall–Martin *Illustrations of the New Testament* (1836), no. 43.

115. *King Arthur*, Bk. v, sts. 86–7.

116. 'Amongst the passages which I had noticed "The Lighting of the Cyrenian Fire-beacons" was a most temptingly noble and striking subject but on further meditation I found that I could not possibly do justice to it in the short time that was to intervene before the reception of the pictures at the Royal Academy.' Martin to Bulwer-Lytton, 7 Apr. 1849 (Bulwer-Lytton MSS., Knebworth House).

117. *King Arthur*, Bk. iii, st. 74.

118. Ibid., Bk. iv, st. 89.

119. Ibid., Bk. iv, st. 91.

120. Martin to Bulwer-Lytton, 22 May 1849 (Bulwer-Lytton MSS., Knebworth House).

121. Martin, evidence to *the Select Committee on the Arts and their Connexion with Manufacture* (1836), quoted Balston, *John Martin*, p. 179.

122. Cf. the water-colour *A Port: Moonlight* (Pl. 132).

123. Martin to Bulwer-Lytton, 22 May 1849 (Bulwer-Lytton MSS., Knebworth House).

124. It failed to sell at the R.A. in 1850 and was shown the same year at the Liverpool Academy.

125. T. J. Wise and J. A. Symington (edd.), *Life and Letters*, The Shakespeare Head Brontë (Oxford, 1932), vol. iii, p. 116.

126. $18\frac{3}{4} \times 27\frac{3}{4}$ in., unsig., n.d. (*c*. 1832), Laing Art Gallery; see above, p. 95.

127. Thomas Campbell, *The Last Man* (1823).

128. Mary Shelley, *The Last Man* (London, 1826), new edn. (Nebraska, 1965), p. 342.

129. Bulwer-Lytton, *King Arthur*, Bk. iv, st. 49.

See also T. Moore, *Lalla Rookh* (1817), 'Paradise and the Peri', lines 194–5:

And oh! to see th' unburied heaps
On which the lovely moonlight sleeps!

130. Macaulay's idea was taken up and illustrated by Gustave Doré in 1872. (See Douglas Jerrold–Gustave Doré, *London* (1872), p. 150.)

131. *Alton Locke* (1850), ch. 35, p. 381 of 1895 edn.

132. *Illus. Lond. News*, vol. xiv, 17 Mar. 1849, p. 177. The revised edition of the 'Thames and Metropolis Improvement Plan', published in 1849, included a 'means of consuming smoke' to reduce atmospheric pollution. See letter to Bulwer-Lytton, 22 May 1849: ' I have already intimated to you the hardship I have encountered of gradually seeing just one portion and then another appropriated by *practical* men, who professed in the outset to disregard such proposals emanating from a non-practical man.' (Bulwer-Lytton MSS., Knebworth House.)

133. *The Last Man* (1823), ll. 1–6, quoted by Martin in R.A. catalogue, 1849.

134. See above, pls. 108–9.

135. Byron, 'Darkness (1816), ll. 68–72.

CHAPTER IX

1. $9\frac{1}{4} \times 16$ in., inscribed to 'His gifted friend——' (illegible), sig. 1852, coll. Gilbert Davis.

2. Martin evidently painted at least one further version of the subject; 'A highly finished *Forest Scene, Evening*', for which he asked 50 guineas (Letter to J. C. Fairey, 25 Feb. 1853, Westfield College Library). Two probably comparable water-colours illustrating the poem *Musidora*, now untraced, were exhibited at the Society of British Artists in 1837. A *Flood Scene at Night* ($6\frac{1}{4} \times 17\frac{3}{8}$ in., Indian ink and body colour, sig., n.d., Witt coll., Courtauld Institute) probably dates from this time.

3. 25×41 in., untraced.

4. Goldsmith, *The Traveller*, lines 34–6.

5. This makes a striking contrast to a bold, summary wash-drawing, *The Ruined Castle* ($8\frac{1}{2} \times 10\frac{3}{4}$ in., sig. 1851, coll. Mrs. C. Frank).

6. Pendered, p. 246.

7. Pencil and ink, sig. 1845, formerly coll. Ruthven Todd, reproduced Todd, *Tracks in the Snow*, Pl. 37.

8. Westall–Martin *Illustrations of the Bible* (1835), no. 43.

9. Probably based on the engraving of the Bridge over the Arrone at Civita Castellana in Finden's *Illustrations to Byron*, ed. W. Brockedon (2 vols., 1833), vol. i, p. 68, which was in Martin's library (see Catalogue, Lindsey House Sale, Christie's, 4 July 1854).

10. Descriptive Key to *The Last Judgment* (single sheet), n.d. (London, *c*. 1853).

11. Ibid.

12. See above, p. 2.

13. *c*. 1580, Ducal Palace, Venice.

14. Leopold Martin, 'Reminiscences', ch. 14. Apr. 1889.

15. Exhib. R.A. 1852. Previous versions of the composition appear in the Westall–Martin *Illustrations of the Bible* (1835), no. 13, and the mezzotint *Illustrations of the Bible*, no. 8, published in 1834. Another painting (44×72 in., unsig., n.d., Scarborough Art Gallery), thickly worked and altogether unresolved, could be an earlier, abandoned, attempt at the subject. A painting attributed to Martin, in Wolverhampton Art Gallery (Balston, *John Martin*, p. 275, no. 20), proved, on cleaning, not to be by him.

16. Joseph Bonomi supplied sketches for a panorama of the Nile at the Egyptian Hall in 1850, including a 'most striking presentation' of a sandstorm or Simoom (*Illus. Lond. News*, vol. xvi, Mar. 1850, pp. 220–2).

17. The circular emphasis of the replica version of *Christ Stilleth the Tempest*, 1852 (see above, pl. 131), is comparable to the oval proscenium arch which framed *The Route of the Overland Mail to India* in Regent Street, the most popular diorama of the early 1850s.

18. MS. agreement among Martin's papers (now untraced), Pendered, p. 246.

19. Originally entitled 'The End of the World'.

20. The composition had appeared in miniature in the Westall–Martin *Illustrations of the New Testament* (1836), no. 43, and as the fourth plate of Thomas Hawkins, *The Wars of Jehovah* (1844).

21. Pollok, *The Course of Time* (1827), Bk. x, ll. 545–6.

22. e.g. Westall–Martin *Illustrations of the New Testament* (1836) and the *Imperial Family Bible* 1844.

23. Martin owned engravings of these (see Catalogue, Lindsey House Sale, Christie's, 4 July 1854).

24. *Newcastle Courant*, 10 Feb. 1854.

25. Revelation 6:16.

26. *Paradise Lost*, vi.649.

27. Byron, *Manfred* (1817), Act I, sc. ii, ll. 94–5.

28. *Collected Works*, vol. i (1903), p. 243.

29. Genesis 1:2.

30. Bulwer-Lytton, *King Arthur*, Bk. iii, st. 69.

31. Revelation 21:2.

32. Martin had painted a landscape 'where man never trod' in fresco (now destroyed) on the garden wall of Lindsey House (Leopold Martin, 'Reminiscences', ch. 7, Feb. 1889).

33. T. Moore, *The Epicurean* (1827), 1839 edn., p. 60.

34. Mrs. H. Wood, *East Lynne* (1861), p. 367.

35. See above, p. 203.

36. Brochure, George Wilson, *The Martin Judgment Pictures* (n.d., London), in author's possession. *The Last Judgment* had been first exhibited by Maclean at his shop in the Haymarket in the summer of 1853 (*Art Journal*, July 1853, quoted Balston, *John Martin*, p. 234). Maclean was allowed to take the paintings on tour for as long as was necessary to promote the engravings. Though there was no specific mention of the Judgment pictures in Martin's will, Leopold Martin maintains ('Reminiscences', ch. 14, Apr. 1889) that they were left to Martin's cousin, wife of Thomas Wilson, the son of his host on the Isle of Man. George Wilson was presumably her son.

37. Obituary notice, *Athenaeum*, 25 Feb. 1854, p. 247.
The *Athenaeum*, 4 Mar. 1854, p. 280, printed a letter from J. L. Fairless referring to a remark in the obituary:

'Speaking of his last great paintings—"The Judgment" &c., you say, "Of course these works are left unfinished." The pictures in question are before me, while I write this, and certainly appear to have received the final touches of Martin's pencil, being carefully and elaborately worked out; while his name in an angle of the canvas is the artist's own acknowledgment of the completion of his work. The fact, too, that they are now making the usual provincial tour of pictures about to be engraved, is also conclusive evidence—for what artist would allow his unfinished picture to be engraved? ... It will, perhaps, be well to correct this little error, for although at present it appears a trifling circumstance, it may afterwards be matter of considerable importance.'

M. W. Burger (*École anglaise*) claimed that Martin was working on a *Meeting of Jacob and Esau* at the moment he suffered his stroke (Balston, *John Martin*, p. 236, n.).

38. Elliotson, quoted by Leopold Martin, 'Reminiscences', ch. 16, Apr. 1889.

39. *Athenaeum*, 25 Feb. 1854, p. 247.

40. Leopold Martin, 'Reminiscences', ch. 16, Apr. 1889.

41. *Observer*, 12 Feb. 1854 (Pendered, p. 250).

42. Pendered, p. 252.

43. *Newcastle Courant*, 10 Feb. 1854.

44. *Art Journal*, June 1855.

45. *Illus. Lond. News*, 6 May 1855.

46. *Athenaeum*, 7 July 1855, pp. 793–4.

47. Engraved by Charles Mottram, *The Last Judgment* (26¾ × 41¾ in.), *The Great Day of His Wrath* and *The Plains of Heaven* (each 24½ × 38 in.). Colour versions were produced. James Plimpton, who subsequently owned the plates, remaindered the rest of the prints in 1860. The plates now belong to Thomas Ross Ltd. (see Iain Bain, catalogue note to 'An Exhibition of Victorian Prints', Maas Gallery, Nov. 1971).

48. George Wilson, Judgment Pictures brochure.

49. 'Thoughts on the Choice of a Subject', *Library of the Fine Arts*, vol. iii, no. 8 (Sept. 1831), p. 129.

50. The exhibition was catalogued by Peter Cunningham, the son of Alan Cunningham, who had married Martin's second daughter, Zenobia, in 1842.

51. *Magazine of Art*, 1888, Balston, *John Martin*, p. 25.

52. Such as *Sacred Art* (ed. A. G. Temple, London, 1899) and *The Old Testament in Art* (ed. W. Shaw Sparrow, London, 1904).

53. Sickert, *A Free House*, ed. Osbert Sitwell (1947), p. 203.

54. Sir Wyke Bayliss, *Olives* (London, 1906), p. 32.

55. *The Destruction of Herculaneum and Pompeii* was in fact bought by the National Gallery in 1869, loaned to Manchester for some years, and eventually, after ten years in the basement of the Tate, was badly damaged in the Millbank floods of 1928. The Tate acquired the dubious and, in any case, minor *Fallen Angels entering Pandemonium* in 1943, *The Great Day of His Wrath* in 1945 (cleaned and restored 1971–2), and *The Coronation* in 1946. E. Wake Cook offered to buy *Belshazzar's Feast* for the Tate Gallery in 1923. See E. Wake Cook, *Retrogression in Art and the Suicide of the Royal Academy* (London, 1924), pp. 45–7, an attack on modernism in all its forms in which Cook claimed that Martin 'with his Titanic genius without parallel was without a predecessor or a successor' (p. 190), while assigning him a place in an imaginative tradition descending from Piranesi, Blake, and Flaxman to Beardsley and Rackham. 'The example of Martin is especially needed for the art of the immediate future. He dared the seemingly impossible and wrested from it vast new fields for artistic exploitation. Faulty such work was sure to be; as was Turner's; but the splendour of the achievement remains' (p. 194).

CHAPTER X

1. Redgrave, *A Century of Painters of the English School* (1866), vol. ii, p. 430.

2. The *Library of the Fine Arts*, vol. ii, no. 7 (Aug. 1831), p. 75.

3. Martin to Bulwer-Lytton, 22 May 1849 (Bulwer-Lytton MSS., Knebworth House).

4. C. R. Leslie, quoted Pendered, p. 103.

5. Sir Wyke Bayliss, *Olives*, p. 32.

6. Thackeray, 'Picture Gossip', *Fraser's Magazine* (June 1845).

7. *Athenaeum*, 'Fine Art Gossip', 7 July 1855, p. 793.

8. *The Works of Eminent Masters* (London, 1854), vol. i, p. 352. Joseph Paul Pettitt (b. 1812) also exhibited an *Armageddon* (53 × 102 in.) at the Birmingham Society of Artists, 1852 (see York City Art Gallery, *Preview*, no. 72, 1965). The *Athenaeum* (1 Apr. 1854), describing the painting at its first showing at the Society of British Artists in 1854, noted a 'sign-painter-like elaboration of puppet men and tin soldiers'.

9. [J. B. Waring] *A Handbook to the Gallery of British Paintings in the Art Treasures Exhibition*, reprinted from the *Manchester Guardian* (London, 1857), p. 86.

10. *Athenaeum*, 7 July 1855, p. 794.

11. *A Description of the Picture Belshazzar's Feast . . .* (1821).

12. 1776, untraced, engraved 1777, re-exhibited British Institution 1820.

13. Even so, the *Athenaeum* (26 May 1849) makes mention of 'a particular spot of wall in a particular room to which by some sort of arrangement or admission Mr. John Martin seems to enjoy a presumptive right'. After 1837, evidently, Martin achieved a special relationship of sorts with the Academy.

14. Cunningham, *Life of Wilkie*, vol. ii (1843), p. 56.

15. *Arnold's Magazine of the Fine Arts* vol. iii, no. 2 (1833), p. 98.

16. Frederick Antal (*Fuseli Studies*, 1956, p. 148) was able to identify the class of person who admired Martin with astonishing precision: 'Generally speaking he was a favourite painter with princes, with writers of novels of terror like Bulwer-Lytton, with the large numbers of upper middle-class people who had lower middle-class taste and presumably with the lower middle-class itself.'

17. After an accident at Oswestry level crossing in which *Belshazzar's Feast* was damaged—and, for a time, thought beyond repair—the *Illus. Lond. News* (30 Dec. 1854) commented 'This great loss is, however, the less to be regretted when we reflect what a masterly engraving of it we possess by its own designer and painter. How soon and how completely may the best existing proofs of a great artist's skill be destroyed. A fire or the act of a madman might reduce to nothing the single picture which sustains the reputation of an artist so well known as Paul Potter.'
Leopold Martin, 'Reminiscences', ch. 13, Mar. 1889: 'It was my father's engraved works, those by his own hand chiefly, that made his name so well known in all parts of the world. His popularity could alone be gained in this way, as his paintings were confined to this country, with the exception of the two sent to Belgium, France and the United States.'

18. A. G. Temple, *The Art of Painting in the Queen's Reign* (London, 1897), p. 22: 'Albert Goodwin in England and Rochegrosse in France are not dissimilar to him in some of their work, but Martin differs from these men in that he astonishes but does not satisfy.' Goodwin's *The First Christmas Dawn* (R.A. 1894), showing celestial vaults towering above the fields of Bethlehem, was probably the last and most exaggerated painting to have been conceived in imitation of Martin.

19. Jan Styka's painting, *The Crucifixion* (195 × 45 in., 1894–8) was similarly exhaustively conceived (the artist visited Palestine and had his palette and brushes blessed by Pope Leo XIII before embarking on the work). The painting is displayed in the Forest Lawn Memorial Park, Glendale, California, in a special auditorium with a sound and light system and two-ton velvet curtains. A sequel painting, *The Resurrection* by Robert Clark, is planned. See *Art Guide of Forest Lawn Memorial Parks* (n.d.), pp. 65–75.

20. Humphrey Jennings, the film maker, Surrealist poet, and painter, was fascinated by Martin's satanic imagery and planned a book on the theme of Pandemonium and the impact of the Industrial Revolution.

21. *Arnold's Magazine of the Fine Arts*, vol. iii, no. 2 (Dec. 1833), p. 101.

22. Formerly coll. T. Balston, Victoria and Albert Museum.

23. See 'Comic Strips', *Colloquium zur Theorie der Bildergeschichte in der Akademie der Künste Berlin* (Berlin, 1970), p. 54.

24. 'A story on canvas was never better told', *The Fall of Nineveh*, described in *Public Characters*, vol. ii (1828), p. 144.

25. *Illus. Lond. News*, 25 Feb. 1854, p. 246.

26. Galt, *The Wandering Jew* (1820), p. 438.

27. Much of the material was drawn from Tissot's Bible; from the sets for Gabriele D'Annunzio's spectacular film, *Cabiria*, which opened in New York in 1914; and a painting of *The Fall of Babylon* by Georges Rochegrosse, exhibited in the Paris *Salon* of 1891. See Bernard Hanson, 'D. W. Griffith: Some Sources', *Art Bulletin*, New York, Dec. 1972, pp. 493–511.

28. *Intolerance*, subtitle to shot 939, quoted Hanson, art. cit., p. 508.

29. Cecil B. de Mille's two versions of *The Ten Commandments* (1923 and 1956) include sequences of the parting of the Red Sea which exactly correspond with the viewpoint in Martin's mezzotint *Illustrations of the Bible*.

30. *A Descriptive Catalogue of Pictures now exhibiting at the Egyptian Hall* (1822), p. 24.

31. Wise, *Bibliography of Byron*, vol. ii, p. 101.

32. *The Story of the Making of 'Ben Hur'* (London, 1959), p. 28.

33. Martin, 'Plan for Ventilating Coal Mines', *Report of Select Committee on Accidents in Mines* (1835).

34. *A Description of the Picture Belshazzar's Feast* (1821).

35. Ruskin, *Stones of Venice* (1853), *Works*, vol. ix (1903), p. 448.

36. *Arnold's Magazine of the Fine Arts*, vol. iii (Dec. 1833), p. 100.

37. Galt, *The Wandering Jew*, p. 298.

38. *A Description of the Picture Belshazzar's Feast* (1821).

39. *Paradise Lost*, xii.553–60.

Bibliography

Martin's Autobiographical Notes appeared in the *Athenaeum*, 14 June 1834, p. 459, and *The Illustrated London News*, vol. xiv, 17 Mar. 1849, pp. 176–7. A 'Memoir of John Martin Esq.' in the *European Magazine*, Sept. 1822, was probably vetted by him; a rather less accurate study was published in *Public Characters of the Present Age*, (2 vols., Knight and Lacey, London, 1828), vol. ii, pp. 133–44. Leopold Martin, 'Reminiscences of John Martin K.L.', published in the *Newcastle Weekly Chronicle*, Jan.–Apr. 1889. This memoir was not published in book form.

Thomas Balston, *John Martin, 1789–1854: His Life and Works* (London, 1947) contains exhaustive lists of Martin's pamphlets and prints. Balston's interleaved copy of this book (V. & A. Library) contains further material collected up to *c.* 1963.

Mary L. Pendered, *John Martin, Painter. His Life & Times* (London, 1923) contains biographical material from the diaries of Ralph Thomas which subsequently disappeared (see Balston, *John Martin*, p. 293) and letters and information supplied by Martin's grandchildren.

Thomas Balston, *The Life of Jonathan Martin with some account of William and Richard Martin* (London, 1945) is based on Jonathan Martin's autobiographical publications and on William Martin's pamphlets, many of which are in Newcastle upon Tyne Public Libraries, together with manuscript material.

Ruthven Todd, 'The Imagination of John Martin', in *Tracks in the Snow: Studies in English Science and Art* (London, 1946).

Exhibition catalogues:

Tyneside's Contribution to Art, 'Gallery C. John Martin', Laing Art Gallery, Newcastle upon Tyne 1951 (Introduction and notes by Thomas Balston).

John Martin, Whitechapel Art Gallery, London, 1953 (Foreword by Thomas Balston, and 'The Art of John Martin' by Eric Newton).

John Martin, Artist—Reformer—Engineer, Laing Art Gallery, 1970 (Introduction by William Feaver, catalogue notes by Nerys Johnson).

Index

252

256